High Art Down Home

High Art
Down Home

An Economic Ethnography
of a Local Art Market

Stuart Plattner

The University of Chicago Press
Chicago & London

STUART PLATTNER is director of the Program for Cultural Anthropology, National Science Foundation. He was formerly professor and chair of the Department of Anthropology at the University of Missouri-St. Louis and is a founding member and former president of the Society for Economic Anthropology.

The University of Chicago Press, Chicago 60637
The University of Chicago Press, Ltd., London

© 1996 by The University of Chicago
All rights reserved. Published 1996

Printed in the United States of America

05 04 03 02 01 00 99 98 97 96 1 2 3 4 5

ISBN: 0-226-67082-1 (cloth)
 0-226-67084-8 (paper)

Library of Congress Cataloging-in-Publication Data

Plattner, Stuart.
 High art down home : an economic ethnography of a local art market /
Stuart Plattner.
 p. cm.
 Includes bibliographical references and index.
 ISBN 0-226-67082-1 (cloth). — ISBN 0-226-67084-8 (paper)
 1. Art—Economic aspects—Missouri—Saint Louis Region. 2. Art—
Missouri—Saint Louis Region—Marketing. 3. Art—Collectors and
collecting—Missouri—Saint Louis Region. I. Title.
 N8600.P59 1996
 306.4'7—dc20 96-14864
 CIP

⊗ The paper used in this publication meets the minimum requirements of the American National Standard for Information Sciences-Permanence of Paper for Printed Library Materials, ANSI Z39.48-1984.

For Phyllis, Jessie and Dan

The love and appreciation [of art] is practiced everywhere, and the world treats it as merchandise and bribes; this is indeed a fault of our age.

Cai Tao, Chinese scholar, twelfth century (Alsop 1982, 146)

There is a time line one can draw from cave paintings from Lascaux, in southern France and Spain, to what you are seeing in the Whitney Biennial and what people are writing about in *Art Forum, Art in America, Art International*. . . . Now the center, the international center, for this is New York. . . . Most of the people in St. Louis are not working, consciously working, within this format. . . . Most of the ideas of the people who are working in a city like St. Louis, or anywhere out of the center, are things that they want to be doing. They are not consciously striving to be in the Whitney Biennial next year, or to show at the Carnegie International. They mostly are doing their own thing.

St. Louis dealer

Contents

Illustrations

Preface

Personal History in Art and Anthropology

This is a book of economic anthropology about the contemporary high-art market in a major midwestern city. The goal of the book is to introduce readers to an art market like the majority of places in the country situated below the New York apex. Readers will learn about the economic behavior of artists, dealers, and collectors—the principle triad of the art market—as well as critics and curators, through exposure to their relationships, goals, successes, and frustrations. The main point of the book is that the market for contemporary museum-quality art is a contradiction, always teetering between the heaven of aesthetic theory and practice and the hell of invoices and utility bills.

Since anthropologists usually write about more exotic places and situations, I should explain my interest and experience in the subject of contemporary local art markets. Throughout my childhood everyone thought that I would be an artist. I attended a professional art school, the Cooper Union in New York City, majoring in fine art—in painting. Upon graduation in 1958 I did not want to confront the difficulties of earning a living as a fine artist, so I worked as a commercial artist in advertising and textile design. After a few years I went back to school as the first step on a path to a Ph.D. in cultural anthropology, completed in 1969, with a specialization in the economic behavior of people in peasant marketing systems.

Through the years I studied how people make economic decisions under conditions of relative scarcity and lack of information. At the same time I watched my wife and old friends invent careers as professional fine artists. This meant that they learned to run tiny businesses out of their homes, with no prior training and, sometimes, no aptitude. Artists are taught to make art, not to run businesses, and those who are overtly businesslike are regarded by their peers with suspicion, disdain, covert envy, and other unpleasant emotions. Artists were curious to me because they worked so hard for so little income yet felt conflict about receiving money for their work. I resolved to do a study of the business of art.

Fieldwork in St. Louis, Missouri

My opportunity came in 1992 when I became eligible for a long-term professional-development leave from my employment at the same time that my wife was invited to be a visiting professor at the Washington University School of Fine Arts in St. Louis. We had lived in St. Louis from 1971 to 1985, during which time she had taught art part-time at Washington University and had exhibited and lectured on her work in local galleries and museums. She was well known in art circles, so I had access to key people. Of the 140 people I asked to interview, only 3 refused (a couple of others never returned my calls). I could not have succeeded in interviewing so many different people if they had not known me or my wife and been familiar with her artistic reputation.

The 137 formal interviews that this book is based on were conducted from September 1992 through July 1993. Each interview took between one and two hours. I discussed my intention to write a book about the St. Louis art market and assured respondents of confidentiality in the written material. A bit more than half of the interviews were recorded and later transcribed; the rest were transcribed during the interview. During this time I also attended numerous art functions as a "participant observer," the classical anthropological field method.

In a broader sense, I've been a participant-observer in the U.S. professional art world since 1958. My friends from the Cooper Union had followed the career path of artists during this era, meaning that most became academics to support themselves while trying to "make it" with their art in the relevant local and national market. A few succeeded in supporting themselves and their families from the sale of their art; some switched careers, as I did, while others lived the academic life. I hope this book does not disappoint them.

Method

I describe the nature of a local contemporary art market the way a realist painter would depict a landscape. Like an artist, my goal is to represent reality by applying disciplinary methods through a personal focus. Someone else studying the same subject at the same time might produce a different work, perhaps more heavily weighted toward local history or aesthetic theory. While the reality is multifaceted and this study concentrates on economic behavior, this book does not have a narrow focus. Anyone interested in the contemporary fine-art world will enjoy learning

about the St. Louis case because it is so normal, and because the book has the generalist perspective demanded by the ethnographic method.

The interviewees were selected in order to cover the issues I thought were important, such as seniority, gender, race, and position in the local art hierarchy. The set of sixty-five artists interviewed, selected from a list of approximately eight hundred in St. Louis (see chap. 4), is heavily weighted toward the fine-art and professional-artist end of the spectrum—which I call *avant-garde*. I did not draw a random sample of artists because I already knew the important types to interview, and I wanted to interview the representative, interesting individuals among those types. Therefore, I have not given distributional statistics about the sample of sixty-five artists interviewed. I am reasonably certain that my roster of about eight hundred artists is complete and can be generalized from. A random sampling would focus much more on hobbyists, craftspersons, and on designers and commercial artists, since they form a much larger part of the total than is represented here.

Interviews have been assigned a number code, given after each quote or sequence of quotes from the same person. The interview tapes and transcriptions are available to serious researchers who can satisfy my concerns about the protection of the respondents' privacy.

The material in this book is my personal responsibility and has not been approved or disapproved by the National Science Foundation.

Outline of the Book

The introductory chapter discusses the themes of differentiation and hegemony in the art market, the paradox of art as commodity versus art as cultural capital, and the social construction of value in the art market. The value of ethnography is to show how these general issues are exemplified in the particular, and how global themes are adumbrated in local realities. The key ethnographic strategy is to understand local context, and the starting point for that is history and place.

Chapter 2 summarizes the historical context that set the stage for contemporary art world actors. The phenomenal boom of the 1970s and 1980s and the bust of 1990 provide the historical backdrop against which people act, although the chapter points out that critical features of the contemporary scene are direct outgrowths of the impressionist revolution in the art world in the latter part of the nineteenth century.

St. Louis as a place is introduced in chapter 3, which describes the cultural geography of the city and introduces the major public institutions,

including museums and artist societies. St. Louis is the seventeenth largest metropolitan area in the United States, ranked by population. It is big enough to have practically every cultural institution one would want, but too small to have more than one of each.

Artists, dealers, and collectors are described in chapters 4, 5, and 6. The description of their life strategies and situations, relations, and expectations, both positive and negative, forms the heart of the book, giving ethnographic richness to the abstract issues introduced here.

Chapter 7 summarizes the theoretical issues covered and generalizes the relevance of the material. Transactions in the U.S. art market are compared to those in peasant markets, because of the asymmetrical information available to both parties in the transaction. Reliance on personal relations and trust is a common thread in transactions where the risk of losing is high and the cost of information to lower the risk is unacceptable. Finally, the pros and cons of living one's life in the St. Louis art market are summarized.

Acknowledgments

My primary debt is to my wife, Phyllis Baron Plattner, with whom I've discussed art and anthropology for over thirty years. She gave me the benefit of her editorial criticism while I was writing this book, but the opinions expressed are my own. If I have inadvertently displeased any member of the art world, they should understand that I am responsible, not Phyllis.

The National Science Foundation through its Long Term Professional Development and Independent Research Plan programs allowed me to work on this project. Richard Louttit was my Division Director when I began, and his encouragement, support, commitment to excellence, and clarity of purpose were inspirational.

Frank Cancian read an early version of a few introductory chapters and made extremely valuable comments. I am also grateful to the colleagues who attended the 1995 Society for Economic Anthropology meeting in Santa Fe, New Mexico, for their critical reactions to a paper on some of the material in this book.

I am grateful to the many people in St. Louis who agreed to help me by giving me their time and expert opinions: Barry Ames, Michael Ananian, Dan Anderson, Ken Anderson, Leon Anderson, Adam Aronson, John Baltrashunas, Rick Barchek, George Bartko, Alexandra Bellos, Dominic Bertani, Ernestine Betsberg, Steve Boody, Gretchen Brigham, Jan Brod-

erick, Mary Brunstrom, Jim Burke, Tim Burns, Carol Carter, Norm Champ, Bill Christman, Elizabeth Cohen, Jennifer Colten, Tim Curtis, Stephanie Davis, Blane De St Croix, Joe Deal, Patsy Degener, Roger DesRosiers, Dick and Denise Deutsch, Dion Dion, John Donoghue, Hans Droog, Yvette Dubinsky, Bob Duffy, Gilbert Early, Michael Eastman, Sue Eisler, Gail Fischmann, Linda Gibson, Gary Godwin, Terry Good, Jeanie Greenberg, Ron Greenberg, Sue Greenberg, Clay Greene, John Greene, Vernon Gross, Dan Gualdoni, Dawn Guernsey, Gene Harris, Lucy Harvey, Bill Hawk, Ginny Herzog, Leon Hicks, Leonard Hines, Gene Hoefel, Michael Holohan, Gerald Ieans, Stan Jones, Hal Joseph, Mary King, Helen Kornblum, Nancy Kranzberg, Lucian Krukowski, Jane Lander, Ron Leax, Joseph Losos, Fifi Lugo, Esther Lyss, Peter Marcus, Mitchell and Joan Markow, Mary McElwain, Jim McGarrell, Jill McGuire, Jay Meier, Mel Meyer, Carolyn Miles, Betsy Millard, Earl Millard, Terry Moore, Betsy Morris, Kim Mosley, Bill Nussbaum, Jennifer Odem, Robert Orchard, Arthur Osver, Gary Passanise, Robert Powell, Emily Pulitzer, Duane Reed, Jim Reed, Dan Reich, Nancy Rice, Eleanor Ruder, Michael Sanders, Jane Sauer, John and Luray Schaffner, Jack Scharr, George Schelling, Jim Schmidt, Pat Schuchard, Martin Schweig, Ray Senuk, Bill Severson, William Shearburn, Horty Sheiber, Mary Ellen Shortland, Shirley Simmons, Nancy Singer, Linda Skrainka, Beej Smith, Elliot Smith, Vernon Smith, Stan Soloman, Mary Sprague, Marian Steen, Robert Stein, Patience Taylor, Steve Teczar, John Thomas, Sissy Thomas, Ron Thompson, Harriet Traurig, Nancy Triplett, Jean Tucker, Joseph Tucker, Liz Vann, B. Z. Wagman, Peter Wallach, Denise Ward-Brown, Mark Weber, Roseanne Weiss, Don Wiegand, Jerry Wilkerson, Rodney Winfield, Charlie Wylie.

The list presented is not complete: some people asked not to be listed. I thank them just the same.

1 / Introduction

I am very hesitant to go into a gallery and buy pictures because I don't know whether I'm being cheated or not, and . . . I find you have to bargain, and I hate that. I'm a poor bargainer, because I really don't know the values. [A dealer] said, "Well, we don't do that [bargain] at all. Ours is a fixed price." So I said, "Ah, finally, an honest dealer!" So . . . I went into his gallery, and . . . [he] pulled out some things and showed me. And I said, "How much is this?" And he said, "Well, that's normally three thousand dollars, but for you, two thousand dollars." And I thought, "Oh, shit! Another god-damned thief."

St. Louis collector

In the summer of 1990 Vincent van Gogh's *Portrait of Dr. Gachet* was sold at Christie's New York auction house to a Japanese buyer for $82.5 million.[1] It is truly ironic that this was the highest price ever paid for a work of art, because van Gogh was the prototypical modern artist: marginalized by society, fiercely devoting all of his energies to making his uniquely personal art, emotionally tortured (Dr. Gachet was the physician who watched over him in the months before his suicide) (fig. 1). Although van Gogh's brother Theo was an art dealer in Paris during the 1880s, Vincent's paintings never sold,[2] and he lived and died in poverty. Van Gogh's marginalization, poverty, intense commitment to his art, and lack of market success during his lifetime are cherished facts to contemporary artists. No matter how difficult their own career, they can rationalize to themselves, friends, and family that van Gogh had it worse.

Members of the international art market were astounded at the price paid for *Dr. Gachet*. The tide that produced a fabulous price for an important van Gogh also raised the prices of mediocre art to unprecedented levels. The market seemed overheated and due for a correction, and the bust, in fact, came in the same year. The big-spending Japanese withdrew, speculative buyers in the United States lost money, sales decreased, dealers went out of business, and artists who had been living off their painting sales began looking for teaching jobs to pay the rent.

While this drama was being played out in New York, London, Paris, and other art market centers, another, parallel reality coexisted "down

I

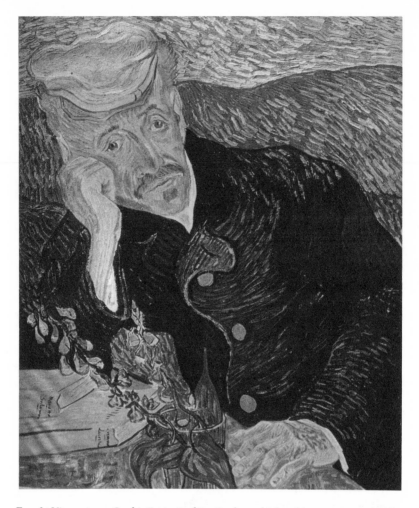

FIG. 1. Vincent van Gogh's *Portrait of Dr. Gachet*, which sold at auction in 1990 for $82.5 million. The artist died a miserable death about a hundred years before, having been a commercial failure in his lifetime.

home" in the wider society. Artists who were not fabulously successful, dealers whose average sale was less than one ten-thousandth of *Dr. Gachet's* price, and collectors who wouldn't dream of owning an original van Gogh lived their lives in the context of regional art markets.[3] This book describes one such market, the contemporary fine-art world in St. Louis, Missouri.[4] St. Louis is one of several dozen medium-sized cities

with lively art markets where most of the nation's artists, dealers, collectors, critics, and curators of contemporary fine art live.

Such regional markets exist in the hegemonic shadow of New York. The geographic distance implies a drop in value: the work of regional artists is appreciated less than the same art would be if it were created in New York, by the same artists. Art created in a regional market, "not in New York" (or "not in Paris," or "not in London"), suffers a devaluation of its perceived quality *at home,* independently of the objective qualities of the work, simply because it is not in the hegemonic center. Robert Hughes, art critic for *Time* magazine, calls this self-denial of artistic value "cultural colonialism," meaning "the assumption that whatever you do in the field of writing, painting, sculpture, architecture, film, dance or theater is of unknown value until it is judged by people outside your own society" (1990, 4). He describes growing up as an artist in Australia, suffering the reflexive "cultural cringe" of "demanding of yourself that your work measure up to standards that cannot be shared or debated where you live" (4). This is the situation for most art market actors all across the country, if not the world, and the material in this book can be generalized to all such representative local communities wherever they exist. The first of this book's major themes is the brute fact of New York's hegemony and the ways art market actors deal with their peripheral status.

To drive home the idea of hegemony: it seems clear that most of the thousands of art world actors *in* New York have more in common with their St. Louis counterparts than they do with the well-publicized, but extraordinarily few, art stars represented in the national media. Work by the common artist in New York is not represented in elite galleries, and such artists have no chance of earning an income from the sale of their work. Even those *in* New York are socioeconomically *far* from the centers of art market power—the few elite galleries and museum shows that define the state of the art (see Rosenbaum 1993; Solomon 1993). These are the "real people" in the art world.

The value of knowing about down-home art worlds is that they form the base of the pyramid topped by New York. While the "New York scene" is glamorous, it is also atypical, in the sense that the majority (over 80 percent by census figures) of art market actors do not live in the New York, Los Angeles, or Chicago centers. The art world most people in the country interact with is much more like St. Louis than New York. This book shows what the real world is like for most art world actors.

Defining Museum-Quality Fine Art

This study focuses on "museum-quality" visual artworks. These are most often paintings or sculptures that could conceivably be shown in the contemporary art section of an art museum. Fine art has a remarkable status in contemporary society. While most of the artwork sold in the world costs less than five thousand dollars, prices can be fabulous. Paintings by a select few living artists can sell for hundreds of thousands, in some cases millions, of dollars. The auction market alone reached $3.6 billion in 1990.[5] Attendance at art museums reached 164 million in 1992 and has increased since then. While elitists may quibble that museum visitors are only interested in populist blockbuster shows, or that the visitor statistics are inflated by large groups of school classes herded through, the fact is that people are visiting art museums in record numbers.[6] Such is the evidence of high art's importance in society.

Individuals who are known for their practical tough-mindedness and successful economic dealings spend immense sums of money and speak metaphysically about art objects, recognizing that they possess real power to affect their personal lives. Charles Simpson, a sociologist who studied the SoHo art community in New York, points out that high art renews "the vision of civilization" and revitalizes society (1981, 6). Simpson justifies art's unique status in grand terms.

> The art community, producers and informed audiences, believes that aesthetically successful new imagery pushes the horizons of reality away from us all, expanding civilized consciousness. Should the process of creating new vision cease, should the fine-art challenge go unmet, then the world would become visually finite. It would be as if civilization, having trod a path inscribing reality, were to confront again its own footprints and the realization of the closed nature of that reality. (1981, 6)[7]

As melodramatic as this may sound to those unconnected to the art world, it is a realistic figure of speech for people involved in fine art. It justifies the hype and high prices, since expanding our cultural capital is as important as providing food and shelter—more important, some would argue, since art gives meaning to material survival. Fine art is similar to religion, then, as an institution that counteracts the crassly commercial search for advancement in a capitalist world. At the same time, these objects of supposedly sublime vision are bought and sold as commodities. But art is a strange commodity: aesthetic excellence does not necessarily

make for marketability. Work that experts agree is high-quality, significantly avant-garde art does not always command high prices, and often is not salable at all. This paradox is the second major theme of this book: fine-art objects are valued by two different, sometimes contradictory appraisal systems, one of art-historical connoisseurship and one of commodity marketability.

In an age of conceptual, minimal, and performance art, it is often unclear what museum-quality high art is supposed to look like. All sorts of things are exhibited in art museums. In March 1993, for example, the St. Louis Art Museum showed "self-portraits" consisting of pieces of canvas that the artist had laid at the door to his studio for a month. The canvases had vaguely defined scuff marks that, the curator wrote, revealed

> the footprints, and thus the presence, of those (artist included) who entered and exited the artist's studio. Traditionally a self-portrait records the artist's "character" or "essence." With these works [the artist] has left such obvious metaphysics behind by concretizing time and making objects of his experiential, not physical, self. (Wylie 1993)

What is a humble ethnographer, seeking to delimit the field of study of the fine-art world, to make of these sorts of art objects and this sort of "art speech"?[8] It reminds one of those exotic ethnographic situations where a reasonable informant reports fantastic facts, as, for example, when a Mexican peddler told me in 1967 that he had wrestled with a supernatural witch-spirit in his backyard. The anthropological strategy is not to impose a viewpoint or set of standards on "native" cosmology. We study the world as we find it and try to make sense of what exists. It seems impossible, at this postmodern moment in art history, to define in philosophical or aesthetic terms the formal physical characteristics of high art in such a way that a well-intentioned, intelligent, educated observer who was not expert in the art world could apply the criteria without error. This introduces the third broad theme of this study: the social life of fine-art objects is in large part independent of their objective physical qualities.

It is the art critic's job to distinguish fine work from junk. Robert Hughes, for example, is sharply critical of art he considers to be bad (1990). But for every authoritative pronouncement that contemporary art by hot names such as Jean-Michel Basquiat, Jeff Koons, and Julian Schnabel is trash—that the emperor has no clothes—there is an equally authoritative assertion of the art-historical significance of the same work

(e.g., see Littlejohn 1993). And the auctions, which have the legitimacy of published prices behind them, suggest that this sort of art must be significant because its price keeps going up (at least until the 1990 crash). In any case, no critic, art historian, or sociologist of art has proposed an objective theory that has any general acceptance to distinguish "really important" from "merely trendy" fine art.[9]

This study follows the sociological practice of defining museum-quality art as the work shown in places that are commonly identified as dealing in high art (Becker 1982). This is a circular definition: "What is high art? That which is shown in places that show high art." This merely shifts the problem to defining high art *places,* but there is much more agreement on these. A definition is only a tool, and this one has the virtue of allowing us to get on with the job of studying the behavior of people in the art world without getting bogged down in the seemingly impossible philosophical task of defining what fine art should be.[10]

High Art versus Low Art

People in all contemporary urban societies are differentiated in wealth, education, and power. The "high" fine arts that aim to advance our cultural vision are appreciated primarily by social elites, in contrast to "low art" that appeals to the masses, a fact that makes most artists who think about it fairly uncomfortable.[11] While only an insignificant proportion of all the wealthy and powerful people in any society are active art supporters, these few become the leaders in the art world through their support of avant-garde art (cf. Halle 1993 on the taste of the elite). Popular art by definition appeals to a mass market and so does not need the support of connoisseurs. This section argues that the connection of fine art with elites predetermines the stratification of art markets as well as the domination of New York and other major centers, since elites are oriented toward financial centers.

The nominal criterion for high art is some meaningful contribution that advances our cultural vision. The other end of the continuum of art objects is purely decorative work that, if it found its way into a museum, would be in the "popular culture" section. "Low" art refers to such work or to functional crafts with no pretense of a transcendental effect on the viewer (see appendix 2). The important distinction is between art that makes a personally valid statement and that which is pure decoration or has practical utility.[12]

While the specifics of artistic merit are contested by workers in differ-

ent media, there is agreement that high art should give the knowledgeable viewer a "transcendental" aesthetic experience that can change the way the viewer looks at reality. This sort of art is often challenging to the average viewer, difficult to interpret, and sometimes ugly, confusing, or otherwise upsetting. For the connoisseur, high art can stimulate intense emotional and intellectual responses. This book will show that people often love the art that they buy, in the serious meaning of the term. Something that is merely decorative cannot help one to see the world differently and cannot change the appreciation of reality, as high art can for those few with the educated capacity to appreciate it. The long shadow of the impressionists, whose work was considered outrageous in the beginning but now looks comfortably pleasant is additional justification for accepting contemporary work that looks outrageous, and downgrading contemporary work that is pleasant to look at or "accessible" (this will be discussed in chapter 2).

High art is an elite, middle- and upper-class consumption good. Sociologists like Bourdieu (1984), Gans (1971), Halle (1993), Lamont (1992), and Peterson (1976) have studied the nature, transmission, and boundaries of the "cultural capital" needed to appreciate fine art. The usual prerequisite is a good education, with the income that implies. While that is true in general, this book will show wide variation, with some significant art market actors coming from backgrounds with absolutely no hint of artistic preparation.

All art markets are stratified. The low end is defined by frame shop galleries and art fairs, selling mass-produced posters or original work that appeals to the most popular taste. These galleries tend to be located in suburban shopping malls or local neighborhoods, although they can be found adjacent to the most elite galleries. The level is defined by the quality of the work, not by the prices. Many low-art works sell for prices greater than those paid for high art. For example, most elite art market actors would rate Norman Rockwell's or LeRoy Neiman's work fairly low in aesthetic value, but their paintings are worth far more than the work of most high-art painters. This is part of the paradox of fine art: aesthetic excellence does not necessarily correlate with price.

The high end of local markets is composed of dealers and more restrictive art fairs selling museum-quality art. While elite galleries tend to imitate the industrial-space look of New York galleries, there are again many exceptions to any rule. The highest end of the national market is composed of a small set of gatekeeper galleries in New York, and the secondary

market of elite auction houses, such as Sotheby's and Christie's.[13] The auctions are significant because they publicly announce the prices of the most valuable work. Sotheby's and Christie's accept only work judged to be of significant art-historical or investment-grade quality that has an assured market. The very presence of work at auction is thus a validation of the work's status.

The major themes of this book have been introduced: the hegemony of New York in the national (if not the international) art world, so that New York defines what is interesting and significant; the paradox of contemporary art's high cultural value and unpredictable commercial worth, whereby art selling for what seems to be an outrageously inflated price and art that is unsellable look the same, while both are said by experts to be important works; and the social construction of fine-art value that makes the social setting of a work paramount over its physical characteristics. These themes are set into a broader theoretical context in the following sections.

New York's Hegemony in the National Art Market

Anthropologists have long been concerned about hegemonic relations between the peripheral local communities we have tended to study and the distant centers of power that dominate them (Wolf 1982). This book shows that hegemonic relations are as relevant to life in an elite institution in the heart of the most powerful nation in the world as they are to the poor in the less developed world.

The national market is centered in New York City, meaning work is sold there to buyers in all other places in the nation and the world. Although Los Angeles, Chicago, San Francisco, Santa Fe, and other centers have large demand areas also, New York is *hegemonic* on the national and even the international level, meaning that only elite-gallery exposure in New York creates art-historical significance. It is not just that New York has the largest market, but that it has controlled the definition of "interesting" or "important" art in the entire country. It is home to the major national art magazines, and when the writers and editors look for art to write about, they find little need to go past Manhattan's borders to the other boroughs of the city, still less to leave the city to see the art of Washington, Minneapolis, Dallas, or St. Louis.

A senior painter in St. Louis described the importance of New York.

I believe it does help your career to live in New York because that's where the writers are and it's where everybody else from

every other place goes. In fact, . . . my dealer told me very early on, he said, "You know, you would make it a lot more . . . if you lived in New York because then you get to know people, people get to know you. When they meet you at a party, they get interested in your work, or if they get interested in your work, then they want to meet you, and that enlivens their interest." And particularly that's true of the writers. If the writers start writing about your work, then everybody gets interested. . . . The important writers are going to be there because that's where most art is. There's no substitute for it. (Int. 6)

New York's hegemony is strongest for paintings, weaker for photography, and weakest for crafts, but it exists throughout the market. One behavioral measure of this regional stratification is that New York dealers often send their artists' work to dealers in other places, but dealers in smaller cities have more difficulty sending their local artists' work to New York galleries.

Regional, Local, and Sectoral Markets

The national art market is a network of many regional systems ranging from single metropolitan areas like St. Louis to regional groupings of several local markets like "Southwestern art" or "Bay Area art." Each local market has its own demand area, where most buyers live. Insofar as people who come to the area from other places buy art there, the local market may have a distant hinterland. New York's market area would include most of the world; Los Angeles's, San Francisco's, and Santa Fe's would include most of the country; St. Louis's would include southern Illinois, Missouri, and parts of Arkansas.

The national market is composed of fixed retail galleries and dealers (many of whom work out of their homes), wholesale distributors of prints and multiple editions, a wide array of advisers and consultants who provide art services to businesses and institutions (ranging in size from professional corporations to home-based operations that are really adjuncts to a person's collecting activities), and an extensive network of art fairs. Art fairs form a complex submarket, numbering in the hundreds, if not thousands, and ranging from low-level crafts to the highest-level art drawing dealers from all over the world.

The spatial geography of markets is cross-cut by networks of artists, dealers, and collectors interested in particular genres of work, such as fiber art, African-American art, "outsider" art, and so on. Since the work

FIG. 2. A frame shop gallery that sells "wearable art," meaning jewelry and hand-made clothes, as well as paintings, prints, sculptures, and ceramics.

sold in each is not directly substitutable for the other, price movements in one submarket are not smoothly reflected in the other markets. But the markets are ultimately connected, since the work is indirectly substitutable. Print collectors may shift to paintings, or African-American art buyers may broaden their taste to nonminority art, and glass collectors may shift to sculpture or paintings, or vice versa.

Price movements in New York affect prices in local or regional markets with a significant lag and diminished impact. Prices don't rise or fall as far or as fast in regional markets as they do in New York. Neither the boom nor the bust (described more fully in chapter 2) hit St. Louis as hard as it did New York.

Each local area has a stratified set of places to show art, graded from high to low. In St. Louis, the St. Louis Art Museum is the most prestigious place to exhibit art, whereas neighborhood outdoor art fairs or frame shop galleries are the bottom. A graded array of places including private dealers and public locations exists in between (fig. 2).

This section has discussed how differentiation is integral to art markets. At every level, in every region and sector, actors try to claim higher status and contest attributions of lower status. The collector of Erté[14] or Norman Rockwell will claim the same status as the collector of Louise

Bourgeois or the grittiest avant-garde art and will resist any attributions of low taste. The lack of any accepted criteria of quality and the differentiation of the market into many sectors, each claiming higher status, means that prices are not necessarily a guide to art-historical standing. Thus the buyer must beware. Each art object is unique, so standardized prices do not exist. Even when the physical object is an ordinary item of mass production, the artist's signature can distinguish it as art and inflate its value—for example, the shovels and latrines exhibited as art by Duchamp in the early twentieth century or the contemporary work of Jeff Koons. The chance of making foolish purchases means that the art-buying transaction is complex and risky. It calls for an economic analysis that rises above the mere focus on price to consider social and cultural issues. This is where economic anthropology is most useful.

Economic Anthropology

Economic transactions are social events. As a work of economic anthropology, the book follows the tradition of studying how people solve their normal economic problems to make a living or accomplish their long-term social goals. The typical economic anthropologist explains why transactions that seem strange by Western, capitalist standards are reasonable once the local cultural context is understood. The paradigmatic case is the woman in a developing country who refuses to sell her bushel of produce to a foreigner for a fabulous sum of money. An outsider might interpret her refusal as an uneconomic act (or an economically irrational decision), perhaps a preference for socializing in the marketplace over earning a higher income. The more locally informed view understands her need to be a reliable supplier for her customary trading partners. The one-time windfall would harm her chances of long-term survival because it would injure her reputation as a reliable trading partner—that is, her position in an enduring pattern of social relations (Granovetter 1985; Plattner 1989, 213). This is not to say that all acts are economic, but that seemingly irrational economic decisions may be sensible solutions to hidden economic problems. The key notion distinguishing an anthropological from a purely economic analysis is community, of people acting in social and cultural contexts with a past and a future, and not as isolated short-term decision makers.

Economic anthropology has not only taught us that apparently uneconomic behavior may follow economizing principles, but has also pointed out that overtly commercial institutions have ceremonial, religious, and

political causes and functions. After all, retail sales in the United States peak at Christmas time, and stores in many communities cannot sell liquor on Sundays because of the religious calendar, not because of any economic necessity (cf. Plattner 1989, chap. 1).

It is apparent to a student of art markets that the transactions between artists, dealers, and collectors have intriguing parallels to the behavior of peasant marketers. The critical role of trust and the embedding of economic dealings within social interactions are similar and derive from similar causes: a fundamental uncertainty about economic value. In the third world this uncertainty stems from shortcomings in basic social and economic infrastructure for communications, transportation, and contract enforcement and consumer protections, as well as variations in quality of goods produced with primitive technology (Plattner 1989, chap. 8). Poverty of infrastructure is certainly not a problem in the art market, existing as it does in the heart of the elite centers of power of modern capitalism. But the history of critical theory in art has resulted in a "postmodern" crisis of authority that has heightened risk in art market transactions, as will be discussed subsequently.

The art market is theoretically interesting because artists are not expected to act like economizing individuals, yet the goal of most artists is to subsist from the sale of their artwork without recourse to teaching or commercial work (see chap. 4). Although St. Louis is not as exotic as other places anthropologists study, the economic decisions of U.S. artists, embedded in the most commercial society in the world, may appear every bit as strange as those of the woman in a peasant market. Most artists who produce work aimed at the highest sector of the market sell only a small portion of their work. Simpson, in his study of SoHo artists, estimates that 94 percent of the artists in New York "are not . . . significant sellers" (1981, 58) Of the eight hundred or so artists I identified in St. Louis, roughly 1 or 2 percent earn a living from noncommissioned artwork alone. Singer (1990) found that only one out of three very select artists who began their careers with shows in the most elite national galleries were successful enough to have their work sold at auction. This study will show that the chances of success are far less for average artists.

Economic Models: Tournaments and Superstars

Some theoretical work in economics is helpful in explaining seemingly quirky economic decisions. The fact that fine artists are producers who for the most part work very hard for variable, insignificant payments, in a market where extremely few players receive enormous payments for

their work, does not make them unique. As in the case of the peasant market woman, the anthropological understanding looks at the long-term life strategies and goals of actors. Economists recognize this sort of behavior as similar to the model of tournament employment contracts (Lazear and Rosen 1981).[15] In this model employees at the highest end of the scale (such as chief executive officers of large companies) are not paid according to the value of their output or even their input, as traditional economic theory assumes. Instead they are paid an amount corresponding to their status, which they receive because of their rank order along a scale, such as executive position in the company. Lower-ranking workers are paid according to their productivity or effort, but the closer one gets to the top executive positions, the less the large salaries reflect easily measurable qualities. This makes the achievement of the top wage analogous to winning in a contest or tournament, where each worker competes against all others with similar credentials for the prize.

This model is relevant to the art market because it describes a situation of workers receiving payments that don't seem related to their input of effort. The model shows that it may be economically rational for companies to pay workers according to such a plan, and by extension for society at large to pay workers whose productivity is hard to measure yet important, as if they were engaged in a tournament. The crux of the model is that workers competing for the top level will accept relatively smaller wages in the short run in hopes of someday winning the lottery and getting the balloon prize. This maintenance of a dream of success seems to apply to fine artists, most of whom fantasize about being discovered and lionized. The level and quality of work input of serious artists—most of whom are workaholics—is not commensurate with their short-run art income. As chapter 4 will show, serious artists work so hard for many reasons, among them the dream of national success.

In another article Rosen discusses a model of the market for superstars, where some people—his image is of sports and entertainment stars and best-selling authors—reap gigantic payments for work that is not proportionally better than that of other slightly less talented producers in that field (Rosen 1981). Here the explanation for the size of the top payments is that the mass media distribution of the "product" (be it a sports or entertainment performance via television or print media) rewards small differences in quality with large increases in audience. Since audiences prefer higher quality, the better ("star") performances, although they seem to be extraordinarily expensive, easily dominate lesser performances in net revenue because of the mass demand and low distribution cost.

The Synergy of Consumer Capital

Lazear and Rosen's argument has been extended by Adler (1985), who points out that in situations where knowledge is a factor in the pleasure a consumer receives, such as the arts, stars can emerge who have *no* perceivable superiority of talent. Adler assumes that a consumer's knowledge is dependent on social learning, on discussing art appreciation with other like-minded consumers. For those types of art (e.g., performing arts) the more available the potential discussants, the easier it is for a consumer to amass more expertise, or "consumption capital," which increases one's enjoyment all the more. Adler argues that when an artist rises in popularity, on any grounds not necessarily connected to superior performance, it makes sense for consumers to patronize the more popular artist. The reason is that the larger the group of fans, the lower the synergetic cost of searching for knowledgeable discussants. As Adler puts it, "Stardom is a market device to economize on learning costs in activities where "'the more you know the more you enjoy'" (1985, 208).

Towse (1992) provides an empirical case study of these theories as they apply to the market for singers of classical music. She finds corroboration in the fact that

> people who know very little about opera will buy a record by a singer "they've heard of," in order to avoid disappointment; opera houses can always fill seats by performing "warhorses." . . . As there are many more people with a little knowledge, this explains why superstars have much bigger markets. (211)

Towse notes the key element in the theory deals with search costs for information, and she discusses the problem faced by opera companies looking for singers. The average company deals with significant search problems, since it must hire about three to four hundred principals a year and relies on a wide range of informational devices, from auditions and national competitions to agents and promoters.

Towse defines talent as a "bundle of services—voice, voice type, stage presence, physical appearance, musicianship, ability to work with others—and a 'talented' singer is one with the right combination at the right time" (1992, 213). Defined this way, she notes, talent is socially determined. Adler's concept of consumer's capital with synergistic interdependence between consumers implies that star singers, whose talent is widely known, attract large audiences and demand high fees. In performing art, the size of the fee can correlate with the cost of the ticket; hence consumers recognize that higher prices denote higher talent. Lowering an

established fee for a singer indicates waning talent, since the fee is a marker of demand for the singer's bundle of services. Towse notes that "at the bottom end of the market the result is that struggling singers cannot increase the demand for their services by lowering their fees, since all that indicates is that they are struggling! Instead of a lower fee stimulating demand, it will depress it" (214).

This is of course an economic paradox in a capitalist society, where lower prices are supposed to increase demand. It exists in the market for visual art also. A St. Louis artist recalled her dealer's pricing some work, saying (only half-jokingly), "Let's put it at twelve hundred dollars. If it doesn't sell, we'll raise it to eighteen hundred dollars" (int. 138). The explanation of such paradoxes is that art consumers mistrust their own judgment and use price as a measure of quality. In the absence of a well-defined set of rules for judging quality, price and how widely the work is distributed are taken as a signal of excellence.[16]

The superstar model is also relevant to the visual-art market, in that it describes a few producers earning the lion's share of the money spent on comparable products. It explains why museums will pay huge sums for artwork, since the cost is amortized over the huge audiences that the "art star" can attract. It explains why buyers in the private-dealer market hesitate to spend significant amounts of money for work that is not "museum quality," since they do not feel supported by a wide enough group of coconsumers (the visual-art standard is whether the art has "legitimacy"; see chapter 6 on collectors). Towse's argument about the disjunction between the price of a singer's services and the size of the singer's market reminds us that the standard economic relationship between price and demand often fails to hold for art goods: most artists cannot increase demand by lowering prices, because a reduction in price signals a reduction in demand, except for those with established markets. The basic reason is that art commodities are different from other commodities because average consumers can't discern quality from visual attributes alone; therefore, price works as a marker of quality (Veblen 1934; Liebenstein 1950).

Explaining the Price of Artworks

Just what is it that people buy when they buy an original work of art? A Mercedes-Benz is more expensive than a Mercury, its price *reflecting* its higher quality rather than *defining* it. Part of the price of a luxury car like a Mercedes, Jaguar, or Lexus may be due to the prestige of the brand name, but this is a minor portion of the cost. A consumer seeing another car without the Mercedes's status but with comparable physical features—a

finer finish, superior road handling, heavier-gauge metal, and so on—would certainly understand why it costs more than a Mercury. A similar consumer would have no idea why a watercolor by one artist is worth thirty thousand dollars while another artist's watercolor of comparable size, shape, coloration, and style is worth three thousand dollars and a third artist's worth only three hundred dollars.

Two German economists, Frey and Pommerehne, in a chapter titled "Why Is a Rauschenberg So Expensive?" tried to explain the variation in art prices (1989b, chap. 6; see also Schneider and Pommerehne 1983). They code auction prices for the works of one hundred "top" international contemporary artists in 1971–81, chosen by their high standing on several measures of accomplishment. Frey and Pommerehne's regression analysis explains the variation in the price of works of art by a complex factor they call the "aesthetic status" of the artist, estimated by coding the artist's style—pop art, op art, New Realism, and so forth—number of exhibitions, prizes awarded, years of experience, and past prices. Also coded in their regression analysis are the medium (sculpture, painting, graphics), quality of material, size of the piece, advertising activity of the gallery, the artist's past prices, real rates of return from stocks and bonds, the trend in per capita income, inflation, whether the gallery was avant-garde, and whether the artist was alive. Their regression accounted for about three-fifths of the variance, but the artist's past prices alone accounted for 60 percent of this outcome. Explaining current prices by past prices is reasonable, but not very enlightening about the causes of the past prices, which is the crucial question. The combined effects of the important non-price variables of style, history of exhibitions and prizes, and so on, explained less than 10 percent of the variance. While one may quibble about technical details of their analysis, Frey and Pommerehne have done about as well as anyone in identifying the major factors that determine high prices in contemporary art.[17]

Dealers and expert collectors—connoisseurs—understand the market forces determining price differences between works: the different history of museum shows, prizes, publications about the artist, and other separate factors studied by Frey and Pommerehne. Experts can estimate the effect of these factors on knowledgeable dealers' and collectors' interest in the work and willingness to pay the price. But this information is not readily apparent to an average buyer. There is a disparity in the information available to the dealer-seller and to the buyer of art that places the buyer at a disadvantage and allows prices to be used as signals of quality.

George Akerlof explained the importance of asymmetrical information in markets in a seminal paper in the economics literature (1970). Using the example of the used-car market, Akerlof pointed out that sellers of used cars know if the cars are lemons or cream puffs, but buyers don't. Two cars may be equally polished and have similar mileage, but the seller knows that the engine or transmission is bad in one car and good in the other. Since this knowledge comes from using the car, the buyer cannot know it, and so, being rational, the buyer will offer only the value of a "lemon" for any car. Since the seller of a cream puff knows the car is worth more than an average lemon and is equally rational about money, he or she refuses to sell at the price of a lemon. Thus the market fails in formal economic terms, since sellers and buyers meet but cannot come to terms.

However, we know that used cars are in fact sold, and Akerlof discusses several solutions to the apparent economic problem (see also Plattner 1985, chap. 5 and 1989, chap. 8). The solution followed in the art market is for collectors to establish personal relations with dealers as well as artists. But it takes time to personalize transactions. Since few people love art enough to spend the time to develop a relationship of trust with a dealer (let alone learning themselves what they need to know to make sensible purchases), the market for contemporary fine art is smaller than might be expected from the number of persons with levels of income adequate to buy art. This explains the common finding that art buyers are a small sector of the elite and of the middle class, many more of whom might be expected to appreciate art and want to use art purchases to validate their relative status (cf. Halle 1993, chap. 1).

In this section I have argued that artists with aspirations to art-historical significance—the high end of the art market—do not produce normal economic commodities. Art prices are not standardized across physical characteristics such as size and medium. Since collectors learn to appreciate art in a social process, their own aesthetic reaction to the work tends to be influenced by esteemed sources of information, such as other admired collectors, elite dealers, critics, and curators (each with a personal interest—aesthetic or economic—to further). Prices for art not of "star" status cannot function in the normal way, as manipulators of demand, since the consumer information needed to evaluate prices is hard to master. This creates the paradox that lowering a price does not raise demand, as is the case for normal commodities, but instead lowers demand.

Aspiring artists work hard for low incomes in hopes of winning the "tournament" of New York acclaim. The information asymmetry between

dealers and art buyers and the risk faced by buyers limits the size of the art market. These economic models of behavior, no matter how different from the usual models, are still based on the assumption that people act rationally in their own economic interests. Once the long-term and situational concerns of actors are understood, the apparent paradoxes are resolved.

Art as Commodity: Provenance

On the finger of a queen, the basest jewel is esteemed

The famous opera singer Luciano Pavarotti told reporters that he woke up one morning with an "unexplainable mania" to paint. His paintings and prints, although quite amateurish, have sold for several thousand dollars. Art reporters discovered that his painting of a bridge in Venice was copied down to the last (erroneous) detail from an art store how-to-paint booklet (fig. 3) (Muchnic 1993). The magazine reproduced the two images, which are practically identical. The original artist was not upset, since her book was meant to be copied. But she was bothered about the price paid for Pavarotti's copy of her image, complaining, "If anybody gets any money from my paintings it should be me."

What did the buyer of Mr. Pavarotti's painting get for the money? It clearly was not merely the experience of the image, since that image was of minimal aesthetic quality. It was not the art-historical value of the particular artworks in Mr. Pavarotti's oeuvre, since he had none. The price of the painting reflected the popular fame of the singer and had nothing to do with its aesthetic quality. The value was created by the painting's social-historical connection to the extraordinary performing-arts reputation of Mr. Pavarotti. The value of the work was not aesthetic but was comparable to the markets for memorabilia or signatures.

The documentation of ownership of a work of art is called its *provenance*. The term is normally used in the art world to describe the documentation whereby the history of ownership for a work is established, to affirm the work's authenticity (that it is not a copy). Provenance can be used to bolster a work of art's value by establishing its prior ownership by acknowledged connoisseurs. The value of a work of art is increased if the piece was selected by well-known collectors in the past. As one collector put it,

> A lot of the price of a work of art . . . was dependent on the provenance of the work. If it came from Nelson Rockefeller, the same

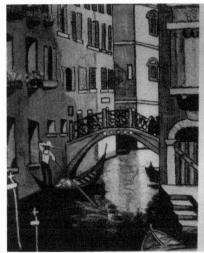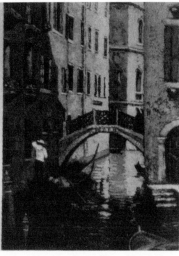

FIG. 3. Left, the great singer Luciano Pavarotti's painting of a scene; right, from a how-to-draw book. Pavarotti's name on the work added far more commercial value than merited by his painting's aesthetic quality. (Photograph courtesy of *Artnews.*)

> piece would bring a lot more money than if it came from Joe Smith from Clayton, Missouri. There is a line in one of the Shakespeare sonnets, "On the finger of a queen, the basest jewel is esteemed."[18] I've seen this happen commonly. (Int. 117)

The social-historical context of the thing, not the physical quality of the thing itself, determines its value. A current buyer thinks, "The previous owner's collection is famous for its high aesthetic quality, this piece was in that collection, so this must be a significant piece." As Pavarotti's artwork shows, the social-historical context gives value independently of aesthetic quality.[19] Most dealers will affirm that, for a majority of buyers, provenance is far more important than personal aesthetic taste in the decision to buy. From the collector's point of view, an esteemed provenance validates their own aesthetic judgment.

The Ultimate Consumer Good

The St. Louis Art Museum has a large installation piece by the contemporary German artist Kiefer that was rumored to cost a million dollars. Nothing in the work's materials explains the phenomenal cost; it is made

of lead, glass, and paint. Like the prices of most artworks, the price of the Kiefer has very little to do with its physical attributes (except for size—smaller works in an oeuvre are usually less expensive than larger pieces). High prices are usually due to the fact that other, competing, buyers would have bought it at that price, that is, pure market demand.[20]

Art is one of the few commodities (similar to antiques and other "collectibles") where the relationship between production cost and price is practically nonexistent.[21] As will be seen in chapter 4, high-level artists make art because they define themselves as artists—they must make art in order to survive as social beings. This contrasts with other professions, for example engineers, who practice their professions in order to make a living. If jobs in military microwave technology dry up, the engineer who transfers to consumer products is still considered an engineer. In contrast, an artist who gives up fine-art sculpture for industrial-model building or painting theater sets loses his or her essential self-definition. For this reason people retain the identity and keep producing fine art, even though their art incomes do not match their opportunity costs (they earn far less from art than they could earn from other jobs). To most fine artists their actual production costs for work are irrelevant, or else merely a constraint to be dealt with, rather than a key element in a strategy to make income.

Since the price of fine art is not related to its cost, the only remaining determinant of prices is demand. Art is the ultimate consumer good: its value exists almost entirely in the consumer's subjective appreciation of its aesthetic (visual) and market qualities as influenced by dealers, critics, collectors, artists, and a few others. The key factor influencing collectors' opinions is the perceived status of the artist in the relevant sector of the art market.

Demand: A Piece of the Oeuvre

As time goes by and the opinions of experts solidify in history, the relation between art-historical significance, aesthetic quality, and price stabilizes. The masters become distinguished from the merely popular painters. It is common to note that provincial museums tend to own third-rate works of such masters. It is easy to understand why they own lesser pieces, since their budgets are insignificant compared with the buying power of the major museums. But why buy an inferior piece at all, when there are so many good works by lesser-known artists? Collections that pretend to significance must display work of significant artists regardless of the narrowly aesthetic qualities of the particular work. The artwork

does not stand alone; it evokes the entire body of the artist's work. The aura of the artist's general position in the art world—determined by a lifetime of work—attaches to every piece, even the least significant. Thus a bad work by a great artist is worth much more than a great work by a bad artist.

The treatment of fakes illustrates the insignificance of a work of art's physical appearance if its relation to the artist's oeuvre is questionable. Although a fake may fool the eye, thus giving visual pleasure identical to the real thing, its lack of authenticity makes it valueless except as a curiosity. One collector told how he reacted upon learning that a piece he owned was a fake.

> I had several [artist X] watercolors bought at different places, and this was by far the most beautiful. Then came time we decided to sell it, and I sent it to Parke Bernet, . . . and . . . I get a telegram: it sold for five thousand dollars. Terrific, it should, that was about the market, it was a first-rate watercolor. The next day I get another telegram, "Question being raised about the authenticity." . . . They said, "We'll have to take it to the [artist X] museum, over in Germany somewhere, and they'll find out." They took it there, and they said, "This is a fake. What should we do with it?" I said, "If it's a fake, I guess you keep it. I don't care." They said, "The [artist X] museum wanted to keep fakes to show what was fake and what wasn't." So they kept it, and I never saw it again. (Int. 117)

This collector's extreme reaction, washing his hands of the piece to avoid further contact with something that he had thought was "by far the most beautiful" example of the artist's work, shows that his visual appreciation, however real, was legitimated by the piece's (presumed) historical connection with the artist. When this connection disappeared, his love for the piece vanished. These aspects of collecting will be dealt with in chapter 6.

This section has discussed how the price of an artwork is influenced by social and historic factors more than the physical nature of the work. The artist's position with respect to comparable artists in the relevant sector of the market is a primary factor in explaining prices. While the physical attributes of a work of art are not irrelevant—works on paper cost less than canvases, small pieces are cheaper than larger works, pieces made of more valuable materials are worth more than otherwise—these factors just modify prices within the general price level established in the market for that artist's body of work. What determines the price level? Studies have

pointed to the importance of the general style (i.e., realism generally costs less than abstract art at the highest levels of the contemporary auction market), prizes won in competitions, the artist's history of shows, and representation by important galleries.[22] Since the market is complex and segmented, buyers tend to have relatively little knowledge in comparison with dealers, which places dealers in an advantageous position. A buyer may "fall in love" with a painting seen in a vacation place, where the buyer has no knowledge of the local art market. How to know whether the price, which may be $300, $3,000 or $30,000, is reasonable? As in every market, there are two strategies: appeal to authority and trust your dealer. How this works out in practice will be discussed in chapters 5 and 6.

Economic and Artistic Decisions: The Paradox of Art Markets

The art market is a fascinating case in a capitalist, commercial society precisely because economics is *not* supposed to matter in art. Artists are supposed to make art to advance and expand our vision through their intensely personal expression, not to make money. This means that an individual artist's oeuvre should have a trajectory, spirit, and an integrity of its own. The challenge to artists is to create work that is personal and unique, with significant aesthetic quality. Changes in an artist's image, meaning the appearance of the set of individual pieces that make up the oeuvre, should be driven by an aesthetic imperative and no other. Artists justify this single-minded, selfish focus on their unique personal vision because they believe (or act as if they believe) that society has entrusted them with the task of expanding our cultural capital, as Simpson claims (1981).

The typical artist aspiring to museum recognition would be insulted or contemptuous about advice to "market" artwork.[23] When friends sincerely advise artists to make smaller, more affordable work in order to maximize their total income, the artists are often unable to respond. How to explain a whole system and strategy of lifelong professional development to one whose horizon seems limited to short-term transactions? Although artists are embedded in a market, those aspiring to high art are not producing work for the market, but for history. Their primary goal is to make valid art, not money, although they are quick to say they appreciate the money.

The hint of a commercial motive controlling the aesthetic decisions of most artists is enough to seriously damage the work's quality for people at the high end of the market.[24] A young sculptor put it this way.

The worst kind of sellout is [artist X]. His work is horrendous, shiny, slick, devoid of personality—how can it not be for anything but to sell? It is void of any kind of personality of the artist. Slickness, you sacrifice yourself to anything just to sell. I don't think I can avoid putting my sensibilities into the piece. (Int. 133)

The artist here is expressing the common artistic value: a work of fine art must be a sincere expression of the artist's personal aesthetic standards, not merely a clever solution calculated to exploit a market opportunity. Artists, above all people, are expected to maintain their independence and develop their personal style.[25] This leads to another paradox: art is sold like a commodity but is produced like a religious calling, as an object of intense personal expression. An artist who produces a work that experts agree is a major creative contribution may find that the work is unsalable. The artist properly interprets a failure to sell as a personal rejection by society, which embodies the artist's dilemma: praise from aesthetic experts and rejection by the market.

The antimarket mentality extends to art buyers also. Collectors who openly admit to buying art as an investment, in order to make money, are disparaged by other market actors, including those who sell them the work (but not to their face!). Collectors aspiring to social recognition are supposed to define their own image of meaningful art, and their collection should reflect their creative activity in following their personal vision, in a direct parallel to the artists. Visions direct behavior as if they had an independent existence, leading artists and collectors in aesthetic directions they had no idea they were going. When artists lecture on their work, they often talk as if they were surprised at the development of the work's content. Likewise, the "true" collectors' visions lead them to buy when they should not, according to purely economic values (see chap. 6).

Dealers in the Middle

Dealers are on difficult ground in this tension between vision and profit. Most artists don't expect to make money from art, although they would like to. They can always comfort themselves with the difficulty of selling "challenging" or avant-garde work. Their memory of van Gogh eases the pain. Collectors don't normally try to resell their purchases in the short run, so they rarely discover how little value may endure in the work hanging on their walls. When they do, they can justify their expenses by appealing to a higher cultural goal of "supporting the arts," or to the personal fulfillment of "falling in love" with the art. They can rationalize that buying art is not supposed to be a profit-making business. But

dealers *are* in a business. Even wealthy dealers (and most dealers have some wealth supporting them, for reasons discussed in chapter 5) can't justify losing money year after year. They cannot for long rationalize losing money in order to support art and advance culture. If nothing else, they get demoralized.

The business of selling contemporary art is still commerce, once the pretensions of eliteness are stripped away. Art dealers are like dealers in fine cars, or any nonessential good, for that matter. As Alfred Taubman, the shopping-mall magnate who bought Sotheby's auction house, said,

> Selling art has much in common with selling root beer. People don't need root beer and they don't need to buy a painting, either. We provide them with a sense that it will give them a happier experience. (Quoted in Watson 1992, 385)

While it is true that art dealers have much in common with sellers of other luxury goods, art has special economic characteristics. An expensive car is made of expensive materials finely put together, but the most expensive contemporary work of art is not distinguished at all by its material.

The Artists' Social Compact: Studio Brain and the Vow of Poverty

Since they have little real expectation of market rewards, most fine artists can work as if connoisseurs—important dealers and collectors—will respond to their work on the basis of its image alone, without consideration of its socioeconomic context or their prior lack of success. They can live in the world of their own aesthetic imagination without regard for the unpleasant accommodations they would have to make if their work had to fit the interests of a buyer. Artists dream that they may be "discovered" by critical gatekeepers and propelled to heights of art-historical significance from their humble studios. Like any creative worker, they are capable of spending enormous amounts of effort on a piece of work out of proportion to the monetary reward they can reasonably expect to get. A former artist who worked full-time for a bank called this "studio brain" in describing the difference between working on art in your studio and working on art for a business.

"Studio brain" is the frame of mind in which a worker creates enduring value without regard for short-term productive efficiency. For artists, it is the work ethic that lets them contemplate their work for fifteen minutes,

or half an hour, before approaching the canvas again. Their goal is to "get it right," to produce a piece of art of significant, enduring aesthetic value, not to create output per unit of time.

> You know [when you work for the bank] you've got to get through this process, but you can't stand around admiring each facet or part of the process like you can with a piece of art, and evaluate it and turn it over in your hand five times and look at it fifty ways. You've got to get through the process. . . . "Yeah, OK, so I've got my red dot up there, now I'm going to smoke at it and figure out where my next red dot is going to be." (Int. 68)

But how can artists delude themselves that the subtle and precise physical qualities of the work are paramount in the eyes of connoisseurs, when the art market shows social-historical context to be all-important for artistic gatekeepers? Fine-art artists live the dream that all they have to do is labor in their studios creating valid, significant art and hope for the connoisseur (dealer, curator, or collector) to show up and discover their quality. In a world where their chances of real success are so small, this may be the only reasonable position to take. The alternative would be to give up the artists' dream of success, to settle for the gray reality of regimented work for a middle-class income.

Fine-art artists face a deal offered by society: the benefit is their unique status—marginalized yet relatively high as compared to their income—and independence, meaning self-definition of their conditions of work and freedom from the normal constraints on social behavior. The cost is poverty (or negligible income from art), with the tiny chance of art-historical and market success.

Is the artists' social compact a fair deal? The artist who believes that he or she is responsible for advancing the cultural vision of reality—for being the cultural avant-garde—has a heady task. Artists rely on the importance of their responsibility to explore their personal vision to excuse themselves from social constraints. Artists are freer to adopt deviant or idiosyncratic clothing, such as blue jeans at formal social events, that would be inappropriate for lawyers, teachers, and others with comparable education and social standing (including most dealers, who value fashionable elegance). Artists can show deviant social behavior, such as public drunkenness or drug addiction, which is excused as somehow related to their artistic creativity, where it would be ruinous to any other middle-class professional.[26] Artists' housing, often loft living-working spaces, can be

rough, industrial—otherwise inappropriate as housing for people with their college-educated status.[27]

Artists can enjoy these social freedoms, which most other people of their educational and class backgrounds would not be interested in, because the ideology of a "real" artist is often to sacrifice social niceties and physical comforts in the service of their work. The job of advancing the cultural vision is too important to be deflected by conventional concerns about social respectability.

Without a body of artwork to justify the deviance, this lifestyle degenerates into bohemianism. "Real" artists are not bohemians, in the sense that their purpose in life is to create art, and their lifestyle is an efficient, low-cost means to that end. For others like bohemians and hippies, the lifestyle is an end in itself. Serious artists, who tend to be self-centered workaholics, despise this as mere hedonism.

Is the freedom worth the poverty? The answer may have more to do with the stage of life for any artist than with personality. Rough loft living is one thing for a childless couple and another thing when the quality of the local schools becomes relevant. Sooner or later the person's middle-class background can surface in a desire for a more conventional lifestyle. In fact, most serious artists never accept the full deal, and instead opt for a career as an academic if it is available. Here their income is secure, although usually the lowest in the institution, and their artwork is equated to academic "research."

2/ The Rise of the Modern Art Market

> In art there is no progress, only fluctuations of intensity. Not even the greatest doctor in Bologna in the seventeenth century knew as much about the human body as today's third-year medical student. But nobody alive today can draw as well as Rembrandt or Goya. (Hughes 1991, 376)

> The success of the individual artist is ultimately measured by the demand, or lack of it, for the artist's works in the higher reaches of the art market. . . . No fully comparable situation has ever existed anywhere or at any time in the previous history of art. (Alsop 1982, 41)

The national art market saw phenomenal price increases during the 1970s and 1980s, with common auction prices of several hundreds of thousands of dollars for single artworks by living artists. The culmination was the record price for a living artist of $20.7 million dollars for a 1955 de Kooning *Interchange* painting at Sotheby's in November 1989 and the van Gogh sale mentioned in chapter 1. Both sales were made in New York to Japanese buyers.

These increases occurred at many levels in the market. Joseph Helman, a former St. Louis art dealer who has operated the Blum-Helman gallery in New York City since 1973, felt so sure of the rising market in the early 1980s that he told an interviewer:

> The financial risk for a collector who buys the work of young artists is very small. If an artist has one show in a top New York gallery, the odds are that it will sell out, given today's art market. That means he will have a second show and that his prices will go up substantially. Tax laws are such that a collector will often get his money out through a donation after a brief period. (de Coppet and Jones 1984, 162)

This sort of confidence in a booming market was centered in New York but reverberated throughout the country. Followers of the art market were aware that immense sums of money were being paid for modern art, and that a few lucky artists were not only supporting themselves by the sale of their work, they were rich and idolized in their corner of the world as culture heroes. By 1990 the party came to an abrupt end, as the auction

market contracted to a fifth of its size the previous year. Dealers went out of business, and artists who had come to expect good income from shows watched glumly as their exhibitions closed with trivial sales.

The vast majority of artists, dealers, and collectors had looked at this economic feast from the shadowed sidelines of regional art markets. Although influenced by New York, these markets rose and fell much less than the hyperactive center. In this chapter I will summarize the historical patterns that led to the boom and the bust. This brief historical sketch will provide a context for the reality of local markets like St. Louis, where most work sells for less than five thousand dollars, and where art market actors may worry about paying the rent as much as about paying their capital gains taxes.

The long-term historic trend in the art market is easily summarized: an enormous growth in numbers of artists, galleries, collectors, and art institutions, such as schools, museums and regional markets. This has produced the situation that this book focuses on: an ever-larger and more diverse aggregate national art market composed of many relatively healthy but low-profile local art markets, and the (gradually weakening but still powerful) hegemony of New York on the high end of the national market. The focus on the personality of a golden few, predominantly New York, artists as the vanguard leaves the great masses of "regional" artists to rationalize their existence without market success.

Preimpressionists, the Academy, the Hegemony of Paris

There is no point in trying to fix the "beginning" of the modern art market in any one historical moment, as the transition from guild to academy to a market of a relatively few dealers and many independent artists was a steady historical process.[1] Much of the modern-art dealer-critic-curator system developed in France during the eighteenth century.

The Paris guild of painters and sculptors was created in 1391, when painters were skilled craftsmen and tradesmen searching for a monopoly to defend their interests. There were no dealers as such, since each artist entered independently into contracts with clients for commissioned work. The guild craftsmen maintained control over their increasingly narrow traditional style of work while resisting newer forms of artistic activity that pretended to a higher cultural standing. This tension between art as excellence in craft and art for art's sake prefigures the contemporary struggles between artists and craftsmen.[2]

By the seventeenth century the Royal Academy of Painting and Sculpture was founded to accommodate artists who felt more affinity with

members of a "liberal profession" than with traders and merchants (Moulin 1987, 10). These artists felt that they were expanding the cultural vision of reality, rather than applying technical skills as specialized decorators. Although over thirty provincial academies were set up by 1786, Paris set the standards for the entire country. Artistic renown was given only in Paris, and the Parisian authorities controlled the prestigious Prix de Rome and entry into the salons (White and White 1965).

The pressure of ever-larger numbers of artists in Paris strained the academy system's ability to administer the art world. There were about three thousand painters in Paris in 1860 and about one hundred dealers, at a time when the city may have had a population of around 1.5 million (White and White 1965).[3] White and White calculate the average productivity of several famous impressionists: Pissarro created 1,267 paintings in forty-eight years, or 26 per year; Manet, 9.9 per year; Degas, 8.6 per year, and so on, from which they derive an average productivity of 18 paintings per year. They conservatively estimate that some two hundred thousand canvases were produced in each decade after 1850 by "reputable" French painters. The Salon of 1848 exhibited 5,180 artworks by nineteen hundred painters, and paid attendance often reached ten thousand visitors per day. Napoleon III established the Salon des Refusés in 1863 for paintings rejected from the official salon, but this was a stopgap measure. In spite of the thousands of paintings exhibited in the salons, the Whites note that the density and productivity of artists in Paris seriously overloaded the exhibition system.

The Impressionists

The art movement called impressionism developed in Paris in the latter half of the nineteenth century and was immensely important in shaping the cultural reality of contemporary art.[4] The impressionists followed the success of a group of open-air landscape painters known as the Barbizon school (so-called for the forested area near Paris that they painted in). These precursors enjoyed the freedom to paint outdoors because of the novel technology of oil paint in portable tubes and the new railroad system, and they had success after a period of disdain and rejection. The Barbizon painters represented a coherent style of art that was not easily accepted at first, yet that gained market success relatively soon. They functioned like a test case for the impressionists, paving the way for the latter's spectacular success. The impressionists exhibited their works in a series of notable exhibitions independent of the salons over a period of years, culminating with their show of 1886, their last group show, which

finally established their acceptance by key critics and collectors. The impressionists fixed the artist's role as creators of avant-garde, if not outrageous, art for art's sake, while participating in the evolving triumph of the new dealer-critic system.

The impressionists showed that financial success for artists was possible through the activities of key dealers and friendly critics, independent of state or official patronage. Moulin points out that Pissarro, Degas, Monet, Renoir, and other impressionists earned incomes commensurate with those earned by government civil servants (1987). Their "outrageous" art, when sold to discriminating, adventurous collectors, produced middle-class incomes for the artists.

The impressionists also demonstrated that dealers and supporters of avant-garde artwork could enjoy significant profits. The impressionist dealer Durand-Ruel believed in their importance and bought their paintings in exchange for subsistence stipends. This great dealer lived to see prices reach extraordinary heights. Enormous wealth was being created in the Western world, and the newly rich of America wanted to buy European art. Meissonier, the French art star of the 1880s, sold a painting to Vanderbilt for the current equivalent of $1.5 million. Millet's painting *La Bergère,* a popular Barbizon work, sold in 1890 (after the artist's death in 1875) for the current equivalent of $5.2 million. The new art market system of private dealers, independent shows, and auctions was gaining status, and by the twentieth century succeeded in establishing itself as the successor to the Academy system. By 1912 a painting by Degas sold for $95,700 (equivalent to $5 million currently, a world record at the time for a work by a living artist) to an American collector. A group of elite young Frenchmen known as the "Bearskin" collecting club bought impressionist art collectively beginning in 1904. In 1914, after only ten years, they auctioned the collection off for four times what they had paid. A quarter of the auctioned works were bought by members of the Bearskin group themselves, who complained that they would have bought more but for the high prices (Watson 1992). These fabulous profits from the purchase and resale of works of art that were so recently reviled, and the cultural legitimacy they implied, had a great impact on the modern art world.

The Death of Critical Authority in the Art World

The impressionists proved the point that going against the received wisdom in contemporary art could be profitable for artists, dealers, and collectors.[5] Potential taste-makers in society learned that the negative

opinions of major critics and gatekeepers, who had dismissed the impressionists' work because of crucial flaws and inadequacies, did not necessarily undermine the eventual success of the work from an aesthetic or market perspective. In fact, the impressionists' work was collected early on by a few elite collectors and relatively soon by established institutions. The state bought a Renoir by 1892. Impressionist art in a short period of time went from being so outrageous that coachmen were seen screaming at a Monet painting in a gallery window (according to the dealer Daniel-Henri Kahnweiler), to being valued, respected, and emulated.

This was a powerful lesson. Work rejected by both elite and popular taste could prove to be a good aesthetic choice as well as a profitable investment without a long wait. If the critics of impressionism were so wrong, if their cries of almost moral outrage over the apparent incompetence of impressionist artists turned out to be merely the petulant complaints of orthodoxy incapable of accepting change, then the claim of other critics about ineptness or fraud in contemporary work would be suspect also. As we will see, this proved to be the case with the abstract impressionists and the pop artists in the United States decades later.

The Importance of the Dealer-Critic System

The dealers' exhibitions labeled the impressionists as a unique art movement and highlighted them apart from the masses of paintings in Salon. Although much of the publicity was negative, the artwork was well known and notorious. In a modern marketing sense, the impressionists, their dealers, and the critics created their own brand name.[6]

The impressionists' success ended the power of the Academy to be sole arbiter of new movements in art. This new system was defined by networks of influential dealers, friendly (if not hired) critics,[7] and influential collectors eager to make their own reputations as avant-garde trendsetters. By the turn of the century the dealers had worked out a customary set of expectations with painters. In exchange for exclusive control over an artist's output, the dealer agreed to pay a guaranteed annual income out of his 30 percent commission on sales, to organize shows, publish catalogs, and plan a general marketing strategy for the artist. This social system provided sympathetic recognition and encouragement as well as steady incomes for artists. The dealer system was ultimately capable of wider and more abundant support for the artist community at large than the Academy system, although the power in the French art world remained centralized in Paris. However, the social upheavals in Europe and the population

and capital movements toward America shifted the center of the art market to New York in the twentieth century.

The Death of Art Criticism and Market Success

A critic in *Artnews,* a major American magazine, concluded a review article on the work of the controversial artist Jeff Koons with these words:

> most of the . . . objects struck me . . . as purposely dumb and perverse, acid, totally aware criticisms of the needs and preferences of the Great Western Unwashed *and* of the attitudes of smirking, sophisticated collectors willing to pay huge prices in order to mock the bad taste of their inferiors.

This is pretty serious and negative. But the final words of the critic's essay are surprising.

> But that's not the way they strike Jeff Koons . . . or, indeed, the way they strike many of his critics. *If these things seem to you either desirable or profound, I know of no way to persuade you that my response is worthier than yours.* (Littlejohn 1993, 94; emphasis added)

Of course, it is the critic's job to persuade readers of the salience of his or her taste. The abject admission that a critic has "no way to persuade" means that he or she has no theory of good and bad in contemporary art, no accepted set of aesthetic values to refer to. This lack of values is part of the impact of the impressionist's success.

The audience for art gradually realized after the impressionists that much criticism, meaning pronouncements about art quality by elite connoisseurs, had lost its authority. If so many of the "important" critics and curators were so wrong about the impressionists, why should today's commentators be different? This caution primarily affected those who were negative about new work—why should they be any less wrong than their predecessors who rejected the abstract impressionists, pop artists, the P-and-D (pattern-and-decoration) artists, conceptual artists, or any other of the styles that aggressive artists and dealers pushed on the eager art-buying public? The underlying lesson was that it is dangerous not to "embrace the new." If a respectable authority did not "get" the new art, and it later became successful through the efforts of other critics, curators, marketers, and collectors, the so-called authority looked foolish. This fear encouraged an (un)critical rush to be the first to recognize the merit of the newest trend (which then engendered its own backlash of critical com-

plaints that "the emperor has no clothes," that much of contemporary art is, in fact, aesthetically vacuous (Hughes 1991).

The rejection of the censorious authority of the critic led to a problem: the only available short-run measure of artistic significance, aside from the opinions of critics and curators, was market success. The market defines success in the present, and the lesson of the impressionists was that market failure today does not *necessarily* mean that the work will have no artistic significance in the future. Art market actors remember van Gogh, who sold only one painting in his lifetime yet whose work, a hundred years after his death, sold for the highest prices ever. Artists took this fact to heart. The art world has also institutionalized the memory of Meissonier, Alma-Tadema, and the many artists like them, stars in their lifetimes whose work sold for the contemporary equivalent of millions, yet whose aesthetic significance is trivial now. Artists today might not remember their names, but the lesson that market success or failure in the present does not have to mean future artistic importance or irrelevance permeates the value system of the contemporary art world. Good artists don't *necessarily* sell paintings, and all of the paintings that sell—even for high prices—are not necessarily good. Only the long run of history can affirm aesthetic significance. This understanding encourages artists to persevere in the development of their work and not to be devastated by negative criticism or market rejection (fig. 4).[8]

The New York School and Abstract Expressionism

Just as England used its industrial wealth to buy the art treasures of the continent in the seventeenth and eighteenth centuries, so the nineteenth-century wealth in the United States brought old masters across the ocean.[9] The idea of a reverse flow, of Europe buying contemporary artwork from America, was ludicrous at that time.

Social upheavals in Europe led many well-known artists to emigrate in the early twentieth century. The rise of the Nazi party in Germany, and then the German conquest of France, made emigration more attractive for artistic leaders, especially Jews or homosexuals who were marked for discrimination. The Europeans found a vibrant society in New York City. The 1913 Armory show had introduced abstract painting to New York, and Alfred Stieglitz had opened his gallery in 1914, showing contemporary European-American art. The Museum of Modern Art (MOMA) had opened in 1929, the Whitney in 1930, the Guggenheim in 1939, all in New York, and all featured work of living artists. These museums at first felt

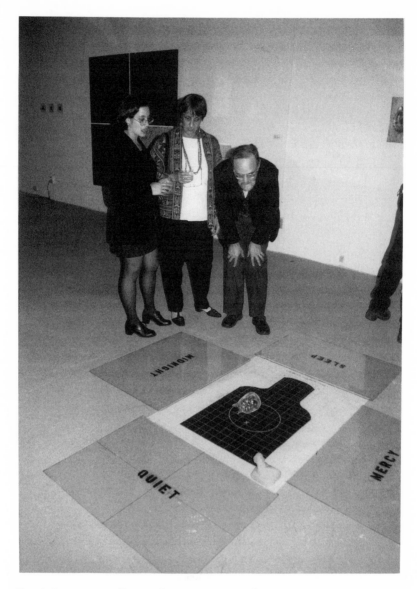

FIG. 4. Prospective collectors discussing a piece of avant-garde work.

that they had the great world masters in Picasso, Braque, and other European artists and saw no need to support contemporary American art. But the energy produced by the interaction of the artists from Europe and the local New York artists stimulated exciting new work.

Peggy Guggenheim, who briefly had a gallery of contemporary art in

London, opened her New York gallery in 1942. Art of This Century featured avant-garde European and American art in a setting designed by an architect to reflect the modernist nature of the work, and it remained open until 1947.[10] She gave Jackson Pollock his first show and paid him a stipend of $150 a month (worth, roughly, about $2,200 now). Although she never sold a Pollock for more than $1,000, her gallery made him well known in the American art world. *Life* magazine had a color spread on Jackson Pollock in 1949 titled, "Is He the Greatest Living Painter in the U.S.?" Other well-known galleries soon opened, by Sam Kootz in 1945, by Betty Parsons in 1946, by Sidney Janis in 1948. The art market was not booming (Kootz sold one picture in 1949, a de Kooning for $700) but the excitement about New York school art was certainly building (Watson 1992, 286).

The tight social relations of the artists, whose meetings (including key critics and collectors) at the Cedar Bar and The Club were well known, helped define the abstract expressionists as an avant-garde group (Ashton 1973; Crane 1987). Prices gradually increased in the 1950s, and by the 1960s the New York market heated up. This work looked outrageous to the uninformed, but to art connoisseurs it was terrifically exciting (an echo of the public's reaction to impressionism and other avant-garde art movements). Leo Castelli, who was to become America's Durand-Ruel, opened his gallery in 1957 and took on Rauschenberg, Jasper Johns, Stella, and pop artists such as Lichtenstein. Castelli's aristocratic manner, provision of artist stipends, and expert public relations were reminiscent of Durand-Ruel's support of the impressionists. His gallery became known for the boom in contemporary art prices. Castelli cultivated a small group of faithful collectors, notably the Tremaines, Count Panza, and the Sculls. After Rauschenberg won the Venice Biennale prize in 1964, the value of this art was "proven," and prices for the gallery's artists rose. Castelli was held in such awe that he was accused, without evidence, of influencing the prize decision.

The 1973 auction of the Sculls' collection was a landmark event in the history of the contemporary art market. New York taxi company owner Robert Scull was an early and avid pop art collector whom the art world loved to despise for his boorish manners and transparent attempts to use art to increase his social position. He in fact had a serious interest in contemporary art and had backed the Green Gallery in New York (opened in 1961 and managed by Richard Bellamy). By the early 1970s he had over 260 paintings, 135 sculptures, and 300 drawings, and he decided to cash in his collection. His auction at Sotheby's in 1973 publicized the rise in

prices for contemporary American artists.[11] This sale was comparable to the Bearskin sale of 1914, because it announced to society at large that "difficult" contemporary art was bankable, no matter how outrageous it appeared to be. The impact of this auction can be seen by a sample of the artists and prices.

Jasper Johns, cast of two Ballantine ale cans, bought for $960, sold for $90,000

Jasper Johns, painting bought in 1965 for $10,000, sold for $240,000

Rauschenberg, painting bought in 1958 for $900, sold for $85,000

Rauschenberg, painting bought in 1959 for $2,500, sold for $90,000

Larry Poons, painting bought for $1,000, sold for $25,000

Andy Warhol, painting bought for $2,500, sold for $135,000.

The auction sold fifty pieces and made $2,242,900 overall. Robert Rauschenberg was reported to have been infuriated because all of the increased value went to Scull. The drunken artist punched the collector when the auction ended, shouting, "I've been working my ass off just for you to make that profit!" (Meyer 1979, 183). His complaint against Scull aside, the rise in prices affected his current and future art as well as his past work and made the artist a very rich man. Before this period, avant-garde artists in the United States had little expectation of earning an income from their artwork. The news traveled fast that serious artists like Stella, Rauschenberg, Johns, and others were becoming wealthy.

The Growth of the U.S. National Art World

Changes in American society after World War II created an enormous number of opportunities for artists of all sorts, who began to think that art might provide enough income to support a middle-class lifestyle. The growing wealth of the postwar U.S. economy increased the number of universities, museums, and cultural organizations supporting the arts. Public support of higher education dramatically expanded the number of institutions of higher education, including the new junior colleges, in addition to universities and four-year colleges. This expansion created opportunities for students to study art, at the same time that new jobs for professional art teachers were created.

American art moved from the fringes of bohemian life to the center of middle-class values during the period after World War II. Sharon Zukin analyzes this process in her book on SoHo (1989). She points out that high prices for the few successful artists' work, coupled with the regularization of their employment as artists, "enabled them for the first time in

history to make a living off a totally self-defined art" (96). Zukin cites the artist Larry Rivers saying that "one could go into art as a career the same as law, medicine, or government" in the early 1960s (97). The *Life* article on Jackson Pollock and several experiments at mass-marketing contemporary fine art, among other things, made an art career somewhat more familiar, if not fully acceptable to working- and middle-class families.

The sales prospects for art seemed so rosy that dealer Samuel Kootz had a show in 1942 of 179 paintings at Macy's department store, and he also tried to sell art at Gimbel's department store (Marquis 1991, 235–36). Even Sears and Korvette's (a discount store in New York) tried to sell original art, from limited editions for the most part, between 1966 and 1971 (Zukin 1989, 99–100). Zukin argues that the abilities of more artists to earn a living from "self-defined" art (i.e., not from commissions or production work), coupled with the art world's abandonment of the "radical ethos" of the prewar period for a "basic consensus" with the middle classes, made art a part of middle-class life. Artists "saw the same world that the middle class saw: a 'continuous past' made by rapid social and technological change, the passing of industrialism . . . and a mass production of art objects and cultural standards" (97). Rivers and Zukin notwithstanding, art students still joke that no one's father ever sat them down and said, "Your mother and I would be most happy to see you consider a career as a sculptor."

By the 1980 census, 153,162 adults in the United States identified themselves as "painters, sculptors, craft artists, and artist printmakers," up 76 percent over the 1970 census figure, and a striking increase in comparison to the overall increase in the labor force of 28 percent during this same period. By 1990 the labor force for visual artists had increased to 224,000, a 46 percent increase during a period when the total labor force increased only 16 percent (source: NEA 1994 and Census Bureau statistics).

An increasing number of artists had higher educations. By 1989 there were 1,146 institutions in the United States offering bachelor's degrees in visual and performing arts, and 362 institutions offering master of fine arts (M.F.A.) degrees, the terminal professional degree for artists (National Endowment for the Arts 1990, table 3-42, 1992, tables 3-2, 3-4). Over the nineteen-year period from 1970 to 1989, these institutions graduated 733,099 bachelor's degrees and 157,982 master's degrees in the visual and performing arts. I estimate that 42 percent of the bachelor's and 33 percent of the master's degrees were in the visual arts, for a total of some 307,900

bachelor's degrees and 52,100 master's degrees in the visual arts alone.[12] On an annual basis, this is an average of around 16,200 bachelor's and 2,740 master's degrees in the visual arts.

For comparison, in 1988–89, there were 30,293 bachelor's degrees in English awarded; that same year 37,781 bachelor's degrees were awarded in the visual and performing arts, of which 16,172 were in visual arts. In 1988–89 4,807 master's and doctoral degrees were awarded in English and 8,989 master's and doctoral degrees in visual and performing arts, of which 2,924 were in visual arts.

The increase in educational opportunities was paralleled by museum construction. More than twenty-five hundred new museums opened between 1950 and 1980 (Marquis 1991, 275). Fifty-eight percent of 749 arts organizations (museums, art centers, and corporate collections) studied by Crane in 1987 were founded after 1940, and over one-third were founded after 1960 (6).[13] Between 1960 and 1975 the number of dealers and galleries listed in the New York telephone book almost doubled, from 406 to 761. Crane examined the date of origin of 290 New York galleries she identified as specializing in avant-garde contemporary American art. She found that 80 percent of them were started after 1965. She also estimates one-person exhibitions in New York at eight hundred in 1950 and almost nineteen hundred in 1985.

The growth in the postwar U.S. economy allowed many corporations to use some of their wealth for art collections. Beginning in the 1960s, corporations of all sizes increasingly began to collect art (Martorella 1990). While most of these collections were closed to the public, the IBM corporation opened a public exhibition space in New York that put on important shows.[14] Except for the very largest and wealthiest, most corporations did not have specialists on their staffs. A new niche in the art market was created for "art consultants," who specialized in buying art in bulk, as well as in curating and conserving corporate collections.

State legislative appropriations to arts agencies went from a U.S. total of $2.6 million in 1966 to $214.7 in 1992 (down from a high of $292.3 million in 1990). By any measure the growth in public investment in arts has been impressive. The increased wealth of the U.S. economy was clearly associated with a booming interest in the arts.

While the cause of the increase in the art world ultimately lies in the increased wealth of the country, focused government support was an efficient stimulus. During the 1960s, interested arts supporters convinced the federal government that the arts were a vital weapon in the cold war. Sena-

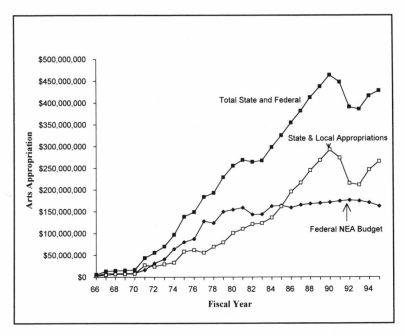

FIG. 5. Public funding for fine arts. Source: National Assembly of State Arts Agencies Public Funding Sourcebook.

tor Jacob Javits argued to Congress in 1963, "A comprehensive national arts program . . . will enable us—far better than we do today—to meet the challenge of the Communists' cultural ideas in the world, on which they are spending great amounts of money for their propagation, and which . . . are designed to 'bury' the free world" (cited in Zukin 1989, 103). This sort of argument was successful. The National Endowment for the Arts was created in 1965, modeled on the New York State Council on the Arts, established by Rockefeller. Its initial budget was $2.5 million. Beginning in 1970 the agency's budget enjoyed rapid growth, to $159 million in 1981, when the Reagan administration's attack managed to first cut, then slow dramatically the rate of increase. The agency became embroiled in political controversy with a major scandal in 1989 over NEA support of exhibitions that included the outrageously homosexual photographs of Robert Mapplethorpe and the anti-Catholic sculpture of Andres Serrano.

Figure 5 shows the trend of federal and state funding for the NEA, in current dollars. The relative decline of the federal government's role in comparison to that of the state agencies since 1985 is apparent. The most

striking aspect of this data is the enormous growth in total funding until 1990, then the decline in response to increasing economic pressures on the government. By the fiscal 1996 budget the Congress was openly discussing the termination of the NEA's funding.

Artists as Public Personalities

The public's fascination with artists has a long history that has been celebrated in literature and performing arts, in novels like Joyce Cary's *The Horse's Mouth,* or operas such as Puccini's *La Bohème.* Citing Balzac, Zukin points out that part of the interest has been the belief that "The *bohème* consists of young people, who are still unknown, but who will be well known and famous one day" (1989, 97). Simpson notes the relation between the middle class and artistic values: "The modern artist figure is a liberation dream born out of the fear of incorporation into a routinized and bureaucratically entrenched life-style" (1981, 6). He points out that while the artist's freedom to make creative work contradicts the work constraints of his middle-class patrons, they value it nevertheless: "The creative work of artists is understood to be of primary importance for the welfare of society because it renews both perception and the perceiver, preventing the onset of spiritual atrophy" (1981, 7).

The late-twentieth-century twist on this theme is to focus less on unsuccessful "starving artists" and their sacrifice of material comforts to make their art, and more on "stars." The artists who are famous are also rich. The fabulous rise in art prices and the semilegitimization of art as a middle-class professional career occurred alongside the fascination of the media with artists as culture heroes. Picasso and other great European artists had been internationally recognized as geniuses and had amassed fortunes in their lifetimes. The U.S. contribution was to blatantly pander to the media for publicity. Andy Warhol was the most successful at this sort of public relations, creating a thriving business involving portraits and interviews with media stars. Hobnobbing with the rich and famous, he became a social phenomena himself. He became such a public personality that he was mobbed by four thousand screaming students at a 1965 retrospective of his work in Philadelphia. Warhol commented, "I wondered what it was that made all these people scream. . . . But then, we weren't just *at* the art exhibit, we *were* the art exhibit, we were the art incarnate" (Warhol and Hackett 1980, 132).

Magazines such as *Home and Garden* featured stories about contemporary artists. For example, the artist Julian Schnabel's loft dwelling was fea-

tured in the October 1992 *Home and Garden,* not because of his own paintings but to highlight his collectibles. The artist's painting sales had generated such fabulous wealth that his home was decorated with antique furniture, carpets, and expensive old-master artwork. The same issue features Louise Bourgeois's home. This artist's work has always been challenging and not particularly trendy, yet she is described as having "emerged as a solid 'art star' in the eighties." This artist's home, unlike Schnabel's, has no antiques and collectibles, only the aged artist and her work. Yet the magazine's editors believed that her "lifestyle" was fascinating to their readers. The 1960s pop artist Andy Warhol's image of himself as a walking media event has been generalized to a small group of artist-personalities.

Artist Superstars: Basquiat

During the 1980s the speed at which dealers, critics, and curators in New York were able to move artists from first recognition to phenomenal commercial success increased to a frenzy. The tragic career of Jean-Michel Basquiat is a symptom of the dehumanizing quality of this procedure.[15] Basquiat was a New York artist of Haitian ancestry who was championed by Jeffrey Daitch, an art consultant, Henry Geldzahler, the curator of contemporary art at the Metropolitan Museum of Art, and Peter Schjeldahl, the art critic for the *Village Voice* in the late 1970s. Basquiat knew how to make connections with influential people and collaborated with Andy Warhol on paintings, one of which sold for three hundred thousand dollars in 1982. By association with a true pop art superstar, his own artistic stock began to rise. Basquiat's ability to affiliate himself with art culture stars like Warhol and gatekeepers like Geldzahler helped make him famous.

By 1984, when the artist was twenty-four years old, his paintings were being sold for twenty-five thousand dollars. Much of the art world's interest seem to have been stimulated by his claim of being abused as a child, his history of life in the streets, where he painted graffiti, and his generally wild behavior. Basquiat made hundreds of paintings and earned enormous sums of money, which he spent wildly. The young artist was a notorious drug addict whose increasingly out-of-control behavior caught up with him in 1988, when he died of a heroin overdose. Immediately after his death, his paintings sold at auction for up to five hundred thousand dollars. The work that all this hype focused on was executed quickly, made of graffiti slogans combined with sketchy cartoonish figures. The

"lightning bolt of fame and fortune" that struck Basquiat is inexplicable in terms of his art alone. (The Whitney Museum had a retrospective of his paintings in 1993, which, coming so soon after his brief career, did not clarify his position in art history.) The artist's minority status and supposedly difficult life history seem to have appealed to collectors, who praised his "primitive" style in a kind of reverse racial bias. (Actually he was brought up in a middle-class home in Brooklyn, where his father was an accountant.)

Artists who worked at producing a body of art that represented their investment of expertise, care, and craftsmanship could only look on Basquiat's career with amazement. Collectors who bought his work early in his career enjoyed fabulous profits, after holding the work less than ten years. The media's fascination with the artist's life and death helped spread the news to investors about the enormous profits that art could return.

Changes in Collectors: Art as Investment Gamble

The art market has always involved financial investment. Watson's book on the international market shows that contemporary prices of art masterpieces have usually been substantial (1992). Art markets have always served the wealthy and middle classes who collected original art since they enjoyed the education and "cultural capital" to have informed taste (Bourdieu 1984). The contemporary art market is characterized by its large size and scope, and by the entry of speculators in response to the price boom of the 1980s. People saw the prices for contemporary art go ever higher and assumed the bubble would never burst. Million-dollar prices for contemporary art "classics" were frequent, and prices in the hundreds of thousands were common. The Scull auction of 1973 was an early sign of the fabulous profits awaiting collectors. Other well-known sales were the Tremaine auction of 1988, where Jasper Johns's *White Flags* sold for $7,000,000 to a Swedish collector; the following day a Johns painting sold at Sotheby's for $17,000,000 to the dealer Larry Gagosian. The November 1989 auction sales of work by living American artists included seven de Kooning paintings and one sculpture that sold for a total of $27,263,000, including the most expensive painting ever by a living artist, a 79" × 69" oil for $18.8 million plus the buyer's 10 percent commission, or $20.7 million; a Jasper Johns mixed-media piece for $4,070,000 and an oil for $11,000,000; a Stella 1959 painting for $4.6 million; and Wesselman 1967 nude for $418,000. The market was so hot that two Wesselman pencil drawings on paper sold for extraordinary prices: a 17" × 22" still life sold for $85,000, and a 6" × 6" sketch brought $25,000.

These prices attracted ill-informed buyers to the market who thought, or were advised by sellers like Helman (mentioned in the beginning of this chapter), that no price was foolish for "blue chip" artworks. They were wrong. As one collector said in 1993,

> The market is gone. You know they can't sell these things. They are sitting there with huge price tags on them, and they would have sold at those price tags ten years ago, or five, or even two years ago. But today, they are sitting there with the price tags on them. Because no one really wants to spend that kind of money. (Int. 13)

The news reports of the art auctions in the 1990s commonly described major losses, such as the report from fall 1994 Sotheby's auction.

> Pablo Picasso's 1901 *The Clown and Monkey* [sold] for $827,500 (est. $800,000 to $1 million). The same Picasso page-size canvas brought a staggering $2.42 million at the height of the art boom in November 1989 at the same house. (Tully 1994)

The boom tide did not raise all boats equally. Philip Pearlstein, a senior contemporary realist, had four oils auctioned in 1989 for an average price of $38,300 at the same time that the Wesselman pop art painting sold for over $418,000. Crane analyzes auction prices by the style of the artwork, from 1970 to 1982, for her sample of avant-garde artists. Abstract expressionism was the most expensive, with a top price of $550,000 and a median price of $128,750 (note that this was before the real boom in prices); pop art was next with a top of $240,000 and a median of $25,000; next came minimalism, with a top of $420,000 and a median of $3,684; then photorealism, with a top of $130,000 and a median of $6,875; and last Figurative work, with a top of $26,000 and a median price of $4,250.

$17.50 Posters for $13,200

The epitome of the problems awaiting ignorant collectors was the scandal of the Lichtenstein lithographs. Ignorant collectors in the auction market thought they had a good buy in the offset lithograph of Roy Lichtenstein's pop art painting *As I Opened Fire . . .* The work is owned by the Stedelijk Museum in Amsterdam. As is customary, the Stedelijk made a commercial lithographic poster of this painting for sale in its gift shop for $17.50. Poster Originals, a New York retailer, was selling them for $45 apiece at the beginning of the 1990s. In recent years, some of the prints were described in auction house catalogs as a 1964 "limited edition" of three thousand, and as such they have fetched as much as $13,200 at

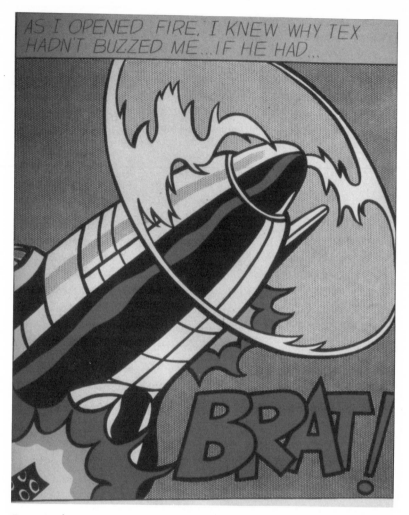

FIG. 6. Lichtenstein's painting *As I Opened Fire* . . . Reproduced as a poster by a museum, it was mistakenly sold at auction as a fine-art print to eager but uninformed art collectors for over $13,000.

Sotheby's and Christie's auctions of contemporary prints. Unsigned and unnumbered, the prints are posters, indistinguishable from another print run that the Stedelijk made when the first group sold out (fig. 6).

When the fact that they had misrepresented the poster-prints was made known to auction house staffers, they called the museum in a panic to ask if there was some way to tell the supposed early "limited edition"

and later editions apart. To their dismay, the museum personnel told the auction house staffers that the two editions were identical (Decker 1990, 32).

Boom and Bust in the Auction Market

The only way to know what art really sells for is through the published records of the auction market, since gallery sales are confidential and private (Smith 1989).[16] Information about art sales at auctions, although easily available, has to be interpreted with care, since it is neither complete nor accurate. Unless one knows the specifics of each sale, including the condition of the piece and the financial details of the transaction, one cannot assume that the price for a specific transaction will necessarily generalize to similar transactions. One must remember that the auction market deals only with the top of the art market, the sales of investment-quality or blue-chip art. The major houses like Sotheby's and Christie's accept only established artists' work, for which they have a pretty good idea of the demand, since they fear that unsold works will demoralize their buyers. Thus buyers who would like to convert their past purchases into cash are unable to use the major auction houses and resort to lesser houses or the nonpublicized dealer system for these "secondary" sales.[17]

The auction market for fine art has existed for hundreds of years. Stories of bidding rings are common, where small groups of dealers collaborate to buy objects for low prices, which they then redistribute among themselves at a profit (Smith 1989). But it is a mistake to think that "sharp" practices are a recent creation of our commercial times. Even the great Rembrandt was known to buy his own work back at auctions to keep up the price (Alpers 1988, 100ff.). The phenomenal boom and bust of the auction market during the last half of the 1980s is shown in figure 7. The outline of the spectacular "market bubble" in 1988–90 is clear in this data, as well as the more recent decline.

Artists everywhere experienced a decline in their sales at the end of the 1980s. Whereas they would sell out shows in the mid-1980s, by 1990 it was common to have a show with insignificant sales. Some interpreted the decline personally, thinking that their style was getting "tougher," more demanding of sophisticated artistic taste and less decorative (see the vignette of Paul, the artist in chapter 4). Others saw their sales drop in multiple locations and understood that the rules of the game were changing. Dealers went out of business in all the major markets, and some speculative collectors got their just desserts. Prices dropped dramatically in

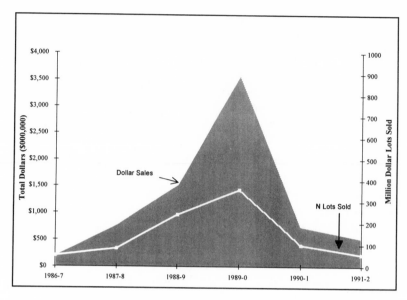

FIG. 7. Boom and bust in the auction market. (Drawn from data in Theran 1982.)

some cases. One St. Louis dealer told this story in 1992 about his experience at the Chicago fine-art fair with a dealer in prints.

I'd been showing some Christo prints. Well, I saw them go up from $2,500—when we had a Christo show, we had them priced from about $1,000 to $4,500 for the most expensive one. Suddenly the most expensive one, which was $4,500, which I sold to a dealer in New York for $4,500, that very print which I sold to her, that very number, suddenly I see it at auction and I see it brings $13,500. This was before the fall. So those things were just going up like mad. They were like the tulip craze in the Netherlands in the seventeenth or eighteenth century. But I couldn't raise my prices here, because nobody would buy them. So I kept it pretty much even. Well, at any rate, so I go to Chicago, and I'm saying, "Well, we had pretty good luck with Christo," and she said, "Oh, here's a Christo print, the price is fifteen thousand— but [whispering] we're selling it for five." The point is, the prices were bid up and many dealers are having a real problem saying that [the] market has disappeared, so even though they put a price on there of fifteen thousand because that was the last auction price, nobody's buying it for that anymore; they are buying it for five thousand. (Int. 10)

While some dealers and artists might have sold well in the early 1990s, the dominant experience for artists and dealers has been a significant, depressing falloff in the sales of artwork since around 1990. Artists who were used to earning twenty, thirty, or fifty thousand dollars a year from art sales found their income disappearing. Dealers who had expanded their business cut back or went under.

There is some debate about the real causes of the market bust. The role of the Japanese seems critical, and appendix 4 provides some information about the activities of Japanese buyers in the art market. But general changes in the economy are also a factor, as the downturn in federal and state funding of the arts since 1990 reveals. Whatever the cause, the experience for art market actors has been a sobering, difficult decline in economic activity in the art market.

As always the boom and bust were exaggerated in New York and moderated in the hinterlands. Most cities in the country did not experience wild price escalations, and gallery scenes boomed more in the imaginations of art enthusiasts than on the streets of midwestern cities. As the next chapter will show, St. Louis experienced a steady, significant growth in the size and scale of the art market commensurate with its growth as a major metropolitan area.

3/ The St. Louis Metropolitan Area

Good art comes from good artists who are able to make art. If you're
comfortable, you are going to make more art than if you're hungry and
cold.

<div align="right">Artist</div>

St. Louis is soft and easy. St. Louis artists tend to make work for the
market here. Collectors here are conservative, insulated.

<div align="right">Dealer</div>

I think there has been a failure of stimulus on the part of the institu-
tions. I don't think the museum has fulfilled its proper function.

<div align="right">Collector</div>

St. Louis is a comfortable midwestern city with few pretensions, lo-
cated at the junction of the Mississippi and Missouri Rivers.[1] It began in
1764 as a colonial trading post exploiting fur and other forest products for
New Orleans, and it flourished as a nineteenth-century entrepôt facilitat-
ing the western expansion of the nation.[2] During the middle of the nine-
teenth century St. Louis was briefly the dominant urban force in the
Midwest, but eventually Chicago prevailed.[3] For much of the period be-
tween 1860 and 1900 St. Louis was the fourth largest city in the nation,
after New York, Philadelphia, and Chicago. By 1990 it was the seven-
teenth largest metropolitan area in population as well as in economic ac-
tivity.[4] This chapter will describe the city's development, situate the art
market in St. Louis's cultural geography, and introduce the major arts in-
stitutions. Readers wishing to quickly get to the behavioral material may
wish to read the first three sections of this chapter for historical context
and a brief cultural introduction, then delay reading the following, more
detailed sections until their interest is piqued by the case material in chap-
ters 4, 5, and 6. Readers curious about how St. Louis compares with other
major urban centers should read the section "St. Louis in Comparison to
Other Art Centers" at the end of this chapter and look at the figures and
statistical summaries in appendix 5.

Settlement and History

St. Louis became the "gateway to the West" by provisioning the westerly migration of settlers. Travelers had their last opportunity to buy eastern and imported goods in the city before setting out on the overland route to the Pacific. In the first half of the nineteenth century the city exchanged manufactured goods for raw materials with Santa Fe, in the same way that St. Louis had served earlier as the colonial exchange entrepôt for New Orleans and Philadelphia (Primm 1981, 135). The "gateway" theme was commemorated for the city's two-hundredth anniversary in St. Louis's stunning arch, a monumental stainless steel arch 632 feet high overlooking the riverfront.[5]

The configuration of the rivers allowed St. Louis to capture the region's mercantile business. A change in the depth of the Mississippi River at St. Louis made transshipment necessary, since the heavier cargoes shipped downriver were not possible above the city. The grain-filled river barges heading south toward the port at New Orleans, and the return shipments of manufactured and imported goods from New Orleans and Pittsburgh destined for the upper Mississippi or the Missouri, originally had to be unloaded and reloaded in St. Louis (Primm 1981, 139).

St. Louis's access to riverine transportation and rich farmlands early on attracted German immigrants, who settled communities in the surrounding countryside as well as in the city. By 1850 St. Louis was the most foreign-born city in the nation. Immigrants from Germany, Ireland, Italy, eastern Europe, and Russia settled in the city to work in rapidly growing industries. By 1870, St. Louis was third in the country, after New York and Philadelphia, in the value and number of its manufacturing plants (Faherty 1990, 62). The large German population encouraged the growth of neighborhood breweries. Two enormous companies emerged in locations very close to each other, the Lemp Brewery, producing Falstaff, and Anheuser Busch, producing Budweiser. Today the vast Anheuser Busch brewery is still in production, while the Lemp facility, with its colossal grain storage towers and million square feet of undeveloped "rough" space, is home to a number of artists enjoying cheap industrial studio quarters in the downtown Benton Park neighborhood (see fig. 8).

Although divided in sympathy between slave owners and abolitionists, Missouri sided with the Union during the Civil War. After the war ended, the city developed rapidly. The first bridge across the Mississippi, which spurred the development of railroads, was built in 1874. By 1894 the

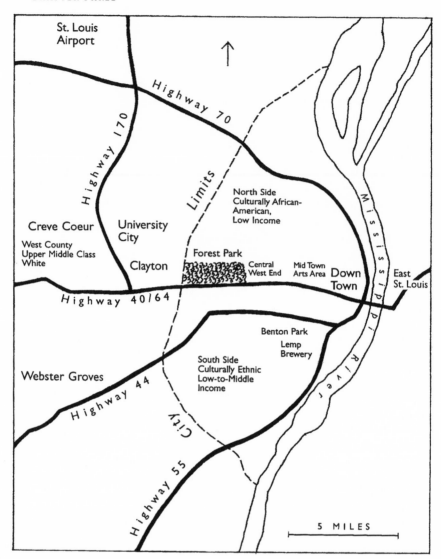

FIG. 8. The St. Louis metropolitan area.

newly opened St. Louis Union Station was the largest rail terminal in the world, with four hundred passenger trains daily (Faherty 1990, 86). Nevertheless, the city had lost its initial supremacy over Chicago by the 1870s. Chicago's advantageous location, closer to the wealth of the northeastern seaboard, let it draw the enormous grain product of the upper Midwest on the most efficient route to New York and Boston. Powerful northeastern capitalists invested heavily in rail lines to Chicago, which provided the

stimulus for that city's explosive growth and eventual dominance (Primm 1981, 234–38).

St. Louis's Conservatism and Growth

An enduring myth grew up that St. Louis lost the struggle for leadership over the Midwest because of the conservatism of its elite classes.[6] The argument was that St. Louis's southern and French traditions favored river over rail transport, old over new commerce, and the traditional north-south orientation over the developing east-west one. As the story goes, Chicago's aggressive businessmen with their dynamic vision of the future capitalized on their geographic advantage and outhustled St. Louis.

Primm's history of St. Louis (1981) makes a convincing argument that Chicago's advantages (mainly the closer connection to eastern sources of investment capital) were not surmountable, and that St. Louis's businessmen were as aggressive as any in railroad investment. Nevertheless the idea that St. Louis has a southern-style, conservative, tradition-loving elite persists to this day. It is the heart of the common rhetoric to explain problems in community support of avant-garde art activities. This statement by an art dealer is typical.

> St. Louis is soft and easy. St. Louis artists tend to make work for the market here. Collectors here are conservative, insulated. (Int. 113)[7]

Although falling behind Chicago, St. Louis expanded its hegemony over the area to the south and west. Immigrants flooded in to work in the expanding manufacturing industries and created the mosaic of ethnic neighborhoods that give the city its diverse cultural flavor. The city's optimism and energy culminated in the World's Fair of 1904, held in the western end of Forest Park and in the leased brand-new campus of Washington University. The fair was a spectacular success, with about 20 million visitors. It and the arch, built sixty years later, are the most familiar cultural symbols of St. Louis.

During the twentieth century the St. Louis metropolitan area grew to its current population of about 2.5 million.[8] In common with other cities in the country's northeastern quadrant, its manufacturing capacity peaked around mid–twentieth century. Since then the region has gradually declined in importance relative to the South and West of the United States. Manufacturing has also suffered from the flow of imported products. The giant General Motors plant in the city stands vacant, along with a large federal munitions plant and many other heavy-manufacturing facilities.

The population of the city itself, separate from the surrounding counties, declined to 397,000 by 1990. This is the lowest figure since the 1880s, and less than half the city's population in 1950. The remnant urban population is heavily minority, poor, and crime ridden, similar to many of the other major cities in the nation.

Cultural Geography

The early city nestled on a bluff overlooking a bend in the Mississippi, just to the south of the Missouri River. During the nineteenth century the population clustered along the river. In searching for cleaner air and larger house plots, people moved to the west as the twentieth century progressed, creating rings of suburbs. Presently St. Louis is largely segregated residentially, with blacks living in the north and pockets of ethnics (traditionally "scrubby Dutch" and "Hoosiers," lately Southeast Asians) in the south (see fig. 8), and with primarily white suburban expansion in the west. The streets of the tiny downtown business district are vacant and menacing at night. Sporadic development projects, recently the Union Station mall and a relatively new convention center, try to lure suburban shoppers back to an urban experience in which they see little value. The major arts institutions and neighborhoods exist in a transect through the center of the region, running from the suburban west to the relatively industrial, undeveloped riverfront that defines the eastern border of the city.

An Art Market Transect

The art world of St. Louis is centered in an area running from the upper-middle-class homes of collectors in the western suburbs to the galleries and artists' studios of the city in the east. There are few art institutions of major importance in the far northern or southern areas. The trip from the far western suburban periphery east to the central city passes through communities of single-family homes with neat lawns and lovely shade trees where collectors are apt to live, through a ring of older communities whose social characteristics are intermediate between city and suburbs (making them good residential locations for the more middle-class artists), across the city line through the streets of magnificent mansions and interesting shops of the Central West End (a neighborhood that has always had the potential to be the area's art center and is home to the most elite galleries), through depressing neighborhoods of empty, often burned-out buildings in the northern half and changing ethnic communities in the south to confront the Mississippi and its malodorous heavy-

industry plants. This most urban area is home to a few artists and galleries looking for a minimal-cost, gritty existence.

Across the river is East St. Louis, Illinois, a community that has the infamy of contending for the title of poorest, least-developed, worst-governed, most crime-ridden community in the nation.[9] Continuing east beyond that are small farming communities of Germanic heritage, many as closed and xenophobic now as they might have been one hundred years ago. The heavy industry along the riverfront, coupled with the perception of danger across the river, means that the cultural life of the city focuses west toward its suburbs rather than extending equally across the river and state border. Even Southern Illinois University, with a thriving art department located in a rural area just a fifteen-to-twenty-minute drive from downtown, is ignored by most art world actors in the St. Louis area.

Several communities and neighborhoods on this transect are important in the art life of St. Louis. A few wealthy, older, relatively close-to-downtown western suburbs (mainly Creve Coeur, Ladue, and Clayton) are home to a disproportionate number of collectors. These locations boast excellent school systems, which were de facto segregated until a major regional school-discrimination lawsuit was settled in the 1980s. Transportation from the large, solid brick houses, tall trees, and airy yards to the professional and business offices of the inner city takes only twenty minutes along Highway 40, the main east-west road bisecting the metropolitan area. In the past twenty years a major migration of business out of the central city has made Clayton, home to the St. Louis County government offices, the dominant business location in the county. This makes it attractive for gallery locations.[10]

Just to the north of Clayton, adjacent to the Washington University campus, the older community of University City was a way station on the migration of upwardly mobile Jewish families out of the inner city toward greener house-plots. In the era after World War II its excellent school system and liberal community values were a major draw for academics, artists, writers, and musicians. University City was the first middle-class community to peacefully integrate its housing in the late 1960s. Its enlightened residents and local government were able to maintain a vibrant cultural life in the face of massive immigration of lower-class blacks from the city and a commensurate middle-class white flight further west and south. It has been the home of several regional arts organizations, including an arts-and-crafts center offering courses and studio-gallery support to area artists (Craft Alliance), a multipurpose arts center located in a re-

modeled synagogue (the Center of Contemporary Arts, COCA), and the dominant regional music conservatory (the St. Louis Conservatory and Schools for the Arts, CASA), located in another remodeled synagogue. The main street of University City, known as the Loop, has recently blossomed into a center for live music and open street dining, with one gallery of art fair quality and the only private gallery in St. Louis specializing in African-American art. This suburban neighborhood, more than any other, is home to artists.

Further east across the city line, still along the central east-west axis, the Central West End neighborhood has long been the region's center for lively urban shopping and dining experiences that sophisticated consumers compare to New York's Upper East Side and Greenwich Village, Boston's Newberry Street, and most of downtown San Francisco. Twenty years ago this was the only neighborhood in the area where middle-class people could feel comfortable strolling to shop in bookstores and art galleries, sip coffee in outdoor cafes, and dine in cosmopolitan restaurants. The few blocks where this experience is possible are bounded by the vast Washington University hospital center on the south, a community of mansions on private streets to the west,[11] and variable housing and light industry on the north and east. While street crime is not particularly common in this neighborhood, the few instances of assaults and robberies committed against visiting middle-class suburbanites are not forgotten. This neighborhood is home to the oldest continuously operating gallery in town, and to two other successful galleries, one dealing in expensive blue-chip contemporary art and one in local art, as well as two newer galleries. These will be described in chapter 5.

The Central West End is bordered on the south by Forest Park Boulevard, a divided avenue connecting the inner suburbs and the central city. Just to the south of the boulevard is a neighborhood of mixed residential and light-to-medium industrial usage that blends into the residential south side, with its ethnic mix of neighborhoods. This near-south-side central-western corridor is adjacent to a medical-center complex and a couple of lower-middle-class neighborhoods with marked (mainly Italian) ethnic identities. Housing is cheaper here than in the Central West End or University City, making it attractive to some artists.

Continuing further east along Washington Avenue toward the Mississippi River one reaches Powell Symphony Hall, the home of the St. Louis Symphony. The theater, rehabilitated for the symphony from an abandoned movie theater in the late 1960s, anchors a newly developing midtown cultural center along Grand and Washington Avenues. Two re-

habilitated theaters (the Fox and Sheldon) joined Powell Symphony Hall in the 1980s. These three theaters and a few public-arts and cultural organizations fly the flag of high culture while surrounded by low-income housing, light industry, and the abandoned and burned-out buildings that are so unnervingly common in the centers of many American cities. On symphony nights the police appear in force along Grand Avenue, directing traffic and waving the elegantly dressed symphony-goers across the streets, announcing by their presence that it is safe to walk a few blocks to your car without fear of mugging.

The "Grand Center" redevelopment group, an association of private and public organizations hoping to develop this neighborhood as an arts and entertainment center, hopes to attract visual artists to the area also. So far only two visual-arts organizations have located there: the Forum, an art space or quasi museum dedicated to introducing avant-garde contemporary art to the St. Louis community through the exhibition of traveling shows, and the Portfolio Arts Center, an exhibition-plus-classroom space devoted to fostering African-American arts.[12]

Some artists have settled further to the east in living-loft spaces along Washington Avenue, in several buildings converted from light manufacturing à la SoHo.[13] Sympathetic landlords of ten- or twelve-story loft buildings and a cooperatively owned artists' studio building anchor this as the midtown visual-arts center, although it is invisible to the uninformed. Galleries try their luck in this area from time to time, but it has not coalesced into a viable gallery neighborhood. Parking along the deserted evening streets is an adventure for middle-class art supporters, who arrive at coordinated gallery openings with the nervous gaiety of those who have survived a dangerous trip.

Continuing further east, one reaches the tiny downtown area of tall office buildings and the underdeveloped riverfront. While art galleries come and go, as they find serendipitous, sometimes free space, no center has been able to maintain itself downtown. Turning south paralleling the river, the Lemp Brewery in the Benton Park neighborhood contains a small community of artist studios (see, e.g., fig 9, p. 93 below). The abundant cheap space is rough, and no one, so far as I know, has set up living quarters in the brewery itself, although the neighborhood is home to several artists.

Institutions

The private worlds of artists, dealers, and collectors are sustained by a public world of art institutions. The most well known of these are public exhibition spaces such as museums, art spaces (quasi museums showing

traveling exhibitions without permanent collections, often referred to as a *kunsthalle*) and art parks. St. Louis, big enough to have almost everything but too small to have more than one of each, has its elite museum, the St. Louis Art Museum; its university museum, Washington University Gallery of Art in Steinberg Hall; its kunsthalle, the Forum for Contemporary Art; and its outdoor park-museum, Laumeier Sculpture Park; as well as various artists' organizations and several university-college art exhibition spaces.

The metropolitan area has a large array of educational institutions, with several universities and an extensive system of public and private, secular and religious, small and junior colleges. The two largest private universities, Washington University and St. Louis University (a Jesuit institution) have fully developed programs including medicine, law, and business. During the educational boom of the 1960s urban branches of the University of Missouri (UM–St. Louis) and Southern Illinois University (SIU-Edwardsville) were developed. All together, these provide a large number of study opportunities for students and teaching positions for artists, although in the 1990s full-time tenure-track jobs have become quite limited, and many artists have to patch together a set of short-run course assignments to earn the most minimal income from teaching. This array of arts institutions is presided over by the two oldest fine-art institutions in the area: the Washington University School of Fine Arts and the St. Louis Art Museum.

Washington University School of Fine Arts

The major generative force in the St. Louis art community is the master of fine arts (M.F.A.) program at Washington University art school, which has provided a stream of artists to the area through faculty and graduates. The art school was established in 1879 and has been distinguished because of its close association with a full-fledged academic university. The school moved to its present location in 1909, after the World's Fair. Most of the office and studio facilities are just below the "hill," the Washington University arts and science campus, which sits across a wide north-south avenue separating St. Louis city from the county.

The St. Louis Art Museum was originally part of the Washington University art school but separated to become the City Art Museum (later given its present name) at the move in 1909.[14] The art school developed as a provincial department until the 1940s, when a new dean was hired to upgrade the faculty and to establish a new bachelor of fine arts (B.F.A.)

degree program.[15] After complaining that the faculty was "inbred," and that "there is no single instructor of outstanding professional accomplishment in painting or drawing" (Defty 1979), a few well-known artists were employed. Philip Guston taught at the school from 1945 to 1947, when he was replaced by Max Beckmann. The wealthy St. Louis collector Morton May bought Beckman's paintings along with other German expressionists' work and created the St. Louis Art Museum's outstanding collection. Beckmann and Guston, who were at the school less than four years each, are remembered in St. Louis to this day for their connection with the campus.[16]

Washington University offered commercial-art programs (graphic art, illustration, and fashion design) and painting, drawing, sculpture, and photography. A new dean was brought in from New York in 1969 to start the new graduate program.[17] The M.F.A. program, the first in the region, began in 1970, designed for about fifty candidates.[18] SIU-Edwardsville soon also started an M.F.A. program, with special strength in ceramics. Since that time the Washington University M.F.A. program has graduated ten to twenty artists a year, while the SIU-E program graduates another five to ten. Many of these artists remain in the metropolitan area. The contemporary art world in St. Louis has been shaped by the faculty and M.F.A. graduates around Washington University, who formed a core of artists interested in the highest level of art.

The post–World War II boom in educational institutions peaked in the 1960s and 1970s. The junior-college system began a period of significant growth just at the time that the art school began graduating more artists in the late 1960s. Arts programs were offered in private colleges, including Lindenwood, Fontbonne, and Webster College (now University). The community of artists formed of Washington University graduates and artists trained elsewhere found full- and part-time jobs teaching at the expanding institutions in the metropolitan area.

Until the 1970s the art school was associated with the St. Louis Artists Guild, a group of elderly conventional painters (see below). The higher university administration at that time wanted to lead the school toward a less provincial, more mainstream approach, which in practice meant finding artists with larger reputations in New York. As has been true in most art schools, this attempt has not succeeded. Although there were a couple of faculty members who have had major New York dealers and national reputations for some time, the cohort of active senior faculty in 1992–93 could not be said to have been distinguished. Only one full-time faculty member

had representation in a first-rank New York gallery, and none had a presence in the auction market. A knowledgeable artist at Washington University characterized the faculty through their stance in advising students.

> The faculty rather advised kids to get a teaching job, get a middle-class life. By and large, the students responded; they did not think they should tilt against history. . . . Here, to tell a 20-year-old already in debt to go to New York to try to become famous is a terrible fantasy. (Int. 65)

Washington University is not significantly different from most professional art schools in the country with respect to distinguished faculty. Schools rarely have more than one artist with a significant national reputation, since the income that goes with renown frees artists from the burden of teaching. Few of the most visible painters in the country teach on a full-time basis.

The St. Louis Art Museum

Just as the Washington University M.F.A. program hegemonically controls the pedagogical side of the art world, the St. Louis Art Museum is the grandest and richest exhibition space in town. The extraordinary price of historic art means that most communities can afford to have only one institution that pretends to offer the full range of art history. The St. Louis Art Museum exhibits art from all periods, while newer, smaller organizations like the Forum for Contemporary Art or Laumeier Sculpture Park focus on contemporary art. This division of labor notwithstanding, all public arts exhibition spaces in St. Louis exist in the shadow of the St. Louis Art Museum.[19]

Without personal acquaintance with artists or dealer-galleries, the world of art seems mysterious and distant for most people. Public museums, supported by tax revenues, can serve in principle to clarify the mysteries, although of course the majority of the public never sets foot in a museum.[20] The vast, elegant spaces filled with art that often combine the qualities of respectable eliteness and irreverent scandal make the art museum a cosmopolitan place to go on an afternoon date (for those few who appreciate it). Like all modern museums, the St. Louis Art Museum (SLAM) has a stylish cafeteria and gift shop for visitors who tire of looking at its extensive galleries.[21] Parents take children there for an experience of high culture, and the museum has an extensive program of public education, which recorded over seventy thousand "visits" to organized programs and classes in 1992. At the SLAM, these cultural riches are available

with the extra benefit of free admission, since the museum is substantially supported by property taxes.[22]

The museum was originally founded in 1881 as part of the Washington University art school. In 1900 the site of "art hill," near the western edge of Forest Park, was chosen for a grand permanent structure to crown the site of the St. Louis World's Fair, which would remain as a museum after the fair ended. The building was occupied in 1906, and in 1909 the museum formally separated from Washington University to stand alone as the St. Louis Art Museum.

The St. Louis Art Museum's $16 million budget (well over half from its presence in a metropolitan taxing district supporting the SLAM and the St. Louis Zoo), half a million visitors per year, and sixteen thousand contributing members signify that the museum is the preeminent art institution in the metropolitan area.[23] Sitting on top of "art hill," overlooking a pond originally built for the World's Fair, the art museum defines and controls high-art status. In a typical year the SLAM offers about four to five major shows and a dozen or so minor special exhibitions in addition to its own permanent collection, only a portion of which can be shown at any one time. In the 1992 calendar year these exhibitions included a show of one local artist's work as well as several shows on modern and contemporary German art, one of the SLAM's areas of expertise. It is also well known nationally for its collection of pre-Colombian, African, and Oceanian art. Both areas of expertise stem from donations of immensely valuable collections by local elites.

Relations between Art Institutions

The SLAM's hegemonic control over high art in the metropolitan area constantly frustrates many local art world actors who want the museum to lend its prestige and resources to legitimize and support their particular interest. People involved with the other major public art exhibition places, Laumeier Sculpture Park, the Forum for Contemporary Art, and Steinberg Hall (the Washington University art museum) reproach the museum for not cooperating. A curator at one of the other exhibition spaces complained about the unwillingness of the museum's senior staff to work with her on exhibitions and programs.

> It always got down to dollars and one-upmanship. The museum [acted as if it] was the only arbiter of artistic value in the community. The museum demanded the sole high position of arbiter of taste.

Knowledgeable people in St. Louis are aware of the rivalry between the various art institutions. The same curator quoted a local art philanthropist's response to her request for support: "I won't give any money to [your institution] because you are beginning to compete with the St. Louis Art Museum" (int. 45).

The SLAM's virtual monopoly on local support at the highest level for the visual arts means it does not see much need to cooperate with other organizations. The most prominent collector in St. Louis is quoted as complaining about the current SLAM director in a popular magazine.[24]

> He's not interested in working with other institutions in the city. Is this a problem? I think so. I think this is a small enough town that everyone has to work together. There's a museum collaborative that he doesn't participate in. (Tucci 1992, 60)

This sort of direct public criticism from a person leading the SLAM's vital constituency, the million-dollar-patron category,[25] could not be ignored. In the 1992–93 season the SLAM put on (for the first time) an exhibition in cooperation with the Forum, a nonprofit exhibition space in which the elite patron was heavily involved.

Whose Museum? Struggles over Constituency

The museum must balance the demands of various groups: since half of the budget comes from regional property taxes, the museum must be responsive to issues of "diversity," the code word for involving minority groups with the institution. The museum's education division schedules classes for art education and organizes shows to involve the public, meaning people with no special interest in or knowledge of art. While the education programs have been a success, this activity—which sometimes goes far from traditional art education—is resented by people who wanted to limit access to the museum to those who already love and support fine art. For example, a former employee of the education division, who characterized herself as a "profound egalitarian," who believed that "everyone should benefit from the art museum," said she finally resigned when her boss asked her to submit a grant to the Missouri Arts Council for pony rides (int. 47).

These sorts of complaints notwithstanding, no tax-supported institution can ignore the pressure to justify its budget by increasing its visitor counts. This causes a profound crisis of identity in art museums, whose essential underlying function, according to sociologists like Bourdieu, is to validate unequal social and economic statuses in society.[26] While the

museum administration seeks new ways of making the museum more accessible to people of all backgrounds, to increase its visitor count so as to legitimize its receipt of public funds (and to generate new funds through museum shop sales),[27] it risks alienating its natural allies, the local elite who collect art.

Collector's Criticisms of the St. Louis Art Museum

Some collectors who were actual and potential donors of money and art to the museum's collections were critical of the way the museum treated them. They complained that the museum wanted collectors to donate money and then stand aside to let the curators buy art. These collectors wanted a more active role. They wanted the curators to advise them about how to collect art that they would ultimately donate to the museum. One wealthy and very focused collector in his forties criticized the SLAM.

> There are not many ["real"] collectors in town because the museum is at fault. The museum is more interested in getting money than in cultivating collectors. The museum's greatness here was caused by a few great collectors: Pulitzer, May, Weil, Steinberg. They were the historical collectors of the 1950s. They were stimulated by . . . the people who were there [i.e., the curators working in the museum]. The museum has turned its back on educating the collector to form a collection they will give to the museum. They want people to go out, make money, and give it to the museum. They will give you the social cachet in return, [and] put you on the museum board. They take your money and give you social standing.

This man considered himself an extremely knowledgeable collector of contemporary art from the international market. Like all but the two or three wealthiest collectors (who were a full generation older), who bought historically significant work at any price, he collected art in the price level below about thirty thousand dollars. He sneered at the museum's cautiousness in collecting.

> The museum will buy a few very expensive pieces, art that is so expensive that they can't lose. I prefer to take the risk of buying a ten-thousand-dollar painting. (Int. 17)

Previous curators at the SLAM had accommodated local collectors with local shows of work for collectors to purchase. An older collector recalled how these worked.

> In 1955 . . . there was the first Collector's Choice show at the art
> museum. At that time the art museum believed that one of its re-
> sponsibilities, one of its functions, was to encourage interest in
> art in a direct, honest, straightforward way. . . . They had these
> shows probably every other year for awhile. . . . [The curator]
> would select certain things from galleries in New York. . . . He
> would hang paintings; they were always for sale. A painting
> would cost, say, $400 in the gallery in New York, and he would
> add 15 percent to it so it would be $460 here. The $60, some of it
> went to the museum.

The collector stressed the importance of expert advice from museum pro-
fessionals.

> When you first start out, you have no knowledge, no background,
> you need some support. A collector needs some support mecha-
> nism somewhere.
> [*SP*: Which the museum gave you?]
> The museum *never* gave me. The Collector's Choice shows
> were fine, but you needed some evidence that what you were do-
> ing was not idiocy. (Int. 26)

A 76-year-old collector recalled how a previous curator personally so-
licited specific pieces for the museum and thereby advised the collector of
value.

> [The curator] used to come to the house once a year, and he
> would walk through the house and he would say, "These are the
> things I would like to have, and that I will accept," which is im-
> portant. Then you also know what you have that is particularly
> valuable with [the art museum]. He'd say, "These are my A
> choices, these are my B choices, these are my C choices. But any-
> thing you'll give us we want, of this group." If you [i.e., a curator]
> put on a good show [at the art museum], you are educating col-
> lectors and you are educating the public. . . . You educate by
> showing, by saying, "This is museum quality, this is the cutting
> edge, this is worth having." . . . I think that you educate by hav-
> ing the right art. (Int. 44)

The SLAM cooperates with a private group of museum supporters called
the Contemporary Art Society, which is designed to educate collectors.
The group has educational programs and travels once a year to other cities
(every other year to another country) to view art. A collector described her

experience in a group of about twenty-five on a recent trip to San Francisco.

> It's like for four or five days. And it's marvelous because you got into museums and you meet with curators. You can do that on your own, but the thing that's wonderful about it is that you go into all these private collections and private homes and they have parties. Like you would go for dinner in some private home and look at their collection. You would spend, like, a day; maybe in the morning you would go to some galleries and then maybe to the museum, and then you would go to two or three homes in the afternoon for tea or for cocktails, and then that night you would go out to dinner at a private collector's home. (Int. 81)

I observed a similar visit by a group of about twenty-five matrons from the Boston Museum of Art to a collector's suburban home in 1993. They arrived in a chartered bus with a local guide, an upper-middle-class woman who ran an art tour business as a sideline. Wine and hors d'oeuvres were served by caterers as the husband and wife placidly interacted with the strangers invading their home. The tour trooped through each room, chattering pleasantly as they admired the rugs, furniture, and decoration as much as the art. The owner did not collect local art, and his visitors saw the same smattering of relatively inexpensive blue-chip contemporary artwork (i.e., pieces costing less than $50,000) that could be seen in hundreds of homes across the country. The owner entertained them with the story of his misplaced sculpture: a Campbell's soup can ("signed by Warhol") that was missing after a new maid came to clean, and that was found in the kitchen pantry.

This sort of activity happens in every urban area and knits the national community of active art collectors together. While social scientists may question details of the relation between high-art expertise and social-class status, no one denies its reality for the relevant portion of the elite.[28] The national network of contacts created by these art tours has tremendous potential for smoothing social and economic interactions for this wealthy, white sector of society. But as valuable a social resource as the Contemporary Art Society is, several wealthy younger collectors were critical of its relation to contemporary avant-garde art.

> The St. Louis Art Museum has never had a contemporary art movement that's had any real substance or support.
> [SP: Well, they have the Contemporary Art Society.]

Right. We were very active for a long time, but we just got fed up and dropped out. . . . We made an effort to try to bring in some different speakers. . . . They haven't funded or budgeted for acquiring [contemporary art]; they've done some wonderful things, and it's a museum that I'm proud of in general. It's got a very nice collection, but not a contemporary collection. We also always believed that there should be a Museum of Contemporary Art in St. Louis[29] . . . of people who are alive, of people who are producing art right now. . . . Really, you go to the art museum and everybody's dead or almost. . . . But I don't see them [the SLAM] as having much enthusiasm for real current, kind of happening-now kind of artwork, and that's really what we were trying to do.

[SP: You're not criticizing the museum for not supporting local art, you're criticizing it for not being in depth in its support of contemporary art?]

I'm really not criticizing it at all. I'm just saying that the contemporary art society at the art museum was not contemporary art as far as we are concerned. That was our opinion. (Int. 80)

The Docents Program

The Contemporary Art Society is a private group administered by the SLAM whose main function is social and educational. The SLAM also formally administers several programs of volunteers. The "Friends" is the museum's membership support organization, which puts on programs to support the SLAM.[30] The most elite volunteer organization is the docents program, which consists of a trained staff of about sixty volunteers who lead groups through the collections. One female collector and part-time arts administrator described how it works.

I'm also a docent at Laumeier Sculpture Park, but the art museum is still the plum of volunteerism. I think they had over one hundred applicants, and they took twenty or thirty in this last class. And you're trained for between five and six years in all areas of the collection and tested both written and orally, which is really quite different from most museums in the country. Most docents specialize in one area. And considering that our museum is a full-scale museum, that's a lot. Like, for example, tomorrow I have to do an African art tour, and I have to go back and study. It's a fairly sharp group coming. . . . The requirement is, I think something like giving twenty-five tours a year, plus twenty-five hours of enrichment that you have to take. Plus there are special training sessions even after you become a senior docent, twice a year. And the

training until you're a full-fledged docent, as I said, takes about five or six years. (Int. 92)

The docents program has enormous respect in St. Louis because of the discipline and accomplishment it demands of volunteers. But no art museum can be healthy over the long run without the support of elite collectors, and the discontent expressed by a few collectors represents a dangerous pressure. The institution is financially healthy but lost an important political struggle in 1992–93 to expand into Forest Park. At the time this study was done, the position of chief curator for contemporary art was vacant, and the community was waiting to see what directions the museum would take.

Artists' Criticisms of the St. Louis Art Museum

Local artists want the SLAM to further their careers by showing their art in the museum's exhibition spaces, and by making contacts for them with other prestigious exhibition spaces. Since the late 1970s the museum has had a program of smaller exhibitions of contemporary art called its Currents show. In the fourteen years since its inception in 1978 the Currents program has shown seventy-five artists in fifty-one shows, including seventeen shows of local artists. When most local artists complain of feeling ignored by the museum, that means that they have not had a Currents show.

The SLAM defines its responsibility as showing "the best" art. If the support of local art uses resources that could be used to display avant-garde art from New York, then the museum would be damning itself as irrelevant to the mainstream of art history. Midwestern institutions run the added risk of being labeled provincial if they dare to ignore the New York center. A curator at the museum brought up these issues in his resistance to the idea that the SLAM should devote a permanent space to showing local art.

> When I walk into someone's studio, I judge them against anyone, wherever I go. It doesn't do anyone any good to "fill a St. Louis quota." If the criterion [for museum shows] is geography, I don't know how that really works. . . . I have not done a show of local [artists]. . . . It's a dilemma. Do you give people a showing here or bring in people from the outside? . . . I do shows that I think would be of interest to local artists. (Int. 58)

This view was echoed by another curator, in answering the question, "Why doesn't the museum open a special room for St. Louis artists?"

We don't have enough room for everything here. No room for lots of large contemporary works. There just isn't enough room. A well-run Art St. Louis [a local artists society—see below] would serve a similar purpose. It would be nice to be like the Art Institute of Chicago and have a "Chicago and Vicinity" show, but you know there are always bitter complaints about the choices made in these shows. When [local artists] Bill Hawk or Pat Schuchard had their shows, artists complained to me about the fact that they felt their work was as good or better and they had not had Currents shows yet.

But the idea of supporting the local art community is clearly important to the museum also. The curator concluded:

It would be interesting to do periodically. It would take planning. It would be good to highlight the contemporary arts of this community. There is only one museum; it should be comprehensive. (Int. 51)

There is no ideal solution to this problem because the goals of highlighting local art and introducing "the best" international art are contradictory. No matter how much an institution does for local artists, there will be criticisms of bias and favoritism from those left out. No matter how many avant-garde shows are brought in from outside, there will be accusations of ignorance and poor judgment from those with pretensions to higher degrees of connoisseurship.

The Forum for Contemporary Art

These criticisms are particularly acute for the Forum for Contemporary Art, a small art space trying to introduce world-quality art to St. Louis. This kunsthalle is a not-for-profit organization dedicated to showing (but not collecting) contemporary art from around the world. Supported by grants from the two major arts-funding organizations (the Missouri Arts Council, the Regional Arts Commission) as well as by local corporations, elite collectors, and dealers, the Forum sees its role as introducing the vanguard of contemporary art to the conservative St. Louis art world. One curator described its mission.

The purpose of it was to show art that can't be seen elsewhere, and that meant often the more experimental work . . . the things that would be shown in New York or Germany or L.A. that you wouldn't see here because they won't sell in the commercial gal-

leries. . . . So we were . . . aggressively going out and looking for that more challenging kind of work, that we could bring people up to snuff. The audience for that was the most sophisticated upper-educated elite. (Int. 62)

Another curator had a similarly patronizing view.

We hopefully can kind of kick people in the pants a little bit, make them think about things. And by doing that, it's healthier for the artists—that this [St. Louis] is not a vacuum. . . . The world is too small now . . . for St. Louis [artists] to think that they don't have to play in the big, in the same league as these [internationally known] artists, and that they don't have to pay attention. (Int. 13)

By trying to show cutting-edge artwork, the Forum faced the problem of St. Louis's peripheral location in the international art world. A curator complained,

The problems became, hitting the art market in the 1980s, when things were at a very fast pace, very high price. Artists in New York and L.A. and Germany and Spain could care less about sending their stuff to St. Louis. It's not going to get them anywhere; they don't even put it on their résumés. So getting the art was becoming more and more difficult.

Not only was it difficult getting cutting-edge art to St. Louis, but once there it was hard to get anyone to come and see it.

Sometimes there were two and three people in the audience. Sometimes the [visiting] artists said to me, "Are you sure there is nobody else?" . . . So that was really frustrating.

The lack of support from the local community for seeing emerging, avant-garde art made the Forum personnel resent the established art institutions. The curator interpreted the problem as due to St. Louis's restricted size, because each premier institution had no competition.

It's hard to have a lively art environment when you have an isolated university and an isolated museum. . . . So there is nothing else in town, since they are the only ones, there's nothing pushing them to be.

She was particularly bitter about the lack of support from local artists, who should have been her natural allies in any attempt to introduce cutting-edge art to the area.

> I went out to approach artists, and they were really angry that we
> weren't just showing their works. . . . Not once that I know of did
> we have a Washington University art class come to the Forum to
> look what we had brought in from New York or L.A. or Ger-
> many. . . . I thought . . . , "We're not showing art that's better
> than the faculty, or better than the museum, but it's different. It's
> different art. Aren't you even interested to see the idea process?"
> (Int. 62)

Another curator commented on the differences between an agile, small
organization like the Forum and the huge SLAM.

> Museums, particularly big museums like this, encyclopedic mu-
> seums, move very slowly. . . . They don't know how to deal with
> living artists. . . . You try to do an installation, and artists who
> like to work at night, you can't get into the galleries at night, or
> you have to hire the guards, and so that has to come into your
> budget. . . . There is very little flexibility . . . very little risk-
> taking. (Int. 13)

In spite of their freedom to exhibit diverse, challenging work, organi-
zations like the Forum are doomed to constant frustration. Forced to
scramble to earn their budget from grants and donations, their peripheral
location in the national art market makes it difficult to get the artistic
pearls they wish to display, and then they suffer the indifference of their
natural art-world allies, as well as that of the local community. It can easily
lead to demoralization among the staff. The Forum enjoys one special fac-
tor: the chairwoman of the board is the most prominent world-class col-
lector in St. Louis. Her extraordinarily active involvement in the Forum's
programs, with the upper-class attention and support that her presence
commands, assures the organization's survival. Although its base of sup-
port is somewhat thin, the organization has made a sophisticated, state-of-
the-art contribution to St. Louis's cultural life.

Laumeier Sculpture Park

The Forum is not alone in the St. Louis area in its mission to educate
the public about cutting-edge art. The Laumeier Sculpture Park is a com-
parable institution with an important difference: a more assured funding
base from its association with the St. Louis County park system. The im-
petus for its founding came from the only artist in St. Louis with a pres-
ence in the auction market: the sculptor Ernest Trova. In the late 1970s
this artist, who had married into a wealthy family, became interested in

establishing a permanent exhibition of his sculptures in St. Louis. The idea piqued the interest of a local banker and art supporter, whose energy, contacts, resources, and gusto made it happen. By 1980 the Laumeier Sculpture Park existed around a core of Trova sculptures. The professional staff, with the support of an active segment of the board, then developed its mission. They introduce site-specific art by emerging artists, with full representation of art by women, as well as exhibit major pieces of outdoor sculpture without necessarily aiming for a full permanent collection.

A monumental abstract sculpture by Alexander Liberman was installed in a prime location in the beginning of the decade, announcing by its dramatic presence that this was not merely a display of hometown work. Laumeier's active program of exhibiting (and commissioning) avant-garde outdoor sculpture and its innovative programming of popular outdoor events (a winter solstice "Fire and Ice" spectacle in which a gigantic commissioned ice sculpture is burned in a giant bonfire; a major national juried arts-and-crafts fair in the summer; and a fall "Day of the Dead" exhibit and celebration of Latin American folk art) put it on the cultural map as a resource for the area with few rivals nationally.

Part of the genius of the original development of Laumeier was its affiliation with the county park system. Half of its million-dollar annual budget comes from public funds, justified by its continually growing visitor counts. The rest comes from its developing endowment and grants to the nongovernmental Laumeier Sculpture Park Foundation. The spectacular growth and dynamism of this institution gives the lie to the complaints of "St. Louis conservatism." Given the right combination of vision, people, and resources, new organizations are possible when their scale fits with local constraints.[31]

Laumeier does not show any local work, aside from its founding art endowment (except as juried into its annual arts fair). Because of this the dynamic young organization has avoided the resentment of local artists who complain about feeling unsupported by their local community. There are several local organizations artists can resort to for support when they have problems. Two artists' societies, the St. Louis Artists Guild and Art St. Louis, provide social and exhibition services, and one free advisory service, the St. Louis Volunteer Lawyers and Accountants for the Arts, gives technical assistance.

Artists Societies: The St. Louis Artists Guild

The Artists Guild is a traditional group with an active program of juried shows for its large membership of predominantly suburban,

middle-class, middle-aged hobbyist artists. Art St. Louis is a smaller, more heterogeneous, and younger group, representing artists making (in general) higher-level, more avant-garde art. In addition to these two main organizations there are several small neighborhood artists' societies (the South County Art Association, the North County Art Association, etc.) that put on cooperative shows of lower-level hobbyist work.

Artists who have dealer representation often do not bother to affiliate with artists' groups, since one of the societies' main function is to show the work of artists not exhibited elsewhere. This was not always so. The Guild was formed in 1886 to integrate woman artists into a preexisting "Sketch Club" composed of only male artists. Incorporated in 1905, the Artists Guild built its own elegant building downtown, which it occupied from 1907 to 1973. At the beginning of this time the Guild was the heart of the local art world, closely tied to Washington University. Leading painters in the local area taught at the University, were involved with the St. Louis Art Museum, and were members of the Artists Guild.[32] As the art world developed in the 1960s and 1970s, the Washington University art school became more professionalized and focused more on the national than the local art scene. The Guild gradually lost its eminence in art circles and became the institution for amateur artists and their followers.

A 68-year-old artist described the Guild in the 1950s.

> Since it was the only institution in town outside [of] the art museum (and in those years the art museum was doing very little in the way of contemporary art), . . . a lot of people put their energies into the Artists Guild, which was not at all pleasing to the old Guild members, who thought of us all as interlopers. (Int. 106)

By the 1970s the deterioration of the inner city forced the Guild to abandon its downtown location and to purchase a house in the south suburban community of Webster Groves, which it has occupied since 1973. The old guard gradually won the struggle for control of the Guild as the more professional artists found other opportunities in the increasing number of other art activities in St. Louis. The Guild presently exists to serve the exhibition and social needs of middle-class, white, suburban hobbyists. More professionalized artists (who tend to have M.F.A.'s) disdain the Guild as composed of older women who began painting after their children left home, who continually take workshops but never make a strong commitment as professionals. In aesthetic quality, Guild art takes no risks but explores familiar, decorative themes and forms.

The few more professionalized artists who came to St. Louis from elsewhere and looked for a group of peers and who mistook the Guild as a society of professional artists soon discovered that it was the wrong place for their more committed approach to art. One successful local artist remembered her experience at the Guild in the 1960s.

> When I came here, I was from Palo Alto and San Francisco, where there was a [local] scene, and if you were an artist you participated. . . . I got here and I looked around, and I was looking for the annual show, and there was nothing, and I was looking for anything. So I found the Artist Guild. [I said,] "Ah, money prizes, that must be where it is." I mean, I didn't know. And I was looking for "where you go to find the artists," and that was the only place that I could find. And I went and I participated there in . . . the first three shows that I found forms for, and it was swell. But I thought, "This is sort of an odd group here. It's worse in St. Louis than I thought." And I always won the prizes. And then I was embarrassed, so I stopped doing that. It just wasn't right. And I was distraught 'cause I couldn't find anything else going on. I went to the art museum, and [they said] "No, they didn't have any plans for anything" [like a show of local art]. . . . It was a real down time when I really felt like I'd gotten dropped off a plane in the middle of the desert or something. (Int. 34)

Another artist described a similar experience, of arriving in St. Louis in 1968, fresh out of his master of fine arts program, and mistakenly thinking that the Artists Guild was the society for professional artists.

> When I got here as a 24-year-old, out of college, someone on the staff [where he taught in St. Louis] was showing there. I got a prize in a portrait show; that was my first and last. [The Guild] is like a community thing. . . . They are a community of people interested in art. They are . . . like the amateur ranks. (Int. 16)

An artist in his thirties who immigrated to St. Louis from Europe and also searched for a group of peers focused on the marginalization of the Guild from the dominant, elite art institutions.

> It was in 1986, in my early days here. That was a lot of effort [at the Guild] to show my work. Nothing came out of it, not one response, really nothing. I've never heard people say, "Let's go see that gallery." I never hear people talk about it. (Int. 110)

An artist in her forties was more clear, if apologetic about her elitism, in describing the difference between professional and Artists Guild artists.

> I think they're hobbyists. . . . I mean, it's just a different arena, I think. I sound real elitist. I can describe them as being little old ladies.

The artist went on to clarify that it was not the art medium she was referring to, but the artists' commitment to their work and the resulting quality of the art they produced.

> It's not an art-craft thing, it's more about . . . I think my work is the focal point of my life. It is very important to me. I've lived my life around my work. I question what I'm doing, and I tend to be very upset, and I get obsessed with it, I think about it all the time, and I do it as much as possible. A lot of the . . . Artists Guild types, it plays a part . . . [implying that art is merely one of their many activities, but not central to their lives. She then connects commitment to the aesthetic quality of the output:] The work isn't real challenging. . . . Artists Guild stuff, it's pedestrian stuff. (Int. 8)

However invisible the Artists Guild is for the elite art society, as a social organization it has thrived. The Guild provides a peer group and social environment for its nine hundred members as well as other amateur artists and art supporters who are shut out of the more professional gallery and university scene.[33] By the mid-1980s the Guild realized that its building was inadequate for its programs, which included a juried show each month and many lectures, workshops, classes, drawing and painting groups, and purely social events.[34] But neighbors in Webster Groves opposed any expansion of the facility, and so the Guild looked elsewhere. In 1992 the Guild agreed to rent a public building in a park in Clayton, a wealthy suburb somewhat more centrally located than Webster Groves. This building had been the home of a local science museum and was elegant and spacious. The Guild was committed to raising over three-quarters of a million dollars to renovate the building and move.

The Guild's amateur orientation is most apparent in its membership rules. It has a complex bureaucratic set of procedures for certifying artists as members, involving successful juried entrance into several Guild shows or the equivalent. In order to maintain membership in the Art Section of the Guild, members must be juried into a show every three years. The full page of procedures detailing conditions of Art Section membership shows

the insecurity the members feel about maintaining their "artist" status. This contrasts with the loose membership standards of Art St. Louis, the organization catering to the needs of St. Louis's more professionally active artists.

Art St. Louis

Art St. Louis is the other major artist organization, about half the size of the Artists Guild, with a membership of less than five hundred. Supported by grants from the Regional Arts Commission, the Missouri Arts Council, and the Arts and Education Council, this organization serves the needs of more committed, professionalized artists. Art St. Louis puts on about half a dozen shows, but the quality of the work, although predominantly decorative, is generally much higher than that shown at the Artists Guild. Existing in donated space, Art St. Louis has had to move every few years as space became available, but the organization has remained downtown since its founding in the mid-1980s. Its openings are far more exciting, grander affairs than those of the Artists Guild, with music, elegant food (all donated), and some of the excitement and crowding of a successful gallery opening, instead of the Guild's suburban neighborhood feel.

A young artist described his experience with Art St. Louis.

> The first show on opening day it was like the whole St. Louis art world was there. The second year was also very exciting. And then it looked like it was going downhill somehow. The excitement was disappearing. My feeling is that it's leaning more towards the Webster [i.e., Artists] Guild too much. I don't want to insult anybody, but it's to me the Webster Guild, it looked like a Sunday morning coffee–type thing. . . . I'm not impressed with the artwork as much anymore. . . . I joined them, I get contacts through them, but as far as the organization itself, I think it has its purpose here in St. Louis. It gets artists together, and it's very helpful in many ways. (Int. 110)

The organization's main functions are to put on juried shows of members' work, to publish a quarterly newsletter, and to do whatever it can to promote the visual arts in the St. Louis area. With a paid staff of three extraordinarily active people, Art St. Louis also operates a gallery space. Art St. Louis grew out of several preexisting organizations of artists. The Community of Women Artists (CWA) existed in the 1970s to support and encourage women at a time when opportunities were restricted. Formed

during the early days of the women's movement, it played an important part in encouraging women to take their art seriously and to commit themselves to devote significant amounts of time to making art. After a while the more serious artists felt that the CWA was being taken over by hobbyists and people more interested in feminism than in art, and they became less active (McCall 1975, chap. 4). It evolved into a local affiliate of a national organization, the Women's Caucus for Art, but the activities were still fairly meager in high-art accomplishments. This left no organization to represent the interests of the higher-level artists.

By the mid-1980s the bank workshop (to be described in chapter 6) involved a group of artists in community issues, and several artists approached the Regional Arts Commission for financial support for an organization to represent their interests. With the advice of the executive director of the Regional Arts Commission, the artists formed Art St. Louis, which as an incorporated not-for-profit organization was eligible to obtain grants from local funding agencies. As the artist quoted previously shows, the artwork shown in Art St. Louis is not accepted as the leading edge of the avant-garde, but the organization fills a real need in the community. Art St. Louis is the association professional artists would turn to for any sort of help in representing their interests. The Art St. Louis newsletter publishes informational and advisory articles and sponsors panels and forums on topics of general interest to artists.

St. Louis Volunteer Lawyers and Accountants for the Arts

The St. Louis Volunteer Lawyers and Accountants for the Arts (SLVLAA) usually has a column in the Art St. Louis newsletter. The SLVLAA is part of a national coalition of not-for-profit local organizations of professionals serving the needs of visual and performing artists. These organizations offer free advice and schedule public lectures on legal and accounting aspects of the business of art. Their primary support to fund their minimal staff and program costs comes from grants from local art-funding organizations. The labor of the professionals is of course voluntary.

Why should professionals like lawyers and accountants give public service to defend the economic rights of private art producers? After all, artists and art organizations are not the only groups in society that tend to be poor, ignorant of their rights, and frequently exploited. Why aren't there Volunteer Lawyers and Accountants for Newspaper Vendors, or Small-Restaurant Owners? The answer of course lies in the public-service,

culture-creating nature of art. Lawyers and accountants accept the claim that artwork expands the cultural horizons for everyone. The SLVLAA volunteers must also judge the artist's "social compact," discussed in chapter 1, as coming up short in delivering income to artists. For similar reasons, St. Louis, like all comparable urban areas, has several funding agencies that award public funds to arts groups and individuals in order to enrich the cultural life of the community.

Funding Agencies: The Missouri Arts Council, Regional Arts Commission, and Arts and Education Council

The Missouri Arts Council (MAC), a division of the Department of Economic Development, is the state agency entrusted with supporting cultural programs. Its budget is about $4.5 million, granted to arts organizations all over the state in amounts from a few hundred dollars to a rural school district to well over half a million to the St. Louis Symphony. While the overwhelming majority of the funding is for performing arts, the MAC does support local arts organizations such as the St. Louis Art Museum, the Artists Guild, Art St. Louis, and SLVLAA. The amounts range from almost one hundred thousand dollars for the SLAM to two or three thousand for the smaller organizations.

The Regional Arts Commission (RAC) is a St. Louis organization funded by a portion of the regional hotel tax (currently the RAC's budget is about $2.3 million). The St. Louis Symphony, the preeminent cultural organization in the city, gets about 25 percent of the total each year, although the RAC makes about 175 total grants a year to arts organizations.[35] RAC administrators struggle constantly to resist the demands from large institutions like the symphony. While administrators may feel strongly that the smaller organizations need to be funded, to encourage some "froth" to the city's cultural life, it is difficult to stand up to the professional and aggressive development staff of the St. Louis Symphony. The RAC also supports the local Gallery Association with about eight to ten thousand dollars per year to fund the gallery guide, which is given away free.

The Arts and Education Council (AEC) is the private counterpart of the RAC. The AEC raises money from corporations and has "funded members" who get 90 percent of all the donations but who then do not raise money on their own. There are about 160 members of the AEC, of which 5–10 are funded members. The organization is not an active supporter of visual-arts organizations.

St. Louis in Comparison to Other Art Centers

Robert Hughes alleges that

> in the 1980s New York not only lost its primacy as an art center but also began to go the way of its predecessors, Paris in the 1950s and Rome in the 1670s—over the hill, into decline. The point is not that New York has been replaced by some other city as a center. It has not been, and will not be. Rather, the idea of a single art center is now on the verge of disappearing. (1990, 7)

Is New York's primacy actually weakening? How many artists live out of the major centers, and what is the trend? In the 1970 census the New York, Los Angeles, and Chicago metropolitan areas together had about 25 percent of the nation's visual artists (13.1 percent, 6.3 percent, and 5.5 percent respectively [National Endowment for the Arts 1984]). By the 1980 census this total had decreased to 21 percent of the total (11.1 percent, 5.9 percent, and 3.8 percent respectively).[36] The 1990 census showed that the three major centers' share of the total had declined to 16 percent (with New York having only 7 percent of the total) (National Endowment for the Arts 1994). The national trend is clearly toward more decentralization of the arts, and toward the decline of New York's absolute hegemony.

St. Louis is a "middle American" city culturally, but how does its art market fit into the national scene? Data on the numbers of artists and exhibition spaces in the thirty largest metropolitan areas show that St. Louis consistently falls within a group of comparable areas (see the graphs in appendix 5). For example, when the number of exhibition spaces in each urban area is displayed, New York has about four times the total of the next largest market, Los Angeles, and over five times Chicago's total (app. 5, graph 1). While the latter two cities are reasonably close to the average for their size, places like San Francisco and Santa Fe stand out as having extraordinary numbers of exhibition spaces for their size. St. Louis is unremarkable in number of artists, number of art exhibition places, exhibition spaces per artist, and spaces per 100,000 population (see the figures in appendix 5). For this reason it can be taken as fairly representative of the mass of places that are not the "high end" of the contemporary art market.

St. Louis's main virtues are low rent and living costs, easy livability, and the sense of community that the art crowd is able to sustain. Openings of exhibitions and other art world happenings may be attended by a rela-

tively large group of people (compared with openings in comparable cities), many of whom know each other and feel solidary and supportive. The main limitations of the St. Louis art world are the other side of the same coin: the affordable costs mean that sales are limited and that art prices for local work cannot be raised to New York levels; the well-defined community means that opportunities are limited and missteps not soon forgotten. Visitors from larger centers may find St. Louis too restricted— lacking an "art scene"—because of the small number of high-art galleries and their unclustered locations. Those from smaller centers may feel invigorated by all the diverse activities they find.

The culture of the community is such that it is a better place to live, to bring up a family, than to visit. There are enough public and private arts institutions to satisfy the needs of those interested in organizations. Neighborhoods have solidarity and identity, and persons with secure incomes feel that life is easy and pleasant in St. Louis.

But St. Louis is not isolated. The hierarchy and hegemony of the national art world affects the artists, collectors, and dealers who live there—they are forever "not in New York." How individuals cope with the realities of life "down home" in St. Louis is described in the following three chapters.

4/ Artists

It's a very personal thing that most artists do. And dealers could sell cars for that matter; it's all the same thing.

<div align="right">Artist</div>

Making the art is my job. Selling it is really a hobby.

<div align="right">Artist</div>

Some of my best friends are artists. I want to say, too, that they expect more of the world than other people. . . . You can never satisfy them. You can never have enough shows, you can never tell them enough how good their work is. Nobody else gets that kind of stroking. Nobody else. I mean when you wrote a paper, did you have a party where everybody came to read it and tell you how great it was?

<div align="right">Collector-curator</div>

High-Art Values

Artists face the existential problem of making a living as well as making art. There are three basic strategies: Some try to create museum-quality work and value their art making above all else, earning a living any way they can; they tend to have M.F.A.'s, and I will call them *high-art* (or *avant-garde*) artists[1]. Others place income generation paramount and make art to please customers in order to support themselves; I call these *business* artists. And others have not committed themselves to their art making enough to warrant a significant investment of time and energy; I call them *hobbyist* artists. These are my terms. Artists in the first group, the elite category produced by graduate training in fine arts, call themselves "real," "serious," or "good" artists. They often scorn and resent the others and use terms for them like "sellout," "hack artist," "Sunday painter," or worse. The business and hobbyist artists usually resent the attempt to deny them the status of artist and rationalize the differences between their own work and high art as merely stylistic, saying that ugly, "gritty" work has taken over the art scene. Though loose and subjective, the categories define positions along a status continuum and thus are contested at every level. The ethnographer must be careful not to inadvertently insult people by referring to them with a lower-status term during an interview.

High-art artists make art because they have to—they have a self-imposed imperative to do so.[2] Faced with the hard choice between solving the aesthetic problems they set for themselves to make meaningful art that rarely sells, or to make insignificant art that earns them a living, they choose the former. James McGarrell, a full professor at Washington University with a national reputation (and a secure salary), put the difference this way.

> Almost every good artist I know, once bread can be put on the table, is more ambitious to have his or her work seen than to have it sold. . . . Given a choice between selling everything we do without exhibiting it and being able to show everything with no sales at all, we would go for the second option. (McGarrell 1986, 12)

These are the "art for art's sake" people, for whom art is not merely a profession but an activity necessary for their survival as a human being. Artists often brought this up in interviews.

> It's not a job at all, it's what I do, it's what I am. So basically I spend as much time as I can here [the studio]; it comes before anything else. . . . My strongest feeling is that I make my art because I'm driven to, I have to. If I don't make it, you might as well lock me up in the crazy house. If nobody buys it, nobody reviews it, that's OK, I don't need it. On the other hand, it's wonderful to be noticed, wonderful to have people want your work. (Int. 137)

> When I'm doing my artwork, I'm not saying it's like a psychiatrist, but it keeps me sane. (Int. 136]

Business artists make art in order to make a living. They forgo much of the pretense of cultural significance in order to support themselves and their families by doing what they love to do. While usually scorned by the high-art artists for "selling out," they are able to combine the independence, pleasure, and relative prestige of art with the income produced by a successful craft to lead satisfying, productive lives. They may have the best of both worlds.

Hobbyist artists are not "real" artists to themselves, much less anyone in the two categories above them, but are the most numerous. They fill the ranks of artist organizations like the Artists Guild and fill the classrooms and pay the salaries of professional artists who teach the art workshops offered by schools, museums, and public institutions. They provide the public support that amateurs provide for so many professions, from ar-

chaeology to zoology. For the most part, they are distinguishable from the other categories because they devote less time to work; their art tends to be decorative "picture painting," that is, unchallenging and trite (McCall 1977). They simply do not take their art seriously enough to devote significant amounts of time to it, or to face the tough aesthetic issues involved in creating high art.[3] Some would say they have less talent. Some artists can produce quality work with less effort than others, but the differences of time, effort, and dedication are primary.

My categories of high-art, business, and hobbyist artists are not distinguished by the medium of the work. Painting, sculpture, multimedia art, or any other type can be made by artists in any category. While in general the "look" of the work tends to become more acceptable to popular taste as one goes from high-art to business to hobbyist artist, the amount and purpose of the work, not the look, determines how artists are classified. Michal McCall's study of female artists in St. Louis in the mid-1970s categorizes them by degree of "seriousness" (is their work aimed at high-art status?) and "dedication" (do they keep making art without market success or social recognition?) (1975, 72–74). McCall uses these criteria to produce four types: "B.F.A. Mothers—Serious but Not Dedicated," whom I would call hobbyists because they don't work much at art production; "Semi-Picture Painters—Dedicated but Not Serious," whom I would call business artists if they were supporting themselves or hobbyists if they weren't; and "Non-Faculty M.F.A.'s" and "Faculty M.F.A.'s," both "Serious and Dedicated," both of whom I would call high-art artists.[4] McCall's attention to the purpose of the work and the amount of work are useful, so long as one understands that the dimensions are indistinct, in large part subjective, and variable. A change in an artist's life circumstances can produce a dramatic change in her or his dedication to making art, as will be seen in the vignettes of artist's lives that follow, and the same person is capable of making conceptually challenging or decorative work in different circumstances.

How Many Artists Are There in St. Louis?

A Washington University faculty artist told me about his conversation with a new painter, who had just arrived in town and had asked,

"Are there many artists in St. Louis?" I said, "Yeah." He said, "Well, how many serious artists are there in St. Louis?" "Well, that depends on what you mean by serious." For the first time, I

thought, could I say there are a dozen really serious artists in St. Louis? (Int. 6).

In principle it should be easy to determine how many artists there are in any place. The 1990 census found 2,219 artists in St. Louis.[5] How does the figure of "a dozen really serious artists" relate to that number? The role of artist is self-defined, complex, and stratified, so it is no surprise that different people will get diverse answers to the question of how many exist.

This study focuses on fine-art artists, to the exclusion of all the types of employed and freelance commercial designers and specialists (such as advertising designers and illustrators) who would count in the census. The craftspersons making production ware, such as the potters selling mugs, casseroles, and so on, the papermakers, jewelry makers, doll makers, and the like, all of whom are likely included in the census, are not studied here. Certainly there is no sharp line dividing high arts from crafts. One person's overpriced teapot is another's clay sculpture, and calling a painter's work decorative may elicit a pleased smile from a hobbyist but an outraged and injured glare from a high-art producer. Any attempt at a roster of such a fuzzy category as fine artists should be approached with serious humility.

I answered the question of how many fine-art painters, sculptors, and graphic artists there are in St. Louis by consulting lists of members of the two major artist organizations, Art St. Louis and the Artists Guild. I supplemented this information with lists of full- and part-time teachers at local art departments, recent exhibition announcements, and expert informants such as knowledgeable staff at artists organizations and senior artists who had lived in St. Louis a long time. I came up with an inclusive list of 812 "practicing artists" in St. Louis in the 1992–93 period. I assume that the difference between this number and the census figure of 2,219 is the difference between my interest in practicing fine artists and the Census Bureau's "labor force" approach and broader definition.

The 812 names on the list do not form a neat population, in the statistical sense, because names could be added or withdrawn with more study. Given the unknown number of hobby artists and business artists who are not involved with artist organizations, galleries, or schools, as well as the fluid movement of artists in and out of town, any pretense that a number is final or complete would be spurious accuracy. The figure should be taken as a reasonable estimate of the total population of fine-art producers in St. Louis in 1992–93.[6]

"Real" Artists

There is still a good distance from approximately 800 practicing artists to around a dozen serious artists. I asked several centrally located people in the art world for information about the work of the artists.[7] Each artist on the list was characterized as more or less active and professional. Once again I caution the reader that these results are not to be taken to reflect a precise measurement of a hard-edged underlying reality. There is no reliable and cost-effective way to measure the distribution of artists in each category. Painters who are active one year may give it up in the next, as will be seen in the vignettes to follow. One observer will rank them for their past work, another for their present activity. Some crafts artists with successful mug-and-casserole production businesses also make ceramic sculpture that is fine art by any measure. One observer will categorize them for the production work, another for the artwork. Artists who showed recently were obviously active, but this measure is simplistic: most people would agree that one of the best artists in town, in terms of sheer aesthetic quality, innovation, commitment, and productivity, has not had a public exhibition of her work for several years, for various personal and circumstantial reasons. Exhibitions in themselves are not valid evidence of high-art productivity, since several artists have secretly rented gallery spaces for their exhibitions. This sort of show, like vanity press publications, is not the validation of their artistic status that it would appear to be (these issues will be discussed more thoroughly in chapter 5).

In principle, given unlimited time and resources, a researcher could get precise information on all the relevant actors and so create a taxonomy of artists. I doubt that this would be worth the substantial cost, since no question is posed requiring this data for an answer. The figures presented should be taken as the best estimate available given the time, resources, and my ethnographic interests.

Of the 812 artists, 222 (about one in four) are judged "active, serious, professional, real" by the knowledgeable peers interviewed. If the 222 "serious artists" were further reduced to those with gallery representation in other, larger markets, like Chicago, Los Angeles, San Francisco, Santa Fe, and Washington, as well as those special cases of extraordinary artists who don't show much, the number would shrink to about 40 or perhaps as few as 25. If one were strongly influenced by the "cultural cringe" and characterized as "really serious artists" only those who had representation in

respectable New York City galleries within the previous few years, the number of artists would drop to around 5.

The main focus of this book, however, is the roughly 200 or so high-art artists, since they are the vanguard of the St. Louis art world. Although they are not the majority of all those who identify themselves as artists, they set the tone of the entire art world. But their example is one of struggle, difficulty, and dedication, since so few succeed in earning a living from the sale of their self-determined art. Local artists remember that Frank Stella, Julian Schnabel, and dozens of other successful contemporary artists once labored alone in their studios, making art for art's sake. This image of market success hovers over every serious artist, whether or not they have significant sales and recognition, and even if they overtly reject the concept. The idea of market success is a burden left to contemporary artists by the achievements of the American art world in the twentieth century. Artists before the boom never dreamed of wealth through art sales. Contemporary artists face the possibility of market success or failure—they may react by ignoring it, understanding that success is impossible for them, but the image confronts them in art magazines and gossip. I will describe this dream of success as a generic model of a successful artistic career. This "dream career" will show the strategies high-art artists consider to translate local success into national and international renown.

Steps toward a Dream Career for Artists
Step 1: Create a Body of Serious Work

The most important factor distinguishing serious from nonserious artists is the quantity and quality of work produced. "Real" artists are totally dedicated to their work. Like all workaholics, artists will sacrifice friends, family, and social responsibilities to create their art. For example, it is common to hear artists talk about conserving their best energy for making art, their real work, and giving what's left over to their gainful employment.

> Arthur Osver [his painting teacher] always said he gave his job the benefit of his loss of energy. He would get up in the morning and work in the studio and then he would go to his job, so they got what was left of him. (Int. 59)

Another painter talked about running up debts to keep working.

> So I started to live on credit cards, 'cause I figured the most important thing is for me to get my art done. The way to get this art done

is to get these teaching jobs, and I'm going to do what I'm going to do [i.e., create a body of art to enable her to succeed in a job interview]. I knew that I was about to get in terrible financial trouble. But I just did it. (Int. 33)

The lesson is, it doesn't matter how they do it, but they must create a substantial body of work.[8]

Step 2: Show Work in the Highest-Status Places

This means the art is exhibited in the most prestigious museums, art centers, galleries, and anywhere important collectors, critics, curators, and dealers will be likely to see it. As a corollary to this, *have the work represented by a prestigious dealer.* The better the dealer, the more likely that museums and art centers will ask to exhibit the work, and vice versa. The ideal dealer does several things.

Sells the work to an ever-widening circle of important collectors;
Places the work in important museum shows;
Generates media coverage of the work in reviews and feature stories and ultimately arranges for monographs on the work;
Makes contacts with important dealers in other cities;
Helps to place the secondary-market work at prestigious auction houses and acts to maintain the price level.

Success in New York is easier to translate into success in other markets, whereas local success does not carry over to New York. The critical step in the dream career is to become nationally and internationally known.

Step 3: Get Gallery Representation in the Major U.S. Art Markets and in Europe

The New York gallery presence is critically important, and the quality of the New York gallery will influence the success of all the other career elements.

This activity is focused on one end, the next step.

Step 4: Establish a Reputation as a "Hot" Artist

In this way, important collectors ask to be on a waiting list to buy work, colleagues invite the artist to do "visiting artist" lectures, and the work is requested for major international exhibitions.

This is the dream that high-art artists learn about in graduate school.[9] They fantasize that their lonely, gut-wrenching hard work in the studio

will pay off in the form of the fairy godfather—someone like Leo Castelli, the fabulous New York dealer of the pop art era—who discovers them and makes them rich and famous, the way Castelli did for Jasper Johns and Robert Rauschenberg. Castelli was visiting Rauschenberg's studio in 1957 when Jasper Johns appeared to bring ice from his refrigerator, downstairs. Castelli had seen Johns's work already and asked to see his studio. Castelli recalls, "To say that I was tremendously impressed is understating it. I was bowled over. Then and there I asked him to join the gallery" (de Coppet and Jones 1984, 88). In less than a year Johns had a one-man show at Castelli's gallery, his painting appeared on the cover of *Artnews,* and a work was in the Museum of Modern Art.

In fact, such career paths are extraordinarily rare. Artists like Chuck Close or Jennifer Bartlett earn good incomes and are well known in the art world without having become stars of popular culture like Andy Warhol. But there are relatively few who achieve their level of success. Leslie Singer, an economist who studied the careers of a sample of artists who began their careers with exhibitions in prestige galleries, found that the odds were 1 in 111 of "success," defined as sales in the auction market (1988, 38–39). Simpson, in his study of SoHo, concluded that "94 percent of all the artists in New York are not, then, significant sellers" (1981, 58).

Most artists, in New York or out, have neither successful dealer representation nor thriving careers. They make a living in daily conditions that involve more work like teaching than the dream career promises. In an environment like St. Louis, these less glamorous lives are shaped by the low-expense, supportive lifestyle that the environment allows.

Professionalism in Artist Careers

A dream dealer will take care of all the business and financial aspects of selling, leaving the artist free to think of nothing but art. In addition to promoting the work in the media, placing it in important museum shows and galleries in other parts of the country, and selling the work to important collectors, the ideal dealer will take responsibility for photographing, documenting, packing, and transporting the work. In the real world of most artists, they must do these professional tasks for themselves.

A painter who was a full professor told me about his standard orientation lecture to beginning graduate students.

> I usually tell students that the artist is . . . the only profession in
> our society where you have to be, first of all, a common laborer;

second, a highly skilled technician; third, a highly skilled and/or a marginally skilled technician in other crafts than your own. That is, if you're a painter, you have to know about making slides . . . carpentry, matting, crating. Technical skills in other professions than your own, unless you can hire them done. Most artists can't. Fourth, a small-business person, an entrepreneur, a manager of your own career, which is part of that. But, to deal with dealers, you have to at least prepare your accounting practices for your accountant when you file your income tax and so forth. Then, finally, an intellectual. In addition to that—not finally, in addition to that—you have to find a second profession to make a living. (Int. 6)

Most art schools don't formally teach all the skills he cited, but he was being honest with his students (photographing, crating, and recordkeeping are discussed in appendix 7).

Career Management

The last thing the senior professor mentioned was management of one's career. While the dream career involves hard work in the studio leading to serendipitous discovery by key dealers and critics, this occurs too rarely to wait for. The reality is that careers must be actively built and maintained. This involves constant monitoring of the artist-dealer relationship, as well as constant application for grants, awards, competitive exhibitions, and the other résumé-building items that give potential buyers the confidence to part with thousands of dollars for a work of art. Social connections can be important: while it is possible to discover opportunities from the media (publications like *Art Calendar* list upcoming shows and deadlines), the best source of information is other artists and dealers. Collectors become interested in an artist's work through galleries and exhibitions, and they value personal contact with artists (see chap. 6).

The dealer is the critical element. Given the multiplicity of artists, the market power of dealers, and the difficulties of selling art, most professional artists are continually preoccupied about their relationship with dealers. The first step is simply to get a high-class dealer to look at the work. Most galleries are approached by many more supplicant artists than they can represent each year, and elite galleries may deal with hundreds— in some cases thousands—of unsolicited packages of slides. Some dealers will only talk to artists one day a week, some will never talk to an artist without an introduction from another artist, a dealer, or a collector. Dealers

are just swamped by the volume. In most elite galleries an artist's attempt to show work to the decision maker is frustrated by a coolly elegant young receptionist. The mortification of being snubbed by these stylish young clerks is especially galling to artists.

While artists dream of being quickly selected to join an elite gallery, the reality of selection is more like a drawn-out courtship. Dealers sometimes will follow a young artist's career over several years, inviting them to show work from time to time and visiting their studio. If interested in the work, a dealer may take a piece or two for the gallery's back room, to see how they and their clients react over time. If the dealer has a positive response, the work might be included in a group show. Finally, the artist may be invited to join the gallery's "stable," which means the dealer has exclusive rights to sell that artist's work and claims a share of all sales made in the local market (see chapter 5 for more details).

It may not be obvious that a successful art career often includes social activity: attendance at openings, lectures, events, and parties where the important dealers, curators, critics, and other artists are likely to be. An artist must become known as an artist and interest people in coming to the studio to see work. Some artists are better at this than others—in fact some prefer the socializing to making art. Others are terribly awkward at social art events and just can't bear to "play the game." As difficult as this intense sociability might be in a small environment like St. Louis, it is much harder in New York. Distances are greater, costs exorbitant, and people used to more aggressive interaction. This is not a social arena that personalities drawn to the solitary life of an artist are usually comfortable in. As one social-psychological study of artists noted, "The image of the artist as socially withdrawn, introspective, independent, imaginative, unpredictable, and alienated from community expectations is not far off the mark" (Csikszentmihalyi, Getzels, and Kahn 1984).

Are the requirements for a successful artist's career that different from those for any professional career? The details might differ, but every profession requires ancillary specialized expertise. Anthropologists, for example, must be knowledgeable about computer hardware and software for word processing, data analysis, and information management; about travel and local politics for getting to and from their field sites; and so on. Academics have the advantage of institutional support for these things, whereas artists must reinvent their procedures alone in their studios. Sociability is a key element for professional advancement in every field. Success rarely comes to anyone as serendipitously as it came for Jasper

Johns, in the form of a key gatekeeper entering his studio after a chance encounter. In most fields the important professional information comes as much through informal as through formal networks (e.g., Granovetter 1973). In these professional aspects, artists' careers do not seem unique.

Case Studies

The first artist to be described is in the middle of a struggle involving considerable sacrifice to build a career in the national art market. He is confronting New York's hegemony in the only way he can, by diving into the belly of the beast. His case is followed by a vignette of a more senior artist who is successful locally but lacks a wider market, who has dealt with the problem of the larger art world by ignoring it. A veteran artist with an international reputation follows as an example of a successful professional. These first case studies serve to introduce the major issue of New York versus local success.

Paul, a 41-Year-Old Painter and Sculptor (Int. 85)

While most artists dream of "making it" in New York, few have the strength and perseverance to try it, beyond sporadically sending packages of slides with self-addressed envelopes to New York dealers. The slides are usually returned with a brief form letter of rejection (the reason becomes apparent when one sees the hundreds of slide packages received by any first-rate New York gallery during a year). Paul,[10] a thin, intense St. Louis native who got an M.F.A. from Southern Illinois University at Edwardsville, is one of the very few who has made a determined, focused effort. Paul decided that he wanted New York representation enough to pay the cost when he was in his early thirties, married, with one small child. He had always been aggressive and successful in selling his work and building up a set of loyal collectors in St. Louis. His first gallery show was his M.F.A. graduation show, which almost sold out, including one piece bought by the St. Louis Art Museum. After this unprecedented beginning he supported himself by selling work through dealers in St. Louis, Chicago, Aspen, and San Francisco, by selling directly to St. Louis collectors, and by making frames commercially. His abstract, somewhat geometric paintings and sculptures have pleasing colors and interesting textures. He is one of the few artists in St. Louis who had resisted the dealers' demands for exclusive control over his local sales. (Dealers expect their commission of all sales, even those made by artists directly to buyers out of their studio. This will be discussed in chapter 5.)

Since 1984 Paul has bartered for his studio space with art. The building owner as well as the owner's mother and sister have been loyal buyers of his work. The space I interviewed him in on Washington Avenue had two thousand square feet, with skylights, and as he said, "If my friends from New York could see this place—this is a million dollars in New York." By the early 1980s he had a history of sales, and enough self-confidence to try New York.

> I didn't really start going to New York until about 1982 or 1983. I had this initial success here. It was sort of all I could do to sustain, to keep that going. My first son was born when I started graduate school. . . . So . . . I was doing a lot. I was trying to take care of everybody and get my graduate degree, and I had this [framing] business. It was crazy.

At that time Paul was just getting out of a difficult relationship with a St. Louis dealer who had withheld perhaps twenty thousand dollars in payments (see chap. 5). He was supporting his family with painting sales, the frame shop, and bartering.

> Well, there are some years that I made maybe thirty or thirty-five thousand dollars, but for the most part it's always been around twenty-five thousand. I was audited this summer, and the auditor asked me the same question, "How do you live with this much [i.e., little] money?" and my answer was, "We're poor people." . . . I've bartered with dentists and for contact lenses and all those things that you need in a family that are a tremendous expense. . . . I bartered for the furniture we have, which at one time was nice furniture. Now it looks like hell, but I did a trade with designers and people that I knew. I got a car with a trade. . . . I've been able to do a lot of that which has really sustained us.

After his experience of being defrauded by his dealer, Paul realized that he had to take more control of his career.

> I've got to be responsible for myself. I've got a family. I can't sit around and wait for [his dealer] to sell something. . . . I had just started going to New York and trying to break in there, and it was very expensive to do that and the gut-wrenching process of leaving the family for two weeks or whatever and going up there and being immersed in that kind of a viper pit. . . . That's been a real difficult road. Back in 1983 I guess I just started going there and trying to meet people and show my work and just figure out the

whole thing. I mean I kind of looked at it as a learning experience, me trying to get a gallery. It just seemed to me from going to the galleries, I would see work, and I always felt that my work was easily as good if not better than what was being shown. But I couldn't break in, I just couldn't get a break. I received every signal to get out of town.

But it became clear to me that if I was going to get anywhere in New York I would need to have a presence there. I would need to have a studio, needed to have a body of work there. Once somebody saw slides, and they liked it they wanted to see the work. I kind of figured out early on that I really needed to have a studio there. I rented a space, not until about 1985 or 1986. The first one I rented, I shared with a guy who lived in this loft, and he was an artist. He was a commercial artist, and he had an extra space, and I just went there and I started painting in New York, and I started building a body of work there and just going to see all the shows, going to the museums, and just little by little I was meeting people and becoming part of what was going on there, mostly as an outsider though.

[*SP*: But your family was here, so what part of the time were you able to go to New York?]

I would go like once a month. Originally I would go for a couple of weeks. I wouldn't go every month, but I would go for two weeks, then I would be home a month, and then I would go up for two weeks and I would work there. It was very difficult to do that. It was difficult on my family, and it was difficult on me. It was all part of making me, making my work though. It was my real education about art, about being an artist.

[*SP*: How do you mean?]

The commitment involved. It took a great deal of energy and time and money and emotional trauma to go to New York and do that, and I was just very serious about making that work. So every trip, it wasn't like I was going there on vacation or something or like I was a tourist. I was studying while I was there. . . .

I just kept going, and I kept making contacts and kept talking to people. I earned a little bit less during that time, and I brought all the work up and put it in storage in different places. There was a place in New York called Michael Leonard's storage, and they have a gallery space sort of, and they will rent you by the hour . . . if you have a client to show your work.

[*SP*: And you did that?]

I did that and other things to keep alive there.

Paul sold his frame shop business in the late 1980s to concentrate on making art and trying to succeed in New York. He was also teaching courses in several St. Louis schools, since his work had been selling somewhat slower in the past few years.

> I never looked at my work as being decor. I always thought that it was this higher thing and it was educated work, it was intelligent work, but it still had an acceptability quality. You know what I mean? That was the reason it was successful, I think: they were nice shapes and nice colors. Then the work got tougher. Things would happen, or my work just developed in a way that became a little less salable. . . . A stronger influence from New York, and my father passed away. A lot of things happened that made my work a little less accessible to the general St. Louis public.
>
> [*SP*: Because it's less decorative?]
>
> I think that was pretty much it. I dealt with some little bit tougher issues than color. . . . But at the same time I was striving towards something a little higher, and then there were a couple of years where it was just virtually unsalable.

By the early 1990s Paul had an established reputation and network of contacts in St. Louis, and he got a couple of lucrative commissions for architectural sculpture. In both cases the search procedure for an artist had begun when Paul heard about the opportunity through friends, and he asked if he could make a proposal on speculation. This work is extremely rewarding, as he noted.

> [The art consultant] thought that I should charge a fee of forty thousand, and I said let's ask for sixty thousand, and we ended up at fifty thousand dollars. Her commission was separate from that, her fee. . . . It was almost embarrassing how much money I made from this one thing compared to all the work that I've done.

After several years of renting provisional spaces in New York, Paul wound up in 1991 sharing a fifteen-hundred-dollar-a-month loft in SoHo with another artist. In 1993 he finally realized his dream of a one-person show in New York, and a few pieces sold. He then faced the reality of having accomplished his goal , and he found that a show in New York is just another show. For Paul, the dream career is still a dream. The fairy godfather, in the form of Leo Castelli or another elite dealer, did not appear to tap him for stardom. There was no substantial change in his life in the few months after the show.

One artist friend of Paul thought he had spent $75,000 over five years in order to get that show. Paul's friend estimated five years of rent at $500 a month for $30,000, airfares at $400 six times a year for five years for $12,000, and he assumed Paul had spent at least another $500 extra or so each month for his New York expenses. Paul did not reveal whether he ever calculated his expenses, although he had thought about moving to New York. But Paul could not duplicate his fabulous studio, nor could he afford his substantial home, or school for his children in New York. As a relatively young man he had the possibility of a wider presence in the national art world if he could keep his efforts successful in New York. His base in St. Louis was solid and supportive.

Flora, a 58-Year-Old-Painter (Int. 34)

"St. Louis is a wonderful place to be an artist," Flora said. I was interviewing her in her studio, half of a 3,500-square-foot floor of a rehabbed loft building in the decaying neighborhood of the "midtown art center." Flora had moved to St. Louis from California in the mid-1960s because of her former husband's academic job. She was a full professor at a local community college, which meant she taught several introductory-level courses for a good salary. Flora enjoyed considerable local success as a painter. The St. Louis Symphony had just bought one of her brightly colored, beautifully drafted figurative paintings to use for a widely distributed poster and cover for its program guide, her work was in demand by a devoted group of local collectors, and her local dealer was supportive and sold her work steadily. She had no dealers or gallery connections outside of St. Louis.

Flora was part of a five-person cooperative that had bought and remodeled the three-story building for artists' studios in 1986. This was her primary residence after a recent divorce. Her 1,750 feet of high-ceiling living-loft space, which had cost less than $30,000, was totally paid for, and she had traded paintings for her kitchen construction and appliances. Her monthly operating cost for her loft was $185, which paid for utilities, taxes, insurance, and, with what money was left, a co-op party fund.

The building was fireproof, with an industrial elevator, new utilities, and protected indoor parking, as the local streets were not safe. Four of the artists who owned it were middle-aged and economically comfortable, two because they were full professors (one of these was Flora), and two because they were married to spouses with high incomes. Two of the art-

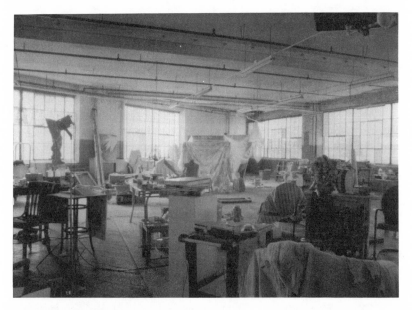

Fig. 9. A St. Louis avant-garde artist's studio. The rough but extensive and extraordinarily cheap space in a semiabandoned industrial complex houses several other artists as well. The artists enjoy low cost and ample space but suffer from the lack of services and the danger to their personal security.

ists made incomes from the sale of art, albeit significantly less than either of the professor's salaries; two of the other artists sold very little. The fifth owner was much younger, a graduate student whose wealthy local family supported her studio. This comfortable, solid building was thus primarily supported from incomes other than art sales.

Flora and two of the other artists in this building were extraordinarily close friends. They had an open invitation to a tightly inbred group of other artists to stop by on Friday afternoons for drinking sessions. They were a common sight together at parties and openings, and it was clear that their social lives were entirely circumscribed by a small circle of art world people.

I asked about the effect on one's art of being an artist in St. Louis, far from the center of power in New York.

> I think quality is terrible in most art, most places, New York absolutely included. Good art comes from good artists who are able to make art. If you're comfortable you are going to make more art than if you're hungry and cold.

[*SP:* So you're saying that the easy living here . . .]

Makes it possible to work. And if you really want to work, you will. Now if you really want to work, and you're cold and you're hungry, you'll work too. I know that some of my best work has been done with migraine headaches because I'm so focused and you don't waste anything. But that's a real fallacious idea, that you have to suffer to make art. That's as silly as [the idea that] the only art is in New York. . . . Look at this [gesturing around at her loft space]. It's perfectly free. Those people from either coast come here and they die. Because they can't afford to do something like this.

Joe, a 62-Year-Old Painter (Int. 6)

From the outside Joe's studio looked like a corner storefront in St. Louis's near–south side central-western corridor. The storefront windows had discreet designer blinds and house plant foliage, with no sign that they housed an artist's studio in this neighborhood of lower-middle-class homes, light industry, and local bars. The space inside was not large but was elegantly designed: a small sitting area with upholstered furniture, a coffee table, and some carved antique wooden columns to define the space, a large library of neatly ordered books and music, and a kitchen and small rest area adjacent to the primary work space of about five hundred square feet.[11] Joe designed the work surfaces and equipment and had them built to fit the space and his style of work. The studio projected the impression of a serious, professional work-space belonging to someone who was experienced and very organized and who enjoyed leading a civilized life while working.

Joe was one of the few artists in St. Louis with an international reputation. His figurative, expressionist-surrealist paintings had been represented by an elite dealer in New York for years, and he also had dealers in St. Louis, Washington, Philadelphia, Atlanta, New Orleans, Chicago, Los Angeles, London, Rome, and Milan. He had been the youngest artist in a key exhibition of Figurative art at the Museum of Modern Art in 1959, and he had enjoyed a successful career, including representation in five Whitney Museum biennials, since then. His work had been bought by the Metropolitan, the Whitney, and the Museum of Modern Art in New York, the Art Institute of Chicago, the San Francisco Art Institute, and other major institutions.

A tall man with a neatly trimmed beard, Joe was about to retire as a full

professor. Although his sales had declined in recent years, like so many other artists', his production of oil paintings, prints, sculptures, and ceramics assured him an income independent of his relatively high academic salary. He had taught in a leading Midwest art department before coming to St. Louis twelve years ago. In his previous position he had arranged to teach half-time, so that he could spend the rest of the year painting in Italy. His painting sales had been stronger in Europe than in New York and supplemented his half-time teaching salary to support two homes. He decided to spend more time in the United States in the mid-1970s when his dealer advised him that he should have more shows in New York.

> As [the New York dealer] told me at the time . . . "Once they start seeing your work in New York, if they don't see it every other year at least, they're going to forget you." That happened to me in the seventies. My recognition quotient in the sixties really dwindled in America. I was doing very well in Europe and was having many shows. The dealers there published catalogs. Then, the work disappeared either into their inventories or into private collections. It didn't go into public collections there, the way it had been going into public collections as well as private collections in America. So it became important for me to have my work seen in America. It wasn't that I wanted to be famous or anything, but I wanted my work to be seen. I wanted my work to be known; I wanted to be a kind of factor.

Soon after he returned to full-time teaching, he was offered a position at Washington University, and he moved to St. Louis. He bought his two-story brick studio building a few years later, after it had been rehabilitated. The building paid for itself, since he rented out part of the ground level as business space and the second floor as living space.

Joe is in demand by schools nationally as a visiting artist, someone the host department invites to lecture on their work and criticize students' work. When I interviewed him, he was preparing to spend a month as visiting artist at an Ivy League college. He was also preparing to ship off several large oil paintings for an upcoming show at his New York gallery. He averages four or five one-man shows a year. Joe is a disciplined worker who spends long and regular hours in his studio and is exceptionally productive, creating works on paper as well as his large oil paintings. His long history of involvement in graduate-level art education has given him a broad network of colleague and student contacts nationwide.

I asked Joe about living in St. Louis.

> Obviously I wouldn't be in St. Louis if my teaching job weren't
> here . . . [but] . . . I don't find that any great hardship. There's no
> other place that I pine to be. . . . I lived in New York for six-
> month stretches. That might not be the same as living there per-
> manently, but still. I found that living there, for all the enjoyable
> things, there were also [hardships with] just the getting on with
> life. Getting your laundry done, going to the grocery, just the or-
> dinary things of living are harder, are very hard there. They take a
> lot of time there, and here they're easy. Stopping off at the super-
> market in your car and buying a case of wine or something of the
> kind was a nuisance in New York. Culturally, I see all of the films
> that I want to see. I can get any book that I want to get.

Joe's national prominence let him be successful no matter where he lived.

Joe and Flora are among the elite in the artist community of St. Louis.
They both have secure institutional incomes, dealer representation, col-
lector encouragement, and peer support. That is not to say they are satis-
fied. Joe feels that his contribution has not been recognized enough (for
example, no one has written a monograph or a catalogue raisonné on his
work), and that his prices (currently in the twenty-thousand-dollar range)
are too low. Flora is bitter about being ignored by Washington University
and having no access to graduate students or dealers outside St. Louis. But
they have both clearly "made it" in St. Louis. Paul is also fairly successful,
in that he does not have to teach full-time and has earned enough to fund
his campaign to establish a New York career. But the cost to him and his
young family must have been significant. The next couple of artists to be
introduced, although successful, have a bit more difficult time of it with-
out the support from full-time teaching.

Sam, a 49-Year-Old-Painter (Int. 82)

"My first show with [an elite New York gallery] was sold out before
the opening," Sam said. I interviewed him in his home, a brick house in
the same general area as Joe's studio, full of the contemporary art and
crafts that he collected. He had had significant success two decades ago.

> This is when I became a full-time artist. I had a sellout show in
> New York, and this was all mid-1970s, [a] sellout show at the [St.
> Louis Art] Museum, and I had a sellout show in Kansas City.[12]

Sam had grown up in a small town in Texas. After attending a small Texas college he came to St. Louis to study in the brand-new Washington University M.F.A. program, where he graduated in 1968. His contacts with a local collector paid off with the supreme prize, a New York dealer, in 1975.

> Actually, [X, a wealthy St. Louis art collector] came over to look at my work one day and got on my phone and called [Y, an elite New York gallery owner] and said, "I'm sending someone up here, look at his work." So I went up to see [Y]. [Y] liked the work and said it should be shown right away. At that point he was booked for two or three years. He's usually booked that far ahead, at least two years. So he said, keep sending me slides of your work and let me find you a gallery. He wanted to get [me] a show. And within a year I had a show with [a nonelite gallery], which was across the street. . . . And my show was about the last show that he had . . . and then he closed the gallery and he went to work as the director of [Y's gallery]. . . . My work at that point went from [the nonelite to the elite gallery]. He took a few of us artists that [Y] had sent him.

Before this, Sam had taught art for various short-term public programs to scrape some income together. After getting into the well-known gallery, he lived from the sale of his artwork as well as his wife's income as a social worker. Food elements appear often in his artwork, which is representational and pleasant. He has had an interesting supportive relationship with a local bar and grill: He designed their menu, and the owner had bought and displayed his work. The owner had also backed the publication of several limited-edition lithograph prints.

> It worked out real well. There were a couple of years there when most of my sales were made through [Z's] restaurant. He was my best dealer. So it worked out great, because it [the work] was shown, people asked, and I was doing a lot of printing at that time, and of course there it was a very social thing, so I was meeting a lot of people that are real good friends now.

Sam enjoys life in St. Louis. With four galleries selling his work, in St. Louis, Kansas City, New Orleans, and the all-important prestige gallery in New York, he is free to live anywhere. Since none have been selling well in the past couple of years, he knows that his St. Louis location has little to do with the drop in sales. The slowdown since 1990 has made him consider getting a teaching job, but his expenses are low without children, and his

wife's job provides the all-important medical insurance. His small, neat studio is in the basement of his house, but he does his work-on-paper anywhere, including the kitchen table. He appreciates St. Louis's low housing costs and the supportive community provided by his wide network of contacts.

Sam has some art market success, although far less than Joe. Without the support of an academic income like Flora's, Sam is relatively dependent upon his wife's income and benefits to maintain his lower-middle-class lifestyle. The next artist to be introduced is even more dependent upon his spouse's income.

Phil, a 41-Year-Old-Painter (Int. 72)

Phil's one-thousand-square-foot studio at the Lemp Brewery costs $150 a month to rent. The high-ceiling industrial space is a bit rough, with a dirty public bathroom out in the hall, but within his wall partitions (which he made of studs and wallboard) he has good light and space. His current work, darkly colored nudes, was on the walls, in addition to two sensitive portraits of his 13-year-old and 10-year-old sons, which he was going to give them as Christmas presents.

He told me about his grueling teaching schedule.

> Six or so courses a semester. . . . Yeah, that's what I have now, at three different schools. Actually I was at UMSL [University of Missouri at St. Louis] for a number of years too. Right now I'm teaching at Forest Park, Webster University, and Maryville University, and I'm the director of the gallery at Forest Park as well. . . . Every one of my chairmen . . . give[s] me the best possible schedule I could have. I have about two and a half full days here in the studio. I have all day Tuesday and all day Thursday and usually Friday afternoons. Now Monday and Wednesdays are booked up pretty solid, and at Maryville I teach in what's called the weekend college program. So that's usually a Saturday morning and a Sunday afternoon or something like that.

Phil was brought up in Wisconsin and graduated from Washington University with an M.F.A. As soon as he graduated, he was offered a part-time instructor's position at a local school, and he has been scraping together instructorships since then. He earns about twenty-eight thousand dollars a year by teaching what he calls "a full load" for the academic year, plus a summer school session. He has never been able to get a full-time position at any of the local schools.

Phil's wife has worked as an administrative secretary at Washington University for eighteen years and provides the base income and benefits for the family. In addition she will qualify for tuition assistance from the university for their children's college. I asked about child rearing.

> Before I moved down here, I had my studio at home. . . . So I basically raised the boys. I was home with the boys all day. . . . For the couple of hours a day or whatever that I was teaching we had a babysitter or whatever; we dealt with that. But for the most part I was there, and it worked out pretty well. . . . I've never been one to want more time or need more time. I think I have plenty of time to work. I'm not the kind of person who likes to be in the studio alone for too long. Two full days, usually some time on the weekends and some time on Friday, that's a lot of studio time. I work relatively quickly too.

Phil does not have any gallery representation now, although he had some success in the past. In 1977, a year after his M.F.A., he got into an excellent gallery for local artists. He explained how it happened.

> It was completely on a fluke. I was taking a piece downtown to a group show—it was down on the riverfront—that was a juried show, and I had gotten accepted in that, and on the way upstairs in the elevator I ran into [the gallery owner]. She just looked at the painting, and she said, "Oh, that's very nice." We sort of got to talking on the elevator, and her floor was first. She said, "Where are you going with that?" and I told her about the exhibit, and she said, "Why don't you stop back down on your way out?" So I did and went in and invited her over to my studio. I had my first one-person show with her about a year after that. And then that's how that all got started, so she was my first dealer. . . .
>
> I also had other galleries. I had a gallery in Kansas City . . . and I've had three galleries in New York, in I guess it was the late seventies through the middle eighties or so, something like that. . . . The story of New York galleries is they open and close rapidly.
>
> [SP: What galleries were you in?]
>
> One was called [X, a nonelite gallery]. That was my very first gallery. It was a hot gallery. I loved that. Come to find out that when the director of the gallery was leaving, he gave me a call and he said, "Well, the owner of the gallery doesn't like your work a whole lot, but I do, and that's the reason why your work is here. I'm leaving . . . and if you would like to go with me, I would like you to come to my new gallery, but [here] they won't handle you

any longer." So then I was with the [Y] gallery. . . . He moved
down on Bleeker Street just outside of SoHo there. I was with the
gallery, and then he closed down, and I was with another gallery
called the [Z] Gallery for a couple of years. They were in
SoHo. . . . And then that gallery went science fiction, and I wasn't
interested in doing science fiction images . . . so I was out of
there.

While he was in the galleries they sold his work very well.

They sold everything, for more money, and they sold everything I
sent to them. So I did very well with them.

His paintings were selling for two thousand dollars and under, and he
estimated that he earned about five thousand dollars a year from the sale of
work after the dealers' commission and his costs. He was with a local gal-
lery until last year, when they stopped representing his work. In his view,
it was a mutual separation: "They're dealing with a lot more decorative
types of images now, and they are not able to market some of the more
aggressive Figurative types of things that I am interested in pursuing right
now."

Phil complained that the dealers he knew weren't interested in his
creative process.

Just about every dealer I've ever had has always told me that they
don't want to hear about the art. They don't want to hear about
content. . . . When you try to talk to them about what you are up
to they say, "I don't want to talk about that." It's primarily a sell-
ing situation that they're interested in.

[SP: But I would think that knowing . . . what you were think-
ing about when you were making your art would help them com-
municate with potential buyers.]

They ask for little one-line things that they can say to
people. . . . But they don't want it more than a line or two. . . . I
think those kinds of people could just as easily sell shoes.

He seemed in a mild depression about the professional side of his life. I
asked him if he had work in storage at home.

Oh yeah. The whole house is filled. The basement is filled. Under-
neath everybody's bed is filled. The closets are filled too. You
might want to write this down, too, that I do have the largest col-
lection of [Phils] in the world right now. . . . I don't get along
with most of the dealers that I've been with. . . . I don't know if

it's necessarily even personally. I think it's more business and ethics in business. . . . I just feel like they are preying on me. . . . I found that a lot of dealers, not just myself, a lot of dealers just treat artists pretty badly. It's a very personal thing that most artists do. And dealers could sell cars for that matter; it's all the same thing. . . .

[SP: So what you're saying is that you're really turned off to them, the whole marketing side of making art?]

I think so. And I've built my world so that I don't have to rely upon them. . . .

[SP: But I guess I've already asked you this question. In some sense, sooner or later you are going to start saying, "I'm not making this just for myself. If I'm making paintings, I want people in the world to see them." You will have to then confront that issue again.]

I'm just not thinking about that very much right now. . . . I'm trying not to avoid your question. But I think, I don't know if I've really asked myself these questions. So it's like the first time they are coming at me, and I'm trying to figure out how I feel about them. That's why I'm hesitating a little bit. . . .

I feel a little selfish or a little protective . . . [about] holding the art, not allowing it to get out. And my family, my wife, and everyone has been over the last few years after me to sort of get back into all of that. It just doesn't feel right, right now. Economically I'm not pushed in that direction, and I don't make art to sell. I've seen a lot of people compromise in order to sell. I mean that's a real thing.

Phil was making art because that was what he did in life; it was his responsibility to himself. The market clearly was irrelevant to his productive activities at the time I interviewed him.

Sam and Phil have had differing market success. Both have had, and Sam still has, representation in New York at excellent galleries. Sam's sales have slackened, but his expenses are low, and he is innovative in finding new sources of support, such as his relationship with the restaurant. Phil was responsible for child care until recently, which cut into his work time, and his luck ran out with his New York gallery representation. His strategy to earn some regular income is to work a complicated, demanding schedule of part-time teaching. His schedule is full, with whatever child care is still necessary for his teenaged sons, with maintaining his household—on the day I interviewed him he was taking the afternoon off to arrange car

repair—and with fitting in his art work when he can. His recent falling-out with his local gallery seems to have left him in a funk, unable to recover his momentum. It is easy to understand how the weight of one's past work, stuffed into every available storage space, becomes a drag on one's enthusiasm to create new work. Yet he keeps on working, creating art with no public outlet. In spite of these difficulties, both artists enjoy the support of spouses who provide basic incomes and insurance benefits.

The next pair of artists have no such security.

Lisa, a 31-Year-Old Sculptor (Int. 133)

"St. Louis is OK, but I don't want to stay here," Lisa said. The Louisiana native had come to St. Louis to teach directly out of her M.F.A. program in Florida. She had chosen between two job offers, a three-year position at Washington University and a six-year position at the Portland School of Art in Oregon.

> I liked Wash U's location, and the school had a good reputation. Portland seemed too distant. I guess I made the right decision, I don't know. . . . I was ready to go after three years, but Webster [College] picked me up. I went to Chicago to the CAA [College Art Association, the main job market conference for artists] to interview, and got a one-year replacement job at Webster.

We were sitting in her living space in the back of her 20' × 75' storefront studio, located in a lower-middle-class neighborhood of the "near south side" in the western half of the city. She had originally rented it for $375 a month, but later asked the absentee landlord to reduce the rent to $300, which he did. A cot lay against one side wall, and a stove, refrigerator, and sink against the other, with a small round table in between. There was no other furniture in the living space apart from a few kitchen chairs. The rest of the space was filled with an extraordinary clutter of multiple-media sculpture materials, including wood, metal, and found objects. The short, lively, red-haired sculptor was at a point in her life without a focused direction. Although she was critical of St. Louis and wanted to live in a more exciting place, she had just decided to stay another year.

> Webster just offered me a second year, and I signed yesterday. I teach only sculpture, four days a week. I'm the only sculpture person there, in a brand new building. It's ideal. I have forty-five students in three classes.

[*SP:* What does it mean to be in St. Louis, not in New York City?]

Well, I don't really have strong aspirations to be part of the "official" art world. On the other hand, St. Louis is too slow for me. I'd rather be in Chicago, not New York.

Lisa is single and has few attachments here after four years of living in St. Louis. She has no local dealer, although she has had work shown and sold in a gallery in Austin, Texas, and in an elite Chicago gallery. She met the Texas dealer while visiting her sister in Austin. The Chicago dealer contacted her after seeing a photograph of her work from a show at a small college in Illinois. The Chicago gallery had just featured one of her works in a full-page ad in a recent *Art in America,* which made her abstract laminated wood and steel sculpture look extremely elegant. This was an extraordinary break for a young artist. She explained that the Chicago gallery owner had called and said he had been offered the opportunity for a cheap full-page ad and that he would feature her work if she paid eight hundred dollars of expenses, but that he needed her answer immediately. She begged him to give her half an hour to decide and immediately called an artist-friend who had good business sense: "He said, 'Offer the gallery five hundred dollars and insist on a show.'" She offered six hundred dollars (she was afraid five hundred was too little) and asked for a one-person show. The gallery accepted.

Lisa had not determined her opinion about the importance of sales for artists.

None of my work was ever made with the possibility that I might sell it. I tried it once. I made a series of pieces that would be sellable, but they didn't sell. I sold a couple for around two hundred dollars. This whole [Chicago] gallery thing is the first encounter I've had where someone said, "This work might sell more than this work—if you want me to sell the work, do more of these." . . . I think there are different degrees of selling out. Look at the work commissioned by the popes, or the Medicis; that work was commissioned, that doesn't make it any less valuable now. . . . I'm not going to change my style; that's inherent, no one can take it away. Some might say that selling out is letting money influence your work. . . . When the stuff is in the gallery, the only one to buy is higher-class people, one of *my* friends won't buy it. I don't have anything to do on a personal level with those who buy

the work. . . . I make money by teaching. Teaching is my bread-
and-butter.

Lisa's concerns are common to many beginning avant-garde artists
who have a taste of market success. She agonizes over whether to adapt
her style to fit her gallery's demands; she realizes that likely buyers of her
work are not the sort of person she easily relates to; and she faces the fact
that the only way she can be sure of making a living is through teaching,
not by making sculpture. Lisa is a young artist just beginning her career,
with some luck getting gallery representation and full-time teaching em-
ployment. She may become successful with her Chicago dealer. It's im-
possible to say what she would do if her school offered her a permanent
appointment, and difficult to predict what she will be doing in the future.
For young persons whose difficult choices involve marriage, children, and
career, art is like other professions in terms of commitment and time, but
different in that art allows a flexible schedule and home work. But fine-art
work yields a minimal income. If no one else in the household brings in an
income, employment becomes critical, as the next case involving a less
fortunate artist shows.

Louis, a 28-Year-Old Painter (Int. 102)

Louis had just finished a one-year full-time appointment teaching
drawing at Washington University. He had studied for his M.F.A. at
Rhode Island School of Design (RISD) and Yale, two of the best art schools
in the country. Upon graduation from Yale he owed thirty-four thousand
dollars in student loans.

At that time his wife was in graduate art school in New York, so he got a
job in a New York "old master" gallery as a packer and general helper. His
wife graduated in two years, and he obtained a one-year job at Washington
University in the fall of 1992. Louis and his wife rented an apartment twice
the size of their New York apartment for half the cost and settled in. He
spent the year teaching, using one of his two bedrooms for a studio.

None of the galleries in St. Louis was interested in showing his work,
although one said it would be willing to look at it again in the following
fall if he were still in the city. A former coworker in New York had made a
contact for him at a small gallery there that showed contemporary work,
and the gallery had agreed to hang two of his small paintings in a group
show. He was upset at the way his paintings were hung, in conjunction
with another artist's installation, which he felt made his work look silly.

His only other gallery prospect was in Tulsa, where his wealthy in-laws lived. He had given them a portrait of his wife, which they had taken to be framed. The frame shop also sold art and had offered to show his work the following year.

By the end of the year, his future looked bleak. His wife had been unable to find work as an illustrator in St. Louis. Washington University had not (at the time of my interview) asked him to apply for another one-year position, and he had received no requests for interviews at the College Art Association job market. Their options were to move to Tulsa to live with his wife's parents, to remain in St. Louis and try to eke out an existence, or to move to Massachusetts to live near his parents. In any case they could not survive economically without help from their parents.

Both Lisa and Louis were brought into St. Louis by Washington University on short-term teaching assignments. Lisa had some luck and is earning a fairly good salary given her minuscule expenses, although she has no long-term security. But Lisa is not interested in security at this point—she wants to make her art and earn enough money to get by. Louis seemed anxious and depressed, worried about his wife and the state of his marriage, as well as his own professional future. Saddled with a large debt from graduate school, with no idea of how he would earn a living next year, he had a hard time being a productive artist. Having wealthy in-laws helped minimize the danger of real economic difficulty, and of course a job could materialize at any moment. His elite RISD-Yale educational background would help. But it is hard for a young artist in his position to maintain his enthusiasm for making art, unless he is so committed that he simply cannot survive psychologically without creating art.

Lisa and Louis are representative of the situation young high-art artists face in the postboom era of the art market. Their economic uncertainty, powerlessness in relation to dealers, and reliance on teaching for subsistence are common. All of the artists introduced so far have believed in the significance of art market success, even if, like Lisa, they are a little confused about how to react if it should arrive. While the majority of contemporary artists think that the art market is a necessary evil, a clear minority reject any contact with it. The next artist represents this type.

Fabian, a 46-Year-Old Sculptor (Int. 104)

"St. Louis sucks as a city for artists, as far as I'm concerned. I would not be in St. Louis if it weren't for the university," said Fabian. We were sitting in his home, a single-family brick house on the south (i.e., ethnic

white rather than black) side of St. Louis city, in a poor residential neighborhood. Fabian, a youthful, short, thin man with a deep voice, was an East Coast native. He had graduated from an elite prep school, then an Ivy League college, and had lots of life experiences before settling down as an academic administrator at a local M.F.A.-level art school. His sculpture consists of objects subjected to long-term environmental processes, such as books and newspapers that are immersed in brine until they are encrusted with salt crystals and half converted into natural objects themselves. Other pieces were made of materials poured over cubical blocks of white salt, set on the floor in a complex rectangular grid.

When Fabian talked about his work, he used scientific terms like entropy and ecology. He had labeled his most recent work the *Ontological Library,* and he liked to talk at length about the relation of his art to ecology and natural-resource conservation. This work was not designed to sell and did not sell well in any city, but the artist had an outstanding record of grants. His studio was the attached one-car garage of the house and was full of neatly stacked, labeled cartons. Fabian explained that the cartons held several shows that he had to install in the near future, one in St. Louis, one in Kansas City, and one in Maine, where his wife lived and worked as an art curator. All of the shows were in some form of public-museum or art exhibition space (kunsthalle), rather than in a private gallery.

I asked him how St. Louis compared to Detroit, where he had lived.

> Much worse. I would be out of this city in ten minutes. . . . I really think this is a second-rate city in terms of its attention or understanding of contemporary art issues.
>
> [*SP:* What did you have in a town like Detroit that you don't have here?]
>
> You have a much wider range of people that actively collected young artists that are "unknown" artists, that they bought the art because they liked the art. Now Detroit plateaued, you get to a point in midcareer that it's a tough city. I think I'm like midcareer now. But my impression of this city [St. Louis] is that it's a city that sees with its ears. . . . If it's not in *Artnews* or on the cover of this magazine or that magazine [it does not exist]. And most of the galleries in this town, even the better galleries, are getting second-fiddle work that is farmed out from New York. . . . OK, who does [X—a local gallery] show that you can give [X] credit? I mean, he does show some of the best local people around, most of

the people who are attached to the university. He doesn't go out and seek out the eccentric person. There's a lot of social stuff involved. And even the academic artist is already credentialed; he's been approved. But [X] doesn't bring in, doesn't do—somebody else has certified it before it comes to [X].

Fabian has taken another route available to avant-garde artists, of exposing and supporting his work through public institutions rather than the private market. His complaints about the St. Louis art scene "seeing with its ears" are common to all not-in-New York art scenes, and his bitterness seems to have more to do with his personal situation than with St. Louis.

The artists described so far vary in their relation to the art market. Flora could probably live on her art sales, and Joe certainly could, but they don't have to with their full-professor's salaries. Joe is recognized internationally, while Flora has no national presence except for a few local collectors who have moved to other places. Paul's ambitious career goals involve substantial expenses that he covers with art sales supplemented with teaching. Sam earns no income apart from his art sales and was quite successful in the past, but the recent weakness in the national market has hurt his income. His work is sold in the core New York market and so is affected by national trends. He's been innovative about going outside the dealer system to sell his work through the bar and grill and is comfortable with the fact that he's producing a product, albeit a unique one. Phil is withdrawn right now, but he has a record of successful market sales and could be lucky in the future. Lisa is just beginning her career and is conflicted about the issue of money for art. On one hand she is eager for professional success, as shown by her willingness to pay for the national-magazine ad. On the other hand she is concerned about developing her personal style and wonders if her aesthetic decisions could stand up against the lures of money. Her Chicago dealer told her that his customers were interested in work that had political content. But she does not want to explore those ideas in her art.[13] Louis is eager for anything that comes his way and is young enough to keep knocking at the doors. Fabian has chucked the whole thing. Disgusted with all aspects of the art market, he puts his faith into public support of art by grants and makes his bread and butter, like Lisa, by working for an art school.

All these artists have in common their goal of creating high-art work. None of them used that phrase, since their self-confidence was so solid

that the issue of distinguishing their work from more "decorative" art never came up.[14] They were all socialized in M.F.A. programs. But they are a minority in the larger population of people who identify themselves as artists. The next two cases, of non-M.F.A. artists, will introduce people who live in a different world.

Tammy, a 45-Year-Old Business Painter (Int. 112)

Tammy is a pretty, brisk woman who looks ten years younger than her age. I interviewed her in her suburban home in west St. Louis County, a middle-class community of fairly new, single-family brick ranch homes. Her studio was in the spacious basement. She was packing up to move back to Minneapolis after living in St. Louis for over twenty years. Tammy was divorced eight years ago, at which time she had two children, eight and twelve years old.

> My husband told me, "Now you're going to have to go out and get a forty-hour-per-week job like everybody else." I said, "Before I do that, I want you to give me one year, with enough maintenance to support me until I can get on my feet and see if I can do it with my art work. And if I can't, you're right, I need to go out and get a forty-hour-per-week job like everybody else and punch the time clock. But if I can do it, that's what I'm going to do."

In her no-nonsense, determined way, Tammy explained how she supported herself as an artist.

> I knew when I was going to try to support myself, I knew there was going to have to be somewhat of a compromise between painting for myself and painting for others. Because if you totally paint for yourself and give no regard to the market, you are going to have a tough time moving your work and support[ing] yourself.

Her solution is to sell her decorative, abstract artworks on paper directly to people at art fairs. She learned about the network of fairs across the country and methodically built up an annual schedule, visiting fifteen to seventeen outdoor art fairs each year, selling at each for a couple of days. She bought a canopy, a tentlike pavilion of nylon that protects her work from the weather, panels of screens to display the work on, and a battery-powered lighting system. Tammy makes about one hundred paintings a year and sells eighty to ninety of them.

I look at the whole thing as a business. It's not a hobby to me. When I'm not at a show, when I'm off the road, I'm usually in my studio at about eight-thirty in the morning. And I am down there with the exception of maybe three or four hours during the day, when I will pop up and get some lunch or go get the mail or make some phone calls until about ten or eleven at night. I put in a ten- or twelve-hour day.

She had a different perspective on galleries than the artists described above.

I'm with galleries, but you know what? . . . I can send a gallery fifteen pieces of work. They may sit on it for three years, all but maybe one or two, and not move them. I could have taken those same fifteen pieces and moved them within three shows.

On the other hand, Tammy understands the importance of gallery affiliation to establish her legitimacy for buyers. Her work is represented in one of the better St. Louis galleries as well as six others, from Walnut Creek, California, to Coral Gables, Florida. She has put this information on an information sheet that she gives to customers.

But I think it's important to be into galleries. I think it's important for an artist to have a résumé. When I put prices on my work of fourteen hundred to three thousand dollars and people walk in and they've never heard of me, they've never seen my work, all they know is they like it. If they like it well enough that they want to buy, some of them are going to say, "But is she really worth a fourteen-hundred-dollar price tag? How good is she? Who else has bought her work?" I hand them these, and then when they are walking around at the show and they look at it and they see that Lee Iacocca has two in his executive office suite, and they see that Southwest Bell has them, and Digital Corporation, and universities, and Barnes Hospital has about thirty of them, then they will go, "Oh, obviously a lot of people, a lot of corporate collectors think enough of her work that they are using it." I don't have any private collectors on here. That would be another umpteen pages. But that's just the corporate collections, and so then they go, "Oh, she's probably worth it then."

Tammy has taken a different route toward selling her work than the high-art artists described before. She doesn't have an M.F.A., the final professional degree, and hasn't been socialized into having high-art aspirations. She is an enthusiastic supporter of art fairs.

I think that St. Louis doesn't understand the art fair market. I
don't think there are very many St. Louisans [who] know that
there is tremendous work being produced across the country and
sold at art festivals. I think your average yuppie or art collector,
. . . most of them think that if you want to buy something decent
you have to go to a gallery to get it. St. Louis had never had a dyna-
mite show. Laumeier [Sculpture Park, which sponsors an art fair
every May] is a beginning . . . the closest that St. Louis has been
able to come to having a very high-quality show. And I've seen it
going downhill the last couple of years. The quality of the work!
People have started doing things like teddy bear wind chimes. I
mean, come on! How that stuff ever got in is beyond me.[15]

Tammy, like most business artists, conceptualizes the difference be-
tween her art and avant-garde art as "painting for myself and painting for
others." She has none of the doubt that Lisa has about "selling out" her
personal vision for money. But almost every piece of art Tammy makes is
made without knowing who will buy it, "on speculation" rather than "on
commission." This is a relatively recent way for artists to make a living.
Before the nineteenth century, most artists made work to order for clients,
on commission. Portraits were a major source of work for artists until the
spread of photography killed the demand, as photography affected so
much of modern painting. At this point in time there is only one full-time
portrait artist in St. Louis, although two other local artists have done sev-
eral commissioned portraits. The next vignette introduces the last of this
breed.

Skip, a 56-Year-Old Portrait Painter (Int. 43)

Skip lives on one of the streets of splendid mansions in the Central
West End. His home is enormous and baronial, with vast spaces, dark
wood paneling, and stained-glass windows. The photographs of his family
along the hallway make it clear than they enjoy a country life with horses,
dogs, and hunting. His studio occupies the top half of a separate garage in
the rear, large enough to hold five cars, roofed with the same elegant green
ceramic tile as the house. The studio is ample and comfortable, with a
leather couch and easy chairs, interesting curios, and a hunting rifle on the
wall. It gives the impression of a well-off, comfortable, traditional mas-
culine existence. On the coffee table are large display books with color
photographs of the hundreds of portraits he has done. Leafing through
them, one encounters the faces of St. Louis's powerful elite—business-
men, judges, politicians, physicians.

Skip is a St. Louis native. After obtaining a B.F.A. from Washington University he worked as an illustrator in New York City and did his military service there. He and his wife decided to return to St. Louis in the mid-1960s. When they got to town, he fell in love with this house and bought it for the low price such homes sold for in the depths of the city real-estate slump.[16] Skip taught art part-time at several local colleges for about ten years while slowly building up his portrait business. At that time there were three accomplished painters making portraits in St. Louis. The older portraitists were supportive, steering commissions his way. By 1975 the senior portraitists had retired or died, and his reputation was established, so Skip gave up teaching to concentrate fully on portraits. His wife does not have a wage job, and their family health insurance is expensive (even with a ten-thousand-dollar deductible), yet his portrait practice is successful. He produces between twenty and thirty formal, conventional oil portraits each year and is booked into the next year.

Skip has a down-to-earth attitude toward his work.

> Well, I am almost like a businessman. I come out here at eight-thirty till noon. And I go in read the paper, eat a sandwich, and come back and work till about five-thirty. And I do that five days a week.
>
> To be a good portrait painter, you have to be sensitive to what the sitter has in mind, because there's one thing that commercial art taught me was to get paid. And, whereas in fine arts they try to not get too much involved with money and all that, it's not that way at all if you are going to try to make it as a portrait painter. Getting paid is very important. So that means you have to at least listen to what the sitter has in mind, or what the people who are commissioning the painting have in mind.

Skip does not have an M.F.A., but he is aware of the high-art artists' opinions of his conservative style of painting and is defensive about his career.

> I'm sure a lot of people who are artists in this town do not think that much of my work. "This guy, he does portraits, pretty photographic and mainly does rich people." I get great pleasure out of doing this, and I don't care what they think. It works for me. Some day, if I ever put a show on, I think it would impress people because there is a tremendous breadth of work and lots of them.

He justifies himself with reference to the quantity of labor he has put in his work. One of its most gratifying aspects is to deal on a personal level

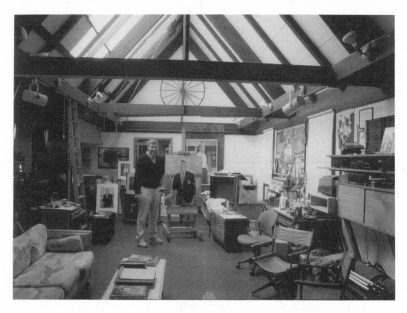

FIG. 10. A successful portrait painter in his studio. His commissions often come on the occasion of the subject's retirement. Part of the job satisfaction is seeing his work given as a gift to his wealthy and powerful models.

with powerful, accomplished individuals. His work is often given as an award or commemoration (for example on retirement) to the subject, and he tries to attend the award ceremony (fig. 10). Skip is thrilled at seeing his work be the subject of so much attention: "I may not be in art museums, but it's really satisfying."

Tammy and Skip are serious, professional, and expert at their art. Their goal is not to advance the cultural vision, but to support themselves by doing what they love, as their own bosses. They both present themselves as "businesslike" and stress the importance of satisfying clients. There are relatively few artists as financially successful, since it requires a lot of skill, talent, drive, and pluck or luck to find the niche—independent from the gallery system—where enough income is forthcoming. Many artists create work of comparable aesthetic quality but enter the market only peripherally. Since they earn no significant income and are equally disdained and ignored by the high-art institutions, they have the worst of both worlds.

The next artist to be described will represent the vast majority of self-described artists, who do in fact create art and who may be extremely tal-

ented and skilled, but who do not have the commitment, values, or need to become professional artists.

Gertrude, a 64-Year-Old Hobbyist Painter (Int. 23)

The high-art artists described above would probably scorn the artistic quality of Tammy's or Skip's work at the same time that they might admire their independence and energy. Most would have no mercy at all for Gertrude. A dignified, bright-eyed woman, she is active in the Artists Guild, one of the two main associations of artists in St. Louis. Some years ago she was a conventional, 44-year-old, upper-middle class suburban housewife and mother when she was stricken with cancer. After a six-year bout of illness she was cured, and the near-death experience helped her decide that she would follow her early goal of being an artist. She had always been part of the large group of people, mainly suburban housewives, who take courses and workshops in art. They maintain their interest as a hobby, but they rarely have the self-confidence and commitment to carve significant amounts of time out of their lives to devote to art. Gertrude was an active mother, housewife, and church member and had always thought of her time making art as stolen from her responsibilities toward others.

After her illness she built a small studio attached to her home and began to do works on paper, but Gertrude never dedicated enough time and commitment to produce a full body of work. Her paintings are pleasing, loosely impressionistic views of popular St. Louis scenes such as the arch or Union Station, done in acrylics, pastels, or watercolors. She recently had two thousand commercial lithographic copies made of several paintings, which she sold to frame shop galleries for $12.50 each. She thought these galleries sold them for $65 each framed, but was not sure. The poster I saw in her studio was signed twice, first in the original, and second on the surface of the reproduction. This imitation of limited-edition art procedures would be particularly galling to high-art artists, as it implies a level of ignorance on the part of collectors that they find insulting.[17] Gertrude's work is handled by one local gallery that sells inexpensive art to a major hospital center to decorate the patients' rooms. She is not on their show schedule and has not tried to have a one-person show.

Gertrude represents the mass of art enthusiasts who dip their toes into the art market but never dare to jump in and declare themselves professional artists. They join groups like the Artist's Guild and attend lectures, workshops, and classes but can't bring themselves to tell their friends and family that they will take significant amounts of time from other activities

to make art. They are art hobbyists rather than professional artists. The difference lies primarily in their commitment of time and willingness to grapple with the challenging issues of personal creativity in their work, and perhaps secondarily in their ability, originality, and sophistication.

Special Cases

The artist vignettes presented above represent the lives of important types of artists in St. Louis. But in any ethnographic project one meets people in extraordinary circumstances, or remarkable people whose lives reveal something special about the local situation. Several special cases are presented here.

Art and Race: Albert, a 56-Year-Old Painter (Int. 124)

Albert lives in a tiny two-story home in the north side of St. Louis city, a residential neighborhood of burned-out buildings, empty lots, and small convenience and liquor stores. He lives near Fairground Park, a large green space surrounded by once-elegant homes. The general neighborhood is "The Ville," which was a stable middle-class black neighborhood for many years, but which has experienced severe social and financial problems in recent decades. A tall, thin, soft-spoken man who looks ten years younger than his age, he asked me to leave my shoes at the door when I came to interview him. The room I entered was dark, its windows blocked with paintings. Albert's art covered the walls. His work consists of sensitive, beautifully rendered portraits, paintings on religious themes in oils, pastels, and watercolors, and collages and lettered statements on African-American religious history and philosophy.

Albert studied art for three years at Washington University when he got out of the Marine Corps in the early 1960s, but had never graduated. He worked full-time at night at the post office while studying. After thirteen years at the post office he quit to try to survive as an artist. He could not earn enough money from art sales and got jobs teaching as a substitute and special art teacher in the St. Louis city school district. He had set up his home for the past ten years as a museum of his own art on themes of current and historical black culture, and invited classes of schoolchildren to visit. He also attends art fairs, where he draws portraits.

I got a strong sense of isolation from Albert. His artwork is skilled in several different mediums, and there is a fair amount of it. Albert is not connected with the dominant art community or art institutions. Is this because the effective segregation of St. Louis society or because of his per-

sonality? When I mentioned his name to the directors of two local African-American art institutions, they mentioned his "unique" personality in a way that made me understand he was a difficult person to deal with.

Albert said he did not go to the art museum often and had not seen a recent show at the art museum of the work of an inventive black artist (Willie Cole, an artist from the New York area who makes sculptures reminiscent of African masks out of old irons and ironing boards). In the past Albert had exhibited his work at the three places in town where African-American art is shown, one private and two public, but he had no connections with any exhibition space at the time of our interview. He intends his house to be his exhibition space.

While there are relatively few black artists in St. Louis, and even fewer involved in the major artist organizations, some African-American artists are central. A full professor of printmaking at Webster University is in constant demand as an exhibition curator, is on the boards of several art institutions, and is visible in attendance at as many openings and public art functions as any other local artist. The two other black faculty artists are not so socially active. This variation of a few individuals who are socially visible and a majority who are invisible seems to be the same for all social types of artists.

The scarcity of African-American artists at Art St. Louis and the Artists Guild meetings, and at openings of white artists, is always striking, but no more noticeable than the proportional racial composition of symphony, dance, and most other "high-culture" events. Unless the performance has some direct connection with African-American culture or society, blacks are often conspicuously absent from the audience. As Bourdieu has pointed out, high culture requires an elite level of educational background that is not available to the great mass of society, and certainly not to underprivileged minorities (1984). The St. Louis art world, like so many contemporary American cultural institutions, is a white, middle- and upper-class society existing in a multiethnic and diverse socioeconomic environment.

Art and Religion: Brother Jim, a 64-Year-Old Painter and Sculptor (Int. 67)

Brother Jim is a short, stocky, dynamic man. When I called to set up an interview, he asked me to come in the early evening so that he would not lose any of his work time. This concern was expressed by fewer than five of the sixty-five artists interviewed and is sign of his "workaholism." I met him in his gallery, a clean, new, elegant two-story A-frame building of

red cedar, located on the Catholic order's grounds in southwest county. The professional-looking gallery was full of brightly colored paintings and sculptures, both abstract and figurative. Large, metal, abstract sculptures were installed on the lawn outside. All of the work except for a few small sculptures was by Brother Jim, who had designed and built the gallery and ran it as well. Connected to the gallery was an enormous workshop of several thousand square feet, with heavy machinery for metal and wood sculpture and space for easel painting. All this was Brother Jim's domain.

He had joined the Catholics as a young man, after attending a Catholic high school. The order sent him to college in Dayton, Ohio, and to graduate school at Notre Dame, where he majored in art. After graduation the order supported him for an independent year in Europe, in 1957, studying religious art treasures.

> I was stationed officially with the Paris [Catholic] community, and I bought my motor scooter, and I was on my own, and sometimes I would find a community where I went and stayed with them. Other times I would stay anywhere.

He traveled alone, driving his motor scooter through France, Italy, and other European countries, visiting museums, cathedrals, shrines, and religious communities. His goal was to familiarize himself with the masterpieces of religious art.

> So it was just like continually absorbing, I'll tell you. I would go some days all day and wouldn't eat a thing. I wasn't even hungry, I was so involved. I took a lot of slides. I came home with all that, maybe a couple of thousand slides. . . . I went, like, to Chartres. I was there thirteen times during that year and saw Chartres Cathedral from early morning to late at night—all the variations of the kind of light that came into that space. . . . I was moving this ladder in front of the mean, old Western facade, and I would take detailed shots of all of these figures around the side. And only after I had gotten around the second side, then one of the guys saw me and he said, "Hey, you're not supposed to do this, this is a national monument," and he made me stop. But he didn't take my film away or anything. . . .
>
> It was a fantastic year. But I didn't splurge. I didn't stay in hotels or this kind of stuff. I looked for pensiones, I slept under bridges, I slept in haystacks, I really roughed it, you know what I mean? I had a saddlebag, and I took one seat off of this Lambretta and I put a saddlebag on there and I had my sketch pad on there

and my suitcase. On my one set of saddlebags I had all of my
watercolor supplies, and in my other saddlebags I had my loaf of
bread and some cheese, and that's how I traveled. It was really
bohemian. I didn't dress as a brother in black or stay in a hotel and
check in and check out.

When he returned, he taught art for ten years in the Catholic seminary
and then got permission to remodel an old structure on the grounds to
serve as an art studio. He built up a reputation as a designer of chapels and
religious art, at the same time that he maintained his creation of secular
art, scrounging for materials like any other artist.

> I would go to these steel companies. I would be in their dumpsters
> picking out scrap metal. I would be making things out of their
> punchings. Army surplus, we would go to army surplus. I would
> get rolls of canvas from army surplus . . . and like the lights in the
> chapel are 105 mm shells. I bet I cut hundreds and hundreds if not
> thousands of shell casings and made candleholders out of them,
> . . . real decorative things. But that's where I started at, with that
> kind of junk, if I can call it that now. It was my bread and butter,
> and after my first year here I had so many commissions to do I
> asked to be freed from doing any teaching over at my mother
> house, so that my second year I was free.

He recently built the modern A-frame gallery structure and is busy
with commissions, as well as art he makes like any other artist, on specula-
tion. He has several steady clients, among them the owner of a chain of
large hotels who has bought his work in bulk to decorate the hotels. For a
while he accepted students who came to study with him, but more re-
cently he has devoted himself full-time to making art.

> I have people continually asking me to come and work here. I
> don't have time. I tell them I just don't have the time to be both-
> ered with people coming here and using the space, taking up the
> space. I don't want to be hard nosed about it, but how would I get
> any commissions and stuff done if I'm continually working with
> these people . . . ?
>
> In my position here with the freedom to do what I'm doing and
> creating, not just the commission but fun stuff in the gallery,
> would you want to have somebody coming in here and standing
> next to an easel and you're taking your time to teach them how to
> paint? I kind of feel there are so many places for them to do this
> already that I don't know if this is the place.

Brother Jim is one of the most successful artists in St. Louis in terms of sales, although his work is ignored by the established galleries and museums. He generates enough money from commissions and art sales to hire an assistant for twenty thousand dollars a year, pay all his materials and costs, including a new van every few years, and contribute at least fifty thousand dollars to the order's general funds every year.[18] Once or twice a year he hosts a banquet to thank all of his "benefactors," the donators of scrap material and his collectors. He hosts about fifty people at a catered meal with music and gives each person a personal gift of artwork. In addition he maintains an active travel life. Since 1971 he has traveled all over the United States and Canada, and in France, Ireland, Spain, Germany, Italy, Greece, Peru, Japan, India, and Nepal. Brother Jim makes no distinction between his artistic and religious life.

> To me, religious life has impregnated, has built, has made everything that you see here, and the reverse of that is also true. What you see is what helped make me.

In his single-minded dedication to his work Brother Jim is like any other serious high-art artist. He solved the artist's existential problem—how to make fine art and how to support yourself—by embedding his art making in a religious brotherhood. The social legitimization that secular artists get from gallery representation is available to him from his church, although his entrepreneurial drive is impressive. Brother Jim ranks as one of the most prolific, energetic, and successful artists in St. Louis, despite his invisibility to the high-art social institutions.

Art and Business: Tom, a 45-Year-Old Sculptor (Int. 128)

Tom's studio is far into the west county, where the denser suburbs give way to fields, a small airport, and developing industrial parks along the highway. The studio, built onto his home, is on his family's land. Tom, a bachelor, designed and built the home and studio himself. He knew as a teenager that he wanted to remodel a ruined old slaughterhouse near his family's store into a place where he could be an artist. His parents gave it to him as a teenager, and he began cleaning, planning, and planting trees even then. It is an impressive space with high ceilings of heavy wooden beams and a heavy Germanic romantic air about the antique furniture, old musical instruments, and armor on display. Tom is immensely proud of his home and studio and boasts of it as a projection of his artistic personality and part of his marketing technique.

> It was important to me to create a striking building which would impress clients and make them unable to estimate the cost. I calculated that I wanted them to think I was very stable and secure. I wanted them to be impressed.

After receiving his B.F.A. from Washington University he enrolled in the M.F.A. program to study sculpture. But he soon quit because of a difference of opinion with the faculty.

> They all wanted me to develop my own style as an artist. But I wanted to learn anatomy and sculpture techniques.

He had a single-minded focus on his career even as a student. The studio was full of his realistic portrait busts, bas-relief plaques, and full figures in cast metal. He was working on six commissions at the time and had eleven projects in production, including new copies of multiple-edition pieces.

Tom is a successful, busy businessman-sculptor. At the time of my interview he was making a full-body life-size figure of a small boy who flew in from Connecticut to pose. The boy's wealthy grandmother lived in St. Louis and had commissioned the sculpture as a gift to match an earlier one of the boy's sister: "The price is about $100,000 to $125,000 if they want a unique piece, but I'll do it for $50,000 if I can make multiples."

Tom went into business with a partner in 1981 to create and market multiple editions of commemorative portrait busts of famous people like Charles Lindbergh and Mark Twain. The first bust, of Lindbergh, was a terrific success. They had a few of the edition of one hundred left and had raised the price from the original five hundred dollars to forty thousand dollars. Through political connections, he had succeeded in presenting a bust of Twain to President Reagan in 1985 and a bust of Ernest Hemingway to President Bush in 1989. His work has been placed in prestigious local and national institutions such as the Kennedy Library and the Smithsonian. At the time of the interview he was making a portrait bust of a wealthy cardiologist demonstrating a surgical technique, a bas-relief to be marketed in benefit for the Olympic National Committee, and other sculptures in connection with national marketing projects.

He employed four people on his own: a part-time secretary, a sculptor assistant, and two sculptors as finishers at the production facility he and his partner operated nearby: "I figure my ongoing operating costs at about ten thousand dollars per month, for interest payments on notes, overhead, utilities, insurance, taxes and labor."

Tom runs a fully professional organization that is invisible to the high-art community in town. He had no connections to any local galleries and is uninvolved with the art community, since his work is marketed on a national basis through his own business and through networks of frame shop galleries. He is a fanatically focused person. He had a vision of the life he wanted to lead as a child and constructed his career precisely where he planned it, in the rehabilitated old slaughterhouse structure he played in as a child. His stroke of luck was to go into business with a dynamic marketing expert, who began distributing his work and then branched out into national promotions.

The three artists just described are invisible to the elite, dominant art institutions in St. Louis. In terms of aesthetic quality their work was well within the borders of avant-garde art, yet each had created a meaningful life in another social institution: Albert in race, Brother Jim in religion, and Tom in business. Each had constructed a private gallery to show their own work, a feat of substantial hubris. Albert's studio is isolated from the larger society and devoted to racial issues, which seems an understandable reaction to a difficult racial situation. Brother Jim has the exuberance and dynamism of one kind of archetypical artist (Picasso comes to mind), and his success seems clearly to blend his professional-quality work and the interest of his clients in advancing religion. Tom's business success is a true child of modern marketing, with political connections greasing the way to tie-ins with mass-market institutions like the Olympics. These three artists have impressive self-confidence. The next artist had his self-confidence bound up with his art world identity, which he gave up for personal reasons.

Art and Psychology: Bernard, a 57-Year-Old Former Painter (Int. 103)

I interviewed Bernard at his dining-room table in his small house in the central suburbs. He spoke so softly that I had a hard time hearing him, even though we were sitting alone in a quiet room. I had known Bernard for years as the chairman of the art department at a St. Louis community college, and as a maker of small, delicate works of woven, painted strips of paper. His colors were always soft and pastel-like, and these abstractly patterned paintings were very pleasing to look at. His work became popular in St. Louis while the pattern-and-decoration movement flashed through the New York galleries in the 1970s.

Bernard had had what seemed to be a successful career as an academic

artist. He had taught full-time for twenty-seven years, had an early one-person Currents show at the St. Louis Art Museum, and was represented by a series of good local galleries and an excellent gallery in Chicago. Nevertheless, he had given up making art completely about five years ago and had taken early retirement last year. At the age of fifty he had studied for a master's degree in clinical psychology, and in his retirement he worked half-time as a therapist for a religious family service agency.

He said that the galleries had sold his work well, although his prices were always inexpensive, never topping two thousand dollars. While the galleries were selling his work, he thought he would never stop making art. But things slowed down for him in the late 1980s, and at the same time his early interest in psychology returned to push him toward the degree. He still can't explain why he left art so thoroughly. He relates it to his early childhood experience of growing up in Kansas in a dysfunctional, abusive family. He feels that he needed art to "hold on to" while he was growing up in the difficult conditions of his family. He had needed art for his psychological survival; "it became my entry into the world . . . the only thing I could hold on to." For a long period of time, he said, "I didn't know who I was," and art was his only stabilizing force. He feels now, after a long period of intensive psychotherapy, that art has served its purpose, and he did not need it any more.

Bernard does not think he got "burned out" on art, although he admits that relating to dealers was very difficult. He was upset about his lack of power and his feeling that the dealers did not care to understand the aesthetic issues he was confronting. And finally the loneliness of making art got to him.

> Part of the change was, art is such a solitary thing, after a while I felt too solitary, I felt too alone and needed more interaction. Making art is a very lonely profession.

Artists often say they would "go crazy" if they couldn't make their art (see the statements at the beginning of this chapter). For Bernard, this seems to have been literally true earlier in his life. When he finally got the security of his retirement income, and his lifelong fascination with psychology could be turned into a professional degree and a supplemental income, he just didn't need the art any more. His emotional and mental involvement with his work had changed so that he was less engaged in the creative process. It had never contributed to his income in any meaningful way, and when his sales fell, the cost of giving it up was relatively minor.

Conclusion: Fish and Ponds

Is it good or bad to be an artist in St. Louis? Is it better to be a big fish in a small pond or a small fish in a big pond? St. Louis is the small pond, with lots of exhibition possibilities, some teaching opportunities, cheap housing and living costs, and a small, relatively supportive art community. None of the ways of surviving as an artist in St. Louis are ideal for those who expect New York–style fame and fortune. New York is the big pond, full of sharks and bigger fish. Art is important in New York. The level of devotion to art available there is missing in St. Louis. Art criticism in New York is incisive, impassioned, written as if art really matters. Most of the national magazines are housed there and focus on reviewing local shows, since these set the terms of the national debates. Art criticism in St. Louis is written as if the object is to support local talent and to avoid hurt feelings.

When St. Louis artists visit the center to see what sort of work is in the galleries, they often feel that the work they see is not significantly better than their own. Since the New York work is defined as avant-garde, gets written up in the national magazines, and is priced much higher than St. Louis work, they feel the "cultural cringe" that Hughes has defined (see chap. 1).

Yet moving to New York is no solution, since one would still have to compete against the thousands of artists there without the comfortable and affordable home base available in St. Louis. The high costs of New York—of money, energy, time, and quality of life—make it a difficult place to support a family. If one goes far enough away from Manhattan to ameliorate the costs, the benefits are also minimized. The gatekeepers in New York are notoriously provincial about leaving their home base in Manhattan.

For those whose work has decorative elements, so that a broad range of St. Louis buyers respond positively, life can be sweet. Business artists, who don't have to bear up under the self-defined weight of high-art expectations, can create easy and pleasant lives. They are welcomed at the many local artist groups, wealth in the area is sufficient to support their relatively low-priced sales, and dealers are ready to sell their work. The few business artists whose work is distributed nationally through mass-marketing efforts can live anywhere. Residence in St. Louis or New York is irrelevant once they develop their production and marketing connections.

For those high-art artists whose work is more gritty or unmarketable,

yet who dream of elite success, life is difficult. The recent decline in art market sales exacerbates their problem in making a living. Yet the problem would be worse in New York, where prices are so much higher. St. Louis offers inexpensive housing, a small but adequate range of cultural institutions, and a fair-sized middle-class population. An artist can live a comfortable life if his or her expectations of high-art success can be controlled. The broad range of exhibition possibilities makes it relatively easy to show work at all levels. The next chapter will examine one sector of the exhibition choices, the world of private dealers.

5 / Dealers

Sure, to be the 198th gallery in New York [could be wonderful], because the critics from *Art in America* and *Art Forum,* if you found the right artist . . . they will come there, but they won't come here. I've become popular with some of the local artists because I sell their work, but I have no chance to make a dent in the real big world of contemporary art.

<div align="right">Dealer</div>

It doesn't matter to me if it's a next-door neighbor or who it is, if they are discounting work or selling out of their studios, they are not meeting their obligations, and any artist should do that with any dealer. I'm very, very straight on that. I don't make exceptions on that. . . . It simply is a function of whether you have the trust and the relationship. . . . They have to understand that if they make that decision, we're through.

<div align="right">Dealer</div>

I said, "No, the gallery does not come first. The gallery runs from the 50 percent, and if you can't run it on that, then you'll have to cut back on the number of suits that you buy and the champagne and the women and everything that is making this look like such a class act when it's really not."

<div align="right">Artist</div>

The Dealer Market in St. Louis

The paradox of the art market—that art is both a commercial commodity and a cultural symbol—is a painful fact of life for dealers. Elite art world participants expect dealers claiming high-end status to exhibit art that is "serious," meaning avant-garde, challenging, or "difficult." This sort of work appeals to a very narrow segment of the art-buying public. These few buyers characteristically travel to several markets, primarily New York, have many choices about where they buy art, and value a sophisticated image that shuns a "provincial" focus on local work.

In order to pay the rent, galleries must show work that people will buy. But most people do not want to live with, much less pay money for, the kind of art that is currently enshrined as avant-garde. Dealers imagine greener grass in other places, especially the New York Mecca, where they

fantasize about buyers with the taste of MOMA curators and the disposable income of stockbrokers. In the meantime they must succeed or fail by catering to the art buyers in the local market.

During the 1992–93 period someone interested in looking at contemporary art in St. Louis could choose from about eighty-six places where it was exhibited regularly. Thirty-one were located in public (nonprofit) facilities, including museums, schools, libraries, and religious institutions. Of the fifty-five private-sector locations, forty-four were commercial dealers in retail outlets, three were exhibition spaces located in businesses (including a local bank, a bookstore, and a photography studio), and eight were private dealers or consultants.[1] This chapter focuses on these private-sector art outlets.

The high end of the commercial-dealer distribution was a set of eight galleries defined as "serious" by artists and collectors. Three of these galleries did not deal in local art (they sold art imported from New York galleries). The remaining five galleries were the best option for the approximately two hundred "serious" local artists who wanted high-end dealer representation, or for buyers who wanted local, avant-garde, original contemporary art.[2] The commercial galleries ranked just below the top eight included a couple of new dealers seeking high-end status who had not yet established themselves in the market; other galleries specializing in sectors of the market such as African-American art, tribal art, and crafts; and several specializing in inexpensive decorative or mass-distribution art. The low end of the dealer market consisted of frame shops or retail gift stores selling posters.

Local History in National Context

The spectacular expansion of the national art world in the 1970s and 1980s had its local manifestation in St. Louis in the golden age of dealer-artist relations. Before 1970 there had been small local galleries, some artist cooperatives, one connected to and subsidized by a photographic studio. The first New York–style gallery opened in the early 1970s (fig. 11), owned by two wealthy local businessmen, collectors with a passion for art, seeking something more than money from life. Drawing on their connections with elite New York dealers, they showed contemporary artwork from those galleries, which meant that avant-garde art from the center was available in town. Prices rose so fast in the next two decades that these early works seemed dirt cheap and spectacular investments, with the hindsight of 1992.

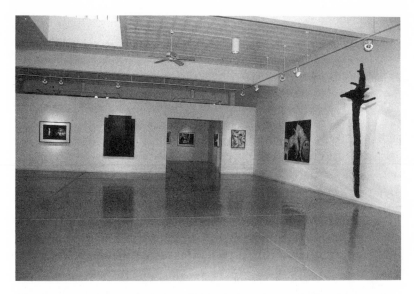

FIG. 11. A private avant-garde art gallery. The huge spaces, high ceilings, and dramatic exhibition style are designed to impress the viewer with the museum quality of the work.

A wealthy St. Louis County matron, who with her husband was a collector and art connoisseur, opened a gallery in her home in the early 1970s. Her clever strategy was to show the work of well-established artists from New York and California with the work of a few emerging artists from St. Louis, thus legitimating the local artists and raising their value in collectors' eyes. The owner was knowledgeable, dynamic, and very enthusiastic, and the gallery soon moved to commercial quarters in the county. Art prices were rising fast, and the dealer's enthusiasm and flair in touting emerging artists made the gallery very successful. She soon expanded her gallery and went into partnership with another wealthy art connoisseur with close connections to the SLAM. But like other wealthy women dealers then and now, she tired of business and moved on to other things. The gallery closed in 1982 and is remembered by local artists as a golden age in dealerships. One artist's memory is typical: "[X and Y] spoiled us. They were really interested in the artists, supported the artists in different ways. They pushed their St. Louis artists" (int. 103).

This dealer was followed by several other middle-class matrons who opened galleries in her abandoned space and in other locations. Each had a similar history of enthusiasm for a few years, then gradual disillusionment and closing, on roughly a five-year cycle. When each closed, another

opened to occupy the social and economic niche. At present several galleries represent local artists, but most are in fragile economic condition due to the downturn in the art market in the 1990s.

In the 1990s, many galleries across the nation fell in a depressing spiral of low sales, making the gallery owner nervous, preoccupied, and irritable. Artists gossiped that these emotions were taken out on the elegant young college graduates hired at minimal wages to staff the gallery. These innocents would then quit to be replaced by other liberal-arts graduates, equally young and stylish but ignorant of the gallery's stock, customer list, and selling practices, which further cut into sales.

St. Louis dealers have been rarely able to gain the respect of the art community by showing challenging work and generating enough local business to be economically healthy. Galleries open and close regularly, but the art market has not crystallized in an exciting location comparable to those in Boston or Minneapolis. The market is small enough so that a few new galleries opening near each other, most likely in the Central West End or in Clayton, could generate the excitement.

The High End: Dealers and "Gallerists"

The art market contains few dealers and many artists. This means that the balance of power is on the side of the dealer, at least until the artist establishes a solid reputation in a wide market. Some artists can establish a satisfying life as a business painter by being their own dealer, as the cases of Tammy and Skip showed in chapter 4. But artists with ambitions to succeed in the national art market, or those who detest selling or are unable to market their own work, need dealers. Not all dealers need personal relationships with artists. Some dealers can function by selling work obtained from other dealers (usually from New York) as secondary marketers of high-level art; other relatively low-status, frame shop galleries can survive by selling posters, inexpensive mass-produced prints, and mass-marketed paintings, without ever speaking with a real, live artist. But in order to have high status in the local contemporary art world, dealers must represent artists.

The archtypical dealer manages a "stable" of artists. That is an art world word, and the connotation of racehorses—fragile, temperamental, vigorous—is probably deliberate. Dealers must maintain supportive relationships with artists in order to get the work they prefer. Members of the art world recognize the high-end dealer's responsibility to be more than a mere vendor, and several people mentioned the European distinction between "dealers" and "gallerists." One curator described the difference.

> A dealer just sells work; he's not particularly interested in the artist's career. . . . He's just a dealer, like you sell bacon. But a gallerist, however, has a space; he or she has a particular program [i.e., vision]; he or she goes out and looks for artists to correspond to that program, his interpretation of art, art trends. He fosters the artist. He publishes catalogs, deals with the intellectual side of things, and . . . it's his intention to represent the artist for an extended time. So gallerists look down on dealers. (Int. 13)

A gallerist is a dream dealer who has a vision of the art he or she sells that is analogous to an artist's vision, and who supports the artist's career beyond merely selling work. Thus the gallerist is a true partner with the artist in advancing the cultural vision of reality, in "expanding civilized consciousness" (cf. chap. 1).[3] Durand-Ruel's role in promoting the French impressionists in the last century and Leo Castelli's influence in the New York art scene after World War II are exemplary. But even in New York, among the hundreds of galleries there are very few comparable to Castelli. In St. Louis, there are none.

While no St. Louis dealer has the ability to affect the national market, a few have tried to make a local impact. The primary requisite is a vision of the gallery's presentation of art. One dealer talked about his aesthetic vision.

> The people [whose work] I sell are people I look at and choose out of the thousands of people who apply to me. And I say, "I think this is good art." Well, you can say what you like about my taste, but I'm putting myself on the line and making a public statement. . . . The people I show have not been in the magazines, and they get to show here because I think they are good. So there is a curatorial function to this that I'm proud of and that appeals to me, using my own taste.

This dealer described his strategy to help his artists.

> One of my purposes is to help the artists advance their careers, so I try to do whatever I can to get involved with museum curators, to meet people who might be helpful to the artists. So, the reason that [artist X] just won a Missouri Biennial . . . is that the judges for that came in here, and . . . I made a good sales pitch and they bought it. So that got him five thousand dollars, and that's part of my service to the artists. I'm here to serve a limited number of artists, and to present their work frequently and try to boost their careers as best I can, as part of my mission.

[*SP*: How long do you carry an artist if they don't sell?]

Oh, I have a lot of people who I've had from the beginning. If they want to keep bringing me work, we might sell something every once in a great while. If it's something I like, and if I like the person, if the person doesn't hassle me because we are not selling, I'll go on as long as it takes. Look [at Y]. I've shown her work since she came to St. Louis. We sell practically nothing of her work, but I find it interesting, and she is a kind of neat person who deserves to be shown because she is doing strong work. And if I didn't show her, no one would, because I'm the only one in town who will show local people who won't sell. And I'm fortunate enough that I can make my sales from other people who do sell, and every show does not have to sell.

This dealer was aware of the limitations of his situation.

Sure, to be the 198th gallery in New York [could be wonderful], because the critics from *Art in America* and *Art Forum,* if you found the right artist . . . they will come there, but they won't come here. I've become popular with some of the local artists because I sell their work, but I have no chance to make a dent in the real big world of contemporary art. (Int. 10)

From the artist's perspective, the dealer should love the artwork and respect the artist. Even the few artists who live from the sales of their art work want artistic respect.[4] The many who need to work at non-fine-art jobs to support themselves, and who must steal their painting time from remunerative work, need validation of their artistic status even more. Recall from chapter 4 Phil's bitter gripe about dealers: "It's a very personal thing that most artists do. And dealers could sell cars for that matter; it's all the same thing."

Like most artists, Phil wanted his dealer to treat the work seriously as an expression of his creative struggle, not as a mere commodity. Other artists expressed their sense of hurt pride at insensitive treatment by dealers. A young female artist complained:

Other dealers have a real snotty attitude, like, "I don't have time for you. How dare you show up to show me slides without an appointment." Like [gallery X], one day they came to see [another artist whose studio is next to hers]. I said hi, and they just ignored me. It is damned bizarre to me; I find that obscene behavior. They have no obligation to take me on, but I'm another human being, for Christ's sake. (Int. 137)

To the gallery, the constant requests for representation from artists diminish the individuality of any one artist, who seems just another face in the crowd. As one dealer put it, "Because there are so many more artists than there are dealers, they are always going to feel like they are getting the fuzzy end of the lollipop" (int. 10).

Like any business relationship, the ideal dealer-artist relationship should be based on respect, trust, and mutual advantage. A dealer who is emotionally supportive, understanding of the artists' problems, and interested in discussing the aesthetic issues of the artwork will have more enduring relationships with artists—sales being equal—than a dealer who is arrogant, uncommunicative, and uninterested.

Dealers and the Art-Buying Community

Serious, committed dealers are like artists and want the members of the art world to be interested in their vision of art. One elite young dealer showing young avant-garde artists from New York complained bitterly.

> I get no support on the young artists except for perhaps a handful of people who come in and are somewhat excited. For the most part even the most educated here of collectors is unwilling to see what I see and is in fact unwilling to come in and discuss young, new artists. . . . I think this city is terribly lacking in any type of appetite and inquisitivity about cutting-edge art.

She criticized local artists for being provincial.

> The artists that I spoke to, they knew nothing about what was going on. Half of them didn't even subscribe to the art magazines. That is, to me, shocking. If you want to be an artist, you sure as hell better do your research. It's like if you are going to be a doctor, you read the medical journals. If you are going to be an artist, it's like a career, you read what's going on.

This dealer also wanted some respect from the community, in the sense of collectors taking her taste seriously.

> But my real disappointment is that there is not a lot of people coming in here and asking me what's going on, and what can they see. And if they don't like what they see in the front room, they should come back here and talk to me about it.

She complained that even those who attend the gallery's openings and lectures do not do so for artistic reasons.

We also sent out . . . handwritten invitations, and on the invitation was my mother's name. It was a lot of social friends, not people who were interested in coming to listen to the artist. (Int. 115)

The first dealer quoted, who was successful in local artists' sales, had a more positive view of his gallery's role in the community. Like the dealer quoted above, he was painfully aware of the limitations of his influence in the St. Louis art market and pined for New York–style greener grass.

> The people [in St. Louis] who are essentially buying artwork are buying for decorative reasons. They don't want to be involved with an intellectual dialogue with the art; they want something that looks pretty with their couch. And that's just the reverse of the people in New York. They don't want something that looks pretty with the couch, because they see the couch as something that's here today and gone tomorrow. But the art, . . . because of the museums, because of the whole milieu of New York, they are much more understanding of the real purpose of art. And there are of course millions of people coming from all over the world; it's not just the people living on the East Side of Manhattan who are buying art, it's people from Bahrain, and people from Japan, and people from Europe. And we don't have those here.

He went on to describe the market pressures and constraints on his gallery in the St. Louis context.

> Most galleries in New York are very pure, and they have a definite focus. . . . The reason for that is that they have such a very large market that you can find a niche. Here, though, in a smaller market, you have to be very much of a generalist. You have to try to capture whatever sale you can, in every segment of the market, because the market is relatively thin. So everybody who walks in the door, you want to try to find something that they can use, that they can have. (Int. 10)

The Dealer as Ideologue: Dave, a 47-Year-Old Former Lawyer (Int. 27)

In the struggle to situate themselves in the impossible space of the art market paradox, some dealers simply ignore the business side of art. One such is Dave, a classic art ideologue. Dave has found "The Truth" and wants to save the world with it. He earns a minimal commission income

advising wealthy friends about purchasing expensive works on the international art market, while he shows "gritty" New York art by emerging artists in his gallery. These are often young artists represented by small New York galleries. The work is often aesthetically ugly, cartoonish, minimal, and inexplicable to anyone who is not an enthusiastic and well-informed supporter of avant-garde art (and even to some who are).

Dave's life has the appeal of a revolutionary's or an ascetic's purity and devotion to a calling.

> I don't support myself well; it's a struggle. . . . I don't have an apartment. I had to give up the gallery or the apartment; it was more important to do the gallery. You are constantly in debt. You're owing the shipper, the IRS, a gallery or somebody, but you try to keep the doors open. You wait for the big sale. It's usually a long wait.
>
> [SP: But at these prices, you'd have to sell the whole show. The prices are very inexpensive.]
>
> It depends on what your goal in life is. I guess if your goal in life is to have an exorbitant income, like a thousand dollars a month or something, that I haven't had for ten to fifteen years, then you would have to sell the whole show. But if you are going to make six to eight thousand dollars a year, then you don't have to sell the whole show, you can keep going. But you are always hoping that you are stocking up your situation for the future. . . . You can acquire a piece every now and then as a gift or as a purchase, and then eventually you will have something to pay your way into the home when you get old. What I'm doing doesn't make any sense [as a strategy to attain economic security]. So what I'm doing, I think is more like an artist. . . . I don't know that I'm the right person for this job, but I don't see anyone else doing it. . . . For me, it's knowing the artists and participating with the artists, that's the life for me.

Dave has attracted a small group of devoted and admiring collectors and curators who believe that his advice about contemporary art purchases will prove as good as Castelli's was during the 1960s. As one young collector said,

> [Dave] has been an accurate picker of winners. It's OK if you like something that retains its value, but it's sweeter if the value goes up, and other people validate your taste. [Dave] picks winners. (Int. 84)

Dave preaches earnestly on the subject of the art-historical significance of the New York art establishment.

> I think in the most simplistic terms, there is a time line one can draw from cave paintings from Lascaux, in southern France and Spain, to what you are seeing in the Whitney Biennial and what people are writing about in *Art Forum, Art in America, Art International.* . . . In general there is an intellectual history. . . . From European to America is the main flow of it. . . . It's just like we have this Judeo-Christian philosophy that is the core of American life. . . . And there is this huge [art] establishment, which includes almost all the major museums, almost all the major art writers, the people whose books are being published by the bigger publishing houses. It includes the collectors who are spending a lot of money on art . . . people all interested in this historical continuum.
>
> And artists attach themselves to it, and art schools attach themselves to it, and people, when they are intellectually vying . . . are working out their ideas within the context of this historical continuum. And that's the group of people I'm interested in showing in this gallery. Now the center, the international center for this, is New York.

He has nothing but disdain for St. Louis artists, who he feels have opted out of this grand historical mainstream because they chose not to live in New York and fight the good fight.

> Most of the people in St. Louis are not working, consciously working, within this format. . . . Most of them are interested in painting as an expansion of their own beings, rather than painting as a competitive situation within the New York museum world context. Of course they'd all like to show in museums, but most of the work they're doing is not really competitive. It's not on the cutting edge of the ideas that are in this historical continuum. Most of the ideas of the people who are working in a city like St. Louis, or anywhere out of the center, are things that they want to be doing. They are not consciously striving to be in the Whitney Biennial next year, or to show at the Carnegie International. They mostly are doing their own thing. . . .
>
> [*SP:* Why do you have to physically be in that place, since, as you say, there are art magazines and people can travel relatively easily?]
>
> Well, of course you don't physically have to be there. But as

they say, it sure helps. Because if you are there, you are addressing these situations on a day-to-day basis. If an artist in St. Louis wants to go to a gallery and see art that is viable within this international context, they can come here [to his gallery] or they can go to [X], or they can go to the public institutions. . . . In New York, there are hundreds of galleries, dozens of museums. . . . But these things aren't here. . . . So, for an artist to go there, an artist gets a thousand times more mental stimulation. . . . Plus, you have a huge proliferation of working artists. Many are struggling, many have day jobs, many do this and that. But they are there because they want to be artists, whereas for better or worse, most of the artists here, as serious as they may be when they come out of college and this and that, become teachers who are also making art. And I think they lose the intellectual commitment to the work.

Dave has the didactic attitude of an ideologue. He describes his current show as follows:

This show has two themes. It's called Introductions. I'm introducing the work of six young artists. These were people whose work I had seen in different shows around New York in the past year. I wanted to show them, but not necessarily have a one-person show, because I wasn't sure about where the work was going or what it is. But I wanted to have some representative pieces, to get people used to seeing some things that they might not see.

[SP: These artists did not contact you?]

The artists don't contact me. That's not the way a gallery like mine or a New York gallery would get work. The second requirement for this show was that the entire show had to fit in the back of my Honda for transportation, because I did not want to pay a thousand-dollar shipping bill. . . . Shipping is my biggest expense. Twelve pieces. We sold one piece out of the show, so that's five hundred dollars income. I'm working directly with the artists. So you can see what fifteen hundred dollars for shipping would do. We may luck out and sell another piece, but I didn't anticipate major sales out of this show. It's a show that's being done for other reasons. . . . It's being done to introduce the work. It's very hard to sell the work of a young artist that doesn't have a lot of catalogs, a big bio, doesn't have any fashionable museum shows. And the audience here wouldn't know a fashionable museum show from an unfashionable one, for the most part, unless I stood there and screamed about it.

Dave's sincere enthusiasm and dedication to bringing hot new art from New York to St. Louis does not help him market it. A local artist whose work he represented for a short time commented,

> [Dave] just isn't very aggressive in terms of selling anything, and he didn't call those people or do the whole thing. I expected certain kinds of things to be done that weren't being done. He thinks that he really represented me as well as he could, and he probably did. So there were also good things he talked about in relationship to New York, and New York didn't happen either. So you know, we got to this point where I said, "I can't do this anymore. I just can't." Sort of like waiting all the time, and waiting. So it was kind of disillusioning again, and so I just dropped out. (Int. 25)

Dave is serious, committed, and self-sacrificing in his pursuit of the latest art trends from New York. He suffers from the "cultural cringe" more than many other St. Louis art lovers since he has written off any possibility of significance for practically all local art but has not developed the capital and personal resources to make an impact in New York. His self-chosen role as a culture broker leads to constant frustration when local people do not support his taste. But he has been successful in developing a small group of followers who depend on him for advice, and he has been active in curating shows for various local exhibition spaces and in managing the career of an artist protégé. His independent lifestyle and fanatical devotion to art makes him more like an artist than any other dealer.

Dealers' Responsibility to Collectors

Many serious collectors expect dealers to inform them of important market trends and to preselect the best work for them. One collector who boasted of the fact that his collections were nationally known explained his opinion about dealers.

> I feel that without the dealer I would not be able to collect in the way that I enjoy collecting, that is, the best pieces from the best artists around. . . . It permits me to see the field and make a selection.

This collector was quite supportive of dealers.

> In order for dealers to exist they have to make money. . . . I share with the dealer what the dealer makes. . . . We become rather intimate, and I know that it's 30 percent, or 40 percent, or whatever

it is. . . . And I get [a discount of] 10 percent usually from that, which is fine. (Int. 86)

Another collector who had a well-known collection of major national artists explained his reliance on dealers to safeguard his economic interest in art purchases.

> So you're really interested in not throwing your money away strictly on your visceral reaction. You go to dealers that you trust and that you know are the right dealers, and then anything you viscerally go crazy for, you can plunge in and afford to go. . . . If you get a dealer you like and you trust and they have good access to the museums, you can have lots of fun, because you don't make mistakes. (Int. 44)

The strategy of not making the mistake of spending too much money on art that the collector loves but that has no investment quality constrains St. Louis dealers' ability to sell art to the most serious buyers. There is a glass ceiling of about five to ten thousand dollars (depending on the buyer, artist, and specific piece) beyond which serious collectors hesitate to spend for local art. The average collector has much lower limits. A dealer described the price limits for painting sales.

> I think fifteen hundred is the average . . . because in this city after about, after eighteen hundred, at twenty-two hundred, people start to cringe. At eighteen hundred they're still OK. But at twenty-two, twenty-five, then it's like, "We're making a serious investment here." . . . But fifteen hundred, eighteen hundred is a good price. You can sell that. (Int. 21)

This means that St. Louis dealers cannot compete with New York galleries for the big-dollar sales. The best dealers can do is try to gradually raise the prices of their artists' work by placing the work in important local collections and in the art museum.

Galleries and the Art Museum

Dealers and collectors understand the importance of museums in certifying the value of artwork. A successful dealer described his strategies for helping artists, in response to my question about how he builds artists' careers.

> Well, it's a matter of trying to get things into museum collections. We've been successful recently in getting three [pieces by artist

X] into the St. Louis Art Museum. We invited the curators here, and we pitched them, and we also managed to get two of the three works donated.

[SP: Did the museum people come and say, "We want to buy the work"?]

They first expressed interest in the work and said they were willing to buy one. Then we said, "If you would like to have more than one, we might be able to find donors for you." [The gallery arranged for friends and relatives of the artist to buy two more pieces and donate them to the museum.] . . . In each of those cases we retained our portion of the sales commission. We made three thousand dollars.

[SP: Tell me some examples when you failed.]

We try all the time. We try with every artist, and every one that they don't buy is a failed attempt. Our job is to call the museum about every artist and say, "Come over here, the stuff is fabulous." And occasionally they come, but normally they don't. (Int. 10)

What Dealers Want from Artists

Dealers expect their artists to understand that the success of the gallery as a business is in the artists' interest. On the simplest level they expect the artists to reliably provide the work to be sold. Stories of artists finishing the paintings the evening before a show are common. One dealer told a typical story, beginning with seeking a slide of the artist's work for the announcement two months before the show.

So they kept bringing me back the transparencies . . . and none of them were going to work. And I finally turned to . . . the photographer, and I said, "Why don't we take something else, this is just not working." And he goes, "There is nothing else in there" [the artist's studio]." I'm going, "What?" He says, "No, there is nothing else in there, everything else is either half-way done or not done." . . . As we get closer to the time, everybody is joking with me . . . about the work, saying, "Are you going to bring a blow-dryer [i.e., to dry the wet paintings], for the day that he drops them off?" He [the artist] called . . . and I said, "Where are you?" And he says, "Well, I'm at so-and-so's house." And I said, "Why aren't you in your studio? How much is done? What's going on?" . . .

I don't want it to be nasty . . . but I'm on a time schedule here, and I'm not going to hurt that and end up with the invitations in somebody's mailbox two days before the event. (Int. 14)

Dealers expect artists to support the gallery's financial success, to understand that money coming into the gallery must be used to maintain the gallery's existence. This means artists should help out by generating their own publicity and interest in their work, attracting a network of buyers on their own, and by always giving the gallery its commission on sales made outside the gallery. Galleries want artists to understand that the gallery sometimes needs to use the artist's money to maintain the business. This last point is important and will be discussed below in the section on business practices.

Some artists are natural marketers, able to generate media attention and attract the social interest of wealthy buyers, but most cannot fill this role. They expect the dealer to do the marketing and leave them with no responsibility other than to create art. These different expectations mean that the relationship between artists and dealers can be tense. Just as in intimate human relationships, commitment—trust that your partner will look out for your best interests—is hard to find and maintain. Artists commonly search for better dealers, and dealers are always eager to find better artists.[5] So long as the art market was booming and sales were brisk, each side had choices. The decline of the market since 1990 has put more pressure on the relationship, as dealers see their sales wither. The few artists and dealers who are lucky enough to have a good long-term relationship value each other even more for knowing how rare it is.

The Average Dealer: Ann, a Frame-Shop Gallery Owner (Int. 114)

Ann's gallery is more like the average business-oriented art gallery found all over the United States than the more avant-garde places already described. Ann's gallery moved in 1993 from the lower-middle-class residential neighborhood in University City to a less expensive, more industrial neighborhood across the St. Louis city line. The daughter of a St. Louis policeman, she worked as a graphic artist for a printshop after graduating from high school. After a few years she took a job as a saleswoman in a suburban Clayton gallery, part of the Circle Gallery chain. This was one of the few national chains offering inexpensive art in a slick, mass-merchandising environment. At the height of the 1980s art boom, Circle had forty galleries nationwide.[6] They sold low-cost art and stressed selling over connoisseurship. Another former Circle salesman described the difference.

> Leo Castelli is from the old world, and his idea is that "I'm going to help you acquire art; no, I'm not selling you art." . . . Circle is

concerned about sales, and whatever it takes to sell the art, that's what happens. (Int. 14)

After a few successful years of selling, Ann opened her own frame shop in the late 1970s. By the early 1980s she had a small gallery selling decorative work, mainly original paintings and prints. She enjoyed the rising art market, using the framing work as a base. About half of the art she sold came from national distributors, and half from local artists (including some paintings selling for fifteen thousand dollars). By 1993 she rented four thousand square feet in a commercial neighborhood in University City for over twenty-five hundred dollars a month, but by then faced the low sales of the times. She was about to move the gallery, saying, "All I do is work to pay my rent." She has cut down on shows, since the sales did not justify the expenses. She described the state of her business.

> I have to regroup. I can't afford to advertise. People I've known for years call to ask if they are on my mailing list, but it's too expensive [to have openings and shows]. No one was spending any money.

Ann owns about half the work in the gallery. The business employs one full-time and one part-time framer and survives by doing framing for universities and hospitals. To help meet costs she rents part of the gallery space to a psychologist who deals part-time in Inuit art, for love. Other dealers of decorative art will rent out part of the gallery to artists who can't get "real" dealer representation, charging anywhere from $350 to $500 for a month's use of the space and services.

The Average Buyer: "Swatch People"

Several dealers categorized their buyers as either serious, meaning that they collected art with an aesthetic strategy and an appreciation of art-historical issues, or as decorators, meaning that they needed something to decorate their room, to go with their new couch or carpet. These latter were contemptuously described as "swatch people"; they arrived at the gallery with a sample swatch of upholstery material to make sure the colors matched. All dealers complained that serious collectors were too rare. For example, a successful high-end dealer in local art characterized his clientele.

> There is a constantly renewing source of new people . . . primarily people who are decorating their homes and looking for something pretty over the couch. That's what our business mostly is,

people who come in with swatches. They are not collectors; there are relatively few collectors in St. Louis.[7]

This dealer was clear about his need to cater to local taste, which he did not think much of, and his parallel but contradictory need to deal in less decorative work to maintain his gallery's status in the art world. In response to a question about the difficulty of selling avant-garde art, he replied,

> Absolutely, almost impossible. But we keep trying. You have to do that, because that's what provides the legitimacy for the gallery, in terms of its serious position in the contemporary art world. . . . So my job is to walk a tightrope between that which is decorative and that which is challenging, figuring that the decorative stuff will carry the challenging stuff. And that's what I've been good at. (Int. 10)

Galleries as Business: The Importance of Wealth

The difficulties of succeeding in the gallery business should be clear by now. faced with the personal desire and social need to show avant-garde, hard-to-sell art to a population that wants merely to decorate, at worst, and will not spend more than a few thousand dollars for local art, at best, how can dealers survive? The answer in the postboom 1990s is, for the most part, by not expecting to earn an income from the gallery's sales. This does not mean that the galleries are run as a hobby. Successful selling is important in our capitalist culture, which values financial success so highly. No matter how wealthy one is, it is depressing to run a gallery with no sales, and dealers certainly try to generate a profit. For example, the typical business arrangement between artists and dealers stipulates exclusivity. The dealer has sole rights to the sale of that artist's work within a defined area (the city, the region, or sometimes the nation). The dealer expects a full commission on all sales and usually insists that all sales go through the gallery. But even with these monopolistic practices, the higher-end dealers tend to have incomes secured apart from their gallery, so that their lifestyle is not dependent upon gallery sales.

The owners of four of the eight highest-ranked galleries do not need income from art sales to support themselves. The two top Central West End galleries belong to men with other business income who also own their gallery buildings. Both owners are intensely involved with their gallery, and each has significant payroll and other business expenses. Neither subsidizes the gallery out of private funds (in fact the most prestigious

gallery began laying off staff at the end of the project year in response to the downturn in the market). Costs can be significant. for example, one large gallery's electric bill was $1,200 a month during the summer, primarily for air conditioning. But costs are still a fraction of those in New York. A St. Louis artist told of his interview with a New York dealer. She told him she liked his work, but it was not for her gallery, for having good work was not enough. Her overhead was $30,000 to $50,000 per month. The gallery would have to sell $100,000 of the artist's work in a one-person show to recoup costs.

Some dealers solve the cash flow problem by limiting expenses. One example is Dave, described above. His gallery is in a loft building in the midtown area occupied by artists' studios and other gallery spaces. The rent is under $200 a month for one thousand square feet, and the gallery's other expenses consist of utilities and a $1,500 per year insurance policy. He lives in a tiny area behind the exhibition room, whose white walls encompass most of the space.

Another minimal-cost gallery is an "alternative space" located in a storefront in the midtown art area. Run by an idealistic group of people in their twenties, all with other sources of income, the gallery charges exhibitors about $50 for the privilege of showing their work in group shows. It is not a simple vanity gallery, renting its space to artists who cannot find dealer representation,[8] but a counterculture group who wants to show art ignored by the "establishment." Most of the artists showing here have not gone to professional art schools, and the gallery's openings are jammed with enthusiastic young people who rarely show up at the other openings.

The high-art end of the dealer spectrum is thus either rich and free of the economic need to earn an income, or living poor. This does not mean that they disdain sales; they want to avoid the demoralization that a dead business produces, and to cut costs where it doesn't affect their lifestyles, primarily by hiring young staff at minimal wages. The nonelite majority of dealers must earn an income and does so by selling more decorative, lower-quality art, for the most part at more affordable prices.

Commissions

Galleries rarely own the original artwork they sell but take work from artists on consignment. The current standard dealer commission in the art market is 50 percent; that is, proceeds from the retail sale are split evenly between artist and dealer.[9] Thus the capital requirements to set up an art dealership do not include the cost of the stock. In fact the only finan-

cial obligation the gallery has toward the artist is to pay transportation one way, usually from the gallery to another location (the artist typically transports the work to the gallery), the costs of printing and mailing announcements, and openings. In many cases dealers insist that artists share in these costs (recall the vignette of Lisa in chapter 4).[10]

The few cases where the galleries own the work are instructive. The largest, most elite St. Louis gallery has been in business since the early 1970s. It established relations with top New York dealers such as Leo Castelli and Ivan Karp and has been part of the spectacular rise in the art market for twenty years through its access to investment-quality art drawn from cooperating New York galleries. The original founder moved to New York and has operated a successful, elite gallery there for many years. This is the only St. Louis gallery to attend international art fairs, and it sells a majority of its works out of town.

In this sort of business the St. Louis gallery buys the work on a discount, perhaps as little as 10 percent or 15 percent or as much as 40 percent—each transaction is unique and secret—from the New York gallery. The demand for blue-chip artwork is such that buyers compete for it, and the St. Louis dealer's successful history of relationships with elite New York dealers gives him assured access to investment-quality art. By buying the work outright, either independently or in combination with ad hoc associations of investors, the gallery has been able to use its capital resources and personal contacts to take advantage of the rising market. The owner has also built a superb personal collection.[11] In the case of the most upper-class St. Louis gallery, the background of wealth, social networks of buyers, and seasoned relationships of trust with New York suppliers have been essential ingredients for the gallery's success.

Another gallery selling a mixture of original works by local artists and prints by nationally known artists owns the prints but sells the other work on commission. The owner is clear that he will invest his capital only in investment-quality, that is, auctionable, work. The majority of the work represented in this gallery is local, without secure resale value, and costs the gallery nothing. Dealers do not risk their capital by purchasing local work since the work lacks a defined resale market.

Trust in Business: Gallery versus Studio Sales

The potential for abuse in the gallery's exclusivity contract with artists is clear, since some bargain-seeking collectors feel they can buy directly from the artist and save half their costs. Most collectors value direct

contact with artists and want to feel that they are using their money to "support the arts." If they buy directly from the artists, they can magnanimously give the artist a bit more cash and still save over a gallery sale.

Obviously, most dealers feel strongly about this issue. One dealer spoke quite heatedly about trust.

> We require an exclusive for the area that we cover, the entire Midwest with the exception of where they [the artists] have existing dealer relationships. I run a pretty tough organization with respect to that. If an artist takes advantage of me, they are out of here . . . where an artist will try to do an end run and do a direct sale with a client or try to cut us out.
>
> [SP: So you will insist on getting your full 50 percent even . . . if the person who comes in is a next-door neighbor of the artist?]
>
> I don't believe that it matters whether it is or not. You either have a professional relationship and you honor it both ways or you don't have one. . . . It's a business arrangement from that standpoint. It doesn't matter to me if it's a next-door neighbor or who it is. If they are discounting work or selling out of their studios, they are not meeting their obligations, and any artist should do that with any dealer. I'm very, very straight on that. I don't make exceptions on that. . . . It simply is a function of whether you have the trust and the relationship, that you are there for the long term. Normally what happens is that when you try to get a quick sale, it is a short-term game. And if it's a short-term game that outweighs the long-term orientation, then that's a decision that they [the artists] have to make. They have to understand that if they make that decision, we're through. (Int. 118)

If a buyer offers to purchase a piece directly out of the artist's studio, the artist is faced with a moral and economic choice, to charge the full retail price and give the gallery its commission, even though the gallery has not done the selling, or to realize more money without a commission. The latter choice defines the gallery's responsibility as the short-run job of selling individual pieces and ignores its role in long-run career-building and legitimization of high prices. If artists cut the gallery out, do they give the buyer a discount? The typical gallery discount for regular customers is 10 percent, either taken from the gallery's commission or shared equally between artist and dealer. Any studio sale discount over 10 percent but less than 50 percent gives the buyer a bargain and still gives the artist more than he or she would earn through a gallery sale. But artists face the risk

that price cuts made in private may become public. Dealers are concerned not just that such sales decrease the gallery's income but also that they devalue the work and can undercut the artist's entire price structure.

Artists faced with the temptation of studio sales worry about their long-term relationship with the dealer. If little work is sold through the gallery, the artist may be dropped and lose the legitimacy that comes from gallery representation. This argues in favor of placing all sales through the gallery. If the sale is to a buyer who has had no contact with the gallery but who has been cultivated solely by the artist, the countervailing argument is that the gallery does not deserve its commission since it has not done any work.

The flavor of the decision making is exemplified by one successful local artist, describing her negotiation with her dealer over a commission on a sale that happened outside the gallery (this artist's income is assured by her full-professor's salary).

> I said, "You didn't get this [sale] for me." I said, "I got this, and besides, I got it before you were even in my life." And he said, "Yes, but . . . you know, you wouldn't be who you are if you didn't have [me as your] dealer." And I said, "Well, of course."
>
> And I always give him half of anything that I sell here in town. I've been very clean about this. But this bothered me a little bit. . . . I said, "Look, you're my hobby. Making the art is my job. Selling it is really a hobby." And I said, "You're a very expensive hobby. . . ." On the other hand, it works out very well. He's been real good for me. . . . Since January I've made twenty thousand dollars. . . . I'm doing fine.
>
> . . . What he did was, he gave up half of his half. So he took 25 percent . . . of the sale price. . . . So I wrote him a check for $500, and now he's happy. I don't think he's happy. He wanted more than that. (Int. 34)

Trust and honesty are central in this dilemma, and there is no simple solution to these problems of moral economics. The St. Louis art world is pretty small, and secrets are almost impossible to keep. Gossip one year had it that an artist was courting a local dealer for admission to his gallery and invited him to her home for dinner. He was astonished to see a work by another artist he represented, which had been exhibited recently in his gallery, had not sold, and had been returned to the artist. The hostess had bought it directly from the artist, and neither had reported the sale to the dealer. The artist-hostess was not admitted to the gallery, and the other artist was ejected.

Can the artist who cuts the gallery out of a studio sale trust the buyer not to tell the dealer? If not, the artist may lose the gallery representation. Can the artist who cuts a gallery into a studio sale trust the dealer to further the artist's career? If not, the artist is paying the dealer for nothing. Can the dealer trust the artist to give over the gallery's share of every sale? If not, the gallery is spending its resources to enhance the artist's status and the artwork's value, but getting nothing in return. Can the dealer trust the buyer not to approach the artist directly and cut the gallery out? If not, the dealer is working for nothing to enhance the buyer's collection and the artist's career.

The average buyer has the least to lose by these trust issues, since the buyer is concerned with specific, ad hoc transactions, while the artist and dealer are bound together in a long-term relationship. Serious collectors, who are involved in long-term relationships, face similar trust issues (discussed below and in chapter 6).

Openings

Galleries generate enthusiasm for the art they sell through openings, occasions in which the gallery hosts a reception for the artist, usually offering cheap wine in plastic cups, and more rarely snack food, to celebrate the start of an exhibition of the artwork. Ideally, the artist is present along with the gallery's regular customers, stable of artists, friends and relatives of the artists, and rich, eager, new customers. Crowds of well-heeled buyers should fill the gallery, making a lively party atmosphere. If the gallery is successfully crowded, it is practically impossible to see the artwork (fig. 12), but openings are occasions to manage social and business relations. Openings often bring people in to see the show who may not ever make the trip to see the work during the month it is displayed.

The point of the opening is to generate excitement about the artwork. Aggressive galleries will have already shown the work to potential buyers on their customer lists, advising them to buy before the opening to acquire the best pieces. Most galleries put a small red dot next to the piece's title to indicate that it is sold (more rarely galleries use a green dot or half-dot to indicate a "hold" placed on a piece). There is no greater success than to sell the work out in an opening. Galleries and artists hope that the sight of red dots proliferating will stimulate a buying frenzy, a not uncommon circumstance during the 1980s boom.

At a successful opening the featured artist spends the evening in the center of excited attention, with faithful collectors, friends, and admirers crowding around to praise the work. Few professions aside from the per-

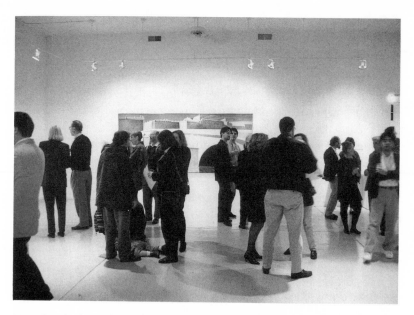

FIG. 12. A high-art gallery opening with a moderate crowd.

forming arts have such public displays of a person's creative output. The artist's work is on the walls, open to public evaluation, vulnerable to derision, praise, or indifference. Every comment heard in the tumult is examined for significance. Did the fellow artist's offhand "Nice show!" mean that he really despised the work? Did the fabulously wealthy buyer with the world-class collection mean it when she said that the work "Looked really strong"? Why did the newspaper critic leave so soon? Won't he review the show? Gallery salespeople usher buyers from the exhibit area to the back room, where prices and conditions of payment are discussed. The crowd density should be impressive, the roar of conversation deafening, and the evening should end with artists and gallery staff exhausted, overjoyed at the rash of little red dots on the gallery walls.

In reality, even when openings are teeming with people, they often come from the social networks of the artist and gallery and are not eager buyers. People are happy to drink the gallery's wine but don't necessarily buy art. When the work does not sell, galleries resent the cost and work of openings, feeling that they are merely parties for the artists' friends.

In hopes of stimulating attention, galleries in the same neighborhood often synchronize openings to bring out larger crowds. In St. Louis the midtown arts area and the Central West End hold coordinated openings,

usually on Friday evenings during the gallery season, which begins in the fall and ends in the summer. When this works, the crowd forms a moving party, flowing from show to show. The strength of an artist's or dealer's sociability or standing in the art world becomes painfully obvious when one goes from a densely packed lively gallery to a funereal opening where anxious staff and artists outnumber visitors.

The Sale Transaction

Galleries have relatively few walk-in sales, where an unknown customer enters, chooses a piece of art, and buys it on the spot. In a business where the average sale price approaches two thousand dollars and often reaches five thousand dollars or more, many transactions stretch over weeks or sometimes months. Customers are often allowed to take a piece home "on approval" to live with for a few days, to see if it continues to intrigue them, or to see how it fits into the space intended for it. Customers may hesitate over a purchase for months or years—fascinated by an artist's work, but unable to make a choice or perhaps to come to an agreement with a spouse about a specific piece.

Buyers' insecurity about their aesthetic judgment can distort the transaction with anxiety and risk. One way the gallery allays this anxiety is to have a scrapbook with reviews of artists' prior work, feature stories about them, lists of prior shows and of collections owning the work, and any other information that can make a potential buyer feel that knowledgeable people value the artist's work.

Economic anthropology has learned a good deal about how people deal with risky transactions. The general solution to the problem is to establish a personalized relation with the vendor, in effect embedding a particular transaction within an enduring and generalized relationship (cf. Plattner 1989, chap. 8). The more social ties an economic transaction is embedded in, the less the risk of being cheated. Thus gallery owners hire salespeople who have grown up in the same social class as buyers, ideally in the identical community. A young gallery director described how she cultivated a customer she had known since childhood.

> I had this client of mine. . . . This young boy at the time was twenty-nine, and he was to inherit a portion of his trust on his thirtieth birthday. . . . And it was more money than God . . . [The client] called me up, said "Hey, I know you're down at [gallery X]. My wife is always talking about this artist. . . . I want to make a little investment for her. . . . Let's start working on that."

> Now I grew up with this young boy, and so he was very open with me. He said, "But . . . it's going to be about five or six months before I . . . inherit my trust, so can we put the purchase off for six months?" I said, "Hey, you will be a great client of mine; you are willing to spend lots of money. . . . I will bend over backwards for you."

She describes how she encouraged her client's interest in the artist.

> We took [the artist] out to dinner, my husband and I, you know, my friend and his wife, [the artist] and his wife, we all went out to dinner. . . . And so I established this really good friendship between this client and this artist.

The first sale was for thirty thousand dollars.

> That's a nice sale, you know. It's fifteen thousand dollars for [the gallery]. . . . And this wasn't the end. . . . My client said, "This is my wife's anniversary present, and we still have to conquer Christmas, and we're going to buy a new house." And so, I was like, "Fine, you pay me when it's comfortable, I understand. . . . When your interest checks come in, you know, fine." . . . I was willing to work with him 100 percent, because you don't look at a person like that and start to nickel and dime him.

She pressed him to borrow work from the gallery to see if he was interested in it.

> "Hey, you want this? Take it home, take it home, throw it on your wall, give me a call in about a week and tell me what you think." And he loved it! . . . He goes, "You don't want any kind of security deposit?" I was like, "I know where you live. I know your mother. Just take it." (Int. 21)

When the dealer is from the same community as the buyer, all the subtle interpersonal cues necessary to minimize risk are already in place. In the case just cited, the gallery could afford to deliver thousands of dollars worth of art without security, since the director had known the buyer and his family for years. Similarly, the buyer could feel comfortable agreeing to spend thousands of dollars on work with no resale value because he trusted the dealer—they had grown up together.

When St. Louis collectors go to another city, they often feel that they suffer because they are not in the right networks. A collector of photographs told of being quoted a price of fifteen hundred dollars for a portfo-

lio by staff in a New York gallery. The collector did not buy it then, but after returning to St. Louis she decided to place her order. She spoke this time with the dealer, who refused to honor the quoted price. The price was now four thousand dollars, since only a last set was available. The collector feared she was being exploited because she was a midwesterner. But being a connoisseur, she knew the artist. She called the artist to check on current prices, and perhaps to buy direct, but was told, "Yes, that's how it's done. The gallery handles that. The show was more successful than she had expected." This expert buyer was able to ascertain that the price rise was a correction in response to demand. Her misfortune was not to have had a relationship with the dealer that would have caused the staff's price quote to be honored (int. 74).

Apart from social connections, selling art is retailing. The salesperson must contact potential customers to get them interested in buying, as several gallery staffers stressed.

> Let's say a new work [is exhibited]. . . . Then I would get my lists out, and I would . . . call everybody I could possibly think of . . . and try to get them in, and play this numbers game, meaning that, if I was particularly good at making phone calls, I could probably make twenty phone calls and get two or three people to come in. . . . And when those people come in, then I need to sell them. . . . It's all a sales game, it's like going into a car place. (Gallery director; int. 14)

> I had a client who had just built a very modern home in west county—completely empty home. . . . I knew a friend of a friend of a friend of hers. And so I contacted her and introduced myself, said, "I'd love to come out to your house, and I know you're interested in modern art. . . . Can I come out, and maybe we can start working on getting your house pulled together?" She said, "God, you're exactly what I want. I want someone who will just take care of me. I know nothing about art, and I have this much money to spend." (Gallery director; int. 21)

Sellers and buyers who live in the same social network build up relationships that can reduce a naive buyer's anxiety about buying contemporary art. Since they have friends and relatives in common with whom they expect to interact over the long run, any propensity to treat the other poorly is (hopefully) controlled. Thus, in principle, sellers should not cheat buyers, and buyers should pay their bills quickly. In practice, of course, things don't always go so smoothly. The dealer's problems are to

cover the costs and make a profit. The elite, culture-building nature of art as a product notwithstanding, the profits must come from sales of things people don't "really" need.

Gallery-Artist Business Problems: From Float to Fraud

A dealer explained the hard facts of business.

> It's no secret that there is a float involved in the operation of the gallery, as there is in the operation of any business. You try to maximize your period of holding your capital before paying your vendors. Frequently it's necessary in order to smooth out what is a very rough and unequal monthly sales pattern. Some months we do very little business. Summer months are miserable. But the lights and air conditioning . . . goes on, and the mortgage bill goes on, and the tax bill goes on, and the employees have to be paid, et cetera, et cetera, et cetera, so what do you do?
>
> Well, you try to pay your vendors slowly and spread it out. . . . An artist expects that, if you get twelve hundred dollars for a sale on Tuesday, that they should get six hundred dollars on Thursday. And they wonder why they're not. . . . That's not the reality of the business world. But they don't understand that. And in fact they would consider it an infraction of their contract with me if I were to admit to them that there's a float, just like the banks used to have a float on their checks. (Int. 10)

From the artist's point of view a gallery's withholding of payments is immoral, if not illegal. Most artists tell stories of delayed payments. The following story is typical in the artist's meek reaction, but most do not have to threaten legal action to get paid.

> I was in a gallery in Chicago. . . . They had a number of pieces and sold one and then didn't pay me for quite a long time. . . . And after about a year I started calling for payment. . . . I called the lawyers, the St. Louis Lawyers for the Arts,[12] and they said, "Threaten them with the fact that you are going to take your claim to the Chicago art association of dealers." The final straw was when they hung up on me when I said, "Look, I want to talk to someone about payment on this painting." . . . I do remember them hanging up on me, and I thought, "That's it, you don't hang up on somebody that you're doing business with." So then my husband called and threatened to take this scene to the art dealers association. They got nervous, paid me, and sent my work to where I requested it to be sent.

This artist then pointed out the moral asymmetry of the float, and the underlying assumption that artists' incomes are superfluous.

> When people don't pay you, it blows my mind, because if I don't pay my framer sixty dollars, he calls me up and I have to pay. But when somebody owes me thousands and it's like, you call them to pay, and they're mad at you. . . . I don't get it. . . . They somehow believe that it's not really money to you. You'll just create another one, and it doesn't really matter. (Int. 105)

The dealer's justification usually seems to be that the artist could not need the money at the time of the sale, since the sale could not have been predicted. A gallery employee reported hearing the owner argue with an artist who came to collect his share of a large sale. The dealer said,

> This ten thousand bucks, it's really going to benefit you and I in the long run [by staying in the gallery's account]. You can wait a few months. . . . *You didn't have it, so what's the big deal? You shouldn't have already programmed to have it.* (Int. 21; emphasis added)

The dealer's logic was that the artist's income from sales was sporadic, and therefore could not have been budgeted, and need not have been delivered quickly. This justification prolongs the float, which has the effect of increasing the irregularity of the artist's income. The injustice is a reflection of the power differential between artists and dealers, which allows the dealer's need for the cash to maintain the gallery to override the artist's need for the cash to maintain subsistence.

The ultimate float, of course, is never to pay the artist at all. Several artists reported this fraud. A photographer told this story.

> A woman who was an independent dealer in France . . . called my home and said that she was representing several California photographers in France, and she told me her connections there and who she was selling to. I knew who the other photographers were. There were a few people that I knew and respected, and I checked up on her, through them at least, and they said, well yeah, she had sold one portfolio of one of the people that I talked to, and she seemed to be doing all right and showing their work . . . out of her home. So I said sure, and we wrote up an agreement, and she took the portfolio. . . . It was a published set [of nineteen photographs], a portfolio, a limited edition that I had done.

> There may have been one or two letters back and forth. After six months, she told me she had sold one, had sold this portfolio, and she wanted me to send another one. And I said, "Well, you send me the check," and I just never heard back from her after that at all. I never got the money, and I never heard from her again. . . . And I tried writing and calling, and she moved or changed address. . . . It was probably five thousand dollars. (Int. 73)

The artist who had trouble in Chicago reported other problems with dealers.

> I just had a show in 1990 in California that was—really, the gallery operation was perhaps three times bigger than [X, a St. Louis gallery in a huge space], and the location was Laguna Beach. The woman came on like gangbusters. . . . I went out to California to get some representation. Everybody who looks at my work says, "You should be in Southern California." So finally I got out there. . . . I just would interview galleries. I would walk in and say, "Are you representing new artists?" And they would say no, and I would show them my work and they would say, "Come on." I had great response out there. I finally picked the best one that I could size up, and she gave me a show real quickly. But what happened was that was right as the war started, the Gulf War, and their economy screeched to a halt. So she proceeded to sell out the show, and since then I haven't seen money or paintings.
>
> [SP: As far as you know, she sold all your work?]
>
> Yes. . . . She had sold fifteen, but she has perhaps another eighteen in her possession and that I can't get back. . . . She's also gone out of business and gone bankrupt and has three judgments against her. I have a bill collector trying to work out the differences. . . . I just can't absorb those losses. . . . It's a year's worth of work. Monetarily it's twenty thousand dollars to me. . . . And that's not with the paintings that I won't get back. That's just what sold. (Int. 105)

The best-known gallery scandal in St. Louis involved one that was in business from 1979 to 1986. When it closed, it owed perhaps a hundred thousand dollars to several local artists. It was run by a young man who "inherited" the gallery and its stable of artists from a wealthy woman who had run it for five years. She had opened it in 1975 in a vast, high-ceiling, white-walled, SoHo-style space to showcase St. Louis artists. By 1979 she had grown tired of the responsibility and gave the gallery to the young man who had managed it and had done most of the work.[13] He ran it for

seven years and was successful in creating excitement about local artists in a crowd of relatively young buyers. He had upscale, catered champagne openings and formal-dress New Year's Eve parties to attract a moneyed crowd and succeeded in raising prices for local art. Years later he recalled his strategy.

> It was easier to sell a five-thousand-dollar painting than a five-hundred-dollar painting. I don't think you can slap a five-thousand-dollar price tag on anything, but when the prices approach that level, the collectors take the work much more seriously. The problem with artists, dealers, and buyers was that the work was not taken seriously enough. (Int. 91)

A consultant who had worked with him described his impact on the local art world.

> Every year [he] would raise everyone's prices 20 percent, whether they had sold anything or not, so that by the time people like [artists X, Y, and Z] left the gallery, they were getting good money for what they were doing. As many problems as [he] has had over the years, I would have to say that he had a real feel for what should happen. (Int. 53)

But he did not have the background of personal wealth or social contacts to maintain the gallery. One local artist who was owed over twenty thousand dollars described what happened.

> I would go to a party, and there would be one of my paintings. . . . They [the collectors] would say, "We love your painting," and he [the dealer] would have sold it to them and not even told me about it.
>
> So I called him on it by walking up to him and saying, "Look, I've got a family, you can't do this." And with [the dealer] it was always, like, "This is business, and the gallery comes first." I said, "No, the gallery does not come first. The gallery runs from the 50 percent, and if you can't run it on that, then you'll have to cut back on the number of suits that you buy and the champagne and the women and everything that is making this look like such a class act when it's really not." So it got kind of rough sometimes, where I would go in there and almost physically threaten him to pay me. (Int. 85)

This kind of violent confrontation is rare, but the potential for conflict is always present in the dealer-artist relationship. Dealers want to earn

enough to cover their costs over the long run, no matter how wealthy they are or how long they are willing to subsidize the gallery out of their personal funds. The pressure to cover operating costs always exists. The vast majority of artists have no expectation of earning any meaningful income from their artwork, although they are hopeful and often living on minimal funds. As we have seen, the regularity of the gallery's need to cover its costs, and the irregularity of the artist's sales income, is a key element in the tension. The demographic reality of many artists and few dealers keeps the scales tipped in the dealers' favor.[14] They often rationalize their business practices by pointing to the nonselling artists whose work they are presenting to the public, thus using the successful artists' funds to cover costs for the unsuccessful artists.

Other Types of Dealers

The discussion so far has focused on the relatively few high-end dealers with retail spaces selling original works. The print business is special because it deals with multiples that have relatively established values in the national market.

Prints: "You Send Me the Money and I Send You the Art"

Sitting in his elegant residential condominium loft in a converted automobile factory, with sixty feet of clear, high-ceiling wall-space covered with contemporary art, a private dealer-collector was reminiscing about how he got into the print business as a naive young man.

> I remember writing this . . . dumb, goofy sounding letter . . . to Brooke Alexander [an established New York dealer] and [saying,] well, I'm this guy in St. Louis, and I'm an art dealer, and . . . how does all this all work, and what do I do, and what if I wanted to get these prints [for resale]? I got this letter back from Brooke, and it said, "You send me the money and I send you the art." I said, "OK, all right, I got it." (Int. 22)

Print dealers can afford to just "send the money" since they are dealing in commodities that, as multiples, have the potential for an established market value.[15] So long as the publisher has a stock of the prints remaining, the publisher's price sets the ceiling, since any collector can buy a copy direct from the source. As the edition sells out, the price rises, depending on the demand, the publisher's need for cash, and any prior agreements with the artist and other participants. The print dealer de-

scribed the process, as part of his explanation for preferring to own the prints he deals in, rather than to get them on consignment.

> Usually what happens is that as a print starts to become unavailable, the price starts to go up. In other words, if somebody publishes a thing at $2,000, that's the price that they're going to be selling them for initially. Well, by the time they're selling the last ones they're generally . . . going to be selling them for $3,000 or $3,500.
>
> Well, whatever the last prints were sold at, that is then the price that is the formal price. Say in this case it was $3,000. Well you know, I can say . . . "It's a $3,000 print." . . . On the other hand I could say, "Hey, you know they sold the last ones at $3,000, but I think it's worth more than that now." I mean, I can basically say whatever I want to say.[16] (Int. 22)

An edition of prints consists of duplicates, numbered "1/n" to "n/n" ("n" refers to the edition size) and signed by the artist,[17] as well as several prints over and above the edition number: *trial proofs,* which are copies of the image struck for the artist's approval before the edition is formally printed; a *bon à tirer* proof, which serves as the ideal image for the edition; and a flexible number of *artist's proofs* and *printer's proofs,* which are extra copies made during the production process and divided up between artist and printshop. An edition of fifty typically has eight to fifteen (and sometimes as many as twenty to thirty) proofs over and above fifty, all of which can be put on the market.[18] In a situation of contrived scarcity like the print market, where the limitation in the number of copies affects the price, the importance of expert knowledge is obvious. In the rising market of the 1970s and 1980s this sort of information was not as critical as it is when prices are falling or flat. In the contemporary market, where buyers who paid top prices in the late 1980s face prices that are a fraction of their original costs, the potential for overpayment is high. The importance of having professional information like the number of proofs that could come to market can mean the difference between a cheap and an expensive purchase.[19]

While auction prices are public, experienced dealers are cautious about jumping to conclusions about demand and value from published prices. A low price could indicate doubtful provenance, poor condition, or that the seller had a critical need for cash. A high price could mean that the particular buyer was eager, ignorant, or foolish. But given these caveats, the auction prices are valuable guides to the price of any artwork. Com-

mercial publications list print auction prices by artist and edition, and print dealers commonly publish their inventory, so the availability and price of prints by nationally recognized artists is well known. In this sense, dealers who buy prints are investing their money in a fairly safe bet. As one dealer put it,

> I generally buy prints by nationally important artists that have an actual value that I can determine. In other words, if I don't sell it here, I can send it to New York, and somebody there will pay at least what I did for it. So I can't really lose. (Int. 10)

The Print Market

For the past ten years a group of collectors and dealers in St. Louis has sponsored a print market, where they invite vendors to display works on paper for a weekend in the spring. The event has been located at the Washington University art school gallery and attracts about fifteen to twenty vendors, including rare-book and map sellers, photography dealers, and contemporary-print dealers. Half the vendors are from St. Louis, the rest mainly from the Midwest and East. In 1993 about fifteen hundred people paid the five-dollar entrance fee to browse the booths of the nineteen vendors (who paid $625 to rent a booth). The vendors do not necessarily expect to sell a lot at the fair, but look at it as a chance to expand their customer lists and advertise their wares. The fact that so many people are willing to pay to enter indicates the existence of a population interested in works on paper.

Five dealers in St. Louis specialize in contemporary prints by nationally known artists. Four of these have conventional middle-class backgrounds that give them access to capital as well as social networks of interested buyers.[20] The oldest dealer has a long history of involvement in introducing her social circle to avant-garde art but has acted usually as an adviser to her small circle of acquaintances. She has never had a commercial space, always preferring to work out of her home, and probably has never earned her primary income from this source. The younger ones are more business oriented, and like any traders, relished the memory of their big deals, when they bought cheap and sold dear. One told of buying (with a partner) a suite of Picasso prints in 1972 from a French dealer for $305,000 and selling them immediately (through a New York dealer) for $500,000.

> This was the biggest [print] deal of the decade, just two guys from St. Louis. The big deals will come in whether you want or not.

You've got to hang out; you can't go out and push. It's the day-to-day deals that are hard. (Int. 111)

This person had just opened a small retail space, but it was too soon to tell the level of his commitment. At the time he represented no local artists.[21] Another private dealer remembered his best deal: he bought a print by the well-known artist Robert Rauschenberg in 1989 with another investor for $10,500, which was three times what it had sold for before. "Inside of two months, we sold it for $25,000, but those things don't happen too often" (int. 119).

By 1992 the younger dealers were hanging on, living on their past investments and hoping for the boom times to return. They faxed their stock lists to a small set of potential customers, including other dealers, chasing after sales. The most interesting private dealer came from a working-class background yet had made himself into one of the most knowledgeable participants in the St. Louis art world.

Sam, a 47-Year-Old Private Print Dealer (Int. 22)

Sam was brought up in a working-class family in rural Missouri with no background in "high culture" at all. He taught himself about contemporary art while living in several academic communities in the United States but never graduated from college. He can't really explain why he developed a deep interest in visual art. In the 1960s he began collecting prints in a small way. The idea of being a dealer grew while he supported himself working as a medical technician. As he puts it,

I just got interested on a personal level and started to delve into it. I really can't say how it happened that I got the idea in my head to be an art dealer, you know. It just sort of somehow evolved into that idea.

In his midthirties he rented some space in a small existing gallery to show his prints. By happenstance he gradually developed a business selling prints out of town, to collectors and museums in cities in Indiana, Iowa, Kentucky, Michigan, and Ohio. Like an itinerant peddler, he would put his inventory in the trunk of his car and take marketing trips about three or four times a year. His sales were minimal, but enough to live on, sustain his interest and self-education, and build his collection.

After a couple of years he opened his own gallery on the edge of University City, then moved a few years later to a more upscale space in a nearby rehabilitated art center. But his personality kept his gallery business from flourishing, and he soon reverted to private dealing. Inexpert art shoppers

could not get past his unsophisticated appearance and style of speech to perceive his extraordinary deep knowledge of the contemporary art scene and impressive eye for quality. He refuses to compromise his high-art taste and carry decorative, salable work. Artists, other dealers, and a few serious collectors see through his surface appearance, and he has developed a small local business servicing local clients while maintaining his bread-and-butter itinerant art trade. Sam explains his business strategy.

> I put everything into inventory. Now other people do it differently. Other people don't put much money into inventory; they just want to have everything on consignment. . . . But I like to have, I like to just go ahead and get the stuff if I like it, if I feel strongly about it. You know, aesthetically, I'd just as soon go ahead and get it because things can go up in value. . . . And if you own them, that's your value. . . . If you have them on consignment, you're not any different than you were before.

Sam closed his public gallery and moved his business into his living space. At this point his lifestyle is like an artist's: he creates his own work schedule with complete independence, using his sporadic income to add to his impressive collection and maintain his business. His wife's regular employment provides health insurance and a reliable base income.

Ethnic Art

The dealers so far discussed sell art from the local area or from New York but do not distinguish the work by its connection to specific racial, ethnic, or social groups. In the 1992–93 period St. Louis had four private galleries specializing in the art of particular groups or areas: African-American, Southwest United States, Inuit (Eskimo), and Australian art.

The African-American art gallery was located in University City, the most successfully integrated neighborhood of the area, and sold fairly decorative, inexpensive art on African-American themes to a black clientele. The owners, a middle-class African-American professional couple in their early forties, began the gallery as a business venture in 1982. They represent most of the few local African-American artists and publish posters that they try to distribute nationally. For the first five years the husband kept his job as a city bureaucrat while his wife ran the gallery, but in the boom year of 1987 he quit to attend to the gallery full-time. The rising art market affected their sales also, and they opened a second location for a short time in a black middle-class neighborhood of North St. Louis in 1989 but could not sustain two locations. They sponsor openings and during

spring and summer have live music and poetry readings in their gallery. This provides a valuable service to the local African-American community, which seems to respond positively. The owners treat the gallery as a business opportunity to advance African-American culture. They are not particularly knowledgeable about the wider art world and do not collect seriously themselves, nor have they committed themselves to promoting the careers of any of their artists. They resent the cost of openings, the husband explained.

> Maybe my attitude is arrogant, but I have to stay in business. It's expensive to have shows. Seven hundred dollars or so for the mailing, another seven hundred dollars for the postage, a couple of a hundred for food, and I haven't made any money yet. The average client buys a six-hundred-dollar painting, I get three hundred dollars, so I've got to sell eight paintings just to break even. (Int. 120)

In his calculus he included his rent, which was about fourteen hundred dollars, including utilities. The gallery ran a frame shop also and seemed to be surviving about as well as any low-budget gallery.

The Southwestern art gallery sold posters, decorative art, jewelry, and pottery secured through mass-distribution channels. The Inuit gallery rented a small space from an existing commercial frame-shop gallery. It was owned by an energetic psychologist who had fallen in love with Inuit art after collecting pre-Columbian art. He began collecting and then decided to market the work. Since he worked full-time, he formed a relationship with a local gallery, paying a small amount of rent and a small commission on sales to show the work in about 120 square feet of space. His sales were minimal, but enough to maintain his interest and feed his own collection. Another "ethnic" gallery specialized in Australian art and was run out of her home by an Australian woman married to a U.S. business executive. This gallery showed work by Australian artists that was comparable to avant-garde work from any international art center, and also represented the unique work of a community of Aboriginal artists. As plucky as the owner was to dream of opening such a gallery in St. Louis (there were few other Australian art gallery in the United States at this time), the sales were minimal, and the gallery was clearly a very personal labor of love.

Consultants

During the boom period of the 1970s and 1980s some corporations used their growing profits to develop art collections. Usually based on the

interest of a senior executive in the firm, some of the collecting became so regular and organized that the firm had to turn to professionals to buy and curate their collections (Martorella 1990). A consultant remembered the beginning of the boom, in the early 1980s.

> This was something that was happening in New York and Chicago and the West Coast, where somebody like Chase-Manhattan Bank or Equitable, IBM, was just beginning in the very late seventies to start acquiring work by artists for their offices. . . . So by the early eighties that was beginning to come into play in the St. Louis area. I remember that the first big job we did was Peat Marwick [a large national accounting firm]. They bought probably twenty-five to thirty thousand dollars worth of artwork, which was unheard of, to actually make a sale that large to a company. . . .
>
> The thing that I remember the most was feeling that I was working as a free public-relations agent for artists. In other words, I would put together presentations for architectural firms or facilities people. . . . I would give presentations, and I would talk about the artists. I can remember that . . . this would be a whole new world to them, and that they didn't know this existed in their city, and that artists did this and that they were paid to do this. [They would ask,] "What does it cost? Who are they? Where do they come from?" (Int. 53)

All of the higher-level galleries in St. Louis reported that they dealt directly with local corporations. In addition there were a couple of well-known consultants who were in business to service the needs of corporate buyers. Private consultants usually worked for set fees and claimed that they were more objective because they could really represent the needs of buyers. They could search the entire national art market, going to all the galleries in an area and buying directly from artists who had no gallery representation. Often they would buy in bulk. Dealers represented their own set of artists, but consultants claimed that they could search for exactly the work that fit the buyer's taste and budget. A consultant described her sales pitch.

> You had to convince them, "Hey, you don't need to buy art directly from a gallery because they don't have your best interest at heart. They're trying to sell you the work of their artists. They're not going to offer you any bargains. They're not going to offer you anything that has a more all-encompassing view of what it is that

you are trying to do." So I found my niche was being able to give clients what they were truly looking for. (Int. 53)

One dealer described how he played both roles.

> On some projects we'll actually switch hats, and we will work strictly as a consultant on a fee basis. . . . If we are working on a consultant basis, a lot of times we will be curating pieces locally, going through dealers in a given city where they want to have some objectivity, and we'll go through and pull art from four or five dealers in a given city and present that and take care of the collection that way. (Int. 118)

Consultants can get a professional discount from dealers and can argue to corporate buyers that their services are effectively free, since the discounted price plus their fee is no greater than the retail price. One consultant described the calculations.

> So let's say the dealer says, "This is the price," but it was 20 percent less to you as a dealer [i.e., consultant]. So there is a retail price. Now what I usually do with my good clients was split my commission. I gave them a better price from me than [they would get by] going into that gallery. I would make 10 percent on the work, and they will get 10 percent less from the retail price. (Int. 53)

Like the rest of the art market, this business slumped in 1990–91. During the year of this research, there were two consultants with formal office space, both subsidized by wealthy individuals, and in addition a small number of individuals who dealt out of their homes on an ad hoc basis but were not full-time or professional consultants.

Designers

Interior designers decorate their client's walls with art in the same way that they help choose furniture. Their status in the art world, where *decorative* often means an insult, is fairly low. A dealer offered his opinion of designers: "Designers are evil, hateful people. Write that in your notes." His contempt was not for their aesthetic taste, but for their business practices.

> Designers are the type of people that, let's say, I [as a customer] hired a certain designer to help with my living room. For instance, . . . let's say that then I walk into [X] gallery, and . . . on my own, I buy some art. . . . Then, I'll call the designer, or the

designer checks in on me. Because they have this sixth sense of when something like that comes down. And they'll show up at the door. "Oh, you have new art! Where did you get it? Oh, it's fabulous, de-da-de-da." Then, all of a sudden, the [X gallery] director here gets a phone call from the designer, "Oh, isn't it wonderful! That worked out so nicely! Now you owe me 10 percent." (Int. 77)

The dealer believed that the designer had no right to the commission, because the designer was not involved in the purchase. In such a circumstance, some dealers would refuse to pay on those grounds. Designers would argue that they steered the client toward the gallery in the first place, or gave their aesthetic approval to the gallery's work, which allowed the deal to happen. The implication is that without their approval, the client will return the piece to the gallery. In such a circumstance, dealers may pay the requested commission to forestall the designer's influencing the buyer or spreading rumors that the dealer does not cooperate with designers, which could hurt their business.

The designers' claim that they deserve a share of the deal because their advice legitimized the client's purchase is analogous to the dealers' claims that they deserve a share of the artists' studio sales because the gallery connection legitimized the value of the artist's work. In both cases the claim is that the legitimization of value, and not the direct market search and choice leading to the sale, deserves financial reward.[22]

Conclusion

The tension in the art market between commerce and culture catches dealers in the middle. The producers (artists) and appreciators (collectors) of art as avant-garde cultural vision can pretend that their activities occur on a lofty aesthetic plane, pure of commerce. But they both need the dealer, the figure linking the heaven of artistic theory and taste with the hell of invoices and utility bills. The elite dealer must straddle two worlds: the work represented must be avant-garde, yet enough must sell to pay the bills. This chapter has discussed the tensions that arise from the contradictions in this position. The central role of trust between artists, dealers, and collectors has been illustrated, a result of the complex nature of art as a commodity and the relative power of artists, dealers, and collectors.

Another theme has been the claims to a share of the art deal, where the establishment of economic value is so problematic. Dealers claim a share

of an artist's studio sale of work to a customer whom the dealer may never have never seen, arguing that the artist's affiliation with their gallery legitimizes the art's standing in the market. Thus the gallery's general support of the artist is claimed as a reimbursable factor in every sale. Similarly, designers ask a share of the dealer's sale to a client, even though the designer may never have set foot in the gallery and, the dealer suspects, never have seen the artwork before the sale. The designer's aesthetic approval of the work's presence in the client's home is claimed as reimbursable. This argument can work only if the buyer, the collector, does not have the reputation of making up his or her own mind in aesthetic decisions, allowing a designer to reasonably claim to have validated the purchase. In a market where clients usually have the right to return a work to the gallery, even after payment, the implicit threat in the designer's demand for a share of the sale is often grudgingly rewarded. These sorts of payments are routinely made and are testimony to the complex nature of art sales. The subjective value of a work of art can vary with subtle changes in people's attitudes. This situation leads economic actors to claim a share of the deal on grounds that their presence in the environment of the deal, but not necessarily in the transaction itself, has positively affected the buyer's attitude.

6/ Collectors

I don't go looking in galleries in St. Louis. I generally feel that if I'm going to look, I'm going to go in New York, where I can see what really is going on.

<div align="right">Collector</div>

A young collector really doesn't know where to start. "Should I pay this? Should I buy that? Should I do this?" And I tell them what everybody else says, "Don't ever buy what you don't love, no matter how good the value." And I say, "Buy the best of whatever artist. Don't ever buy a second-rate piece of a first-rate artist."

<div align="right">Collector</div>

If I'm a collector, if I'm putting together a collection for a reason that I have in my own mind, I have an agenda that I bring to the work, and I'm not going to be swayed by what a dealer says to me about the work.

<div align="right">Collector</div>

The only way that you can make it in this business is to have patrons. . . . They buy, they are interested in development and stuff. It kind of makes it worth doing, people like that.

<div align="right">Artist</div>

Defining Collectors

If the term *collector* is limited to people whose collections have major art-historical significance, there are fewer than five among the St. Louis area's 2.4 million people. These people have the means and interest to be players in the international art world, routinely lend work to important museums across the country, and are sought after for bequests by museum curators. A local collector who claimed this status described his previous activity in buying New York school abstract-expressionist paintings.

I'm thoroughly obsessive compulsive. It doesn't interfere with my work, but it is a burden. And our collection was really a chronologically accurate, superbly eyed collection. . . . You could go through our collection and see the movements from the New York school on up to when we stopped. It was a museum-quality kind of collection.

He claimed not to mind having sold paintings for less than they sold for again soon after, since the high prices validated his eye for excellence.

> The de Kooning that we bought for practically nothing would at market . . . even with today's depressed market, I'm sure would go anywhere from three-quarters of a million to a million and a quarter.
> [SP: Does that bother you?]
> No, that doesn't bother me. That really doesn't. That pleases me because it's an affirmation of my eye. . . . We never collected for a profit. . . . It doesn't bother me for other people to do well, as long as it's not on our back. (Int. 86)

This is an art world "dream" collector, willing to spend significant amounts of money on art, understanding the dealers' need to earn a living, and supportive of artists.

Another collector, a retired industrialist who had a diverse, very personally chosen collection of paintings (including some that any major museum would desire), also described collectors as people who buy things with a well-formed plan.

> I don't even like referring to myself as a "collector." I think that's sort of precious. I bought paintings and sculpture and things like that as a way of enjoying things in life, and I never thought of myself as collecting things, like stamps.

This man, who was quite wealthy, described the level of resources of the sort of person he would call an art collector.

> If you have $200 million and the picture comes up on auction that you really want, for a half a million dollars, you buy it. It doesn't mean anything to spend that half a million dollars, if you have $200 million in the bank. (Int. 70)

While the few "world-class" collectors in St. Louis may sometimes buy work from the one local blue-chip art gallery and tend to be involved as major donors with the administration of the art museum, they consider the local art scene too provincial to merit their involvement. They are part of the international art market, even if they may specialize in American art.

At the other extreme are the hundreds of decorators, or "swatch people," mentioned in chapter 5. These buyers have no interest in developing a collection as a personal aesthetic statement and are not involved in the contemporary visual art world. Art is part of their decorating scheme,

and their connection to the local art world consists of sporadic purchases of art as part of redecoration activities.

In between these two extremes is the heart of the local art world: a relatively small population of local collectors who range from the bottom of the blue-chip scale to the top of the decorators category. At the high end are wealthy people who might once or twice have paid tens of thousands for a piece of art, but whose activities are focused on work costing generally less than five thousand dollars. They think of themselves as supporting contemporary art and may be faithful advocates of local art activities or may focus on collecting unknown, "emerging" New York artists. They may collect any art that strikes their eye, that they "fall in love" with, or they may have a strategic plan to create a collection with some art-historical coherence. Some buy art to fill their walls and then slow down their activities, while others may follow their passion as it shifts from one area of art to another, building and selling several collections in their lifetime. At the low end are people who are not moneyed, who might never have spent more than a few hundred dollars for a work of art, and who buy for decoration.[1]

How Many Collectors? The Social Nature of the Collecting Community

The definition of a *collector* focuses on involvement in the art world, not merely on art purchases in the short run. Those who are not active now but who were in the past are included, as well as those just beginning to buy art. Current involvement in the market is not the overriding criterion, because even serious art buyers find themselves with full walls and lagging energy as they grow elderly. On the other hand, someone who spends twenty thousand dollars on paintings in one year during re-decorating, but who leaves all the decisions in the hands of a decorator, is no more interested in their art than they are in their sofa or drapes. They are not collectors by any meaningful standard. A collector, then, is someone involved with the art world who buys art, either now or in the recent past.

In principle one could estimate the size of a city's market for avant-garde art by counting buyers and dollars spent over a significant period of time. This sort of information is not available. Gallery owners are secretive about their mailing lists, as well as their sales. During the 1992–93 period of this study, only one of the galleries selling high-end work seemed to be making substantial sales to local buyers, judging by the red dots and the

visible activity in the gallery. Suppose this most active gallery sold about two hundred works a year, to perhaps two hundred people. If it had about a third or a quarter of the local market, a rough guess yields about six to eight hundred buyers of avant-garde art in a year. The precise numbers are not important since no question is at stake whose answer requires an accurate estimate. The point to argue is that the community of dedicated art supporters in this metropolitan area of two and a half million is quite small.

While there are important exceptions, the average serious art supporter is white, middle-class, professionally educated, and often ethnically Jewish (out of proportion to Jewish representation in the population). This means that after a fairly short time, any active participant in the art scene will meet and know most of the other participants. One commonly hears in any city that the art world is very small.

Why Buy Art? Love, Investment, and Ego

Collectors prefer to discuss their love of art rather than costs, yet many admit that they at least consider the aspect of financial investment in buying art. Few, however, are eager to talk about the egotistical and social-climbing functions of art collecting, at least in relation to themselves. Yet these functions are often present, as love, investment, and ego are the fundamentals of collecting.

Love

People in the art world joke that when collectors get together they talk about their passion for art, whereas artists talk about money. The ideal collector has an intense emotional involvement with art, and most collectors learn to speak of art in terms commonly associated with romantic or familial love. A middle-aged art supporter described the agony he and his wife went through in deciding whether to sell a collection of art glass to get money to buy paintings.

> We just decided that we couldn't part with it. We just decided it's not worth it to give it up. It's worth it to us to keep it even though we might, say, take the proceeds from the sale of the glass collection and buy other art with it that we love. It would be too expensive for us emotionally. We really love the stuff. (Int. 80)

A middle-aged businesswoman spoke of trying to develop a rational plan of buying art, but failing because of her compulsion.

> I should have a wall and then buy for it, and then I shouldn't buy
> any more, but that's not what I do. I like going to galleries, and I
> like going to openings. And I go and then I see something that I
> love, and then I feel like I can't live without it, and then I buy it.
> And then I walk around my house and say, "Now where can I put
> that?" And then maybe I'll take something I don't like as much
> anymore down and stick it under a bed and put that new piece up,
> or maybe I'll just crowd some more things on the wall. But . . . the
> one . . . restraint I guess you could say that I put on myself . . . I
> absolutely know that I can't pay more than like six thousand dol-
> lars or something, or at least I don't choose to. (Int. 81)

A collector in his seventies has been ruled by his collecting passion for
his entire life, so much that others criticized him for neglecting his profes-
sion. He and his wife built and sold several distinguished collections in
their long involvement with the art world. He told me his personal theory
about loving works of art.

> I believe this way about collecting. I believe you shouldn't marry a
> work of art, but you can fall in love with it. In other words, you
> can have mistresses in art (you are not supposed to in life), . . .
> but there are a lot of beautiful things in the world. And you have a
> Prendergast watercolor for ten years, and you see something else,
> . . . so in order to get the something else you sell the Prendergast.
> So your collection is evolving constantly. That to me makes it
> very interesting. . . . If I had the Mona Lisa hanging on that wall
> for thirty-five years, I wouldn't see it anymore. I don't care what it
> is, because art is static. . . . It isn't like a piece of music, the organ
> sounds different every time you hear it played. But the art, I like to
> change it. I like to have affairs with works of art. I don't like to
> marry them. (Int. 117)

This collector enjoyed being iconoclastic. His history of creating and
then disposing of several outstanding collections—watercolors, prints,
photographs—showed him to be that rare type, a collector's collector, one
who is passionately addicted to collecting. Most people build only one col-
lection in their lifetime. His enthusiasm for changing the work displayed
on his walls, for mastering new areas of aesthetic expertise, is very per-
sonal. Art market actors more commonly say that good art constantly
renews your vision and changes your appreciation over time. One art con-
sultant told how she argued that clients who could afford expensive furni-
ture should spend comparable amounts for serious art.

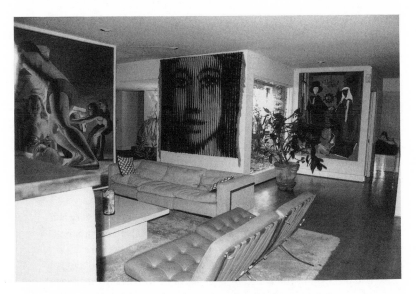

Fig. 13. The living room of an avant-garde collector's home in St. Louis County. The aggressive images and intense display of art mark the collector as serious, committed, and independent in his taste.

> Because when you look at things, you see new things every day. That's what a piece of good art does, it shows you something different every time you look at it. . . . But you don't get that from your eight-thousand-dollar leather couch. Well, it's good-looking, it looks good in the room, it's comfortable, but that's a very different idea than what a piece of art can bring in. (Int. 30)

Speaking of collecting in terms of love raises it above mere commerce and aligns art consumption with art creation. Collectors who act out of passion or a compulsive need rather than from gain-oriented calculation are like artists who make art because they must. Such collectors buy art because they "fall in love" with it, and "must have it," meaning that their actions are no longer the result of rational, strategic calculation. By focused collecting and support of the arts, serious collectors can share the culture-creating status of artists (fig. 13).

Investment

The consensus about buying art is that it is a mediocre way to make money. Art has generally not yielded better returns than government securities (the lowest-yielding, safest investment), in spite of the spectacular

rise in the prices of some art during this century, and the well-publicized cases of fabulous profits. Several studies demonstrating this point are summarized in appendix 3. Uninformed people, impressed with the stories of spectacular price increases, dream of making vast amounts of money. The idea that you can buy something now for a few thousand dollars that will be worth many thousands in the future is a powerful image to unsophisticated collectors. Professionals, familiar with the hundreds of artists whose prices do not rise to fabulous levels, have a more cautious view. A curator discussed art as investment in 1993.

> First of all, I don't adhere to the idea of . . . art as investment. I think it's an investment in yourself and in your culture. . . . I don't promote art as a financial investment, because it's a very bad investment. . . . You can't get [the art equivalent of] a stock-broker and say, "Let's buy this, this, and this." Because if you don't love it and if you don't understand it . . . you're going to get bad pieces, and you are going to get a collection that's a mishmash of things. And you are going to get some consultant's idea, and if you happen to get a bad consultant, you're screwed. And today, in the early nineties, the art market is so completely different from what it was ten years ago that if you think you are going to go into it, and pretend like you're going to create a collection of work . . . and make huge amounts of money . . . it's not going to happen. It's different now.

She described the poor judgment of a local collector who bought an object from the estate sale of Andy Warhol.

> He paid two hundred thousand dollars, in New York, at Christie's auction house. And it's back on the market again, but now it's down to twenty-five thousand dollars. So this is not an investment.

She belittled the ignorant buyers who flooded the art market during the 1980s.

> Most of those . . . art investors wanted to play; they didn't want to understand. They just got somebody to buy the stuff, and they didn't know the difference between Kippenberger and Clemente [two contemporary European neoexpressionists]. . . .
> The thing with the eighties was there were a huge number of people who got into the art world because it was a fashionable thing to do and they thought they could make a bundle on it. And they treated art like real estate. And there are hundreds of people

who have paintings stashed away in warehouses who don't live with them.

The curator felt that one's involvement with art should be cultural and emotional above all else. She disliked the social aspect of collecting as much as she despised an investment goal divorced from emotion. She was optimistic that the passionate art-lovers would always exist.

> What I do think is going to survive, and has always survived, has always been what makes the art world tick, are the collectors who believe in what they buy. . . . You know, the people are still in there buying things because they have to, they can't live otherwise. But the other people, who have the warehouses full of stuff, and who never look at it, and could care less what they have so long as they have a computer sheet that says it's gone up so many percentage points, they stopped buying in the market because it's not a good investment. (Int. 13)

A salesman who had previously worked in a high-pressure, lower-quality shopping-mall gallery described this sort of ignorant customer.

> They ask, "Is this thing going to go up in value?" and I can say, "Oh yes, that's investment quality." If you were selling securities, you could be prosecuted for this. . . . Here [in his present, high-art gallery] it is easier to say, "Let me give you a little lesson on investment-quality art. If you want investment-quality art, you have to lay down thirty thousand dollars, first of all." (Int. 14)

Serious collectors can thus be divided into those who are concerned about the investment potential of their purchases, who think about the possibility of a secondary market for the work that they own, and those who think of the money spent on art as consumption, perhaps as support for the art world, and who do not concern themselves about resale. The former have learned to moderate their interest in the purely visual qualities of art that catches their eye with concern about its market value. This perspective is summarized by a slogan that I heard several times, the title of the next section.

Like What You Buy, but Don't Buy What You Like

The young lawyer in an elite downtown law firm was just beginning to buy art in a serious, careful, almost ponderous way. He explained what he meant.

Don't buy a piece solely for your emotional feeling about the piece. But always be aware, although it's secondary, about its place in the market. . . . I do think about selling it in the future. . . . And it kind of adds to the excitement in a way. My collecting strategy is that I buy abstract artists, and I like to buy people who are emerging. And I have confidence in [X, a local dealer's] opinions on who is emerging, and I get another secondary feeling from [Y, a curator] about who is hot, you know, who has a chance to be an important artist. . . . I have an opportunity to buy their art when it's not as expensive, and, I have to tell you, there is the excitement that if one of the artists did take off that the painting could become very valuable. (Int. 31)

This collector obviously dreamed about benefiting from a repeat of the fabulous price rises he heard about in the 1980s. An older and far wealthier collector was not concerned about gain, just about avoiding loss. He explained his approach by describing a friend's collecting strategy.

Her husband was a very successful cardiac surgeon. They lived in a very modern house in Ladue, and they had the best abstract art in town at the time, and she knew her stuff cold. She . . . once said to me, "I'm not rich enough to pay a thousand dollars or more for a piece of art that I can't give to a museum or sell." (Int. 44)

The point of this story is that no matter how rich the collector, it is foolish to spend money on art that has no secondary-market or tax write-off value (tax incentives are discussed in appendix 3). A wealthy collector who had thought a good deal about the importance of secondary markets formalized it into a theory.

The Wallpaper Theory of Art Collecting

The collector's home was full of contemporary ceramic vessel-sculpture ("clay") as well as paintings, works on paper, and fiber art. He compared hanging paintings to papering his living-room walls.

Wallpaper, no matter what its cost on the roll, when it is applied on the wall, immediately becomes valueless in terms of a secondary market. You can't sell wallpaper on the wall. You can spend five thousand dollars a roll for the most beautiful, hand-painted flocked wallpaper. You put a hundred thousand dollars' worth on your wall and try to sell it and you can't get ten cents for it. Now there is a price beyond which I can't afford wallpaper.

He explained his reasons for being concerned about the resale value of the work he bought.

> Because our collection is . . . a major part of our estate. And I can't afford to spend over X amount and have it worth nothing. But I can afford less than X amount just for the enjoyment of it, for the wallpaper of it, to see my walls look nice. So we have, in our collection, pieces that are worth nothing on the secondary market, I couldn't send it to Christie's or Sotheby's.

He related the resale potential to the price of the art.

> People are not going to invest forty thousand dollars if they know it's going to be worth nothing, even if they love it. I don't care. . . . The dedicated collectors aren't interested to make money. But we don't want to have our estates devastated. We can't buy wallpaper every day of the week. (Int. 86)

Risk

How do collectors avoid having their "estates devastated"? In this postmodern era, when some experts may admit their inability to distinguish aesthetic value in art, how is an average buyer to avoid being overcharged or even duped? As in any market, the rule in prudent art buying is, "If you don't know the product, know your dealer." A careful buyer wants to know enough about the commodity to be comfortable paying the price for the value. A St. Louis banker, who bought art occasionally but was not sophisticated, remembered buying his first painting while on vacation in Michigan. It was in the 1950s, and the gallery was asking five hundred dollars (equivalent to almost three thousand dollars currently). He called the Guggenheim Museum to ask "if they knew of this artist." Whoever he spoke to recognized the artist's name and said that he was a "legitimate artist."

> It makes common sense. I'm buying the painting because I like it, but I don't want to be had. I don't like making mistakes. It would be different if I went to [X, a local dealer] where I know the gallery. If I'm buying a diamond, I want to be sure the diamond is flawless. I can't see that, I have to rely on the dealer. I bought the painting because I liked it, and my ideas were supported by the fact that he [the artist] had some recognition, he had legitimacy. . . . I wanted to be sure I was doing the right thing. (Int. 42)

Legitimacy means status in some market larger than the local place, so that the buyer's interest in the work is shared by a larger set of collectors. Potential buyers are reassured by the knowledge that the work is sold and written about in a social context wider than the local scene. Therefore, the concept supports Adler's theory of consumer capital (summarized in chapter 1). The larger the set of people who know about that artist's work, the more likely a buyer is to find someone with whom to discuss the work and increase his or her own enjoyment, and the less likely to be deceived about the work's value. If the price seems too high, but the dealer provides information about sales by that artist at comparable prices, backed up by museum exhibitions and published reviews or citations, then the piece is set into a context that supports its value.

The concept of legitimacy refers to two aspects of the economic value of art: the current price and the resale potential. The collector must first assess the current price-value equation, to decide whether the stated price is a fair one. How is one to know what a fair price is? On the broadest level the style of the work affects the price. Contemporary realism is less expensive, other things being equal, than other styles of painting, and art crafts are cheaper than sculpture and painting, for example.[2] The "other things being equal" include factors in the history of an artist's career. The more shows and prizes won and the higher their prestige, the greater the number of galleries handling the work and the more elite their status, the higher the connoisseurship of collectors owning the work, the more articles, monographs, and other media attention—the higher the prices. The physical attributes of the work, whether it is on paper or canvas if a painting, its size, medium, the existence of multiples and use of expensive materials, all affect its cost. Most of these variables have been investigated in studies, summarized in appendix 3. When all is said and done, however, the prices are not well understood, and the difference between an artist who is "hot" and one who is not is fairly enigmatic.[3] After the fact, the success of gallery and museum shows, attention by the media, and so on trace the course of an artist's prosperity, but it seems extraordinarily difficult to predict success before the fact.[4]

A piece of art is fairly priced if comparable works of art sell for similar prices. At lower prices, this has no relation to the investment quality or resale potential of the work, although the two may be confused in many buyers' minds. A piece of local art may be fairly priced at a substantial sum—ten thousand dollars, perhaps—but have no resale value. The higher the price of art, the more established the work's market should be,

and the closer the relation of the price to the resale value (minus transactions costs like dealers' fees).[5] The figure of around thirty thousand dollars mentioned by the salesman quoted above seems reasonable in the 1990s as the lowest price of original work with a solid secondary market.

Collectors, like shoppers in any market, seek security by consulting trusted experts, by reading publications about the work, and by seeing the work marketed in larger markets. A collector mentioned considering a piece of art.

> It had been on the cover of *Life* magazine, one of the "Emerging fine American young painters." . . . I had legitimacy, the guy was on the cover of *Life*. . . . So I bought that painting. (Int. 117)

A lawyer told how his confidence was raised in the value of some work.

> The next piece I bought . . . [was by] a young artist in New York. [The dealer] called me up and said that he was having a show and that there was a piece he wanted me to see. And he was very excited about it and showed me the piece, showed me some articles published in art magazines, an interview with [the artist], and told me more about him. And I went ahead and bought it [for forty-five hundred dollars]. . . . When I was in San Francisco . . . I went to [an art] gallery and she had a [piece by the artist], and that was a real wonderfully reinforcing moment for me and increased my respect for [the local dealer's] opinions. Also, again, it made me feel a connection to an art world that's larger than St. Louis. (Int. 31)

Resale Value of Local versus Nonlocal Art: The Absence of a Secondary Market

The concern for investment distinguishes local art, which for practical purposes has no resale value, from art sold through New York, which is assumed to have a wider market. Of course most work from New York is not auctionable or resellable through dealers, but buyers feel that if any work is, it would be sold in New York. One dealer in both locally produced art and work he obtained from New York dealers put it clearly.

> I generally buy prints by nationally important artists that have an actual value that I can determine. In other words, if I don't sell it here, I can send it to New York and somebody there will pay at least what I did for it, so I can't really lose. Whereas these [locally produced] things that I sell . . . have no intrinsic value on the market. . . . That's exactly what most of this art is about, it's deco-

rative, it's something to enjoy while you have it, but it's not any-
thing that has any kind of intrinsic monetary value. It's like a table
or a couch or your tie, you really can't expect that it will pay
off. . . . There is not only no [monetary] appreciation, there is no
intrinsic value other than the value that one gets, [aesthetic] ap-
preciation, on one's own.

[SP: How would you compare that to a piece by a more nation-
ally known artist?]

Those things have auctionable, salable, intrinsic investment
value. There is investment art, and there's noninvestment art.

He went on to make the point that investment art was not necessarily of
higher quality.

I think that you have to make a distinction here between those
five or those twenty to fifty people who have investment value in
American art, and those thousands of very fine artists who make
wonderful things, whose work has no investment value. And I
frankly don't value an artist's contribution on the basis of whether
their work is investment level or not. A lot of the investment-level
stuff that I see is crap. (Int. 10)

A curator had a similar view of local and nonlocal art.

To be very blunt, I mean, if you collect St. Louis artists, you're not
collecting it for investment purposes, because it's not going to go
up. I mean, it can go up a hundred dollars, a thousand dollars; you
are not going to have the kind of skyrocketing prices that you have
with internationally recognized artists. In the nineties, you are
buying it because you love it, and you want art to be viewed in this
city, and you want the artists to make work, and you like what
they do. (Int. 13)

A collector who worked as an academic, with no background of
wealth, complained about the lack of a secondary market for local work.
He owned a painting done by an artist who was very established in the
local market and who was the wife of a friend. He did not want it any
longer but was unable to sell it. It had been on consignment to her dealer
for a year.

There is no secondary market here. . . . Maybe I could trade it to
[the artist], but what would she do with it? . . . I'm now quite hesi-
tant about buying local artists in this town, your taste could
change, because what are you going to do with the work? That's

one reason I just bought two photographs, by [X, an internationally known artist, whose work is in great demand]. . . . If I could trade this piece for a larger piece, I would do that. . . . It's not a question of money, but of changing tastes. . . . That really limits my interest in buying local art. You have to have the right to have your tastes change, [but] you risk offending the artist. I don't know what to do. (Int. 75)

His dilemma was truly painful to him. His problem had nothing to do with investment, which was not his major goal. The quandary was produced by the complex nature of artworks as commodities and as items of personal expression. For collectors like him, who valued supporting local art but whose tastes were changeable, the problem is severe. He regretted insulting the artist by no longer wanting her work, yet had a hard time actually reselling the piece. This prolonged a difficult personal situation between him and his artist friend, which limited his interest in future purchases in the local market.

Buying What You Love versus Completing the Collection

The concern for resale or potential investment quality thus splits the market of collectors into those interested in the larger market where resale and liquidity are possible, who ignore local work as irrelevant to their larger interests, and those who ignore the investment potential of work in order to just "buy what they like." A wealthy investment adviser, who collected books as well as ancient and contemporary art, discussed his purchases of local art in these terms.

I figured when we bought the pictures by [local artists X and Y] that they were not being bought for investment. . . . It would be very nice if they achieved the distinction which I believe they deserve, but I'm not counting on it. We bought them from local painters, local galleries at . . . shows where they had just been painted. And we expect to keep them all our lives. We are not really concerned that they are not, to our knowledge, major elements in the national or international, the New York–dominated, market. For all I know, they may be, but I don't keep track of that. I know that they are not major, and I know that neither [artist X or Y] has attempted to compete actively in the rat race of New York art reputations. (Int. 66)

This collector was comfortable with "buying what he loved" and did not have a larger strategy in mind for his collection. Another collector ex-

pressed the difference between buying art ad hoc and pursuing a focused plan.

> We're really different from most collectors, in that . . . I've been told by hotshot collectors such as the Pulitzers that you collect in one area, but we don't do that. We just sort of buy what we like and hang it. (Int. 92)

Collectors who try to assemble the best of some focused area think of their collection as an organic entity, an assemblage of work with an elegant design, rather than a mere assortment of work they like. Some become obsessed with the idea of completing their collection, perfecting it into a beautiful whole.

> That's were my downfall came. . . . I was waiting for a [work by Jasper] Johns, and then we were at the Scull auction in New York when the pop artists' prices went out of this world. And a Johns became way beyond our means—that is, a Johns of quality. And I told [my wife] that this collection could never be complete, and I felt uncomfortable with it, and I felt that we ought to get rid of it. And we did, which was a terrible mistake.
>
> [SP: You got rid of it because you felt it wasn't complete because you lacked a good-quality Johns piece?]
>
> That's right. . . . It was like a jigsaw puzzle with a piece missing. It had a defect, and that offended me. . . . That was in . . . the early eighties. . . . So we auctioned the [collection] at Christie's and sold a couple of pieces to private collectors. (Int. 86)

A collector described how the drive to become a major collector became a passion.

> When we started collecting art, we started collecting things that we liked, and then the obsession came to produce this major collection, to be important because of having this major collection. . . . It was interesting because when it got into that, it became a compulsion. . . . "Well, now this collection needs a . . . Betty Woodman pillow pitcher, so we have to look around and find the best Betty Woodman pillow pitcher." . . . It became the void of filling in all the slots along the way. (Int. 90)

The connoisseur who wants to create a collection that has coherence and art-historical value can spend enormous amounts of money for certified masterpieces or can take the risk of buying artists whose art-historical

importance is "emerging." One collector described the difference between merely spending money and searching out nascent masterpieces.

> I don't think people should collect monuments. That's real easy, all it takes is the money. If somebody [else] will identify the monuments, "That's a great Jackson Pollock, that's a great Rembrandt," you are buying monuments. You are not exercising the creative spirit that a collector is supposed to have. (Int. 117)

This recalls the collector quoted in chapter 3, criticizing the museum for its conservative buying strategy.

> The museum will buy a few very expensive pieces, art that is so expensive that they can't lose. I prefer to take the risk of buying a ten-thousand-dollar painting. (Int. 17)

While collectors must rely on the expertise of dealers, some become competitive and aim to close the information gap between collectors and dealers.

> My approach to this is to get as much information as I can possibly get. I want to know more than the dealer. . . . If I'm putting together a collection for a reason that I have in my own mind, I have an agenda that I bring to the work, and I'm not going to be swayed by what a dealer says to me about the work.
>
> I find the dealers beneficial in that they display the work, and they promote the work, and they write, have catalogs about the work and all these things, but it doesn't really matter, because I'm going to get the work anyway. I don't need dealers at this point. . . . I'm forced to deal with them because there's a relationship between artists and dealers, that you have to go to the dealer rather than the artist, but I know all these artists. I know what they're doing. I can call them up and ask them, so the dealer knows this, that I'm on both sides of the curtain. I try to have the most information as I can possibly have. (Int. 17)

Collecting as Creativity: Ego and the Collector's Eye

Collectors often find their activity in competition with someone else's. This usually becomes a clash of egos. Sometimes the competition is indirect, as when one collector boasted of the relative quality of his art as compared with that of another major collector in St. Louis.

> [X] has a crummy collection. . . . He has a terrible eye. . . . For example, . . . he has a very nice [sculpture by internationally

known artist Y], "Guy sitting in a chair." Well, we had a fantastic [Y]. . . . I'm being absolutely immodest with you because I think you ought to know.

For collectors like these, the art in their homes is a reflection of their ability to discern excellence, and they abhor being behind anyone: "I've never been a second banana in anything, and that's a burden, you know?" The collector boasted of his reputation in the international art world.

> I'm important enough that when pieces come up at auction my name is in the provenance. . . . That pleases me. Not the notoriety, but the fact, again, that my eye is regarded to be good enough and our collection good enough to be considered important in an international auction. . . . If I bought a piece . . . the dealer would . . . say, "Do you mind if I tell [other collectors] that this artist is in your collection?"
> [SP: Sure, it's very flattering.]
> Yes . . . sort of an affirmation of my eye.[6] (Int. 86)

Sometimes the competition is open and direct, as when two collectors bid against each other at auction. A St. Louis collector boasted about outbidding an immensely wealthy and famous collector for a print. As often happens, the buyer was not in attendance at the auction but had authorized a dealer to bid for him.

> It was at the Parke Bernet auction in 1966. . . . [X, the dealer] was there bidding against Norton Simon. I wasn't there, I didn't know [whom he was bidding against]. I said . . . I can go to $4,000. For this great print. Calls me up, he said, "I had to pay $4,700, and you don't have to keep it. I know I went over." He said it was really great because Simon stopped at forty-six hundred. "Looked at me disdainfully, that anyone would outbid the great Norton Simon" . . . the man [who] had paid two million three for *Aristotle Contemplating the Bust of Homer,* by Rembrandt! . . . I said, "No, that's OK, we'll keep it." So that bonded him [the dealer] to me. I took it even though it was $700 more. (Int. 117)

Direct competition also occurs at gallery exhibitions, when aggressive dealers tout a few best pieces to selected clients invited to preview the work before the opening.

> You felt like some insider getting these things, and these people would run in there and they would battle for these positions [to preview the work before each other]. But [the dealer] would

never tell them if they were first, second, or third. You kind of just figured it out when you got there and you found that there was a piece sold already. So this added this element of scarcity and snobbism . . . [and] competitiveness between the buyers. (Int. 17)

The collector's goal is to use art purchases to become known as a person of taste and knowledge. A collector reminisced about her former husband, a fanatic art collector.

It was very important to him to be a major collector . . . not to be someone that purchases things that they like to purchase. . . . His main driving force is to prepare a major collection. It's very much of an ego trip, very much so. (Int. 90)

For this sort of person the collection is like an artist's oeuvre. The challenge is to perfect the collector's eye, or connoisseurship, to own artworks that will be known as masterpieces in the future but are affordable in the present. Some individuals are much more interested in the validation of their connoisseur's eye than the money they might earn from their purchases. One collector told how he made $25,000 for a dealer in one day.

[A curator] was assembling his great collection of prints and drawings. He had always said he wanted this [drawing], so I called [a dealer], who was a dealer in New York and Chicago, and I said, "I've got a drawing down here and I want $25,000 for it." . . . He said, "I don't know any [drawing by artist X] that's worth $25,000." But he said, "All right, I'll fly down." So he flew down and took one look at this thing, and I said, "You've got to offer it to [the curator] at the Art Institute. I can't deal with them. I don't want to deal directly, I'm not a dealer." . . . So [the dealer] bought this thing for $25,000 and immediately sold it that day to [the curator] for $50,000, that day. . . . [The curator] called me. He said, ["The dealer] is here with the drawing. We really want this drawing, and he's asking $50,000. Is that all right?" . . . I protected [the dealer]. I said, "I don't know, it's all right with me." So he made more in twenty-four hours than I made by having it for many years. (Int. 117)

For some collectors, then, the most important thing is that the collection reflects and summarizes their ability to discern excellence—their eye (fig. 14). Their ego involvement in the collection is enormous, and as has just been seen, some will forgo substantial amounts of money to support their image of themselves as connoisseurs uncontaminated by a search for

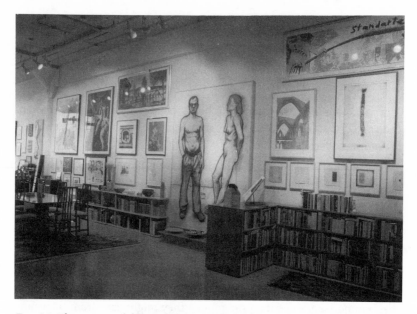

FIG. 14. The converted-factory loft home of a high-art collector. The industrial space is similar to an artist's studio, but this space has all the comforts of a home. The work displayed is an eclectic mix of avant-garde art that impresses the visitor with the collector's depth of knowledge and seriousness of purpose.

profit. That is not to say that their behavior is purely altruistic—in the case just described, the collector had done a major favor for the dealer and benefited later on from the dealer's reciprocal favors.

Status

The ego involvement that many collectors have with their collections is often related to their striving for higher social status. Social scientists from Veblen (1934) to Bourdieu (1984) have argued that people buy art in order to convert their wealth into higher status. Alsop (1982) argues that collecting art objects originated in antiquity, in the desire of nobility in classic Rome and Greece to show off their accumulated treasure by converting precious materials such as gold, silver, and jewels, stored in warehouses, into display objects. People who buy art can share in some small way the culture-building status of the ancient nobility and the fabulously wealthy individuals who have sponsored artists and established museums in the past. In St. Louis the names mentioned are Steinberg and Weil in period just after World War II, and more recently Joseph Pulitzer, a collec-

tor of modern American art, Morton ("Buster") May, a collector of German expressionist and of primitive art, and Barney Ebsworth, a collector of American modernist art.

An outspoken elderly collector remembered St. Louis' early avant-garde dealers.

> Now [dealer X] was the first guy in town who got a whole bunch of young guys his age buying art, because he convinced them it would be a good investment. And most of them turned out to enjoy it, to boot. When [dealer Y] did it earlier, she would say to a lot of nouveau riche people, "If you collect art, you will meet the Weils and the Pulitzers and the Mays, and it is a social stepping-stone." She would con them into buying it, and they all ended up loving it too. In both cases, [they] were getting great art. [Dealer Z] did that a little bit, but she was much purer. She was always selling [art] because it was exciting, it was new. She had the California art, she had ceramics, she had the stuff that the New York scene wasn't pushing, she was pushing it [i.e., she was on the cutting edge of this area of art collecting]. (Int. 44)

High-level collectors will align themselves with these world-renowned collectors.

> I'll say this again in modesty. The world of collectors is really a very small community of major collectors. I was talking with Emily Pulitzer, who is friendly, but not a friend. I mean, we just happened to be talking. . . . And there were at that time fewer than one hundred major collectors of contemporary art in this country. . . . This was five years ago. . . . And Emily considered us a major collector. In St. Louis at that time we counted five people. (Int. 86)

Since it is considered gauche to discuss one's social status, most people do not mention it in interviews. But even those who don't explicitly connect their holdings of art to the famous collections of the fabulously rich can borrow some of the elite status of art institutions. In St. Louis the ultimate acceptance is to become involved with the St. Louis Art Museum, as a docent, or the pinnacle, a board member. Collectors for whom the docents program is not an option can still use their interests in art as a "social stepping-stone" by involvement in other museum activities, such as the Contemporary Art Society (see chap. 3).

The St. Louis Women's Art Investment Group

Most collectors act individually, but from time to time buying groups form. When collectors act in groups, each person's artistic "consumer's capital" is magnified, along with the usual benefits of socializing. A local dealer in non-Western art had formed a group of thirty people to buy a collection of over seventy pieces from one "primitive" society. The dealer had invited them to purchase the collection, allow it to tour for five years, and fund the publication of a catalog (museum exhibition and publications are standard practices to raise the value of art; cf. Marquis 1991). As part of the activity, the dealer planned to organize a travel group to see the work exhibited in its home country. She described the goal as "to invest and to have some fun also" (int. 48).

A group of wealthy women joined together independently from the museum to combine art collecting, investment, and a bit of socialization in an investment circle reminiscent of the Bearskin group mentioned in chapter 2. The 57-year-old woman who founded the investment group had never graduated from college but had a background in high-level art through her deceased husband. He had been extremely wealthy and active in many business ventures as well as in collecting blue-chip contemporary art. After her husband died, she sold most of their collection in the mid-1970s to generate cash and took over several enterprises as an active executive. At that time art prices were rising strongly but had not reached the fevered pitch of the late 1980s. She sold work for far more than she and her husband had paid for it but was chagrined to see the work resell soon after for phenomenal prices. In the late 1980s she organized twenty-one other women into a formally incorporated group to buy art for pleasure and investment. Each partner put $5,000 in and was supposed to add $2,500 after a year. The art was to circulate from home to home every three months.

Their goals were to broaden their knowledge, create friendships around a theme, and "hopefully make some money." They decided not to invest in prints, since

> If there is a downturn in the market, prints go deepest. We decided to only buy the best. In my 1974 experience, art always has value if it's good.

In the beginning they went to New York and bought two works of blue-chip contemporary art for $87,000. Their timing was unfortunate, and she estimated the current value of the works at about three-quarters

of their purchase price. Having bought "the best," she was not concerned, about either the work or her friends' abilities to hold out for a rise in price.

The group had a complex set of rules for calculating a partner's cash share in case one wanted to leave. But when one did want out, the main problem was social: the woman who wanted to leave felt pushed around, while the leader thought she was "flaky." The leader complained because she found herself doing most of the organization and secretarial work for the investment group.

> Between you and me, a lot of these women are very wealthy. Their husbands are CEOs, they are used to having everything done for them, having people hand them their tickets [when they go anywhere]. They are very busy with their charity work, and so on. (Int. 83)

More recently twelve of the women and assorted daughters went to New York to visit museums, galleries, and private collections. The group has also hosted lectures by leading women docents and important persons in the St. Louis art world. They recently bought another piece of art from a local dealer for $85,000. The group had decided to buy a piece of sculpture by a woman artist and felt that they had made a good investment purchase, since the piece had been priced as high as $165,000 in recent years. But the investment group did not seem to have a bright future, since it was likely that the wealthy widow doing all the work would soon tire of the burden, while the majority of the rest of the group did not seem interested enough to increase their involvement.

Building Community Art Institutions

The tax laws have allowed some collectors to do good for the community as they do well for themselves (see the discussion of tax incentives in appendix 3). A few collectors have developed a deep interest in the local art scene apart from the narrowly defined personal tax benefits. The desire to contribute to one's community by supporting art has been an important force for a few dynamic individuals. One collector of local art who had served on several art organization boards had special exhibitions in her home for selected artists. She invited several artists to hang their work in her home in an elite suburban neighborhood, and she invited people to a combination house party–exhibition–charity fund-raiser and jazz concert.

We take all the art [that she and her husband owned] down off the walls and hang the work of the artists. And we have music and wines and cheeses, and we . . . charge ten dollars a person, just to come in. And the artist gets still 60 percent [of any sales], which is unusual. And we give 40 percent to an arts organization. . . .

The first show was really for the artist. I said, "What can I do for you? I really like your work, you should be doing better than you're doing. I want to expose you." In later years [fund-raising for] the arts organization became more important to me. Like I had a benefit for Laumeier one year. Had a benefit for Craft Alliance.

This exuberant woman attracted a large crowd of people to her events and managed to generate funds for the artists and arts organizations, as well as have some fun.

I think originally people came because they knew we were collectors, and they didn't know what they were going to see, and they just wanted to go into a house in Ladue. But what happened is, people come, we always have great jazz. . . . I think we made about five thousand bucks [for one arts organization]. . . . I think at one point we had as many as seven hundred people here over a period of four hours. Now that's unusual. I'd say the average is two or three hundred. But we've had a few real biggies, depending on the day.

[*SP*: Where do they park?]

Valet parking. I mean, it's a big do. (Int. 92)

But after producing about ten such affairs, the inevitable personality squabbles and organizational problems became too much for her, since she had the whole burden of administration.

Medici, St. Louis Style: A Bank Workshop for Artists

One person whose exuberance made a real difference in the St. Louis art scene had the resources of a large business behind him. An ebullient local banker was an early collector of avant-garde art. He had opened his bank in the early 1960s with a show of pop art put on by Leo Castelli, Ivan Karp, and Richard Bellamy, three of the most elite dealers in New York. The show was written up in the *Wall Street Journal* since the idea of this outlandish avant-garde work being shown in a conservative St. Louis bank caught the reporters' attention. The bank soon developed a regular program of art shows highlighting the work of local artists.

We immediately put into effect a high-school art program where every month in the back end of the bank we showed high-school art of a different high school. . . . And simultaneously we would have a professional artist in the front end of the bank with his show. . . .

We had an arrangement with the *South County Journal*. . . . So we were on the front page of the *South County Journal* three out of four weeks and making art in South County something rah, rah, rah. Then one day we went over and we invited all the Southern Illinois University artists in Edwardsville to have a show. . . . We were the first group that made them feel that they were part of metropolitan St. Louis. We really introduced all the Illinois artists . . . to the St. Louis art dealers.

The banker functioned as an impresario of the arts while he built his business into a regional banking chain. His personal dynamism, backed by the growing resources of the bank, made him a significant factor in the local art culture.

In those days all you had to do get on radio or television with an art presentation was to ask. So we were on frequently talking about art, talking about the show. . . . Really we were one of the most authentic galleries in town. . . . When I was in the bank, I always sold it [the art] for them. . . . I was a good salesman, and on the opening party—we had a big party for every opening— and unlike the galleries, we would give them some respectable food and an open bar, and the artists loved it. We would get big crowds. All of our directors and all of our directors' friends, many of whom knew nothing about art, would come. In the process, a great many of our directors became pretty serious collectors.

The banker had an honest interest in supporting the arts, but like any entrepreneur was attentive to the business implications of his interest.

After a few weeks in business, if you said to people like Buster May or Joe Pulitzer, "Who is [the banker's] bank?" [they would answer] "Oh, the bank with the art." If you said to them, "Who is the [X] or the [Y] bank? who were fifty years old, they wouldn't know anything about them. So in fact, the art may or may not have given us any business, but it gave us a lot of publicity, and it gave us a lot of acceptance in the community. . . . We became the arty bank.

As the bank company bought more locations, the banker developed a unit of his bank to employ artists as carpenters and cabinetmakers.

> We got very friendly with all of the professor artists in town. . . . The ones that were going to be serious about it were all impoverished. So I had them working around the house. . . .
>
> We added a shop. . . . Originally we did it purely as a method of letting the art students, mostly graduate students, eat. . . . They worked on an hourly basis. We also bought their art, and we also gave them art shows. . . . What these guys did was . . . they would design and build furniture . . . for the banks. They would help with the art exhibits and the collections which were in every bank. . . . They would help redesign and rehab the bank buildings, so that if we wanted to change an office, we would let them do it, including the painting and everything but laying the carpet. . . .
>
> [Then] we discovered that Washington University was paying them six or eight thousand dollars a year [in the late 1970s,] and they couldn't buy their materials for that. They would call them "part-time." . . . So at that time we said, "Why don't you come work for us full-time and make a living, and we can pay you a lot more than we have been paying you," and still be under union rates of carpenters and repairmen. So it was not that big a deal. . . . These guys could truly repair the stuff, build the rooms, paint the rooms, fix the rooms as well as work with the art. . . .
>
> These guys were learning things [at the bank] that they never learned in art school and might never have learned. So that I would say, "Hey fellahs, I just bought a Jack Beal screen. . . . Why don't you guys build screens? We always need them in the bank. . . . Paint them in your own format." So every one of the artists would design and build one or more screens. When they were all done, we would give them an art show in one of the banks which would get reviewed and photographed, et cetera. (Int. 44)

At its high point there were as many as fifteen artists on the payroll. The bank sponsored a lecture series with visiting artists, had exhibitions for local artists with openings, and bought local artwork to hang in the new buildings. The bank workshop became an adjunct resource for artists associated with the Washington University art school as well as others, giving them a source of employment, exhibition space, and art sales.

This art patron was not without detractors: some artists resented his heavy-handed use of his power to buy their work at bargain prices, well below their normally cheap local prices. The artists suffered mixed emo-

tions of gratitude for the attention, support, and sales, combined with resentment at the hard bargains he drove. After about ten years the banker retired, and without his backing the bank closed down the artists' workshop. It had played a key role in the St. Louis art world by providing support for a number of local artists from the mid-1970s to the late 1980s. The bank had bought their work, given them salaries, trained them in shop skills, and above all, given them the emotional support and encouragement that artists crave. The banker had expanded his role from collector to dealer, educator, entrepreneur, and patron and enriched the local art community.

Corporate Collecting

The growth in corporate collections described in chapter 2 was represented in St. Louis by a few corporations. Aside from the bank described above, Southwestern Bell and Boatman's Bank had well-known collections. The only local corporation to have an art curator on staff was a large brokerage house. After years of buying art for the firm on an ad hoc basis, the senior executive who had done the work realized that the firm had a "collection" that needed to be curated. With significant growth projected for the firm's office space, a curator was hired to manage the collection. She functioned as an executive assistant to the senior executive who was interested in art, and worked full-time searching, purchasing, cataloging, and administering the firm's collection, which totaled some three thousand pieces in 1992.

In a business environment, however, the collection could not be justified as a pure luxury or as public service, since the firm had no interest in focusing on local art. The curator was encouraged to obtain her stockbroker's license so that her employment with the firm would be less subject to internal criticism ("to show that she was part of the team" [int. 50]). While the collection was fairly eclectic, she and her boss had decided to focus on undervalued areas of art (they were displaying European posters in many of the firm's public spaces because it was decorative, large, and inexpensive work). The firm's holdings were kept in what she jokingly called her "art shop," where executives could come to choose art to show in their offices. But the collection was not advertised, and no educational programs were put on. The art on the walls was justified as more cost-effective than paneling or other luxury wall treatments, and the fact that the collection had gained significantly in value during the 1980s was quietly made known to office skeptics.

In this aspect of the art world St. Louis is fairly typical, as measured

against Martorella's (1990) survey of corporate collections. She describes the pattern of an interested executive giving way to a professional curator with heavy reliance on consultants. The work is rarely distinguished or challenging, since the last thing corporations want is to generate controversy or upset employees.

Nontraditional Collectors

Art collecting is normally a middle-class or elite activity, since it implies an advanced level of education as well as available cash. Yet all it really requires is a love of art and some—not necessarily impressive amounts of—disposable income. In recent years a few collectors have achieved national prominence because their collections were accomplished on normal salaries, not inherited wealth or extraordinary business or professional income. Artists treasure these rare cases, since they prove that art can enrich everybody's lives, not just the privileged elite. The secret guilt many artists feel about their dependence upon the upper classes is diminished by the existence of such relatively lower-class collectors. Perhaps the most well known are Herbert and Dorothy Vogel of New York City, a postal clerk and a librarian. The Vogels lacked advanced education or artistic backgrounds but had an incredibly deep love of art and a compulsion to buy the most challenging avant-garde art. They had no children and lived on one salary, spending the other on contemporary art. Their collection grew to have major significance and was eventually donated to the Smithsonian Institution in 1991 (Gardner 1992).

John Brown, a collector in St. Louis, defied all generalizations. He was an elderly black man who had spent his life working as a janitor in a downtown federal building, and who lived in the African-American neighborhood of North St. Louis. Brought up on a farm in Arkansas, with no more than a high-school education and three years in the military, Brown had fallen in love with art as a young man. He bought paintings and drawings by black as well as white St. Louis artists for almost fifty years. His home, one floor of a two-story row house, was filled with art hanging on the walls and leaning against the furniture. The collection was built with eclectic taste and was an average selection of inexpensive original paintings, prints, and drawings, unremarkable apart from the fact that it existed in such an unexpected environment.

In 1991 he had offered to donate a small landscape by a nineteenth-century midwestern painter to the Washington University art gallery, Steinberg Hall. After three months they returned the piece, declining to

accept it and suggesting he donate it to St. Louis University, "since SLU doesn't have the resources we have and would love to have it" (int. 97). He had no plans to donate it to St. Louis University, indicating that he wanted the status of a donator to the more prestigious institution.

An African-American industrialist who focused on collecting black art was more typical in his elite education, income level, and cosmopolitanism. His interest in art that was not central to the national scene gave him a special perspective.

> The art market is not a market. It's comprised of a lot of different segments, and once you develop an interest in a particular segment . . . and you become known, and people call you and you call them. And whenever I travel . . . there are galleries who represent African-American painters. . . . And so you learn about those galleries, and so we stay in touch.

Although he recognized New York as the largest market, it did not have hegemony over the black-art niche he was interested in. Since the dominant institutions ignored the work he was most concerned about, their stamp of approval was irrelevant.

> New York is certainly an important place. . . . I would say that of the things we have purchased, maybe a third to a half have come from New York dealers. . . . I think that African-American painting has never been respected by European-Americans. . . . So, the New York art scene doesn't validate either the people or the images that I'm interested in. . . . [New York's hegemony is] a nonissue for me. (Int. 127)

The mainstream institutions' habit of ignoring these segments of the market is changing. If they receive public funds, they must take steps to insure that their audience is as diverse and broad as possible. The St. Louis Art Museum has recently developed an active program of highlighting minority and nontraditional art.

Conclusion

Since by definition collectors have enough money to buy art, they can, if they choose, try to ignore the tension between aesthetics and commerce that artists and dealers must confront. Some collectors think of the money they spend on art as pure consumption, the exchange of dollars for visual pleasure and stimulation. This is a special kind of consumption, however, that expands culture. Even the humblest collector can feel a kin-

ship with the great patrons of the past, the highest elites, in advancing the cultural vision of reality by supporting the arts. They can't get that by buying luxury cars.

Other collectors choose to be more than mere passive consumers of avant-garde visual culture. Their need to excel, to test their connoisseurship against the outcome of history, leads them to design collections with coherence and integrity. The creative effort and risky choices that this involves are comparable to the creation of an artist's work. The incredible rising market of the 1970s and 1980s led those who chose wisely (or luckily) to earn lots of money and allowed them to preen themselves on their expertise.

This prompted others to enter the market who were interested in speculative investment rather than art for its own sake. The "contamination" of the market by speculators who bought solely for appreciation created a backlash of disgust. Many art world actors despised the hubris of those who would invest money in art without the intellectual and emotional investment expected of collectors.

Why should investors be reviled? People who spend money on art could just as well be praised—and usually are by artists—for supporting the institution at large. I believe that the heat of the reaction to pure investors is due to two factors. First, experts in any market don't like to see their hard-won knowledge cheapened by relatively ignorant newcomers who profit from a rising tide. The art market boom of the 1980s and 1990s certainly enticed many profit-seeking investors into the market.

The second factor involves the art market's schizophrenic attitude towards business. Art is not supposed to involve profit. Overt monetary gain reduces art activities from the heights of expanding cultural horizons to the depths of commerce. Those who make economic gains as a side benefit of their artistic activities—such as the banker mentioned above—may not be criticized so severely. But those who seek gains with no pretense of advancing the culture—who "have the warehouses full of stuff, and who never look at it, and could care less what they have so long as they have a computer sheet that says it's gone up so many percentage points" (int. 13)—threaten to pervert the culture building into profiteering.

But why should profiting from art be morally censured in a thoroughly capitalist society? I hypothesize that the discomfort comes about because different social classes interact in the art world. Collectors who are upper middle class or affluent cannot avoid confronting the difference between themselves and the typically poor artists who make the work they covet.

So long as they concentrate on discussing their love of art and aesthetic theory, this potentially embarrassing difference can remain in the background.

This suits the artists, who tend to be uncomfortable admitting that their creative work serves the rich above all other groups in society (recall from chapter 1 Rauschenberg's fury at the highly successful auction of his work). It suits the serious collectors, who, as shown in this chapter, truly love the art and are fascinated by the artists. This issue does not arise in relations between functional craftsmen and their buyers since only high art is seen as advancing culture as well as being a commodity. When collectors admit to a concern about economic value, it is to avoid wasting money, since no one wants to play the fool. But if they were to wholeheartedly embrace the pursuit of profit through investing in contemporary art, they would focus attention on money as such. The pursuit of more wealth, by collectors who have so much relative to the artists they depend upon to produce the art, would recognize a difference that art world actors are more comfortable pretending to ignore.

A separate source of tension remains between art as consumption and art as investment. The resources spent on art are real and could have alternative uses. Some collectors are concerned about "devastating their estates" by buying art with no resale value. For the same money (and the same visual enjoyment) these collectors can buy art that has the potential to be resold, so that their money is conserved. The structure of the national art market impedes this investment potential for local art and therefore effectively reduces population of potential collectors for local work. Money and attention that could be focused on local art is instead spent on art from New York and other hegemonic centers. The relatively small collector population is subdivided into those who support and those who ignore local art. This split market, and the painful reduction in the already small set of local-art supporters, is a major fact of life in all art markets.

7/ Conclusion

> The whole business is based on relationships. It's all about relationships and trust.
>
> Gallery director

This book has presented the art world of St. Louis—an average place for people involved with fine art. Far from the centers of wealth and power and the New York rat race, "down home" art markets like St. Louis's are encouragingly comfortable and supportive to some, and frustratingly irrelevant and provincial to others. Artists and dealers can enjoy vast, cheap studio and gallery spaces that their friends in New York "would die for"; and collectors can become big names in the local art world, coveted by dealers and courted by artists, through expenditures that would be trivial in New York. But St. Louis is also a place where the same limited set of people show up to gossip and socialize—rather than seriously attend to the art—at many art occasions, where artists and dealers trying to show cutting-edge work often find themselves outnumbering the audiences, and where collectors looking for the art of the next decade complain that they see too much derivative, decorative work.

While St. Louis has its special aspects, the market for contemporary art is essentially similar in most "not-in-New York" places. Its art market has three major features.

First, the market is structured externally and internally by principles of discrimination, hierarchy, and hegemony. The most important fact to know about any work of art is its standing in the hierarchy of values from museum-quality avant-garde art to frame shop, hobbyist, and craft fair art. These invidious distinctions—which relate both to an artist's oeuvre and to an individual piece within it—are supported by expert dealers, collectors, critics, and curators.

New York hegemonically dominates the United States, meaning that art from New York is seen as more exciting and significant than other work and defines the state of the art. Arguments by connoisseurs explaining why art from New York is better reduce to geography: if it is seen in New York, it is judged better than comparable art seen out of New York.

Actually, "seen in New York" really means "seen in a few galleries in Manhattan," since most of the galleries in Manhattan and in the rest of the metropolitan area have little or no more significance than those in St. Louis.

In a parallel fashion, internal to local art markets, the top museums (in this case, the St. Louis Art Museum) and elite galleries define high-art values for art exhibition spaces in the local art market. The elite galleries can spoil the sales of lesser galleries by denying legitimacy to the art ("Why spend so many thousands on a nobody when you can get a work by a blue-chip artist?"). Similarly, the painting market dominates the craft market. The work of masters in glass, clay, and so on is worth a small part of the value of master painters' work.

Not only is hierarchical discrimination the central feature of the art world, but distinction between goods in the market is divorced from the work's material and appearance. Artworks are judged valuable because high-status people say they are valuable, not because they have physical or visual qualities that are generally understood to confer high value. The provenance and other social attributes of a work of art—the recognition of the artist's name by prestige dealers and critics—are as important as its physical, visual qualities. Personal taste cannot be a guide to art-historical value even if one is a connoisseur, and experts are not to be trusted since each has a personal interest to promote. This situation derives from the second major feature of the art world, the disarray of aesthetic theory about merit. The bankruptcy of art criticism and evaluative art theory, traced historically to the triumph of the impressionists and the dealer-critic system that marketed them, means that value is mysterious, socially constructed, and impossible to predict a priori without an expert's knowledge.[1]

Those with knowledge of history recall the outrage of Parisians at the work of the impressionists—the affront to normal good taste and considerations of artistic skill that impressionist work represented in the late nineteenth century. These very same images are now of course decorative icons of popular taste. The odd perspective of Degas's ballet dancers, crude brushwork of Monet's water lilies, and garish colors of Gauguin's Tahitians hang as pleasant posters in dorm rooms and gift shops everywhere. Abstract expressionism in the United States after World War II also seemed visually outrageous and revolutionary, the same images that today are considered safely acceptable and noncontroversial enough to be collected and displayed in legal or corporate offices and bank lobbies.

Although I argue that the problem of identifying art value flourished

because of the impressionists, the nature of modern culture has exacerbated the problem of identifying aesthetic excellence. Contemporary cultural life is "postmodern," meaning that the rules that governed modernist art (including all the arts from architecture to music and literature) are questioned. Self-referentialism, odd conjunctures, pastiches, and other strange, sometimes playful and ironic values govern the high end of contemporary taste. Thus the general cultural environment is no help for someone looking for clear rules of value in cultural products. Pop art, op art, earth art, installation art, performance art, minimalism, pattern-and-decoration, photorealism—art styles have whizzed through the art market at a dizzying speed. A collector may enter a gallery whose high white walls and impressive spaces connote a sacred space to find small brightly colored cubes of wood attached to the walls, or the floor strewn with candies. These works may have price tags of $10,000 and up. The dealer says this is brilliant work, made by an emerging artist who will soon be an important force in the New York art world. What is one to do? Serious, committed collectors find themselves in the position of the St. Louis connoisseur who admitted, "It's always hard to say [about a work of art], 'Oh boy, this is rotten,' because then you have to eat your words a couple of years later" (int. 44).

Someone who wants to purchase avant-garde art is thus in a risky position. Price is no reliable guide to excellence or art-historical value, because paintings in a low-level frame shop gallery can cost more than local avant-garde work in a high-art gallery. The dealer can provide information on prior sales and media stories to support any price. This has produced a problem where the market as an institution fails in its essential task of uniting would-be buyers with willing sellers. The cause of the problem is the buyer's lack of information relative to the seller about value in art—a case of the "lemons market" (discussed in chap. 1). In order for a collector to independently assess the monetary value of a work of art, he or she must know as much as a professional dealer about the artist's history of shows, works in important collections, and publications by significant critics. Since few consumers are willing to invest the time necessary to become experts, they avoid the market because of the risk. Therefore, the total number of collectors is smaller than would be expected from the social distribution of wealth or income and education.

The relative lack of buyers explains why artists have such a hard time establishing themselves in the market. Perhaps the modern artists' insistence on following their aesthetic vision without attention to the mar-

ketability of the work stems from a realistic appreciation of their very low chances of economic success. Remembering van Gogh, artists find good company in rejection by the market and place their hopes in the long run of history. This is the third key feature of art markets, the dissonant feelings avant-garde artists have about sales and production. In contrast to producers of lesser craft-goods, high-art producers live in a value system that is conflicted, not to say schizophrenic, about the importance of selling work. This makes artists in the United States or anywhere in the first world a bit strange, since they are embedded in a democratic capitalist society. The U.S. economy stresses marketing, defined as "getting the right goods and services to the right people at the right place at the right time at the right price with the right communication and promotion" (Kotler 1980, quoted in Dannhaeuser 1989). In a society where consuming is so central to the core values, the producer of a good who explicitly disdains to cater to the preferences of buyers seems perverse and irrational. Tammy, the business artist quoted in chapter 4, uses basic marketing common sense when she says, "I knew there was going to have to be somewhat of a compromise between painting for myself and painting for others, because if you totally paint for yourself and give no regard to the market, you are going to have a tough time moving your work and support[ing] yourself."

But perhaps because of the objective difficulty of selling enough work of any sort to make a living at it, many artists with grander dreams, but lacking Tammy's practicality and determination to support herself from art sales, pursue their own visions. Assuming the culture-creating responsibility of avant-garde artists, they choose to produce work in a style that responds to history rather than to the short-run, often ill-informed taste of someone who happens to have the money to pay. The young artist quoted in chapter 1 revealed standard high-art values in despising another artist who was explicitly concerned about satisfying customers.

> The worst kind of sellout is [artist X]. His work is horrendous, shiny, slick, devoid of personality—how can it not be for anything but to sell? It is void of any kind of personality of the artist. Slickness, you sacrifice yourself to anything just to sell. (Int. 133)

Extraordinarily few artists can support themselves from the sale of their artwork. Most have to teach or find other jobs to pay the rent, or marry an understanding, supportive spouse with a regular job and health insurance. Depending upon accidents of circumstance and personality,

artists who remain active producers waver between two extreme stances. Some live out their professional lives thankful for the ability to make art that they love and that gives meaning to their existence, treating the money from sporadic sales as windfall income, perhaps trying from time to time to get through the forbidding gates of a New York gallery. Others become cynical and bitter about the injustice of New York's hegemony and the lack of social and monetary rewards for their hard work. Some can maintain an impressive work schedule for a lifetime, while others understandably slow their production as years go by, pieces in storage mount up, and the contemporary equivalent of the fairy godfather does not knock on their door, as Leo Castelli did for Jasper Johns in 1957.

The disarray of art theory thus leads to heightened risk in fine-art purchases, which has diminished the size of the market and created a situation where there are many more artists aspiring to avant-garde status than can be represented by dealers. The balance of power is on the side of the dealers, which allows them to enforce exclusionary rules of representation. The main rule is "exclusivity," monopolization of the sales of the artist's work within their selling area. Dealers interpret this as their right to a share of all sales, even those in which they had no direct involvement.

The economic responsibility for an art transaction—the identity of the persons who made the deal happen—has thus been made subject to interpretation, so that profits can be negotiated between interested actors. Dealers demand part of the price from the sale of a work out of the artist's studio to a buyer who may never have set foot in the gallery. The dealer claims to have legitimized the value of the work in general, no matter that they were absent from the sales transaction in particular. Dealers claim that the gallery's affiliation gives the artist status in the local market, which enables the sale even though the dealer was uninvolved with the specific transaction.

Similarly, designers or interior decorators may claim a share of a sale by a gallery directly to a client, even though the designer may never have seen the artwork until after it appeared in their client's home. Their logic is that the designer, as aesthetic adviser to the client, legitimizes (and allows to stand) the purchase, even after the fact. Thus dealers are hoist with their own profit-sharing petards.

In such a postmodern art market, caveat emptor. The vast majority of people who do not relate to contemporary avant-garde work, yet who want some art on the walls, buy inexpensive reproductions from frame shops (cf. Halle 1993). The few collectors who value original art are split

into those who are attentive to New York's hegemony and want to have cutting-edge work direct from the center, and those who want to support their local art world. But among the latter segment of the art-buying population, the cultural imperative not to throw money away limits sales. Most local sales are significantly below ten thousand dollars, most often less than a quarter of that figure, since local work has no resale value.[2] This explains the wealthy collector's statement, "I'm not rich enough to pay a thousand dollars or more for a piece of art that I can't give to a museum or sell" (int. 44). What she meant, in the words of another collector, was "We don't want to have our estates devastated. We can't buy wallpaper every day of the week" (int. 86) (both quoted in chap. 6).

Dealers in local art must confront the reality that their sales are restricted. In order to survive economically most live on nonart money from inheritances, other business, family resources, a spouse, and so on, and hope to keep their spirits up as long as possible. More rarely a few dealers limit expenses drastically and live like artists, sacrificing their lifestyle for the sake of advancing art. It is not uncommon for dealers to become so demoralized or bored that they feel the gallery is not worth their effort after about five to eight years in business.

The art world in St. Louis is like any other art world with respect to the issues just discussed. On top of the difficulty involved in selling avant-garde art, St. Louis artists and dealers face the denigration of local work just because of its location "not in New York." Artists face this existential problem whether they reside in Brooklyn, Boston, or San Diego. The special aspects of life in St. Louis are that it has extremely low living costs and a relatively homogeneous, supportive local art community on one hand, and a midwestern propensity to adopt the "cultural cringe" when confronted by art from larger centers on the other hand. The available data on artists, dealers, and exhibition places offered in appendix 5 shows that St. Louis comes out about in the middle of the largest metropolitan centers in the United States. Since St. Louis falls about where it should by its population size on these distributions, it seems to be a representative, normal art world.

Risky Transactions: How the Art Market Is Like a Peasant Marketplace

I have argued that the core features of the art market create asymmetrical information between buyers and dealers, which heightens risk and anxiety in buying transactions, and that the solution is normally found in social relations. Embedding a purchase transaction within a

long-run, generalized, personalized relationship lowers risk. As the gallery director quoted in chapter 5 told her client, "I know where you live— I know your mother" (int. 21). This is similar to how peasants use socioeconomic strategies to reduce risk in economic transactions. Marketers in agrarian societies are often relatively ignorant about important qualities of goods. The knowledge problem is due to their inadequate societal infrastructure: poor communications services, inadequate roads, and unreliable systems of contract enforcement. There is a high risk of not getting what one expects, in quality, quantity, time of delivery, and so forth. This leads peasant marketers to cut their risk by establishing long-run, personalized trading relationships (well known in economic anthropology as *pratik* in Haiti, *suki* in the Philippines, *cliente* or *marchante* in Latin America, and *onibara* in Nigeria). In agrarian societies, which are poor by definition, these information problems are systemwide. Even mass-produced goods of standardized quality are often traded through personalized venues in order to regularize supply or payment, which otherwise may be unpredictable. Of course transactions in peasant-produced goods, which are nonstandardized and extremely variable in quality, are even riskier (Plattner 1989, chap. 8).

None of the peasant market's infrastructural poverty exists in the contemporary United States, where we are normally flooded with market information, standardized goods, and consumer protection resources. But the nature of the avant-garde art market produces information problems comparable to the peasant market that heighten risk in transactions. Potential buyers do not know how much a unique piece of art is worth. While they may "love" the work, no one wants to get cheated. Buyers with a little experience know that art transactions can be manipulated in ways that may actually be illegal in other markets. As the salesman quoted in chapter 6 said, when buyers ask, "'Is this thing going to go up in value?' . . . I can say, 'Oh yes, that's investment quality.' If you were selling securities, you could be prosecuted for this" (int. 14).

But art dealers are not prosecuted for such statements since they are dealing with unique works whose price is not standardized. A saleswoman remembered being shocked when the dealer she was working for arbitrarily raised the price of a painting for a buyer who had agreed to spend a lot of money at the gallery.

> It listed [in the gallery's private selling-price code] for $2,800. I'll never forget this. And the gentleman said, "That is fabulous! How

much is that piece? I want that piece." And [the dealer] looked him straight in the face . . . and said, "That's $5,000." And so the man said, "OK, I have to have that." (Int. 21)

Was the dealer cheating the client, or correcting the price in response to heightened demand? The answer depends on the general price movements for the artist's work. The saleswoman's surprise says that the dealer took advantage of the buyer's willingness to pay.

One solution to the risk of being cheated is to buy artworks that have "legitimacy," as described in chapter 6. The term connotes a situation in which the art is known beyond the site of one self-interested dealer, so that the buyer has the security of feeling part of a larger community of collectors. Another solution is to establish the art world equivalent of *pratik*. The collector mentioned in chapter 6 who agreed to pay seven hundred dollars more than the agreed-upon ceiling for a piece that a dealer bought for him at auction boasted that his overpayment "bonded" the dealer to him. The dealer did not merely sell him art but guided the collector toward more significant work. For example:

> He wouldn't let me buy a Mary Cassatt from him. He said it was too expensive. . . . It was five thousand dollars [in the late 1960s. The dealer said,] "I don't think you should get that. I'll sell that to some Park Avenue lady" [i.e., a buyer with more money than taste]. . . . So he sold me a Picasso print that was much tougher, . . . and a precursor of the *Guernica* painting. [The dealer] thought that was very important, and it is. (Int. 117)

Several collectors discussed in chapter 6 mentioned how meaningful it was to have relationships with dealers. For example, the New York dealer Joseph Helman began his career in art as a collector in St. Louis. He described how he built a relationship with Leo Castelli by agreeing to give five hundred dollars a month "on account," not for any specific artworks. By helping Castelli pay his normal gallery bills (which included stipends to some artists), Helman showed his commitment as a buyer and assured himself of preferential treatment by the gallery.[3] After several years of increasing involvement, Helman became a dealer himself, first in St. Louis and then later in New York. While Helman's commitment and resources may have been extraordinary, the goal of establishing a relationship, of getting the dealer "on your side" is common for most serious collectors.

This interest in reducing risk by committing to a long-run economic relationship makes wealthy collectors in the most powerful economy in the world comparable to poor traders in developing economies.

The Existential Value of Down-Home Art Worlds

For those who "just" want to live in a pleasant circumstance, bring up a family, and make a living teaching, the art world of St. Louis is agreeable and supportive. There are enough galleries and collectors interested in sustaining the local scene (although the artists will never admit it). But artists must be self-starting to retain a commitment to avant-garde art. Nothing in the local community demands that artists stay on the cutting edge, and the sales pressure is for less-difficult art.

Artists also face the disparagement of local connoisseurs who criticize them for failing to live up to their part of the artists' social compact, described in chapter 1. In exchange for release from many rules of social behavior that others of their status are expected to comply with, they are expected to advance the culture's vision, to "tilt against history." When they make art that ignores the state of the art in New York, they seem to be taking the easy way out.

Collectors, almost by definition, have the resources to travel to New York or anywhere else to see art. Those who want to support the local art scene have it a bit easier than they would in New York, since the relatively tiny size of the local art world allows an individual to make a difference with fewer resources. Perhaps for that reason, the local artists tend to feel that the St. Louis art world is a supportive one.

Dealers, like any small-business proprietors, complain that they have a difficult time. The problem in St. Louis, as in any place out of New York, is the limited size of the population of collectors and the relatively conservative taste, in particular, and the relative lack of exciting local art world activities, in general, so that the benefits of scale are not possible. The advantages are the cheap rents and living costs, on one hand, and the same small scale, on the other, which allow a significant contribution to be made (and recognized) with a relatively small investment.

Curators, critics, and other art world personnel not directly connected to the market face similar existential problems. They can enjoy St. Louis's easy, pleasant quality of private life and reasonable, low-cost scale, while they suffer from the lack of stimulation and local challenge. In this, the art world in St. Louis is similar to the situation for any creative person, including writers, musicians, and academics. St. Louis's Washington Uni-

versity, for all its wealth and accomplishments, is not Harvard, Chicago, or Stanford. Specialists in many fields may confront a "cultural cringe" similar to that faced by art world participants. This issue, however, brings up the general problem of cultural cores and peripheries, a subject for a different sort of study.

Postscript: The Importance of Variation

In an attempt to explain how an institution works, the social scientist will concentrate on ordinary, average, representative things. Artists, on the other hand, prize individual variation above all. The goal of an artist is to depict the extraordinary aspects of behavior, the special characters, and by that to show the viewer that reality is multifaceted, richly mysterious, and always rewarding to a fresh new view. This book has also pointed out the rich variation of individuals in the art market. From artists who live in the grants economy rather than the private-sale market, or who see art as a means to advance racial justice; to dealers whose personal appearance belie their extraordinary love and knowledge of art; to collectors whose love of art surmounts problems of race and class, this book has shown that art has the power to let people rise above their normal, expectable lives to forge an independent, personally rewarding path.

Appendix 1
Glossary of Art Speech

Artists and other members of the art world use words in a special way, valuing open-endedness, subtlety, and multiple interpretations. Many artists are delighted at interpretations of their work that are radically different from their original intent, since they appreciate the creative contribution of viewers. This is different from academic or scientific norms, where the function of words is to precisely convey the meaning of the writer. Being a member of the latter culture, I define some of the key terms used in this book. My purpose is not to impose my own definition over that of anyone else, but to minimize misinterpretation.

aesthetic. Having to do with the nature of the reaction to a work of art; the philosophy or theory of art.

catalogue raisonné. Publication listing all of an artist's certified work to date.

content. (1) The surface subject matter of a work of art, i.e., what is portrayed.
(2) The deep subject matter of a work of art, i.e., existential, conceptual, intellectual, emotional, or religious notions evoked by the surface subject matter and the form.

craft. Art of a functional nature that has lower status than high art. Traditionally used for ceramics, metalsmithing, weaving, woodworking, and basketry.

fine art. Art capable of being shown in museums of fine art and sold in the most elite galleries and auctions. Traditionally painting, drawing, prints, and sculpture whose style is identifiable with an individual artist.

form. (1) The shape of an object portrayed in a work of art. (2) The volume of an object as rendered in an artwork, i.e., light and dark patterns showing roundness. (3) Compositional elements such as centrality, balance, and tonality.

high art. Same as *fine art.*

image. (1) The mental picture an artist has of the desired or ideal appearance of the work, as distinct from its actual appearance. (2) The realized portrayal or actual appearance of the work.

investment-quality art. Art by an artist whose work comes to auction frequently enough so that it has (or dealers can claim that it has) a roughly predictable resale value.

kunsthalle. A public art exhibition space that does not have a permanent collection, like a museum, but mounts shows on a diverse schedule. The fact that this German term is in common use reflects the ascendancy of German art in the world market since the 1970s.

local art market. The artists, dealers, and collectors who make, sell, and buy art as well as the critics and museum curators who influence art prices in any single geographically defined community.

low art. Art of a decorative or functional nature that does not represent a significant contribution to the state of the art.

MOMA. The Museum of Modern Art, in New York City.

oeuvre. The body of work produced by an artist, considered as a coherent artistic statement.

primary market The dealer's market in which work moves from producer (artist) to dealer to consumer.

provenance The documentation of the history of ownership of a work of art.

regional art market. The local art market of a major urban area, usually used by art world members to refer to markets other than New York.

secondary market. The market for works of art owned by a collector, i.e., previously sold by the artist or dealer to a collector. This is the usage common in the art world. (In academic economic usage, the term is usually used to denote sales by a dealer rather than a producer. This book follows the art world usage.)

vision. The artist's image (in the first sense listed), a worldview or interpretation of art as expressed in the oeuvre.

Appendix 2
A Note on Art and Craft

The elite orientation of fine art is shown by the changes in the social status of craft. In one of their empirical meanings, the words *art* and *craft* distinguish artists who make things that advance the viewer's vision of reality (usually paintings, drawings, prints, and sculptures)—called high art or fine art—from craftsmen who make things that have functions in daily life (often out of ceramics, glass, fiber or jewelry metals), which are called low art or crafts.[1] Artists stress concept and vision, while craftsmen stress physical material and the skill and execution through which the vision is made manifest. In the most simplistic sense, this can be seen as the tension between *theory* and *practice*. Theory is abstract and more difficult to comprehend, requiring more specialized training, while practice is concrete and easily comprehensible.

The general reason for high art's status is that it serves as a sumptuary good to validate the owner-collector's high social position (Bourdieu 1984). Leaving aside functional crafts, there is nothing intrinsic to the visual experience one gets from interacting with art objects that distinguishes them from craft objects—the difference lies in the social context of each.

The distinction has been hotly contested for many years, since art status confers much higher rewards. Attribution to the status of art has been shown to be gender biased (Nochlin 1988) as well as culturally biased (Price 1989). Men's and Western society's art production has been raised to the art category, while women's and non-Western, particularly third-world art has been denigrated as craft. A recent discussion of crafts points out that "The fact that traditional craft was often associated with women, outsiders, and people of color didn't help matters much . . . the histories of all the crafts can be seen to be the history of the 'other'" (Cabeen 1993, 15).

The twentieth-century modernist program of art for art's sake, which elevated ideas to an elite cultural plane higher than objects, was a recent element in the devaluation of crafts in relation to art, but, as chapter 2 shows, the tension predated the modernist ideology.

A naive observer (meaning an intelligent, educated generalist without art market experience) looking at artworks in a neutral context will find it impossible to distinguish between art and craft objects in many cases, because the difference is behavioral: artworks, being more like classical paintings and sculpture, pertain to art worlds where they are collected and displayed, not used for everyday functions. The specific reasons for particular art forms being high or low are not always clear, but state societies have always divided art objects into higher and lower status

classes. Among the Aztecs, for example, murals were associated only with the highest state elites, while decorated pottery was associated with a wider and therefore lower range of statuses (Brumfiel 1987).

The distinction is historically contingent since things labeled craft can become art and vice versa. Becker discusses the development of craft traditions in art worlds, when "the originally expressive art works and styles become increasingly more organized, constrained, and ritualized" (1982, 288). He gives the example of engraving, which in the sixteenth century became academic, as the artists shifted "their concern from expressiveness and creativity to virtuosity" and specialized in rendering different surfaces such as glass, metal, fur or silk (289). He describes how this sort of emphasis on formal rules over content lends itself to commercial applications and becomes institutionalized until new rebels overturn the old rules in a search for independence of expression (296–98). The distinction may have originated in the traditional, nonindustrial societies' equation of foreign origin (of goods as well as artist-craftsmen) with elite status and high moral order (Helms 1993).

In recent times, practically all artists working in ceramics, fiber, metal jewelry, and basketry made functional or decorative pieces—until the 1960s. Then a few began making nonfunctional pieces in an overt bid for fine-art status (cf. Becker 1982, chap. 9). These works were shown in fine-art settings and challenged the distinction between art and craft. At the present postmodern time there is an enormous range of variation and fluid boundaries, with some craft objects shown in elite galleries and commanding relatively high prices. But in general the distinction holds, as evidenced by the price differential between the finest craft objects, such as Dale Chihuly glass or Robert Arneson ceramics, which rarely sold for over a hundred thousand dollars, and relatively expensive paintings by comparable figures such as Jasper Johns or Robert Rauschenberg that have auctioned for millions.

This is a contested area of culture. Artists in clay, fiber (the high-art terms for ceramics and weaving), glass, wood, or metal feel that their work is unjustly devalued in comparison with paintings and sculpture, while painters and sculptors feel that craftwork has no business competing with "real" art. Some collectors specialize in crafts because they can buy the work of acknowledged masters for a fraction of the cost of comparable work in painting, while others prefer to buy paintings over crafts because they want the aesthetic significance that they have learned to get only from paintings (these issues are discussed in chapter 6, on collectors).

There is a paradox in the tension between art and craft in the market: many collectors were attracted to crafts because of the physical-material and skilled-execution aspects of craft in reaction to the dematerialization of contemporary art, where idea was ennobled over object, culminating in the school of conceptual art where the object was finally made irrelevant. But many sophisticated collectors favor work in which ideas and concepts dominate craftsmanship and material. Their preferences support the development of the elite end of the art-craft market, which comes to approximate the fine-art market, and the cycle continues.

Appendix 3
Art as Investment

Major academic studies of the investment value of art have been done by Baumol (1986), Frey and Pommerehne (1989a, 1989b), Goetzmann (1993), Pesando (1993), and Singer (1978). Watson also summarizes the experience of the British Rail Pension Fund (1992, 423–32). The main conclusion of these studies is that art investment is risky and tends to give a rate of return not significantly greater than the safest investment possible, government securities, somewhere around 2 percent a year. The shorter the holding period of the artwork, the larger the risk and potential profit or loss.

Baumol, Frey and Pommerehne, and Goetzmann used Reitlinger's compilation of art sales (1960, 1963, 1970) to analyze 640 paintings bought and sold between 1652 and 1961 (in Baumol's study), 1,198 paintings between 1635 and 1987 (in Frey and Pommerehne's case), and 3,329 resales of 2,809 different paintings between 1715 and 1986 (in Goetzmann's case—the latter two studies supplemented Reitlinger's data with more recent sources). The methodology was to note the successive sales of particular works and calculate the rate of return. Frey and Pommerehne point out that the highest gains and losses occur with the shortest holding times, revealing that the art market can truly be a speculator's market. Singer developed his own database of two hundred simulated transactions in fine arts, graphics, silver, and porcelain from auction records from 1955 to 1960. Singer estimates that a portfolio of stocks and bonds would have yielded 2 percent more than the average return on his simulated portfolio (1978, 34).

Pesando analyzed prices for 27,961 repeat sales of modern prints from 1977 to 1992, coded from annual publications of print auction prices. His study is particularly interesting because he dealt with multiples (which in principle reduce the uncertainty of dealing with unique works like paintings) and with modern masters like Picasso, Chagall, and Miró. He also coded prices after the bust of 1990, which corrects for the price and sales inflation leading up to that period in earlier studies. Pesando found that the mean real return on an aggregate print portfolio was 1.51 percent, less than the mean real return for Treasury bills (2.23 percent), long-term bonds (2.54 percent), and far less than stocks (8.14 percent). The standard deviations of the real returns to the print portfolio were almost 20 percent. Thus investors in modern prints suffered more risk for less returns than they would have in the safest alternative investment.

Pesando separated the most expensive works from the others, to test the hypothesis that investment in the best works is safer than investment in average works. A portfolio of Picasso prints (6,010 repeat sales) yielded a 2.10 percent real return with a standard deviation of 23 percent—a higher return with more risk than the entire portfolio, but still a worse investment—lower gain and higher risk—than the safest alternative. Pesando also separated the most expensive 10 percent of all the prints by any artist and examined their price appreciation, which he found to be no better—and sometimes worse—than the average-priced prints.

These diverse studies yield similar results: buying art as a financial investment is a bad idea. The studies have been criticized: Holub, Hutter, and Tappeiner (1993) find fault with all studies based on the methodology of examining repeat sales. They point out problems with the representativeness of the data from this restricted set of transactions, since many art sales have been left out of the database because they were not sold twice, or were donated to museums, or were sold privately, not at auction; the omission of short-term rates of speculation from the database since it focuses on long holding periods, so that a sequence of short-term investments, in which a buyer held the work for ten or twenty years, for example, and sold for high profits, are underrepresented in the conclusions; and the lack of knowledge of the investor's identity, so that professionals who hold insider knowledge are not distinguished from amateurs. Their general point is that broad historical studies are not useful, and that studies based on fuller data from contemporary markets may find a range of outcomes, including high to low rates of returns. This may be true, but the narrower the range of a study, the less it can generalize to a broad set of circumstances. Their criticism does not invalidate the findings of the other studies but merely reminds us that there are many countervailing movements within any broad average trend. The studies do not show that expert insiders cannot make high short-term profits, especially when they are dealers or curators with an ability to manipulate the market standing of certain artists.

The British Rail Pension Fund (BRPF) conducted what turned out to be a real-life experiment in the profitability of art as an investment by experts. The fund decided to invest in art in the early 1970s, as a means of defending its resources against inflation. It hired professional advisers and worked with Sotheby's auction house to develop a collection. Hostile public opinion and political pressure (against a public body "trading in art") made the fund begin to sell off its art in the late 1980s. The BRPF had bought 2,232 objects and had sold about 75 percent of the collection by the end of 1991. Watson reports that their accountants calculated their rate of return as slightly over 6 percent corrected for inflation (without deducting full costs such as administration, transport, and insurance). The BRPF feels that it came out "some 1.5 to 2.0 percent better than Treasury bills over time, but of course a good deal worse than equities" (Watson 1992, 424). The BRPF had professional advice and the benefits of a truly deep pocket, which are not available to private investors without tremendous wealth. Watson notes that the future sale

of major works still in the fund's possession will probably reduce the average rate of return, since the "art boom" is over.

The conclusion to be drawn from these diverse empirical studies is that we cannot predict success in the art market. Speculation is a game for experts who also love art. When their dealings lose financial value, at least they are left with a commodity that they nevertheless cherish for its own sake. Average people looking for a good investment find no support for investing in fine arts from these diverse studies.

Tax Incentives

The federal government has supported the creation of museums, and indirectly the entire art world, by giving income tax benefits to collectors who donate work to public institutions. The deduction as originally instituted allowed a collector to donate a work by signing it over to a museum but to retain possession until death. The government allowed the donation to be valued at the current market price (as opposed to the purchase price) and to be taken when the work was consigned to the museum (but still on the collector's wall). A collector in the 50 percent tax bracket could buy a piece for $25,000, donate it to a museum for an "expert" valuation of $50,000, and write the entire cost off in exempt taxes. Everybody gained: the artist sold the work, the dealer made the commission, the museum secured the art, often immediately on short-term loan (whereby the museum exhibition would have validated its high price), and the collector enjoyed the work, as well as the status of public benefactor, for free (Marquis 1991; Meyer 1979).

The tax laws prohibit artists from benefiting by making such donations themselves unless the market price of their work is unambiguously established, usually through gallery and auction sales records. Feld, O'hare, and Schuster (1983) point out more complex scenarios: imagine that a collector in the 50 percent tax bracket buys a painting for $50,000 and sells it to a gallery for $95,000 on the understanding that the gallery will sell the work to a museum for $100,000 that the collector donates to the museum. The collector spends $150,000 but earns $145,000 ($95,000 from the gallery and $50,000 in tax breaks). For $5,000 the collector has the prestige of a $100,000 donation and the gratitude of the museum and the gallery. The authors point out that the real cost is paid by the general public in lost tax revenues.

The law was tightened over time so that the deduction could be taken only at the time of the work's transfer. Then the deduction was restricted to the original cost, not the current estimated price of the work. As can be expected, donations to museums fell off drastically when the real cost to a collector was the foregone difference between the purchase price and the current value. More recently the federal government has reinstated the deduction on the basis of current market value.

Wealthy collectors have access to expert advice on minimizing taxes. One tax

vehicle is the "like-kind exchange," also called a "10-31" for the name of the reporting form. This law allows items to be exchanged for like items of the same substance, that is, paintings for paintings, sculpture for sculpture, to defer tax on either side. Smart dealers can set up complex trades involving many parties, to allow each side to get the art they want with minimum capital gains tax.

While there is no denying that these tax advantages favor the wealthy and allow them to act as community benefactors "on the cheap," as it were, this public policy is the envy of many European countries. Without comparable laws, the art world in those countries must survive on government aid, with all the problems of centralization and bureaucracy that implies (Bourdieu and Darbel 1990). The American system does facilitate the private support of local art worlds.

Appendix 4
The Influence of the Japanese on Auction Prices

What was the cause of the price rises of the 1980s? The phenomenal increase in wealth of the richest class of American society during the Republican administrations was a large factor for the growth of the market, but it is not a sufficient explanation of the height of the boom. Watson argues convincingly that the extraordinary prices of the late 1980s were due to the influence of Japanese buyers. The shift of global wealth in Japan's favor and their historical preference for impressionist artwork led them into the Western auction markets. Their peculiar pattern of bulk purchases was due to money laundering, Watson argues. Art transactions were not controlled by the government, while regulations limited the maximum profits speculators could gain in real estate or stock exchanges. During the 1980s the Japanese economy boomed, and in particular its real-estate market was the source of amazing amounts of profit, especially when magnified by foreign-currency exchanges. The yen gained value over Western currencies and made Western purchases relatively cheap for Japanese buyers.

Watson gives the example of Itomon, a Japanese textile trading firm, which bought 7,343 paintings in 1990, many from Western dealers and auctions. While most of the purchases may be due to the Japanese thirst for European art, some seem to have been used for illicit payoffs. Itomon seems to have used art to move money around that was earned through real-estate deals. Sellers of land, golf club memberships (which are highly prized in Japan), or politicians who needed to be "reimbursed" for favors would be sold an expensive painting with the understanding that it would be bought back for enormous profit some months later. The "burst bubble" of the Japanese real-estate market seems to explain the cooling of the U.S. art market.

Appendix 5
Statistical Comparisons among the Largest Metropolitan Areas

Quality-of-Life Measures

In most statistical measures (as of 1990) St. Louis comes out roughly in the middle of the top thirty metropolitan areas of the United States. Its population is 81 percent white and 17 percent black and is relatively stable, having changed little in the decade 1980–1990. Per capita economic output is average, although the region has relatively high unemployment (it ranked twenty-second in unemployment) and has seen its well-paid manufacturing jobs converted into relatively poorly paid service jobs (the region ranked twenty-third in a decreasing rank-order of the value of earnings per new job).

St. Louis follows a southern "low-tax, low-service" strategy of government. The region ranks twenty-ninth out of thirty in local revenues as a percent of income, and twenty-eighth in the per capita value of local government services. It enjoys more than an average share of federal funding, ranking second, behind only Washington, D.C., in per capita federal military funding (this is due to the presence of McDonnell Douglas, a major defense contractor; in nondefense federal funding, it ranks nineteenth, in federal grants, twenty-fifth).

The region is average in statistical measures of individual and family well-being such as percent of the population in poverty, teen-aged and unwed-mother birth rates, and death rates. St. Louis is a major medical center and provides high-quality and plentiful medical services to the middle-class population of a vast midwestern area. The region has always boasted plentiful and cheap housing, and in 1990 ranked very well (i.e., low) on one measure of affordable housing, the percent of households paying more than 35 percent of their income for housing.

While St. Louis is average in violent crimes per capita, it ranks poorly in its homicide, suicide, and accident death rates. The most striking statistical comparison is between city and county: St. Louis ranks worst of the top thirty metropolitan areas in the ratio of central city to suburban crime. This means that the metropolitan area is extremely segregated. It has succeeded in confining the worst poverty and its associated crime to the inner city, isolating the outer suburbs from this sort of misfortune. Compared to the other central cities within the thirty areas, crime rates for the city of St. Louis were among the three worst in all major crime categories.

As in most of the larger metropolitan areas, people fear crime when they go from country to city. This impacts the art market for those galleries situated in the downtown area, since middle-class suburban consumers don't feel comfortable searching for parking downtown and making their way on unpleasant streets into the galleries. Downtown gallery owners complain bitterly about the "unreasonable" fearfulness and laziness of the suburbanites whose patronage they need. Gallery owners point to nearby pay parking lots, cite reports of violent crime in the county as well as in the city, and remind everyone that most inner-city crime is between people who already know each other. In the long run, their enjoyment of cheap rents downtown can't overcome the reality that people prefer to shop where they feel comfortable and unthreatened. While successful gallery areas have developed in comparable areas in New York, Chicago, and other cities, the critical mass has never been reached in midtown or downtown St. Louis.[2]

Comparative Art Market Measures

The *Art in America Annual Guide* is a listing of museums, galleries, and artists published by *Art in America,* a nationally distributed monthly art magazine. The 1992 *AiA Annual* listed over eighteen thousand names of artists who are represented in at least one gallery, museum, or alternative space. This can be taken as a measure of the minimum population of active professional artists in the U.S. market in 1991–92. It is probably most complete for the New York and East Coast art markets, since these would be more attuned to the New York–based magazine, yet the rest of the country still looks to New York for information. I will use it as a minimum estimate.

Some listed galleries deal in the work of deceased artists, whose names are listed in the artist section. I found about 2 percent of the names to be dead or inactive in a sample of a few pages. Generalizing this will reduce the estimated total to about 18,000 artists nationwide. There are 94 St. Louis artists listed in the *AiA Annual* (out of my list of about 800 artists in St. Louis), meaning they show work in galleries represented in the annual. Thus, roughly 1 in 10 artists working locally is in the *AiA Annual,* and the total number of St. Louis artists listed in the *AiA Annual* comprises about one-half of 1 percent of all the artists listed.

How does this compare to census data? The 1990 census listed 2,219 artists ("painters, sculptors, craft artists, artist printmakers") in the St. Louis Metropolitan Statistical Area labor force (the Census Bureau defines the figure as those available to work but not necessarily working as artists). The total U.S. work force of painters in 1990 was given as 212,762 (NEA 1994, table 18). Thus St. Louis artists comprised about 1 percent of the national total in 1990. For comparison, the St. Louis population of 2.44 million comprised about 1 percent of the total U.S. population of 250 million in 1990. St. Louis is neither very high nor low in terms of number of artists by the census data, but seems underrepresented in the *AiA Annual,* which we assume is more focused on the New York market (see table A.1

Table A. 1 Artists and Exhibition Spaces, by Metropolitan Area (1990 Census)

Consolidated Metropolitan Statistical Area	Population (in thousands)	Artists	Spaces	Artists per space
1 Santa Fe	75	704	65	11
2 Milwaukee	1,432	1,453	18	86
3 Cincinnati	1,453	1,275	21	61
4 San Jose	1,498	1,186	8	148
5 Kansas City, Mo.	1,566	2,048	14	146
6 Denver	1,623	2,082	37	56
7 Newark	1,824	1,764	3	588
8 Cleveland	1,831	1,554	15	104
9 Miami	1,937	1,471	36	41
10 Seattle	1,973	3,015	45	67
11 Pittsburgh	2,057	1,331	20	67
12 Tampa-St. Petersburg	2,068	1,910	15	127
13 Phoenix	2,122	2,026	34	60
14 Baltimore	2,382	2,314	19	122
15 Anaheim–Santa Ana	2,411	3,361	1	3,361
16 St. Louis	2,444	2,219	36	62
17 Minneapolis–St. Paul	2,464	3,016	35	86
18 San Diego	2,498	2,847	36	79
19 Dallas	2,553	2,801	36	78
20 Riverside-San Bernardino	2,589	1,355	3	452
21 Atlanta	2,834	3,190	40	80
22 Boston	2,871	3,771	79	48
23 Houston	3,302	2,505	44	57
24 San Francisco	3,687	3,434	137	25
25 Washington, D.C.	3,924	5,276	107	49
26 Detroit	4,382	3,148	9	350
27 Philadelphia	4,857	4,786	54	89
28 Chicago	6,070	6,970	157	44
29 New York	8,547	15,058	797	19
30 Los Angeles	8,863	11,464	209	55

for the numbers of artists and exhibition spaces in the twenty-nine largest metropolitan areas plus Sante Fe).

Figure 15 shows the total public and private exhibition spaces in the twenty-nine largest metropolitan areas plus Santa Fe as listed in the *AiA Annual*. New York is off the map, since its prodigious total of around eight hundred spaces is out of proportion to the rest of the distribution. Similarly Santa Fe is outside of the distribution, since its number of exhibition spaces is unrelated to its size (less than 100,000) and more comparable to an area of 3 or 4 million people. New York is the

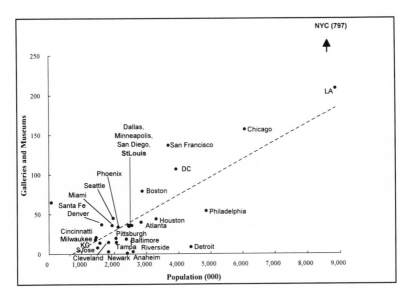

F<small>IG</small>. 15. Exhibition places by population size (1990 Census).

national center for art, and Santa Fe is a major regional market for both the Southwest genre and national-art styles. San Francisco also stands out as having significantly more art spaces than would be expected from its population, while Detroit has many fewer. The straight line is a linear regression that expresses the average number of spaces expected for any population size—the closer a city is to the line, the more average it is, and the further away the more remarkable. St. Louis is not distinguishable at all from Dallas, Minneapolis–St. Paul, and San Diego in this data and is surrounded by the other urban places (the numerical data are given below).

Figure 16 shows St. Louis's position in the largest twenty-nine metropolitan areas as measured by the 1990 census of artists in each area and its total population. New York is again outstanding, with 15,058 artists. New York and Los Angeles are comparable in terms of population, yet New York's dominant position in the art market is revealed by the extraordinary number of artists and exhibition spaces there. It is clear that the city represents a different structural reality. The rest of the metropolitan areas fall somewhat close to the average for their size. Detroit is below the linear-regression line representing the average, with relatively fewer artists for its population; Seattle is above it. St. Louis is not distinguishable by these data, in the middle of a cluster of symbols for Anaheim, Dallas, Baltimore, Minneapolis–St. Paul, and San Diego. These places with comparable total populations have about the same number of artists. In this data, St. Louis seems represen-

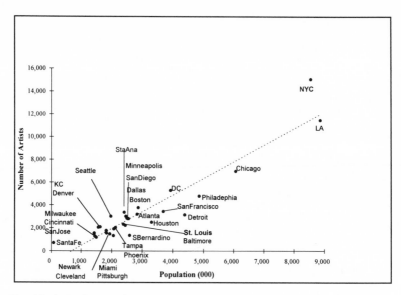

Fig. 16. Artists by population size (1990 Census).

tative of the large number of metropolitan areas that are smaller than New York, Los Angeles, and Chicago.

Figure 17 shows the number of artists (according to the census) per exhibition space. Santa Fe and New York have the lowest number, one exhibition space for about twenty artists. San Francisco, Miami, Chicago, Boston, and Washington, D.C., have relatively higher numbers of artists censused per exhibition space. At the other end of the scale, Newark, Riverside–San Bernardino, Detroit, and San Jose have extraordinarily few exhibition spaces per artist. St. Louis is in the middle of the distribution and similar to Seattle, Pittsburgh, Cincinnati, and Phoenix.

To conclude, statistical data on numbers of artists and exhibition spaces in the thirty largest metropolitan areas show St. Louis as a representative place. This does not mean that every metropolitan area is not special. These data are limited and do not summarize all of the important aspects of the art market in each city. For example, a local artist who had lived in Detroit disputed the impression given by these figures (see the vignette of Fabian in chapter 4). In his personal experience, Detroit had a vibrant art world that he compared quite positively with St. Louis's.

Other artists pointed out that Washington's relatively high ranking does not reveal the widespread feeling that it is a bad town for artists. Women artists (married to lawyers and bureaucrats) who are not fully professionalized are overrepresented in D.C.[5] Artists complain that the quality of the art world, as measured by the solidarity of the local art community, is less favorable than it is in a place like St. Louis. Perhaps towns dominated by government are less supportive of the arts

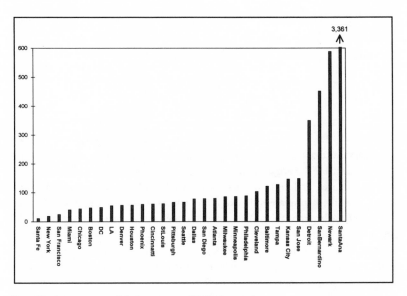

FIG. 17. Artists per exhibition space (1990 Census).

than towns with substantial business. And, finally, Minneapolis–St. Paul seems indistinguishable from St. Louis on the measures presented here, but people who have lived in the Twin Cities claim that art institutions and artists are significantly better supported there than they are in St. Louis. Minneapolis has a local foundation specializing in Minneapolis artists, as well as a relatively dense and lively gallery area.

All of these caveats may be true, as each place has unique features. What this data has shown is that St. Louis falls comfortably in the middle of the measures that are available. The reality of the St. Louis art market should be substantially similar to the reality of the vast majority of art markets, containing the greater part of the nation's art activities outside of the major centers.

Appendix 6
Art in America
and Local Gallery Guide Listings

I assume that the *Art in America* list is incomplete but unbiased as to the type of facility listed.[6] The artist's names are taken from information provided by the exhibition spaces (galleries and museums) listed by the *AiA*. To check on the accuracy of this list, I compared the exhibition spaces in the local St. Louis Gallery Guide to those listed by the *AiA*, and then did the same comparison for the Washington, D.C., guide. A listing in the *AiA Annual* is free if the facility sends in the information; listings in local gallery guides cost nominal amounts of money, currently $175 annually in St. Louis. In both cases the gallery guides had more listings than *AiA* (63 percent more in St. Louis, 7 percent more in Washington). I assume the smaller variance for Washington reflects the greater salience of *AiA* listing for the D.C. area, situated so close the New York.

I identified 76 galleries and museums in St. Louis, of which 60 (79 percent) appeared in one list but not the other. The comparable figure for Washington is 168 places, and 111 (66 percent) not duplicated. There was no pattern in the type of facility listed by the *AiA* or the local guide but not both. Large, small, regional, or local galleries or museums were as likely to be omitted from one as the other in both St. Louis and in Washington. Since I could find no clear bias, I proceeded to use the *AiA* list for this analysis.

Appendix 7
Secondary Skills Necessary for a Professional Artist

Photography

Artists need to have 35 mm slides to document their production for potential dealers, juries, panels, and all of the other gatekeepers who can dispense exhibitions, money, or publicity. For many circumstances a 4" × 5" color transparency is preferred. Some critics complain about slides since they reduce and destroy the sense of uniqueness and scale of works of art (Hughes 1990, 12), but slides are the preferred means of communication of art images. Once a piece is sold, the artist has no better means of documenting its existence for record keeping, lectures, grant and job applications, and the like.

Art is difficult to photograph well. Direct lights create highlights, reflections, and sharp shadows that detract from the image. Film must be calibrated to the lights in order to get a faithful color reproduction of subtle values, which is extraordinarily difficult. Some artists buy the cameras, tripod, lights, light stands, and other equipment and learn how to take their own slides; others hire professionals. The luckiest few artists have dealers who photograph the work as part of their responsibility.

Framing, Crating, Carpentry

In order to get the work to a client in proper format, artists must know how to frame, mat, crate, and transport their art, or else be prepared to pay specialists to do this for them. Matting and framing are, like photography, more technical than they seem, given the possibility of pastes and tapes darkening with age and staining the work, or of frame glass harming the surface. There are many framers in any urban area who can do nonarchival framing, but framing of archival quality is critical if the work is to endure. Crating a piece to be transported is expensive, since the crate must be able to withstand rain and sun as well as hard knocks. The simplest way to transport a work of art is through a specialized art trucker, and active artists with dealers or clients in several cities must be familiar with prices and routes.

Record Keeping

No one teaches artists how to keep their business records, so each artist reinvents his or her own version of the accounting wheel. National volunteer organi-

zations, such as the St. Louis Volunteer Lawyers and Accountants for the Arts, give advice to artists. But artists rarely solicit training early in their career to set up their records in a professional manner. Aside from tax-related records, artists must maintain mailing lists of collectors and records of the current location of works consigned to galleries as well as the disposition of sold works. Those who can afford one invest in a personal computer.

Appendix 8
Gender and Teaching Positions

Gender

The gender biases that structure life in society at large also are important in the art world. Art school student populations have traditionally been at least half female, while art school faculties have until recently been overwhelmingly male. I asked informants to characterize artists on the roster as active (meaning they made work and tried to show it) or inactive. In St. Louis there are slightly more active male professional artists than female (of the 222 artists who are estimated to be active professionals, 55 percent are male and 45 percent female), while the larger group (of 812) they are drawn from is slightly more female than male (56 percent female). The data are shown in table A.2. Another way of looking at this data is that about one out of three of the male artists on the roster is active (34 percent), whereas between one out of four and one out of five of the female artists is active (22 percent).

How can the lesser professional involvement of women be explained? Why aren't the proportions of women the same in the smaller, more active group as in the larger population; that is, why aren't women artists as active as men? The usual explanation for differences in professional productivity is that women have additional responsibilities—child care, food preparation, house care, community and family responsibilities. It seems reasonable that women artists are less able than men to place their personal interest in making art ahead of these other claims on their time.

Teaching

Less than one in seven of the roster of artists (121 of 812) teaches regularly at the college level, and only 66 are lucky enough to have full-time faculty positions. The breakdown of teachers by gender is shown in table A.3. One hundred twenty-one art teachers compares to the total number of 115 art teachers in St. Louis's postsecondary education reported in McCall's study (1975, 38).[7] The trivial growth (5 percent) in faculty positions over seventeen years parallels the slow growth of the region's population (less than 3 percent from 1980 to 1990) and is evidence of Missouri's low-tax, low-service philosophy of education. One light shines (albeit dimly) in the comparison with McCall's study: she found only 17 percent of the full-time faculty to be female; the current figure is 27 percent. Washington University, the region's flagship school, has one female fine-art full pro-

Table A.2 Active and Nonactive Artists in St. Louis, by Gender

	MALE	FEMALE	TOTAL
Active	121	101	222
Nonactive	236	354	590
Total	357	455	812

Table A.3 College-Level Teachers in St. Louis, by Gender

	MALE	FEMALE	TOTAL
Part-time	30	25	55
Full-time	48	18	66
Total	78	43	121

fessor (out of six full professors) and one associate professor, to make two tenured female fine-art professors (out of eleven total). Counting visiting professors and lecturers, there were six female fine-art faculty in the 1992–93 academic year, out of the total fine-art faculty of twenty-one, teaching a student population that is typically two-thirds female on the undergraduate level and perhaps three-fifths female on the graduate level.[8]

Does St. Louis have many or few postsecondary teaching positions in comparison with other cities? The National Endowment for the Arts surveyed artists in Washington, D.C., San Francisco, Minneapolis, and Houston in 1978. Of these cities Minneapolis and Houston are closest to St. Louis in size of population. I estimate from this study that about 141 to 332 artists taught full- or part-time in Minneapolis, and from 80 to 188 in Houston (compared to the 115 reported by McCall

Table A.4 Postsecondary Teachers among Artists in 1978, Various Cities

	WASHINGTON	S.F.-OAKLAND	MINNEAPOLIS	HOUSTON
Artists[a]	1089	2200	693	459
Surveys mailed	516	521	693	459
Surveys returned	226	226	293	195
Estimated minimum number teaching[b]	83	98	141	80
Estimated maximum number teaching[c]	403	946	332	188

Source: Data from Orend and Sharon 1981.
[a]Sample derived from those having a one-person show within the last three years.
[b]Assumes those not answering question did not teach.
[c]Assumes the proportion of the sample who are teaching is the same as in the population.

for St. Louis). The data from the 1978 survey of artists (published in NEA 1984) are given in table A.4. Minnesota's political culture has always stressed the value of culture and education, so a figure higher than Houston's looks plausible. Texas seems more comparable to Missouri in its tax and social-service policies.[9] The St. Louis figures for artists teaching seem in line with this comparable data, given the temporal and regional differences in public services.[10]

Notes

Chapter One

1. Peter Watson's book (1992) on the history of the Western art market gives an eyewitness account of the excitement of this sale.

2. Only one painting sold during his lifetime.

3. The terms *regional artist* and *regional art market* are used in the contemporary art world to refer to persons and places outside of New York. The term *local art market* refers to the activities of people living in one metropolitan area.

4. I will use the word *art* to refer to visual fine art unless otherwise specified.

5. This figure includes all art auction sales, not just high art (Theran 1992).

6. The National Endowment for the Arts (NEA) derived the 1992 figure of 164 million from a national survey of arts participation (National Endowment for the Arts 1993). The data suggested an estimated audience of 50 million persons attended art museums or galleries an average of 3.3 times in the year.

7. The elite art dealer Arnold Glimcher, owner of Pace Gallery in New York, said a similar thing in salesman's language: "Artworks are worth much more than the prices that are put on them, or they're not worth anything. What is X million dollars next to this tool by which society sees differently, understands itself another way? These are the great mirrors of our time" (Schwartzman 1993, 33).

8. Writers in the art world relish multiple, open-ended interpretations. See the discussion of art speech in appendix 1.

9. If such a theory existed, an "expert system" computer program could be made that could distinguish high from low art on the basis of physical, visual characteristics alone. I know of no theory that would permit such a program to be made and tested. But the difference between the concepts of sociohistorical significance and aesthetic quality can be distinguished at least. The former deals with the art object's place in the evolving history of styles, while the latter denotes the work's intrinsic formal attributes. Thus a work of art of mediocre aesthetic quality may be extremely significant in the history of art because it is the first or clearest early example of a new style.

10. Classic statements of this position are found in Danto 1964 and Dickie 1975.

11. See the vignette of Lisa in chapter 4 for a typical young artist's opinion of her buyers. Modern artists continually try to free themselves from dependence on elites, an effort doomed to failure unless they abandon the private-sale market and specialize in grants, or else give up on showing their work in public. See Guilbaut 1983 for a discussion of art and politics in the New York art world in the early twentieth century.

12. *High* and *low* are subjective and ill-defined terms, and of course by definition all art gives an aesthetic experience to those people who care about it. For a reasonable discussion of how to define art in general, see Anderson 1992, for a brief statement, and Anderson 1990, for an extended treatment. For an interesting approach to the origin of the status differential between high and low art see Woodmansee 1994.

13. In popular usage the term *primary market* refers to the dealer's market in

which work moves from producer (artist) to dealer to consumer, while the term *secondary market* refers to previously owned goods moving from consumer to dealer to consumer (often through auctions). Economists use these terms to distinguish sales from producer to dealer as "primary," sales from dealer to consumer as "secondary," and resales from consumer to dealer to consumer as "tertiary."

14. An artist whose work is distributed by the Circle Gallery chain of popular-taste galleries.

15. I thank Daniel Newlon for pointing out the relevance of these economic models. He is not responsible for any misunderstanding professional economists may see in this discussion.

16. Goods susceptible to this sort of pricing are sometimes called *Veblen* goods, since the economist Thorstein Veblen's influential work on "conspicuous consumption," where buyers seek to pay more to display their financial strength (see Veblen 1934).

17. The only omission I see is of a measure of the elite standing of the major collectors of the artist's work. But since this would correlate highly with the elite nature of the gallery, the omission of a second "prestige brand name" variable is not critical. Moulin (1994) discusses the construction of art values in the market for contemporary art in France. She mentions the importance of "leader galleries," "mega-collectors," and international museums, often working together to manipulate the prices of star artists.

18. In truth the lines are "As on the finger of a thronèd queen / The basest jewel will be well esteemed" (Sonnet 96).

19. Another example is Andy Warhol's cookie jars, which sold at auction in 1988 after the pop artist's death for over two hundred thousand dollars. These were ordinary dime-store cookie jars that anyone could have bought for a fraction of the auction price.

20. If a competitive market is working right, the cost of materials and workmanship must be positively correlated with the price over the long run, even though the market prices of commodities are formally set by demand and not by production costs (i.e., material, labor). Although goods are sometimes sold below production costs—at flea markets and similar "distressed merchandise" outlets—this usually means that the goods have fallen out of the normal distribution system. The original manufacturers or some other distributors along the line must have suffered the loss. Normal or long-run prices in an open market must reflect production costs; otherwise, the enterprise will fail and the resources will be shifted to another use. This leaves aside the question of public subsidies for socially important goods and services such as transportation, defense, or strategic technologies.

21. Exceptions include sculptures, in which the materials (bronze, stainless steel, silver, etc.) govern a small part of the cost, and the correlation between size and cost within any artist's work.

22. See Schneider and Pommerehne 1983 and Frey and Pommerehne 1989a for a quantitative economic analysis explaining variations in art prices. Studies of art investment are summarized in appendix 3.

23. Except when the marketing is incorporated into the art in a self-consciously cynical or "camp" statement on art and markets. The most successful example is Jeff Koons (Littlejohn 1993). Other artists who have succeeded in getting their names in the media are J. S. G. Boggs (Roberts 1993) and Mark Kostabi (Marquis 1991, 38).

24. Paradoxically, for some art superstars of the excessive 1980s like Jeff Koons,

the smell of commerce in his slick, out-size commercial reproductions of items of kitsch popular culture made the work more attractive to collectors. They seem to have interpreted it as an ironical comment on the ethos of the times (Littlejohn 1993). Similarly the work of J. S. G. Boggs seems to be valued as a commentary on the meaning of money and commerce. Boggs's art consists of accurate life-size renderings of currency that he barters for commodities such as restaurant meals and even motor vehicles. The collectors purchase the rendered "currency" and the bill of sale or other documentation of the exchange (Roberts 1993).

25. While the importance of the integrity of the work is strongly articulated in art, this standard is not as exotic as it may seem. It is an extreme version of the value of personal integrity also maintained in other fields. Common moral standards criticize those who "sell out." But one factor that is more significant in some other fields than in art is task group cohesion, as opposed to individual independence of action. Lamont (1992), for example, points out that successful U.S. businessmen pride themselves on their flexibility and ability to submerge their personal interests for the good of the enterprise, while the French value personal integrity over group cohesion and task orientation.

26. The abstract expressionist painters of New York in the 1950s popularized a kind of public drunkenness and loutish social behavior that was connected to the artist status. The most famous case was Jackson Pollock, who died drunk in a automobile accident. The case of Basquiat is a terrible example of how deviant behavior is acceptable "in the service of creativity." The young Black artist became the darling of the avant-garde in New York during the 1980s and was coddled by dealers and collectors while his drug-addicted behavior became ever more bizarre, until he killed himself from an overdose (Marquis 1991). Andy Warhol's extraordinary social behavior was beloved by the media, from his ridiculous white wig to his deadpan verbal non sequiturs.

27. Following the cultural avant-garde status of artists, loft housing has become accepted and even admired by nonartists. Zukin (1989) gives an erudite and convincing analysis showing how artists are integral to a process whereby low-cost light industrial urban spaces are converted into high-cost professional housing. With the media popularization of artist personalities in the 1960s, artists' styles, such as casual dress at formal settings and "loft living," became legitimate for upscale consumers.

Chapter Two

1. This chapter relies on several valuable sources: Moulin 1987 and White and White 1965 on the history of the French art market to the 1960s; and Crane 1987, Watson 1992, and Marquis 1991 on the current American art market.

2. The discord created by this difference has a modern parallel in the tension between art as decoration and art as cultural statement, to be described in chapter 3 as the differences between the contemporary St. Louis Artists Guild and Art St. Louis societies.

3. For comparison, no U.S. metropolitan statistical area from the 1980 census with less than 2 million population had more than 2,250 artists, while most had less than 1,500. Most contemporary U.S. cities of that size also have fewer dealers.

4. "The name 'Impressionist' was in the great tradition of rebel names. Thrown at them initially as a gibe to . . . insult them, it was adopted by the group in defiance . . . and made into a winning pennant" (White and White 1965, 111). The Whites note that the writer who labeled them was Louis Leroy, in 1874.

5. This lesson did not apply to classical or "old-master" art, where the opinions of established experts are crucial.

6. For a fuller description, see White and White's book (1965) on this period.

7. Durand-Ruel, for example, founded a new journal of commentary on modern art, the Revue Internationale de l'Art et de la Curiosité in 1869. White and White point out that he "made sure his name did not appear in connection with the publication" (1965, 125).

8. It also taught mature collectors to be humble about their own snap judgments of artistic merit. One collector in his seventies admitted, "I frequently find that the new art of today, two years later, I like. It's always hard to say, 'Oh boy, this is rotten,' because then you have to eat your words a couple of years later" (int. 44).

9. Peter Watson makes the argument that the British Settled Lands Act of 1882 marks the beginning of the modern art market. The import of cheap U.S. grain caused British landed estates to lose market share, and their falling prices coincided with the exodus of rural labor for industrial work in cities. The Settled Lands Act allowed families to break their trusts and sell assets, including old-master paintings, in order to raise capital. These were sold to the American rich, thus closing the circle of exchange of U.S. corn for European culture.

10. This "five year itch" of rich female gallery owners is a common occurrence. In St. Louis all the galleries opened by wealthy women followed this pattern, give or take a few years.

11. Marquis (1991) describes Scull's paying sixty thousand dollars to fund a documentary film on the auction, which she describes as a "circus."

12. The estimate is based on averaging two years of data broken down by subfield given in National Endowment for the Arts 1990, 1992.

13. Crane analyzed only those institutions whose date of origin between 1900 and 1979 she was able to ascertain, excluding museums in New York City.

14. Until it was closed in 1994, a victim of the declining profits of the company.

15. Information in this section is from Marquis 1991, 76–79.

16. Some states have passed laws compelling galleries to have publicly available prices, but this does not mean that the actual selling prices are public. They are confidential.

17. Common usage denotes dealer sales as the primary market and any resales after purchase from a dealer as the secondary market.

Chapter Three

1. *St. Louis* will refer to the metropolitan area consisting of St. Louis city and county, St. Charles County, and adjacent parts of southern Illinois, including the cities of East St. Louis, Alton, and other parts of St. Clair and Madison Counties. When *St. Louis* is used to refer to the city apart from the county this usage will be clearly specified.

2. The vast territory including Missouri was sold to the United States by the Louisiana Purchase of 1803. Although culturally French, New Orleans was formally a Spanish city until 1800, when it was given to France.

3. St. Louis's strategic location was foreshadowed a thousand years before in Cahokia Mounds, the largest Indian settlement in North America, with a population larger than London's at the time. The site is located nearby in Illinois to the northeast of St. Louis.

4. The source used for population and per capita personal income is the 1991 *Statistical Abstract of the United States*. Additional information about per capita economic output is from a regional planning group, the East-West Gateway Coordinating Council (EWGCC). Their booklet, *Where We Stand* (December 1992), lists St. Louis as twelfth in population, rather than seventeenth. The EWGCC does not use the highest-level Census Bureau category of Consolidated Metropolitan Statistical Area (CMSA) and focuses on the two smaller categories included in the CMSA, the Metropolitan Statistical Area and Primary Metropolitan Statistical Area. The difference can be dramatic. San Francisco is ranked twentieth in the EWGCC document, which separates it from Oakland and San Jose, while the *Statistical Abstract* ranks the San Francisco CMSA fourth largest. I will give rankings using both approaches here.

5. The arch, which has become symbolic of St. Louis, was designed by Eero Saarinen and inaugurated in 1965.

6. Primm cites Wyatt Belcher's book *The Economic Rivalry between St. Louis and Chicago, 1850–1880* (New York, 1943) as an influential statement of the myth.

7. Complaints about the conservatism of galleries and collectors are typical in most cities. The 1981 NEA study of artists in four cities, San Francisco, Washington, D.C., Minneapolis, and Houston, stated "With the possible exception of San Francisco, artists in all cities considered the galleries, and, to a large extent, the museums which show local artists, to be conservative in the selection of works for exhibition" (25).

8. The political structure of the metropolitan area is complex, with the city of St. Louis bounded by the Mississippi River to the east and St. Louis County to the west. The metropolitan area has the extraordinary number of 692 local government units, making regional coordination difficult. The city has lost population and wealth to the county, with urban growth proceeding west across the Missouri River to St. Charles County.

9. East St. Louis was the site of a race riot in 1917, when striking white workers at the Aluminum Ore Company murdered forty-seven people, mainly black workers imported to break the strike, wounded hundreds more, and burned three hundred houses.

10. In 1994 two major art dealers left their cheap city spaces to relocate in Clayton, while two new galleries opened next to them to form a new arts center.

11. These communities have the right to close off their streets to restrict entrance and are responsible for street maintenance themselves, while also enjoying regional fire, ambulance, and police services.

12. Portfolio is run by a dedicated cultural entrepreneur, funded by grants from local agencies. The facility offers classes to local children, and like other cultural institutions focused on African-American society has very limited relations with the larger arts community.

13. SoHo is the South of Houston neighborhood in New York City that became the center for contemporary arts in the 1960s. Sharon Zukin (1989) and Charles Simpson (1981) provide excellent studies of the neighborhood.

14. The school's collections were placed in Steinberg Hall, forming a separate museum on campus, in 1960.

15. Dean Kenneth Hudson's tenure was 1938–69.

16. More recently Arthur Osver and James McGarrell, both retired, have national and international reputations in painting.

17. Lucian Krukowski.

18. In studio art, the M.F.A. has been a "terminal" degree, equivalent to the Ph.D. in academic fields. With the dramatic academic institutionalization of art in the United States in recent times, some programs may institute a Ph.D. program in studio art, to lay claim to an academic status comparable to their colleagues'.

19. Similarly, the Museum of Modern Art and the Whitney Museum in New York always felt themselves in the shadow of the Metropolitan (Tompkins 1973, chap. 22).

20. A national survey conducted for the National Endowment for the Arts in 1992 found an all-time high of 27 percent of respondents reported visiting an art museum or gallery at least once during the previous year (National Endowment for the Arts 1993). Thus three out of four Americans have no contact with the high-art world. The question of who "owns" and therefore should pay for museums has a long history. One argument is that the cultural heritage in museums belongs to everyone, and that the museum should be free and open to all. In particular, poor people should not be impeded from access because of entrance fees. This is countered by the argument that full tax support forces everyone to pay for the pleasure of a small elite. Napoleon III argued this point in 1855: "Rather than forcing everyone to pay for something which benefits only a part of the nation, let it be paid voluntarily by those who enjoy its advantages. In the last analysis, someone always pays. To let the cost fall on the State rather than on the public which enjoys the Exposition is to make everyone pay for it in taxes, the provincial artisan or farmer as well as the Parisians, although the former derive no immediate benefit from it" (quoted in Mainardi 1987, 44).

21. Art museums have included cafes since the Paris Salon of 1857 (Mainardi 1990, 158).

22. In 1971 the state legislature established the Metropolitan Zoological Park and Museum District, which receives a portion of local property taxes. The taxing district was expanded in 1983 to include a science museum and a botanical gardens. In 1992 this support amounted to $8.7 million for the SLAM.

23. The SLAM inflates its visitor figures by counting schoolchildren coming in for multiple sessions of a course as independent visitors. One local critic of the museum described it this way: "If six hundred kids come for twelve times each, the museum counts this as 7,200 people-visits" (int. 47). In fairness, all museums inflate their visitor counts this way (Meyer 1979). In comparison, the Metropolitan Museum of Art attracted over 4 million visitors in the early 1980s, the MOMA around 1.5 million at the same time. The Met's membership was just under one hundred thousand in 1990 when it recorded 4.4 million admissions, with an operating income of $75 million (Balfe and Cassilly 1993, 124). By the early 1990s the Met's attendance was over 5 million (Marquis 1991, 319, 327).

24. The collector is Mrs. Emily Pulitzer, who with her husband Joseph Pulitzer owns the most extensive collection of modern art in St. Louis. Mrs. Pulitzer was a curator at the SLAM before her marriage and was the active director of the Forum.

25. Cumulative gift total (St. Louis Art Museum 1991, 1992).

26. Bourdieu's argument is that museums serve to attribute artistic appreciation to innate abilities, when such appreciation is really due to an educational system in the service of the privileged. His studies of European museums focus on difficulties of access that make undereducated people feel incapable of appreciating art: "if the love of art is the clear mark of the chosen, separating, by an invisible and insuperable barrier,

those who are touched by it from those who have not received this grace, it is understandable that in the tiniest details of their morphology and their organization, museums betray their true function, which is to reinforce for some the feeling of belonging and for others the feeling of exclusion. . . . The museum presents to all as a public heritage the monuments of a past splendor. . . . [This is] false generosity, since free entry is also optional entry, reserved for those who, equipped with the ability to appropriate the works of art, have the privilege of making use of this freedom, and who thence find themselves legitimated in their privilege, that is, in their ownership of the means of appropriation of cultural goods" (Bourdieu and Darbel 1990, 112–13; see also Zolberg 1981).

27. Net museum shop income was $600,000 in 1991 and $695,000 in 1992 (St. Louis Art Museum financial statements, 1991 and 1992).

28. David Halle's study (1993) of the art found in a sample of homes in the New York metropolitan area presents a sophisticated discussion of "class and culture."

29. Alluding to a museum of contemporary art, the couple referred to the situation in Chicago, where a group of wealthy collectors who felt disaffected from the Art Institute (the local dominant museum) formed a new Museum of Contemporary Art. This would be extremely unlikely in St. Louis because of its smaller population.

30. In 1992 the Friends organization raised $280,000 for the museum's education program by scheduling a large social event called "Le Bal Rouge."

31. Laumeier Sculpture Park is not the only outstanding new cultural institution in the area. Its growth and national acclaim was reminiscent of the St. Louis Opera Theater, a chamber-opera enterprise with similar goals and characteristics of combining emerging art with established work in a relatively intimate scale.

32. This list includes Halsey Ives, the first director of the Washington University School of Fine Arts and in 1909 the first director of the City Art Museum (precursor to the SLAM), Fred Carpenter, Fred Conway, Siegfried Reinhardt, and more recently Arthur Osver.

33. Only two hundred of the Guild's members qualify as "artists."

34. The Guild was active in receiving support for its programs from local government agencies: the Regional Arts Commission, the Missouri Arts Council, and the Arts and Education Council.

35. Since the SLAM, zoo, and science museum are in their own taxing district, they are not eligible for RAC funding.

36. The 1980 census separated Nassau and Suffolk counties from the New York SMSA, but these were one unit in the 1970 census. The figures given here include the Nassau-Suffolk figures in the 1980 total.

Chapter Four

1. I follow the sociologist Diana Crane in this use of the term. Crane defines the avant-garde as "a cohesive group of artists who have a strong commitment to iconoclastic aesthetic values and who reject both popular culture and middle-class life-style. According to the prototype, these artists differ from artists who produce popular art in the content of their works, the social backgrounds of the audience that appreciates them, and the nature of the organizations in which these works are displayed and sold" (1987, 1).

2. Deep down, perhaps subconsciously, many artists believe their work expands the cultural vision, accomplishing the vital goal ascribed to art by Simpson in

chapter 1. But the self-mandated imperative to produce art, no matter what, whether it ever sells or not, is a key criterion.

3. This a generalization. Some rare hobbyists do grapple with high-art issues in their work but spend a relatively trivial amount of time at it and have little status in the art world. See McCall's "B.F.A. Mothers," below.

4. McCall also distinguished two other types, "Old Style—Serious, Dedicated by Different Standards" and "Art as Self Expression," both of whom I would call "hobbyists" because of their lack of involvement in high-art institutions.

5. The Census Bureau's definition was "Painters, sculptors, craft artists, artist printmakers" (NEA 1994, table 18).

6. As an example of the problems involved in estimating an exact number of artists, near the end of the period of field research I went to a low-level art fair at a county park. In among the stalls selling kitsch was a painter with realistic paintings that reflected considerable technical skill. The artist lived in a far southwestern suburb, was about thirty years old, and had studied commercial art in a community college in Kansas City. He had information sheets for children's art classes in his home, charging $125 for ten lessons. He had been supporting himself for five years by teaching in his neighborhood, and selling about a dozen paintings a year in as many art fairs as he could find locally. He belonged to no artist institutions and had no circle of artist friends. In terms of the kind of art he produced, he qualified as a business artist. The artist was invisible to the art institutions in town, yet clearly was a presence in his local community.

7. They included faculty at local schools who had been involved in the art world for a long time and people active in Art St. Louis and in the Artists Guild.

8. The wonderful British movie *The Horse's Mouth,* based on the book by Joyce Cary, is a classic portrayal of this aspect of an artist's life.

9. Students in the 1980s sometimes felt that this fantasy career was waiting for them upon graduation. The best students felt that their art-school acclaim, when matured with the hard work they were prepared to put into their art after graduation, would quickly yield elite gallery representation, solo shows and a good income. The extremely few that this actually happened to, like Basquiat, who earned a six-figure income in his twenties, were inspiration for the many. Since the bust in the art market students' expectations have become more realistic.

10. All names used in the text are fictional except where last names are provided. In these few cases interviewees understood that they would be quoted directly.

11. This artist had lived in Europe and was consciously imitating a European model of a living-room studio, in contrast to the American model of an industrial-loft workspace.

12. The museum did not sell his work, but after his show, the work returned to his local gallery, where it all sold.

13. Artists can debate this issue far into the night, posturing about how resistant they will be to the siren call of cash to debase and cheapen their work. Lisa is one of the few actually faced with an opportunity.

14. The word decorative is often used critically to denote artwork that is trite or without the consciousness-expanding attributes that high art is supposed to have. In another usage of the word, most people would describe both Flora's and Sam's work as "decorative," in the sense of being undemanding and pleasing to look at, yet it was displayed in high-art settings.

15. An extremely successful art fair has been held in Clayton since this field-work.

16. Magnificent three-story homes in this neighborhood typically sold for less than $50,000 in the 1960s.

17. The artist's signature is supposed to mean that the printer's duplicate, which is variable because it is handmade, meets the artist's standards for faithful reproduction. The signature is meaningless on a machine-made reproduction, where the ten-thousandth image is identical to the first, unless the signer is so famous that it is the connection to their persona rather than the work itself that gives value.

18. As a Catholic brother, he has no private funds, but the order maintains an art account that receives sales money and pays his expenses.

Chapter Five

1. The list was derived from the *Art in America* annual listing (which does not charge institutions for listing their information), the *St. Louis Gallery Guide* (which is published by the local gallery association and charges $175 per year for the listing), and local newspaper advertisements of exhibitions.

2. The ranking includes two private dealers who handle local artists on occasion, but whose primary business is selling high-end prints. Since these dealers do not have exhibitions, they are not included in this discussion.

3. I will use the word *dealer* to refer to all types of dealers and gallerists, since no one really uses the latter term in conversation.

4. For example, an article in the *New York Times Sunday Magazine* on the success of Arnold Glimcher of New York's Pace Gallery says, "Many of his stable would probably agree with Julian Schnabel when he said, 'I feel like he loves me'" (Schwartzman 1993).

5. The importance of enduring relationships notwithstanding, both remember that, after all, as an elderly artist put it, "You know, . . . it's just a business arrangement, it's not for life" (int. 5).

6. The Martin Lawrence chain was similar (Marquis 1992).

7. This complaint is common. A Los Angeles dealer in business for fourteen years complained that "collectors are the 'weakest link' in the Los Angeles art scene." Another dealer remarked, "A lot of the collectors I used to sell to no longer buy, although I'd have to put collectors in quotes" (Smith 1992).

8. New York has several vanity galleries whose owners will rent their space to artists who pay the bills for the period of the show. One St. Louis sculptor from a wealthy family had such a New York show, at a cost of ten thousand dollars, including shipping, rental, magazine advertising (the magazine "guaranteed a review if you bought an ad"), and the rental of display pedestals for the work. Several lower-ranking galleries in St. Louis will sometimes rent a portion or all of their space to artists who will pay for their shows.

9. Up until the 1980s the prevailing dealer commission was 40 percent, but recently the dealers established the 50 percent rate across the country. Some New York galleries now have a 60 percent commission.

10. Dream dealers or gallerists take on more financial responsibilities such as photographing and documenting the artist's work, soliciting publications, and placing the work in museum and other shows.

11. Gallery owners often have a fluid boundary between their personal collec-

tions and the gallery's stock, moving pieces back and forth as circumstances change. Some dealers are criticized for going into business merely to build a personal collection.

12. She referred to the St. Louis Volunteer Lawyers and Accountants for the Arts, described in chapter 3.

13. She followed the five-year gallery pattern of many wealthy supporters of the arts, including Peggy Guggenheim. As one experienced local artist put it, "Lots of rich ladies who open galleries think that it's having shows and parties, and they don't have a clue that they should push artists and build careers." This person suggested that the five-year period was because the IRS will not allow losses to be deducted for more than five years (int. 106).

14. This is the situation for the vast number of artists whose work is not investment quality. The few artists whose work is expensive are in a different situation. The 1992–93 news stories about New York artist Peter Halley indicate the difference. The Sonnabend Gallery (owned by Castelli's former wife) sued the Gagosian Gallery and Halley for breach of contract when Halley left Sonnabend and signed on with Gagosian. The artist had been receiving a stipend of $40,000 per month from Sonnabend and took a number of artworks from Sonnabend to Gagosian for an exhibition. Sonnabend claimed they had presold the works, before their own show, and claimed losses, accusing Gagosian of luring the artist with a $2,000,000 bonus. The case was settled out of court, with the artist paying Sonnabend $162,500 (Vogel 1993).

15. Print (or any art multiple) production involves three economic actors: the artist, who is responsible for creating the image in a medium like lithography or etching; the master printer who is in charge of printing the agreed upon number of copies (edition) of the image in exact duplicate; and the publisher, who funds the process, paying the artist's and printer's expenses for the job. In any specific case these three roles can be filled by the same person, or can be complicated by the involvement of groups. The publisher can be independent, for example an individual, a dealer, or a consortium of investors, or else the artist or printer can publish the print (i.e., fund the production costs) separately or together. At the end of the production process the edition is divided according to prearranged agreement between the three parties, any of whom can put their prints on the market.

16. This seems to confound the point made above that print market prices are more established than prices for painting or sculpture. But the established price is for a print of standard quality early in the sales history of the edition, when there are substitutes available. As the particular specimen becomes more nearly unique, its price becomes less predictable, which is what the dealer was referring to.

17. Most editions of handmade, fine-art prints are less than two hundred. More machine-intensive reproductions, which can be superb in quality but are not to be confused with handmade reproductions, can be in the thousands.

18. With modern high-quality reproduction techniques, relatively ignorant buyers, and rising prices, the potential for fraud is obvious. In 1992, *Art and Antiques* reported police exposure of a multi-million-dollar business distributing fake prints by Picasso, Dalí, Chagall, and Miró. In 1991 federal agents seized over 75,000 fakes, "thus cutting off the world's largest supplier of fraudulent prints" (Sadeh 1992, 18).

19. See the case of the Lichtenstein poster scandal in chapter 2.

20. One was a lawyer who resolved his midlife crisis by becoming a print dealer;

another was married to a wealthy physician; a third was the child of a successful real-estate developer.

21. In the next year he showed the work of a local artist, a sign that he was considering becoming a full gallery.

22. Dealers often have contracts with artists stipulating their interest in non-gallery sales, whereas designers have no such contracts with dealers. The economic logic underlying the contract claim is the gallery's role in legitimating value.

Chapter Six

1. Alsop (1982) gives an overview of collecting as an elite activity throughout art history. Halle (1993) describes the social and cultural functions of art in the homes of a sample of upper- to working-class homes in and around New York City.

2. See Crane 1987, table 6.2, for data on auction prices by art style in painting. Some collectors find themselves driven out of painting and into art crafts by the high prices. They shift their collecting into newly emerging art-craft areas where they feel that they get more "masterpiece" value for their dollar: "Now I can buy a pot for five thousand dollars [made by] one of the three or four world's top ceramists. Do you see? Now, not that painting is not worth that on today's market, and I don't mean to denigrate the work in terms of decreasing the price, but by comparison there is a disproportionate value of the dollar in the market. And . . . we can acquire masterpieces in clay that we could not acquire in painting" (int. 86).

3. The academic studies commonly explain less than two-thirds of the variation in prices, and the largest portion of the explanation usually involves the previous prices, which is really a circular explanation. See the discussion in appendix 3.

4. Singer (1990) found that only one in three artists whose careers began with shows in elite galleries made it to the auction market, a reasonable definition of artistic market success. Of course the vast majority of artists never show work in elite galleries.

5. The price level at which resale value is assured, usually above ten or twenty thousand dollars (depending on whether the item is a multiple or an original and the width of that artist's market), is significant. A St. Louis painter who was extremely successful selling paintings and prints that were nationally distributed through frame shop galleries, work that would be considered slick and purely decorative by the avant-garde, complained that elite dealers spoiled his market with talk of resale: "[A potential buyer would have] already seen my work, they'll go and check me out. They like the work. Maybe [the potential buyer] will go to somebody like [an elite local gallery] and will say 'What do you think about [the artist]?' [The elite local gallery] is going to go, 'Never heard of him.' And [the gallery] will say, 'What are you going to pay for his work?' and they'll go, 'seven or eight thousand dollars.' And he'll go, 'Why would you do that? Why don't you just buy a Motherwell?' And they will look at it, and they'll go, 'But we don't like this.' So he is a gallery that is selling investment, and not whether you can live with the piece or not. But he has almost cost me about two or three sales. The same thing with [another local elite dealer], that's another one" (int. 116).

By distributing his work through a national chain of frame shop dealers and poster print publishers this artist had succeeded in raising his prices to a fairly high level. Dealers could justify his prices with reference to magazine articles and records of comparable sales, but his reputation was not established in the avant-garde art world.

The elite dealer was shocked that someone would pay that much for work that had no art-historical value, while the artist's interest lay in customers' spending any amount for the pure consumer pleasure of having his work.

6. Not all collectors want their purchases advertised by dealers. A collector of local art, with none of the pretension to national significance of the collector just quoted, complained about a local dealer: "I had bought a piece from [a local dealer], and later some friends of mine were in his gallery, looking at similar work. He didn't know that they were friends of mine, and he said, '[She] bought one of these.' I feel it was wrong of him to advertise my name, to trade on my name like that. I don't feel [the dealer] can be trusted (int. 96).

Chapter Seven

1. Recall the econometric studies of art prices summarized in chapter 1 and appendix 3, which explained relatively little of the variation in prices of different artists.

2. Most "emerging" work from New York has no resale value either, but the buyers can feel that the potential for significance is there and they are gambling with history.

3. Helman reported this in an interview (de Coppet and Jones 1984).

Appendixes 5–8

1. See the discussion of Immanuel Kant's position that "true art" must be an end in itself, with no useful purpose, in Alsop 1982, 489 n. 11.

2. Sharon Zukin gives an excellent explanation of the forces operating in this sort of neighborhood development in her 1989 book on SoHo.

3. This measure will be inaccurate, insofar as I have determined that a significant number of exhibition spaces are not listed in the AiA Annual. It will be biased toward those artists who intend to sell their work on the gallery market, omitting artists who sell only at art fairs or who do not sell at all. Thus, the numbers I am reporting are minimal numbers. See appendix 6 for a discussion of these issues.

4. Anaheim-Santa Ana had so few spaces per artist it was off the chart.

5. An NEA study of artists in Washington, D.C., San Francisco, Minneapolis, and Houston in the late 1970s found that Washington had the highest proportion of female artists, 66 percent, in contrast to 49 percent, 42 percent, and 49 percent for the other three cities, respectively (NEA 1981, table 3.3). At that time the proportion of female artists nationally was around 47 percent (NEA 1992, chart 2-4, data for 1983).

6. The list obviously omits those artists who do not believe in showing their work or those who are unsuccessful at showing their work in galleries. Insofar as they are not dealing with the art market, this omission is not important to this study. The omission of artists whose primary sales are at art fairs is a problem, but without a comparable ethnographic study in other locations, comparison is not possible.

7. McCall does not break this figure down into full- and part-time but does break down a subset of 90 of the 115 (1975, 60). There we see that 8 of 48 full-time and 8 of 42 part-time teachers were female.

8. The ratio of one female to two male faculty is at odds with the enrollment in M.F.A. programs in painting, where women consistently total between 55 percent and 60 percent of the degrees (NEA 1990, table 3-42; 1992, table 3-4).

9. This statement compares data from Texas in the 1970s with data from St.

Louis in the 1990s. In both states the educational establishments were in a growth pattern in the earlier period and a fiscal crisis in the latter time. Nationally there was a growth of about 20 percent in the number of B.A.s and 27 percent in the number of M.F.A.'s over that period of time (NEA 1990, table 3-40b).

10. Low-tax states may also have more private schools, which may offer teaching opportunities for artists below the college level. About half a dozen artists in St. Louis teach in local private secondary schools.

References

Adler, Moshe. 1985. "Stardom and Talent." *American Economic Review* 75: 208–12.

Akerlof, George. 1970. "The Market for 'Lemons': Quality Uncertainty and the Market Mechanism." *Quarterly Journal of Economics* 84:488–500.

Alpers, Svetlana. 1988. *Rembrandt's Enterprise.* Chicago: University of Chicago Press.

Alsop, Joseph. 1982. *The Rare Art Traditions: A History of Art Collecting and Its Linked Phenomena Wherever These Have Appeared.* New York: Harper and Row.

Anderson, Richard L. 1990. *Calliope's Sisters: A Comparative Study of Philosophies of Art.* Englewood Cliffs, N.J.: Prentice-Hall.

———. 1992. "Do Other Cultures Have 'Art'?" *American Anthropologist* 94: 926–29.

Ashton, Dore. 1973. *The New York School.* New York: Viking.

Balfe, Judith H., and Thomas Cassilly. 1993. "'Friends of . . . ': Individual Patronage through Arts Institutions." In *Paying the Piper: Causes and Consequences of Art Patronage,* ed. Judith H. Balfe. Urbana: University of Illinois Press.

Baumol, William. 1986. "Unnatural Value of Art Investment as Floating Crap Game." *American Economic Review Papers and Proceedings* 76 (May): 10–16.

Becker, Howard S. 1982. *Art Worlds.* Berkeley and Los Angeles: University of California Press.

Bourdieu, Pierre. 1984. *Distinction: A Social Critique of the Judgment of Taste.* Trans. Richard Nice. Cambridge: Harvard University Press.

Bourdieu, Pierre, and Alain Darbel. 1990. *The Love of Art: European Art Museums and Their Public.* Stanford: Stanford University Press.

Brumfiel, Elizabeth. 1987. "Elite and Utilitarian Crafts in the Aztec State." In *Specialization, Exchange, and Complex Societies,* ed. E. M. Brumfiel and T. K. Earle. Cambridge: Cambridge University Press.

Cabeen, Lou. "This Way Be Dragons." 1993. *New Art Examiner.* September, pp. 13–15.

Crane, Diana. 1987. *The Transformation of the Avant-Garde.* Chicago: University of Chicago Press.

Csikszentmihalyi, Mihaly, Jacob Getzels, and Stephen P. Kahn. 1984. *Talent and Achievement: A Longitudinal Study of Artists.* Report to the Spencer Foundation and the MacArthur Foundation. Chicago: University of Chicago.

Dannhaeuser, Norbert. 1989. "Marketing in Developing Urban Areas." In *Economic Anthropology,* ed. Stuart Plattner. Stanford: Stanford University Press.

Danto, Arthur. 1964. "The Artworld." *Journal of Philosophy* 61:571–84.

de Coppet, Laura, and Alan Jones. 1984. *The Art Dealers: The Powers behind the Scene Tell How the Art World Really Works.* New York: Potter.

Decker, Andrew. 1990. "Museum Print Mix-Up." *Art and Auction,* December, pp. 32–33.

Defty, Sally Bixby. 1979. *The First 100 Years: Washington University School of Fine Arts, 1879–1979.* St. Louis: Washington University.

Dickie, George. 1975. *Art and the Aesthetic: An Institutional Analysis.* Ithaca: Cornell University Press.

Faherty, William Barnaby, S.J. 1990. *St. Louis—a Concise History.* St. Louis: St. Louis Convention and Visitors Commission.

Feld, Alan, Michael O'hare, and J. Mark Davidson Schuster. 1983. *Patrons Despite Themselves: Taxpayers and Art Policy.* A Twentieth Century Fund Report. New York: New York University Press.

Frey, Bruno S., and Werner W. Pommerehne. 1989a. "Art Investment: An Empirical Enquiry." *Southern Economic Journal* 56:396–409.

———. 1989b. *Muses and Markets: Explorations in the Economics of the Arts.* Cambridge, Mass.: Basil Blackwell.

Gans, Herbert. 1971. *Popular Culture and High Culture: An Analysis and Evaluation of Taste.* New York: Basic Books.

Gardner, Paul. 1992. "An Extraordinary Gift of Art from Ordinary People." *Smithsonian,* October, pp. 124–32.

Goetzmann, William. 1993. "Accounting for Taste: Art and the Financial Markets over Three Centuries." *American Economic Review* 83, no. 5:1370–76.

Granovetter, Mark. 1973. "The Strength of Weak Ties." *American Journal of Sociology* 78:360–80.

———. 1985. "Economic Action and Social Structure: The Problem of Embeddedness." *American Journal of Sociology* 91:481–510.

Guilbaut, Serge. 1983. *How New York Stole the Idea of Modern Art: Abstract Expressionism, Freedom, and the Cold War.* Trans. Arthur Goldhammer. Chicago: University of Chicago Press.

Halle, David. 1993. *Inside Culture: Art and Class in the American Home.* Chicago: University of Chicago Press.

Helms, Mary W. 1993. *Craft and the Kingly Ideal: Art, Trade, and Power.* Austin: University of Texas Press.

Holub, H. W., M. Hutter, and G. Tappeiner. 1993. "Light and Shadow in Art Price Computation." *Journal of Cultural Economics* 17:49–69.

Hughes, Robert. 1990. *Nothing If Not Critical.* New York: Knopf.

———. 1991. *The Shock of the New.* New York: Knopf.

Kotler, Philip. 1980. *Principles of Marketing.* Englewood Cliffs, N.J.: Prentice-Hall.

Lamont, Michele. 1992. *Money, Morals, and Merit.* Chicago: University of Chicago Press.

Lazear, Edward P., and Sherwin Rosen. 1981. "Rank-Order Tournaments as Optimum Labor Contracts." *Journal of Political Economy* 89, no. 5:841–64.

Liebenstein, Harvey. 1950. "Bandwagon, Snob, and Veblen Effects in the Theory of Consumer Demand." *Quarterly Journal of Economics* 64:183–207.

Littlejohn, David. 1993. "Who Is Jeff Koons and Why Are People Saying Such Terrible Things about Him?" *Artnews,* April, pp. 91–94.

Mainardi, Patricia. 1987. *Art and Politics of the Second Empire: The Universal Exhibitions of 1855 and 1867.* New Haven: Yale University Press.

———. 1990. "Some Stellar Moments in the History of Government-Sponsored Exhibitions." *Art in America,* July, pp. 154–59.

Marquis, Alice Goldfarb. 1991. *The Art Biz: The Covert World of Collectors, Dealers, Auction Houses, Museums, and Critics.* Chicago: Contemporary Books.

———. 1992. "Mall-to-Mall Art: Is It 'Schlock' or What?" Paper given at the annual meeting of the Popular Culture Association.

Martorella, Rosanne. 1990. *Corporate Art.* New Brunswick, N.J.: Rutgers University Press.

McCall, Michal. 1975. "The Sociology of Female Artists: A Study of Female Painters, Sculptors, and Printmakers in St. Louis." Ph.D. diss., University of Illinois.

———. 1977. "Art without a Market: Creating Artistic Value in a Provincial Art World." *Symbolic Interaction* 1:32–43.

———. 1978. "The Sociology of Female Artists." *Studies in Symbolic Interaction* 1:289–318.

McGarrell, James. 1986. Interview. *New Art Examiner,* June, p. 12.

Meyer, Karl E. 1979. *The Art Museum: Money, Power, Ethics.* New York: Morrow.

Moulin, Raymonde. 1987. *The French Art Market: A Sociological View.* Trans. Arthur Goldhammer. New Brunswick, N.J.: Rutgers University Press.

———. 1994. "The Construction of Art Values." *International Sociology* 9, no. 1:5–12.

Muchnic, Suzanne. 1993. "An 'Unexplainable Mania.'" *Artnews,* April, p. 24.

National Endowment for the Arts. 1981. *The Economic Conditions and Exhibition Processes of Artists in Four Cities.* Washington, D.C.: NEA, Research Division.

———. 1984. *Visual Artists in Houston, Minneapolis, Washington, and San Francisco: Earnings and Exhibition Opportunities.* Research Division Report No. 18, October. Washington, D.C.: NEA.

———. 1990. *A Sourcebook of Arts Statistics: 1989.* Washington, D.C.: NEA, Research Division.

———. 1992. *Addendum to the 1989 Sourcebook of Arts Statistics.* Washington, D.C.: NEA, Research Division.

———. 1993. *Arts Participation in America, 1982–1992.* Research Division Report No. 27, October. Washington, D.C.: NEA.

———. 1994. *Trends in Artist Occupations: 1970–1990.* Research Division Report No. 29, August. Washington, D.C.: NEA.

Nochlin, Linda. 1988. *Women, Art, and Power and Other Essays.* New York: Harper and Row.

Orend, Richard, and Batia Sharon. 1981. *The Economic Conditions and Exhibition Processes of Artists in Four Cities.* Final report PO-81-1. Prepared for the NEA.

Pesando, James. 1993. "Art as an Investment: The Market for Modern Prints." *American Economic Review* 83, no. 5:1075–89.

Peterson, Richard. 1976. "The Production of Culture." *American Behavioral Scientist* 19, no. 6:669–84.

Plattner, Stuart, ed. 1985. *Markets and Marketing*. Monographs in Economic Anthropology, no. 4. Lanham, Md.: University Press of America for the Society for Economic Anthropology.

———, ed. 1989. *Economic Anthropology*. Stanford: Stanford University Press.

Price, Sally. 1989. *Primitive Art in Civilized Places*. Chicago: University of Chicago Press.

Primm, James Neal. 1981. *Lion of the Valley: St. Louis, Missouri*. Western Urban History series, vol. 3. Boulder, Colo.: Pruett.

Reitlinger, Gerald. 1961. *The Economics of Taste: The Rise and Fall of the Picture Market, 1760–1960*. Vol. 1. New York: Holt, Rinehart and Winston.

Roberts, Roxanne. 1993. "Funny-Money Artist Loses Court Case." 1993. *Washington Post,* December 10, p. B13.

Rosen, Sherwin. 1981. "The Economics of Superstars." *American Economic Review* 71, no. 5:845–58.

Rosenbaum, Lee. 1993. "If It's Not Popular, That's Just Too Bad." *New York Times,* March 7, p. H33.

Sadeh, Deidre Stein. 1992. "Fakers Foiled." *Art and Antiques,* April, p. 18.

St. Louis Art Museum. 1991. *Annual Report.*

———. 1992. *Annual Report.*

Schneider, Friederich, and Werner Pommerehne. 1983. "Analyzing the Market of Works of Contemporary Fine Arts: An Exploratory Study." *Journal of Cultural Economics* 7:41–67.

Schwartzman, Allan. 1993. "Can I Interest You in a Schnabel, Mr. Ovitz?" *New York Times Sunday Magazine,* October 3, pp. 31–50.

Simpson, Charles R. 1981. *SoHo: The Artist in the City*. Chicago: University of Chicago Press.

Singer, Leslie P. 1978. "Microeconomics of the Art Market." *Journal of Cultural Economics* 2:21–40.

———. 1988. "Phenomenology and Economics of Art Markets: An Art Historical Perspective." *Journal of Cultural Economics* 12:27–40.

———. 1990. "The Utility of Art versus Fair Bets in the Investment Market." *Journal of Cultural Economics* 14:1–13.

Smith, Charles. 1989. *Auctions: The Social Construction of Value*. Berkeley and Los Angeles: University of California Press.

Smith, Roberta. 1992. "The Los Angeles Art World's New Image." *New York Times,* December 29, pp. B1–2.

Solomon, Deborah. 1993. "The Art World Bust." *New York Times Sunday Magazine,* February 28, pp. 28–34.

Theran, Susan. 1992. *Leonard's Annual Price Index of Art Auctions*. Vol. 12, September 1991–August 1992. Newton, Mass.: Auction Index.

Tompkins, Calvin. 1973. *Merchants and Masterpieces: The Story of the Metropolitan Museum of Art*. New York: Dutton.

Towse, Ruth. 1992. "The Earnings of Singers: An Economic Analysis." In *Cultural Economics,* ed. Ruth Towse and Abdul Khakee. Berlin: Springer-Verlag.

Tucci, Linda. 1992. "Burke's Law." *St. Louis Magazine,* March, pp. 38–62.

Tully, Jedd. 1994. "Auctions: No Records for Moderns at Sotheby's." *Washington Post,* November 9, p. D2.

Veblen, Thorstein. 1934. *The Theory of the Leisure Class.* New York: Random House.

Warhol, Andy, and Pat Hackett. 1980. *Popism: The Warhol '60s.* New York: Harcourt Brace Jovanovich.

Watson, Peter. 1992. *From Manet to Manhattan: The Rise of the Modern Art Market.* New York: Random House.

White, Harrison C., and Cynthia A. White. 1965. Canvases and Careers: Institutional Change in the French Painting World. New York: Wiley.

Wolf, Eric. 1982. *Europe and the People without History.* Berkeley and Los Angeles: University of California Press.

Woodmansee, Martha. 1994. *The Author, Art, and the Market.* New York: Columbia University Press.

Wylie, Charles. 1993. Brochure for Jonathan White Currents 53 show, St. Louis Art Museum, March.

Zolberg, Vera L. 1981. "Conflicting Visions in American Art Museums." *Theory and Society* 10:103–25.

Vogel, Carol. 1993. "The Art Market." *New York Times,* June 11, p. C18.

Zukin, Sharon. 1989. *Loft Living: Culture and Capital in Urban Change.* Baltimore: Johns Hopkins University Press. Originally published in 1982 by Rutgers University Press.

Index